THE DIGITAL DESIGNER

101 Graphic Design Projects for Print, the Web, Multimedia & Motion Graphics

Stephen Pite

THOMSON

DELMAR LEARNING ™

Australia Canada Mexico Singapore Spain United Kingdom United States

THOMSON

DELMAR LEARNING

The Digital Designer
101 Graphic Design Projects for Print, the Web, Multimedia & Motion Graphics
Stephen Pite

Business Unit Executive:
Alar Elken

Executive Editor:
Sandy Clark

Acquisitions Editor:
James Gish

Editorial Assistant:
Jaimie Wetzel

Developmental Editor:
Jennifer Thompson

Executive Marketing Manager:
Maura Theriault

Channel Manager:
Fair Huntoon

Marketing Coordinator:
Sarena Douglass

Executive Production Manager:
Mary Ellen Black

Production Manager:
Larry Main

Production Editor:
Tom Stover

Cover Designer:
Stephen Pite

Library of Congress Cataloging-in-Publication Data

Pite, Stephen.
 The digital designer : 101 graphic design projects for print, the Web,
multimedia, and motion graphics / Stephen Pite.
 p. cm.
 Includes index.
 ISBN 0-7668-7347-1
 1. Computer graphics. 2. Digital media. I. Title.
 T385 .P515 2002
 006.6--dc21

 2002009208

NOTICE TO THE READER

Dedication

This book constitutes a collaborative forum. It offers an entry point into a process in which innovation and communication are continuously refined. Its focus is design education. This project is dedicated to the faculty and students who helped realize its potential.

Preface

Intended Audience

The Digital Designer, 101 Graphic Design Projects for Print, the Web, Multimedia & Motion Graphics intends—first and foremost—to be a companion text for design teachers and learners. It is a useful reference book designed to accompany instruction in any class where the opportunity for portfolio pieces and professional projects are the focus of engagement.

This text is written for those actively engaged in design education and for those who might like to be. It introduces real projects in ways that can extend classroom discussion, reinforce design direction and offer alternatives. It can be helpful to those currently enrolled in college design programs, and will serve as a valuable reference book during the first years of professional practice.

Approach

Over 101 design projects, *The Digital Designer* takes a contemporary "How to. . . Think" approach, and combines it with an exploration of research methods and design strategies that communicate visually and solve business needs. It comes with examples of college student design work, selected from hundreds of submissions from across the country, and articles by college design faculty on professional perspectives that extend the boundaries of contemporary design discussion. The 101 project launches help design students expand their understanding of the discipline and refine their research methods

The Digital Designer makes some fundamental assumptions about the direction of graphic design in the early 21st century, and reflects new ways of thinking about how and why humans communicate and the methods they use to do so. In part, the digital information systems in which we all find ourselves engaged are at the root of the change, hence the title of this book.

The Digital Designer addresses a growing sensitivity in graphic design praxis that new definitions of the ways in which we organize our economic interactions, systematize our decision-making, and create and maintain our culture offer alternatives to the hierarchical systems, unilateral communications strategies, and cultural universalities that informed graphic design in the past. *The Digital Designer* embraces these changes and traces their impact on the methods, practices, and technologies of contemporary graphic design.

By integrating the challenges that inform contemporary graphic communication with focused and practical projects, *The Digital Designer* serves as an informative map to both traditional and contemporary approaches to print media and new broadcast media. It is a map that recognizes their distinctions, but that situates these within a geography that reinforces their similarities. *The Digital Designer* is inclusive and expansive in its philosophy, its design direction, and in its structure as a collaborative project.

From its very beginning, *The Digital Designer* embraced a collaborative approach. The development of the project included the direct participation of literally hundreds of graphic design students and faculty from throughout the United States. The idea was to offer visual evidence that dynamic design programs across the American college landscape are contributing to a new direction in graphic design.

Using This Book

Following an introduction to the intentions and methods of the graphic designer, the text is divided into two sections: Design for Print and Design for New Media, corresponding to the primary media of graphic design, ink on paper, and the new broadcast media of the Internet and digital video.

These sections are further divided into areas of specialization that correspond to the basic divisions in the industry. For Print: Corporate Communications, Entertainment Design, Advertising Design, Editorial Design, Information Design, and 3-D Design; for New Media: Interactive CD-ROM authoring, Web Design, and Motion Graphics. Within each section there can be found numerous projects that range from the simple to the complex, building one upon the next over the course of the section. For instance, the Corporate Communications section opens with logo design, moves through promotional brochures to annual reports, and closes with branding and identity; the Web design section opens with a splash page project, moves through interactive elements to web animation, and closes with a 'zine project. Each project is a stand-alone opportunity for young designers to build their "idea-ization" skills, to challenge their design methods, and to help guide the research process that results in the art and craft of good design.

Key Features

- Student contributions form the visual material of this book. The range and quality of the student design samples submitted during the development of *The Digital Designer* point to some of the important and dynamic changes that have occurred in the field of graphic design and perhaps suggest some directions for future developments. Approximately 250 projects were selected in the end, submitted by 180 students.

- In addition to the 101 graphic design projects, text articles submitted by design faculty who are also professional practitioners are included. These articles look at specific areas of the expanding field of graphic design and sketch some emerging trends, suggest some practical approaches, and share some successful educational strategies.

- Each project includes a Key Ideas section, re-enforcing important concepts

About the Author

My professional work began in advertising design. Over the past 27 years this work has included pharmaceutical and technology products, cultural and educational programs, and film and music promotions. I have managed institutional identity and marketing campaigns for colleges, corporate think tanks, and specialized service firms. I have worked with both large and small publishing houses, and have been selected for web and motion graphics projects as those fields emerged. Over that same time I have taught at the Southern California Institute of Architecture in Los Angeles, the University of Kansas Schools of Architecture and Education, and the Kansas City Art Institute, and I have created design programs where some of the ideas represented in this text were initiated at Briarcliffe College on Long Island and at the Katharine Gibbs School in New York City.

It has been my experience that a significant contribution to the quality of American visual communications occurs through the college classroom where creativity is tempered with reflection, and where definitions of quality emerge under the direction of leading practitioners. *The Digital Designer* project is a glimpse into those college design studios where dedicated professionals, committed to teaching well, are making a difference.

Stephen Pite
New York, NY
2002

Acknowledgements

The author and Publisher would like to thank the following individuals for their insightful comments and suggestions:

Meryl Esptein
Art Institute at Phoenix
Phoenix, AZ

Tom Knights
Northern Arizona University
Flagstaff, AZ

Sherri Taylor
Syracuse University
Syracuse, NY

Contents

SECTION II • DESIGN FOR NEW MEDIA

Design Method

Design method consists of five interrelated parts: discipline, discovery, design, development, and deployment. *Discipline* is fundamental to most skills. In this case it refers to a general approach to problem solving that combines intuitive thinking with strategic thinking. *Discovery* is the research that uncovers the depth and breadth of the business problem at hand. *Design* refers to the creative process whereby our ideas take shape. *Development* refers to the interplay of feedback and refinement. *Deployment* consists of preparing a product for reproduction and distribution.

Discipline

Design discipline has two aspects. The first is the effort to stay focused on the project at hand; the second is the commitment to following the steps of design method. *Focus* means listening to one's own intuition, while consciously seeking out new ideas and innovative approaches; embracing opportunities for growth as a design professional; and respecting the client's intentions, preferences, and desires. *Commitment* means acquiring and using the patience to find the essential concerns of the project, to complete the research thoroughly, and to proceed self-critically through each step of the design process.

Discovery

The first step in any design project is research. Become intimately knowledgeable about the company, people, products and services, past practices, market share, reputation, complaints, awards, strategic partners, and competitors that your client deals with every day. Then research previous design practices at your client's firm, and study design strategies within your client's industry. Be sure to do some historical research related to the product, company, and industry.

Develop your own research tools. Think of the kind of information that would be helpful in formulating a design strategy and develop interview questions, surveys, focus group formats, and other forms of data collection that will help you create innovative solutions. Use your client's products or services. Look at how other companies in your client's industry are "imaged."

Design

At its most basic level, design combines an almost instinctual ability to recognize and create pattern, formulate goals, and craft strategies for achieving them. Do not be intimidated by the blank page. If you are a visual communicator and have done your research, you can design. This book, however, is designed to help you design better.

Design starts with an idea. This idea is informed by the conflict between a desired goal and a present circumstance. The design itself must try to resolve that conflict in specific and appropriate ways. To start, you will develop a strategy to meet your client's needs, such as expanding market share, launching a new product or service, or promoting a public image.

Your research will determine some of the forms you will use, and will suggest some of the visual cues as well. Your client's budget, time frame, and past experiences with designers will act as the project's design constraints. Your design elements will be your typeface choices (fonts), colors, shapes, lines, and textures; your structure will be your composition. We will explore these in detail for each of the projects you will encounter in this book.

Strategic thinking in this field is collaborative. At the very least, you and your client will engage in a dialogue and ultimately you will engage the tastes and preferences of your target market to achieve design communication. In many cases, your design projects will involve other professionals: photographers, illustrators, Web programmers, printers, service bureau staff, market research specialists, public relations professionals—maybe even a financial controller or two.

There comes a point, however, where the design decisions are yours and yours alone. As you think about your projects you will make thumbnails or sketches of various ideas. Some will be successful, some will not. Some may be initially attractive solutions that later on turn out to be dead ends. In any case, be open, think deeply, and sketch, sketch, sketch. Give your mind visual treats by seeking environments that stimulate, inspire, and relax. Fully immerse your mind's eye in the project and seek visual references and influences from varied sources.

As your thumbnails develop, you will see patterns in your visual thinking. Follow these ideas to their ends, work in series, and be sure your ideas can carry over the entire breadth of the project. Sometimes it is a good idea to take wildly alternate routes when they present themselves. You

might purposely try radically alternate tacks such as rotating your principal composition 45 or 90 degrees, changing the dominant colors to their complementary hues, changing from serif fonts to sans serif fonts, or adjusting format size. In other words, try not to become captive to the initial decisions you made about design elements. If they are worthwhile, you will come back to them.

Development

In this stage, all the ideas, strategies, and design elements begin to take form and interact as one visual unit. This in and of itself is a pleasurable experience and you will begin to see the design work pay off as the pieces fall into place, take on new dimensions, and activate new relationships within your composition. However, this stage also presents new challenges. It is here, in development, that your visual hierarchy takes its first road test. It is here that you will learn whether your project achieves its goals and communicates effectively—or not!

You will need to review your decisions about primary, secondary, and tertiary elements. Is the tagline the first place the eye travels? Or does it go to the principal image or some other element? Does the composition enhance or inhibit the visual trip around the page? Does the message say what it was intended to say about the product or service, and does that message satisfy the client's needs? This is not about your own visual entertainment, but about the serious business decisions made by your client and about the mysterious ways in which the public will engage your message. Ultimately, you have to ask, "Does it work?" If the answer is "No," then ask "Why not?" and face the challenge of revising the patterns of elements that affect the message.

Deployment

One of the very first things to do when you begin to move out of the thumbnail stage is call your printer. Seek professional guidance and input from the very beginning of the project. If you do this, you will save time and develop good business relationships as well. If your project will eventually go to the Web, CD-ROM, or video, it's wise to check with other professionals on compatibility issues, technical questions, and project timelines. You would not make a major business decision before checking with an accountant and a lawyer, so why would you make one for your client without consulting other professionals?

Be sure that you craft your project to the very best of your ability, and always try to learn something new with each project. Push yourself to be rigorous, inquisitive, and demanding. Designers need to pay attention to each pixel, every line, shade, and nuance. Never settle in this area. It costs no more to do a job well than to do it half-heartedly, and professionals strive for perfection. This is both our burden and our responsibility. It must also be our reward because no one—when all is said and done—can pay us for our art. We are paid for our time, our ideas, and our craft.

Katrina Peerbolte
University of Wisconsin—La Crosse

▲ KEY IDEAS

- Design method consists of five interrelated parts: discipline, discovery, design, development, and deployment.
- Discipline refers to a general approach to problem solving that combines intuitive thinking with strategic thinking.
- Discovery is the research that uncovers the depth and breadth of the business problem at hand.
- Design refers to the creative process through which ideas take shape.
- Development refers to the interplay of feedback and refinement.
- Deployment consists of preparing the design product for reproduction and distribution.

Getting Started

There is general agreement that one of the most difficult steps for the young designer on any project is getting started. Although this is understandable, it comes mostly from a lack of discipline in using the design method. Once you have begun research, ideas will come to you. The real issue will become how to be selective, not where to begin. The primary means of crafting your design ideas remains the thumbnail. Thumbnails can be expanded into roughs and then further polished into comprehensive renderings (comps). All this can be done by hand before you ever get to the computer-generated design, or you can go from thumbnails to computer comps. It all depends on your style. The point is to develop a sound methodology and stick with it. The following section takes you through the principal steps in turning your inspiration into a finished design that works.

Thumbnails

One of the fundamental benefits of this book is that with each design opportunity, you will push yourself to explore something you have never attempted before, learn new skills by challenging yourself, and apply the method and rigor requisite to become a professional. Thumbnails are a great way to explore a new approach. They facilitate innovative approaches to the basic task at hand: the integration of text and image in the promotion of goods and services.

Ideas will come up during the research phase of any design project. If they do not, you are either on a very wrong track or you need some sleep! Keep your sketchbook nearby, jot ideas down, and then continue research. Eventually, you will shift from cognitive research to design research. This is where the fun starts. Try every good idea that comes into your mind. Work out the details. Do not throw anything away, and every once in a while, go back over all the thumbnails you have created for the project. Try to get a sense of where your creative mind is going. Become a critical observer.

Thumbnails are sketches. They should indicate the basic architecture of your design choices. They should indicate the formal design elements of texture, line, color, and shape. They should include basic type and image—even if you draw with stick figures. They should clarify the essential composition and visual hierarchy of your design strategy. They are not a substitute for computer-generated products, nor do they involve font choice or image manipulation

in any significant way. They indicate basic layout at approximate scale. They provide an opportunity for creative exploration at minimal cost, free from any limits imposed by your knowledge of software.

For any project, a minimum of thirty thumbnails is probably a good target. Generally, I attempt three or four very different approaches, and develop twenty to thirty thumbnails for each. Work in series and take the basic design concept as far as you can to be sure it can fulfill all the aspects of the project and that you have exhausted all the possibilities. Obviously, you will reject more than you keep, but eventually you will pick one or two ideas or three or four elements to combine into two or three different approaches to the design problem. This is when you can progress to roughs.

Thumbnails are methods for expanding your visual thinking. The creative technology of the pencil (invented about 1545 A.D.) allows free rein to the design process. It is the ultimate laptop: fast, portable, unlimited storage, and very user friendly. The important thing here is that you will never have a blank page for long. The thumbnail is a way to free your mind while you engage your design project from multiple perspectives.

Create a ritual out of the thumbnail process and you will get amazing results. If you skip the thumbnail step, your design will be constrained by your computer knowledge. Design method is about control: controlling your design choices to fit the client's needs and to achieve the very best that you can within those parameters. If you give creative control up to your computer knowledge, you have let technology take over your mind!

Roughs

Roughs are where your design begins to take on final form. Having explored your design choices in thumbnail form, you can now select two or three basic versions to develop into roughs.

One important distinction between roughs and thumbnails is that while thumbnails can be approximate in scale, roughs should be exact. Draw out your rough to precise measurements so that you can visualize your design elements and composition. Next, make some decisions about your color palette and secure the proper coloring tools. Markers are best, but oil pastels, colored pencils, and even construction paper can get you on your way. Assuming that you have also made some basic type choices, print out your copy in various typefaces from your computer. Then integrate the copy into your rough.

Move the design elements around, try various shades of your color palette, and explore your typeface choices. When all the elements are brought together to your satisfaction, fix them with rubber cement. Your rough will become a pasteup of what you will be executing, in finer detail, on the computer.

Composition and Grid

There are three basic compositional strategies: a grid with elements arranged at 90-degree angles to the edge of the page, a grid with design elements arranged at 45-degree angles to the edge of the page or, a grid with design elements arranged around a center point.

The 45- and 90-degree grids key off of the outside dimensions of the format you are working with; say an 8" by 10" rectangle or a 4.75" by 4.75" square. The 90-degree grid will align all design elements in reference to evenly spaced vertical and horizontal guides that intersect each other at 90 degrees and at regular intervals. The same is true of the 45-degree grid, except that the guides fall 45 degrees from the height/width intersection of the outside of your format.

The grid that proceeds from the center point of your format and expands, at regular intervals, as far as you want to take it has developed from Web and video media. Content producers cannot predetermine the size of the monitor used for viewing a Web design or the size of the television (TV) screen their motion graphics might be seen on. Think of the design implications as you compare the viewing area of a handheld TV with a drive-in movie projection screen. Center-point composition is used extensively in entertainment design.

You will want to revisit the compositional strategies you chose at the early stage of your design by visually reviewing the grid you developed in your thumbnails and roughs. The easiest way is to abstract your rough to its basic geometric elements, and then rearrange them by changing the compositional grid to see the effect on your type placement, image placement, and basic design hierarchy. You may decide to stay with things just the way they are, or you may discover an entirely new approach.

It is wise to bring your client back into the picture by presenting your final roughs and getting some feedback. This is a good occasion for input and direction and for general review of the project. One of the primary concerns for the designer is to get some feedback on design choices early on in the

process—but not so early as to create chaos and confusion. Wait until you have some finished roughs that you are happy with before you get direct client input that you might have to live with for the rest of the project.

Visual Hierarchy

Every successful design will have primary, secondary, and tertiary elements. These form the vocabulary of your design communication. The place where the viewer's eye goes first, second, and third; the path it takes to do that; and the visual information a viewer's eye encounters along that path constitutes the syntax of your design communication.

Review each design strategy by exploring the following questions:

- Do the primary visual elements lead the viewer into the design, offer the most important information, and create the emotional response that you want?

- What design elements (lines, composition, shapes, textures, etc.) lead the viewer to the secondary elements?

- Does the secondary visual message reinforce the primary message and enhance the overall impact of the design?

- How does the viewer encounter the tertiary elements, and do those elements support the primary and secondary elements and messages?

Too often conflicting information in the design confuses and detracts. Even if you are satisfied with your finished design, break your messaging down one more time to see if you can improve on any part and create a more effective communication.

After your client has approved your basic approach, take your rough and use it to start your computer-generated design. Remember that at all times you will need to stay alert to the possibility for serendipitous accident, create time for inspired innovation, seek constructive input from other professionals and your client, and craft your work beyond your current abilities. The time for translation of the rough into the computer-generated design is full of creative opportunity. If you take this stage for granted, then you will have nothing but a frustrating experience, or end up creating a "flat" design.

Be sure you keep a selection of your thumbnails and roughs. When the project is over and successfully launched into the world, bind them into a book and keep them in your portfolio. Art directors have become increasingly interested in looking at the steps leading up to the finished project when they interview prospective employees. Your thumbnails and roughs are a very good way to help them understand your creative process.

Comps

Comping refers to comprehensive rendering. In the old days, advertising concepts were drawn out in significant detail on tracing paper, called tissue, with markers. This was a highly evolved skill; one that made deals. This kind of visual thinking in full color is communicative, emotive, and effective. You may still find classes on marker rendering techniques, but they are rare and comping is becoming a lost art.

For the purposes of this text, this skill now refers to what is designed in the computer. *Comps* here refers to the first generation of prints that help you see, feel, and make tangible your design. How is this different from your final design product? It is only a test of what the printing press, server, or video screen will offer once your product enters the professional world. Referring to this stage of design as "comping" is helpful because it reminds us that additional steps must be taken before that design will see the light of day.

Assuming that the final product is for the print medium, the first things you need to check are that you have converted to CMYK color space and have all the images (in the right file formats and resolution) and typefaces (PostScript, with both screen and printer fonts) associated with the design. Check for page alignment and carefully proofread your type yet again for consistency and spelling.

Your first comps should be printed in grayscale only. You can check for position, overlaps, and alignment without wasting the expensive cyan, yellow, and magenta toner cartridges. After you make the necessary adjustments, the next step is to print your work out in color. Immediately you will see that the stunning, vibrant colors you had on the monitor screen are now murky and dull. Remember that call you made to the printer? Now is a good time to take in your comps and discuss color correction, in terms of your stock choices, inks, and the specific press your work will be printed on. This is why they are called comps and not final design. Of course, you will have different production issues

if you are printing to video or posting to the Web. The point is that these first color prints are what you will present to your client for approval before you go to press (or Web or video), which is exactly the same function that the old comps served. It is an important moment and you will want to make the best impression you can. Nothing can replace craft, not even a good idea!

▲ KEY IDEAS

How to Start: Thumbnails

- Thumbnails facilitate innovative approaches.
- Thumbnails are methods for expanding your visual thinking.
- Thumbnails indicate the formal design elements of texture, line, color, and shape.
- Thumbnails indicate the essential composition and visual hierarchy of design strategies.
- Thumbnails indicate basic layout at approximate scale.

How to Start: Roughs

- Roughs are where a design begins to take on final form.
- Roughs should be drawn to precise measurements.
- Roughs organize design elements and composition.
- Roughs are a blueprint for digital design.

How to Start: Comps

- Comps are the translation of roughs into computer-generated designs.
- Comping is a huge creative opportunity.
- Comps are a test of what the printing press, the server, or video screen will offer.
- Your first comps should be printed in grayscale only; the second step is color.
- Final color corrections depend on stocks, inks, and press.

Professional Perspectives

Lisa Abendroth
Assistant Professor
The Metropolitan State College of Denver

Seeking Significance: A Design Process Research Methodology

Inquire. Search. Quest. Hunt. Rummage. Observe. Peruse. Examine. Study. Probe. Question. Investigate. Research.

Communication design is consumed with the solving of problems. Problem solving invites a question-and-answer dynamic in which we are relied upon for our expertise in knowing—knowing the answers to a design problem, and knowing how a design works formally and functionally, all guided by need and intended results. Research comes before the *search* for the *answer.* This section explores the important but often bypassed space that exists between the question and the search for the answer. Pursuing a design process research methodology is a way of beginning the search.

As designers we are required to learn. We frequently become experts not only in matters of design but also in the many and diverse fields of our clients. To gain knowledge about a given subject, we must conduct predesign study exploring the innermost center and outermost boundaries of the subject matter. This obligation of versatility is ours alone. We need to thoroughly understand the kaleidoscope that is our subject before we can transform any design into a solution fit for an audience. Creating understanding through inquiry is imperative if we are to be relied upon as translators of visual culture. We take information and extend meaning through form. However, a problem given to us by a client is only the first of many steps involved in moving toward an answer. It is our individual task to open the door to further inquiry for visual problem solving and research. As a creative collective, we must encourage research-oriented learning and observation—especially at the educational level, be it within a studio or a classroom setting. Through the use of specific research methodologies we can begin to establish our own manner of understanding, which is strategically aimed at the problem/answer dynamic.

The term *design* can function as either a noun or a verb. Context usually defines and clarifies its use. I tend to view the term in its most energetic state. I am simply attracted to the action of it all. I see design as a diligent focus on *manner, means,* or *method*—in other words, the process. There are many steps in the process, on the path from point A to point B, of any given project or assignment. Far too often, however, these points are simplistically translated into Concept (A) and Final Implementation (B), moving in a straight, linear fashion. The words *design process* then come to encompass the entirety of design. There is no one area which deserves more or less focus. The whole thing is one large process. But where lies the greatest emphasis? What is it that we spend the most time articulating and laboring over in search of perfection (if there is any such thing)? Let me suggest point B: the conclusion, the final implementation, and the formal application of color, type, and image to substrate. This is commonly viewed as the hottest part of design, and rightly so. It is where we have the opportunity to experiment formally, cut loose graphically, and really do what we do best. Now this is design! I have witnessed this with my undergraduate students, who commonly overemphasize realization of form. Unless given the proper tools, their formal realization often comes without a full and rich exploration of that which comes before. A concept "occurs," is accepted as the answer to the problem, and is promptly readied for implementation. There is a great willingness to uncritically accept the first viable concept that came to mind. Literally, these solutions seem to come from nowhere and are not or cannot be documented with any form of intentionality. Intention is especially relevant when it comes to presenting and explaining concepts to a client. This form of quick decision making, coupled with a general lack of initiative to push the design process forward, is detrimental to the final product, the client, and to us. Rich, multifaceted research practices that are established early on will support informed decision making and sound implementation all the way through the conclusion of the project.

As early as 1940, James Webb Young described a series of steps we may use on our journey to the final product of designed artifact. His small book, entitled *A Technique for Producing Ideas,* suggested a model for acquiring ideas through a research-oriented process: gathering of raw material (specific and general); mental digesting (synthesis a relationship between parts); incubation (letting the unconscious mind take over); birth of an idea (the "Eureka! I have it!" phase); and shaping of the idea (refining the form for implementation).[1] Others have also offered design process methodologies. Referred to as a "travel guide for travelers on design (creative problem solving) journeys,"

The Universal Traveler has proven to be an influential resource for many designers and students alike over the years.[2] In this practical guide, the authors introduce steps for creative problem solving, along with methods, explanations, and examples.

These texts and numerous others put the focus on distinct methodologies for design problem solving and research. However playfully stated, Young's phases attempt to detail what we do in the approach to implementation, through a defined process. Building on these and other proposals for observation, learning, and problem solving, I shift the focus of design process to that which occurs prior to arriving at a concept. I term this activity, which demands a meaningful approach, *Seeking Significance.* The processes of define, search, map, respond, and discover all precede arrival at a concept and directly affect the final design implementation. Seeking Significance is crucial to realizing an answer to a design problem. Drawing inspiration from other methodologies, I see Seeking Significance not as a linear model but as a circular design that can be explored from multiple directions. Bending back on itself, it is reflexive—phases can be repeated or rearranged as necessary to accommodate one's own processes. A methodology of goal-oriented analysis can improve our existing manner of thinking as we delve into the issue of a research method for the design process.

The following paragraphs provide a brief overview of each process phase, presented as an integral component of Seeking Significance. Visual examples are provided to better bridge the gap between theory and practice.

Define

The phase called *define* is concerned with establishing a base understanding of the design problem. The problem should not change once it has been defined, although the facts surrounding it will certainly grow and shift as we progress through preliminary research and view it from a multitude of points. The design brief is an instrumental tool used to break down the diverse components of a design problem. It is an outline, a written document based in truth and fact, and is concrete and denotative. The design brief is particularly useful when multiple members of a design team are involved in various phases or levels of a project and everyone needs to be informed of the same criteria. It can be a living document that expands over time when more is learned about the problem and/or client. A design brief may include, but is not limited to, the following components: project title and participants, project background or overview, design problem identification, client's product/service analysis, audience considerations,

I recently worked with a client who was in need of a visual identity. The project overview from my design brief reads:

Eden Designs is a small, privately owned metalsmithing and jewelry design studio run by a single proprietor. The client requires the creation of a visual identity and accompanying print system that represents his work as a fine custom jeweler operating in Santa Fe, New Mexico.

A portion of my problem identification statement reads:

The client wishes to be seen by his audience as an artisan who takes pride in the quality and originality of his one-of-a-kind silver and gold designs. The visual identity and related system pieces need to reflect and extend these attributes in addition to making the name Eden Designs an integral and relevant component of the design solution.

historical and social contexts, positioning and strategy, and pragmatic concerns such as budgetary limitations and timing.[3] If developing a comprehensive design brief seems too large a step at this point, begin by simply stating the project overview or problem-identification portions of the brief. These may consist of a few sentences each that cite project scope or limitations.

Search

The *search* comprises the physical and mental acts of information gathering— not just facts and data, but also visual elements related to the design problem. Collect information that is related to the problem directly as well as associatively, and conduct the gathering in as open and unbiased a fashion as possible. This is a fact-finding mission and as such is intended to reveal information and connections (both loose and concrete) at a variety of levels. This phase educates and informs. Now it is our job to learn.

We begin the process of unraveling and demystifying a design problem by gathering preexisting materials. Such items may include client, competitor, or content-related Web sites; annual reports; mission statements; capabilities brochures; general informational brochures; newspaper or magazine articles; and book references addressing specific areas of content related to the problem. Don't forget to take a trip to the library! It is also very useful to conduct interviews with individuals who may possess a unique point of view relative to the project. Whatever methods are used to gather information, this material constitutes your (preliminary) search and may be used throughout the rest of the following phases.

Map

In the *mapping* phase, you gather parts into a whole (synthesis) and then separate the whole into parts (analysis). The process of mapping content provides an opportunity to make connections that we might not otherwise have made, by connecting the familiar with the unfamiliar through association. The whole mass of

gathered facts, data, and other information is the raw representation of the search. This content allows us to draw broad-based conclusions about the explored subject (what the subject is basically about in an overview sense). Through synthesis we are able to view, in an expansive fashion, the variety of content perspectives, points of view, and relevant directions provided by the gathered material. Analysis, in contrast, allows distinct ideas, components, categories, and elements—both direct and associative—to rise to the surface. Analysis can allow unexpected yet tangible ideas to come forth as large pieces of content are broken down into smaller more digestible chunks. Synthesis and analysis can be explored through multiple expressions and in repeated scenarios. One method for working with the interplay between synthesis and analysis is called *mind mapping* or *concept mapping*.[4] Mapping pursues a building, associative process, which is not linear but rather circular in nature, much like the design process itself. It most clearly charts

My direct search for Eden Designs included gathering printed materials on the client's creative process (design methods, specific materials used, tools, working environment, etc.). I spent time with the client discussing his process, what clients he typically works for, and why. I came to know his designs and understand what made them unique and different from those of other jewelry designers in the area. I investigated resources that described the historical significance and meaning of the precious stones and metals he used in his work. I examined the relevance of color and shape of the materials used in his designs. Next I explored associative connections to his company name, Eden Designs. The name is intended to refer to the client's studio, located along the picturesque Turquoise Trail. The direct connection to this name is obvious: the Garden of Eden and its symbolic biblical references. What are the associative connections?

our nonlinear creative process, because of its ability to morph in multiple directions as new ideas through association are brought into context (see Figure A-1). Mapping is a highly effective and creative form of exploring relationships between and among aspects of a subject. Exploration may be text-based or image-based.

Respond

Respond is a reflective mode whereby we contemplate connections made within our mapping so that we can begin constructing powerful and relevant meaning. This is where meaningful connections mature in light of the design criteria outlined previously in the design brief. Responding allows us to explore the didactics of poetry and intuition, as well as strong, concrete ideas that simply need further exploration or refinements. This phase also relies upon strategy, logic, and intention as balanced by the needs of the design problem. It is the place where we can begin to get comfortable with honing certain mapping

connections, working toward a number of core concepts (as highlighted in Figure A-2). Core concepts are the most vibrant solutions that clearly resonate and answer the design problem. It may be within the "respond" phase that we make the greatest leaps conceptually. The mapping process has proceeded, and now we can focus on the truly unique ideas, which are expansive in nature. Use associative words that supply visual cues to make the mapping connections more accessible in terms of potential concepts. Make use of relevant found imagery (photos or illustrations) in place of associative words: this process may reveal unexpected design solutions.

Figure A-1

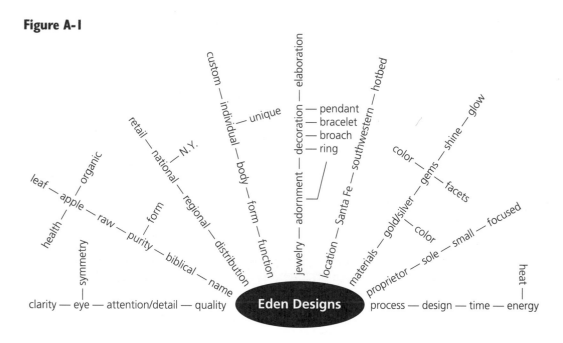

Discover

The *discover* phase is consumed with revealing and defining core concepts: Multiply intuition with design logic and balance it with the needs of the problem. When preparing solutions for a client, we frequently must present multiple directions, or show nuances of difference from one strategy to the next—or perhaps conceptual leaps have been made, as determined by the project. Whichever is the case, our final concepts must be expansive and explored beyond the periphery. In a final state, the solution must be informed and intelligent. This is why discovery is such a vital phase, because this is where we meet with multiple core concepts. We must *not* be satisfied with the first blush of a single valid idea. Our ideas must be diligently pursued—worked and pushed

Figure A-2

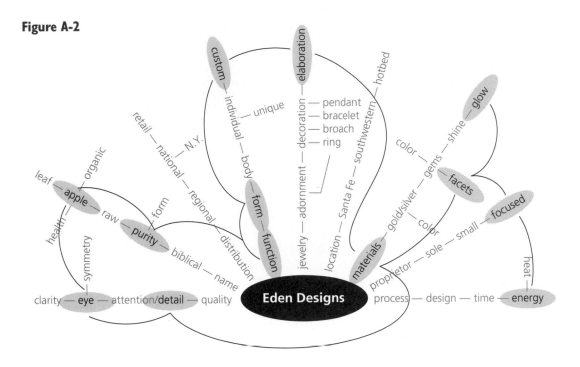

until they become more than their prior form, branching into yet other relevant directions (see Figure A-3). We have done much work and now, in the discover stage, it is time to refine and articulate suggestions of meaning and form into preliminary design solutions. This phase is a very visual stage, as it involves working out conceptual premises into valid visual solutions (see Figure A-4). In some cases, only a handful of primary conceptual directions may really solve the design problem. However, visually there will be various solutions that take the concept to different communicative levels. No articulate solution happens randomly. The "Eureka! I have it!" experience comes only from doing our homework, supported by a thorough investigation and research process.

Figure A-3

Figure A-4

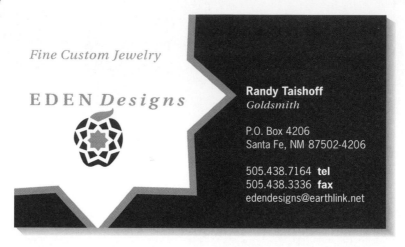

In the end, the best solutions come from a curiosity about the world around us—a natural inquisitive nature, which allows us to Seek Significance in our work, and solve research problems and design problems at the same time. This necessarily implies a commitment to a design research methodology and a subsequent shift in the meaning of *design process* to "that which occurs prior to the concept." I submit the Seeking Significance methodology as a simple model, which requires your definition, reshaping, and modification if it is to work explicitly for you. This is a creative process, after all, and any methodology of the kind requires customization to fit properly. So be inspired to inquire, search, quest, hunt, rummage, observe, peruse, examine, study, probe, question, investigate, and research. When you look back on the search, know that your answers came from a conscientious and diligent pursuit of the question.

Footnotes

1. James Webb Young. *A Technique for Producing Ideas* (Chicago: Advertising Publications, 1940, 1960).

2. Jim Bagnall and Don Koberg. *The Universal Traveler* (California: William Kaufmann, 1972, 1973).

3. Design brief elements as outlined by Professor Thomas Ockerse at the Rhode Island School of Design.

4. The term and process of mind mapping were originated by Tony Buzan.

Bibliography

Bagnall, Jim, and Don Koberg. *The Universal Traveler.* Los Altos, Cal.: William Kaufmann, 1972, 1973.

Dewey, John. *How We Think.* Chicago: Henry Regnery, 1931.

Gowin, D. Bob, and Joseph D. Novak. *Learning How to Learn.* Cambridge, Mass.: Cambridge University Press, 1984, 1986, 1988, 1989, 1990.

Greiner, Donna. *The Basics of Idea Generation.* New York: Quality Resources, 1997.

Jelinek, James J., G.D. McGrath, and Raymond E. Wochner. *Educational Research Methods.* New York: Ronald Press, 1963.

Langer, Ellen J. *The Power of Mindful Learning.* Cambridge, Mass.: Perseus Press, 1997.

Margulies, Nancy. *Mapping Inner Space.* Tucson, Ariz.: Zephyr Press, 1991.

Pietrasinski, Zbigniew. *The Art of Learning.* Warsaw: Wiedza Powszechna, 1961, 1969.

Ruggiero, Vincent Ryan. *The Art of Thinking.* New York: HarperCollins College Publishers, 1995.

Young, James Webb. *A Technique for Producing Ideas.* Chicago: Advertising Publications, 1940, 1960.

section one

Design for Print

chapter one

Identity, Collateral, and Corporate Communications

The design projects you will encounter in this chapter are the "meat and potatoes" of a design business. They are the kinds of projects you will get—and keep getting—throughout your professional career. As this chapter progresses, the projects move from simple business communication problems, such as logo design, to complex identity and branding campaigns. Many of these design solutions are predominantly typographic, especially in the beginning. As we move toward broader marketing concerns, the design strategies will incorporate the suggestive power, expressive personality, and contextual qualities that photography and complex imaging add to identity campaigns.

Logo Design

Logos—by definition and practice—are simple, direct, provocative visual statements about a person, product, or company. A logo is a unique graphic. It can be used on letterhead, on business cards, in advertisements, on products, on billboards, or even on novelty items such as give-away pens and buttons. Logos are often purely typographic. Think of them as word-pictures.

Because logos are high concept, they are also subject to a wide variety of interpretations. Think deeply and clearly; practice the "Tao" of logo design. In logo creation every design element can speak too boldly or too meekly—or just loudly enough. Quiet exaggeration is the key to this high-concept, intensely symbolic design problem.

Joe Lamarre
Metropolitan State College

Logos must be scaleable and fit a wide range of print, Web, and new media applications. Work in spot color so that you can keep the budget down. Develop your logo so that it communicates effectively at both a large scale (say, 2' × 2') and at small scale (say, 1/2" × 1/2").

Brady Bowers
University of Colorado at Denver

The designer's role is to create a visual bridge between the way the company sees itself—now and in the future—and the way the public thinks about the company's products or services. Because both sides of the communication equation are in flux, the logo can have a very real impact on the company's business success. Successful logo design depends on thorough research, with both company representatives and users of the product or service.

Start by finding out all you can about the subject at hand. Interview the relevant people. Ask not only about their impressions of the company, but also about what the company could or should be. Find out how the company is positioning itself. What are its strengths and weaknesses? How is it currently perceived in its market? How does it stand up to its competitors? Does it pride itself on its customer service, its product reliability, or its ability to individualize its services? Is your client a successful mom-and-pop operation with a loyal clientele that is looking for a larger market share, or taking on a big, national chain? Is it a medium-sized company ready to expand its business in a very competitive, fast-moving industry? Is there a breakthrough product that will position the company squarely at the center of innovative, cutting-edge technology?

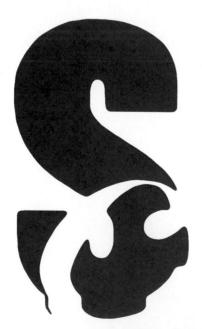

Cory Sova
Metropolitan State College

After you have convinced yourself that you know everything you need to know about the company and its products, services, and personnel, think in pictures. Look around you as

you go about your daily routines. Seek inspiration from the visual world you encounter in your everyday life. This is a good practice in general, and you will be surprised how effective it is. Your creative mind is "imaging" the logo even when you are not consciously dedicating time to the project; so keep your mind stimulated with interesting material!

Go out of your way to place yourself in the world of the consumer of the product or service you are addressing. Go to a relevant industry convention or product exhibit. Take in the noise, the hustle and bustle, and translate it into colors, shapes, and letterforms. Develop at least five different approaches. Then think how each design would look on a business card in a glass bowl, filled with a hundred competing companies' business cards.

The primary elements in any design are colors and shapes—in the form of letters. You are looking for a dynamic and appropriate way to convey the results of your research, combined with your own sensibilities and design strategy, into the company "mark"—permanent, indelible, and unique. This means that, conceptually, you will look to create an enticing and communicative symbol of the company that states its name, implies its business strategy, projects its self-image, and appeals to its target market's desires and aspirations.

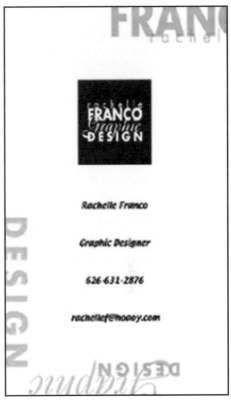

Rachelle Franco
California State University—Northridge

▲ KEY IDEAS

A logo is an enticing and communicative symbol of a company that states the company's name, implies its business strategy, projects its self-image, and appeals to its target market's desires and aspirations.

* Logos are evocative visual statements.
* Logos are word-pictures.
* Logos must be scaleable.
* Successful logo design depends on thorough research.

Logos and the Corporate Client

Large corporate clients will tend to lay claim both to broad, expansive markets and to conservative organizational structures and fiscal management practices. This leaves the designer with a dilemma: how to appeal to the dynamism of diverse, global markets while satisfying the conservative needs of the core organizational structure— which in this case probably includes

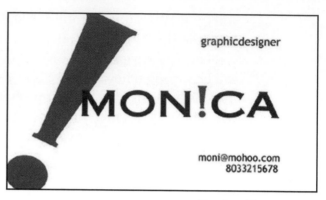

Monica Hernandez
California State University—Northridge

the decision makers who will approve (or not approve) your design. Tread lightly, and never underestimate even your most conservative client's ability to "get it" if you can explain your position. Of course, research plays a valuable role here, not only in identifying and developing design elements and strategies, but also in arguing design decisions.

Design research should develop from market research practices. Conduct interviews within the market research department so that you can hone your design approaches and collect the ammunition you will need to argue for the dynamic, innovative design you have come up with. Never take a combative approach. Design is a collaborative enterprise. Do your homework, develop your design strategies based on the results of that homework, and be prepared to defend your design choices with quantitative evidence as well as with your intuitive sensibilities. Pure typographic solutions can offer challenging innovation while retaining conservative design parameters, so think *Type* in these situations.

Your primary challenge will not, however, be the corporation's conservatism. They would not be speaking with you if they were not interested in changing their image. The greater challenge comes from the sheer complexity of many of today's corporations. They are often multiregional, if not multinational. They have broad product lines and address diverse markets; sometimes their reputation and public perception is part of the very history of the country they do business in. Many are trying to re-image themselves as major contributors to the world that we will come to live in: they use the future to market in the present. Time, and through time reputation, becomes a flexible, mediated

context within which stories, histories, and futures can be woven and brought into the marketing strategy.

It is here, in the strange mix of truth and fiction, that the designer can work best, interpreting past and future imagery in compelling and even dazzling ways. Interweave references to the past with suggestions of possible futures. Seek historical resources by referencing and researching design strategies across the industry and from its past.

▲ KEY IDEAS

- Many corporations are multiregional, if not multinational; have broad product lines; and address diverse markets.
- Time can be a flexible, mediated context within which new stories, histories, and futures can be woven and brought into the marketing strategy.
- Interweave references to the past with suggestions of the future.
- Seek historical resources.

Logos for Small Business

Small business success is generally due to flexibility and acuity, and these qualities are often found in the psychological makeup of a small business's chief officer. This is the person who calls most of the shots, so he or she will most likely be the one to approve your project. Use your research to get inside the mind of this persona.

Certainly an in-depth interview is required, even if it is conducted by e-mail. It is always good etiquette to furnish interview questions in advance of the meeting. You will also get better answers and fewer awkward moments. Craft your questions broadly so that you give your interviewee room to elaborate and expand, but also be specific as to business goals, market data, and strategic objectives.

Designers usually deal with a very hands-on manager with a strong personality and a vague vision of where the company is headed. *Vague* here means that some of the specifics are highly detailed, but the paths to achievement of goals, and the motivations underlying these goals, can be highly complex and even somewhat poetic. Yes, of course the director wants to turn a profit, but you may also discover

David Correll
Rocky Mountain College of Art and Design

that he or she has a need to help others, change the world, or be remembered forever! Early childhood challenges might still be hounding this director, driving his or her need to acquire an ever greater market share; or the director may find some altruistic motivation in the memory of some cherished individual. The fundamental contributor to small business growth is the market's belief that the director motivates, impacts, and informs the entire enterprise. This is a key concept to weave into your logo design.

▲ KEY IDEAS

- The fundamental contributor to small business growth is the market's equation equals the director with the entire enterprise, so research the mind of this persona.
- Logos should incorporate business goals, personalities, market data, and strategic objectives.

David Correll
Rocky Mountain College of Art and Design

Kalene Rivers
Rocky Mountain College of Art and Design

Institutional Logo Design

Institutions such as government agencies, museums, philanthropic organizations, hospitals, colleges, and other multidepartmental, service-oriented organizations, also have to make money. There may be profit even in nonprofits; it is just called "surplus" and its distribution is somewhat regulated. Marketing needs of institutions are not qualitatively different from those of for-profit corporations or small businesses, but the form and content of their marketing plans are.

Three important characteristics of institutions will affect design strategies. One, there is no product; these are service-only organizations. Two, institutions live and die on the quality and delivery of that service, which is almost exclusively delivered through people. Three, institutions are usually site-dependent, identified by physical buildings and/or natural environments. Would the Louvre be the Louvre anywhere but Paris? Would the CIA be anything but American? Would the Forbidden City ever exist without the complex iconography of feudal China?

Institutions are identified, enhanced, and made both practical and abstract by their users' vision of

Matthew Blackford
Concordia University—Nebraska

them. They are icons: two-dimensional mind-images waiting for the color of time, place, and use to define them in three-dimensional space. Without the user-defined reputation gained through usage, they are empty corridors of bureaucratic silence. Your logo, then, has to capture the public's imagination by breathing life into these conglomerates. Because these institutions are so dominant in the twenty-first–century landscape, your logo also has to distinguish one agency or bureau from another by imaging the intended quality and specific focus of its service.

Interview users and middle management, scrutinize the mission statement, and become familiar with the physical attributes of the site(s) and the institution's organizational structure. Historical research on institution archetypes will also help you to identify specific characteristics that individualize the institution. Pay attention to colors and architectural features, record them with a photographic study, watch circulation flows and information displays: in short, find key elements to build your logo with and approach its design in an architectonic way.

▲ KEY IDEAS

- Institutions create no product; they are service-only organizations that deliver their services through people.
- Institutions are often site-dependent.
- Logos image the intended quality and specific focus of institutional service.
- Use historical research, architectural features, circulation flows, and information displays to help you build an institutional logo in an architectonic way.

CONCORDIA ADMINISTRATIVE INFORMATION SYSTEM

Rachel Leising
Concordia University—Nebraska

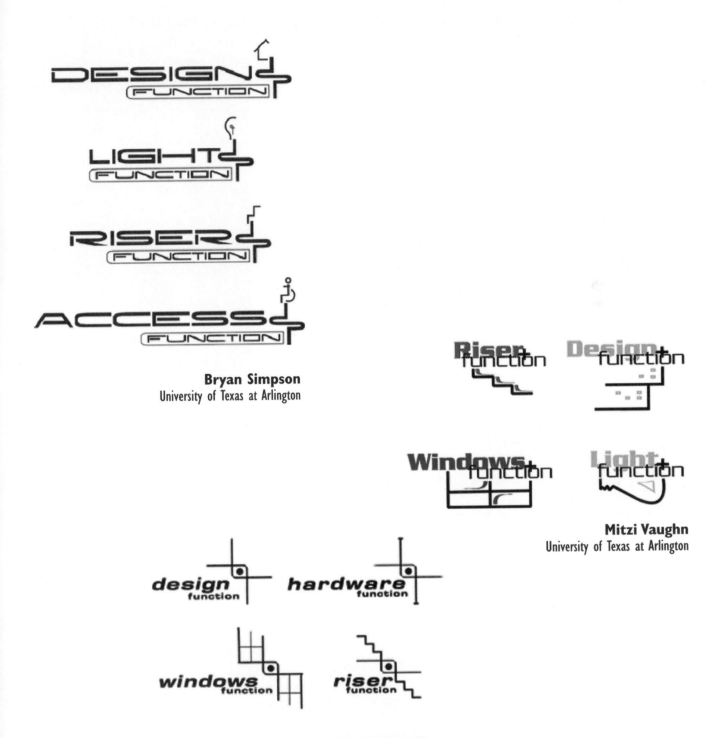

Bryan Simpson
University of Texas at Arlington

Mitzi Vaughn
University of Texas at Arlington

Benjamin Harwell
University of Texas at Arlington

Logo Design in the Entertainment Industry

Through all design is to some extent entertaining, entertainment design is a specific design category. Because three principal media industries dominate our culture (film, TV, and music), design for events in these markets has developed its own strategies, which are slightly different from those of editorial design, promotional advertising, or corporate communications.

Most of you will not be designing for major media corporations right away, but many of you probably know of local bands that need logos for business cards, tee-shirts, hats, and CDs; local theater companies that need to create
a more visible presence; local news stations that need graphic identities; or local filmmakers who need to penetrate a competitive documentary or industrial market.

David Correll
Rocky Mountain College of Art

Logo design for these often youthful businesses can be heady, expansive, and fun. There is often nothing better than to design for artists who work in other media. They are as appreciative as they are broke, so barter is usually the coin of the realm (free tickets, anyone?). Logo design for (small) entertainment businesses must be highly poetic, personal, and generally "over the top." To stand out in this crowd is to make a statement that screams (even if it screams silently in angst).

Research begins with the personalities involved, although there is probably already some personal connection or you would not be considering doing design work for barter. Certainly, the content of the medium must be not only understood, but also embraced. The pace, rhythm, craft, historical traditions, philosophical and aesthetic persuasions, and various personal quirks must be identified. Interview everyone involved, but do not be disappointed if all you get is vague references about artistic influences, personal tragedies, and a laundry list of what is cool and what is not. At least you will have a place to start.

Your logo must address a body of work, and that work will probably have a consistent approach to content. Key off that approach when you make design

decisions about font choice, image, and color. Bold, even loud, design can be effective in this area. Movement (referencing rhythm and pace) and color (referencing sound) should inform your typographic choices. Personalities, venues, and creative tools (people, places, and things) will be instrumental in your imaging choices. Be sure your logo has "legs": it will show up on everything from CD jewel cases to guitar cases; from bumper stickers to business cards; from tee-shirts to tattoos.

▲ KEY IDEAS

- Logo design for entertainment businesses must be highly poetic, very personal, and generally over the top.
- Pace, rhythm, craft, historical traditions, and aesthetic persuasions are the place to start. The various personas directly involved are the place to finish.
- Movement and color should inform typography.
- Personalities, venues, and creative tools should inform imaging.

Business Letterhead and Cards

Every logo needs a home and business letterhead is the starter home for most logos. The architectural metaphor is very apt in this case. Business stationery is the first three-dimensional surface (albeit rather thin) that your logo will enhance. Stock choice is crucial to the success of your logo.

Most companies consume vast amounts of paper, and paper, as it is rather expensive, is often the target of budget cuts and cost-saving schemes. Most accountant-types simply do not understand the poetic value of the feel of paper, and nothing you can say will change their minds. If you are lucky, you will be dealing with a more-knowledgeable-than-average marketing person who understands—within reason—the need for a classy look and feel in the company stationery.

When trees were plentiful and life was more languid, our Victorian predecessors made a good deal of headway in linking the velvety feel of fine paper with prestigious, conservative, and long-lasting institutions. However, your stock choices cannot be outrageous or they will get trimmed when it comes time to review costs and increase savings. Choose wisely, not expensively. Find a stock that projects the right image: understated, but effective; uncommon, but not flamboyant. Consider texture, weave, surface qualities, weight, and tints. Will it

absorb or add unwanted hues to your color choices? Is it reserved for special occasions or for certain levels of management? Should there be a lesser quality stock for middle management and the secretarial pool? Will it photocopy? Fax? Jam in the desktop laser printers? Does the stock come in text and card weights? What about envelopes? Once you have settled on a few stock families and have checked prices and availability, you can proceed to design.

One of the great things about standard, business letterhead is that you do not have to invent the format. It is 8 1/2" wide by 11" high (portrait, not land-scape orientation); standard business size envelopes are #10, and business cards are 3 1/2" wide by 2" tall. That is it for 99 percent of your letterhead work. There may be a few occasions when you work with or develop novel for-mats, and they will probably be for entertainment or design companies. Even then you will probably be designing for some other standard size such as DVD, CD, or videocassette packaging.

Despite the constraints of standard sizes, you will still have many design oppor-tunities when it comes to letterhead. Think about the textual elements that must be accommodated. Your letterhead design must be able to frame a stan-dard business letter (date, inside address, greeting, room for full text and sig-nature, copy list, and enclosures list). There will be some standard copy to include, such as address, phone and fax numbers, and e-mail and/or Web site addresses. There may be a list of patrons, donors, or members of the board. There may be tag lines or special-event copy. Be sure you have all the copy and the correct spelling before you begin to craft your design. There is, after all, very little room to work in the letterhead format, so you have to know what you must fit in and how it is spelled before you start laying out your design scheme.

Once you have your copy, stock, and logo, it is time to go back to design ba-sics. What image are you creating? Ask the same questions you asked about your logo: What does my letterhead design need to say about the company? How can this letterhead reinforce the company's public image? What ele-ments can I use to positively portray the company's business strategy and its relation to its markets?

Although your primary design elements are your stock choice and logo, you can choose auxiliary typefaces for the copy you have been provided, and auxiliary design elements in the form of lines, shapes, colors, textures, and artwork.

Auxiliary Typefaces

A simple choice is to use a version of the principal typeface of your logo. This strategy may, however, result in a lost opportunity to add a bit more information to your design by highlighting—by contrast to your primary typeface—an attribute that reinforces and expands the overall message. Highlighting a sans serif, modern face in the logo by using a serif classic in the address information may add a certain complexity to the design. This overall typographic impression may say more about your client's interests in diverse markets, approaches to customer service, and range of products or sense of history than the logo alone can. However, mixed messages are not particularly effective ones, so choose wisely. If you are going to combine typefaces in this way, be sure your message is clear. Use typefaces that are different enough to effect the drama you intend: classic serifs combined with techno-grunge; outlined heavy sans with bold, lightweight modern typefaces; half-screen script with demi sans. Try radical combinations and let the interaction create the subtleties of the messages.

Auxiliary Design Elements

The purpose of auxiliary design elements is to anchor the primary design elements and organize the space of the letterhead and business card layouts. Lines can frame and connect, or they can act as directional signals for the reader. Shapes, as additional compositional elements, can enhance the logo or legibility. Color and texture can distinguish shapes and areas and create transitional spaces from the logo to the text.

The general idea is to help the reader's eye move from area to area within the letterhead by marking off function areas (company identity, return address, body of letter, signature) and anticipating and directing visual flow (which is different from reading flow). How many times have you read the signature before you read the body copy, or scanned the first line and then jumped to the company logo? We do not usually read the way we write! An astute designer can enhance this experience, creating a permissible nonlinear flow that makes the reader feel welcome.

Auxiliary Art

Adding some art to letterhead is a handy way to compensate for budget-limited stock choice. As long as you are not adding a color, you can put

texture back in, create some subtle variation, or call attention to areas of design or body copy—without spending any more money—simply by adding some pictorial element to the letterhead design. You can add speckles back when you had to opt for a single-tone stock. You can add depth and dimensionality to replace the highly textured feel you originally chose but were not allowed to use. You can enhance your logo and type choices by giving them a visual context: bamboo leaves for a panda conservancy organization; rolling seas for a travel company; consellation maps for an astronomers' club.

A note of caution: If you developed your design strategy based on spot color and now intend to add some photographic material, even as a highly transparent layer, discuss this idea with your printer to be sure you do not incur unacceptable costs. A solution to this problem would be to bring your photographic or illustrative imagery into your letterhead as a monotone or a duotone, using one of the spot colors already present in your logo. This will more fully utilize a narrow color range, and can help tie all your design elements together. An even-toned letterhead is not necessarily less dynamic than one with a wide tonal range; it all depends on how you use the design elements.

▲ KEY IDEAS

- Stock choice is crucial to success, so find a stock that projects the right image.
- Think of stock as a three-dimensional surface.
- Letterhead creates identity.
- Know what textual elements have to be accommodated.
- What does my letterhead need to say about the company?
- How can my letterhead reinforce the company's public image?
- What elements can I use to positively portray my company's business strategy and its relation to its markets?
- Ask:

 What does my letterhead need to say about the company?

 How can my letterhead reinforce the company's public image?

 What elements can I use to positively portray the company's business strategy and its relation to its markets?

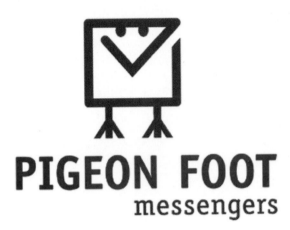

Kalene Rivers
Rocky Mountain College of Art and Design

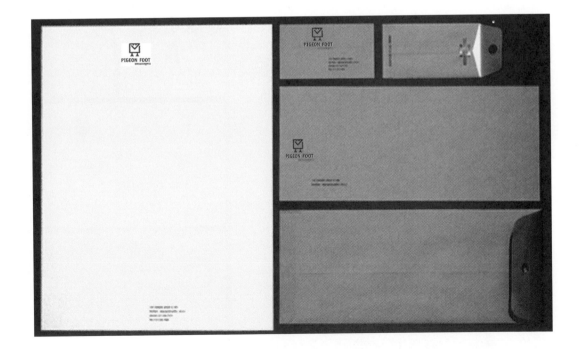

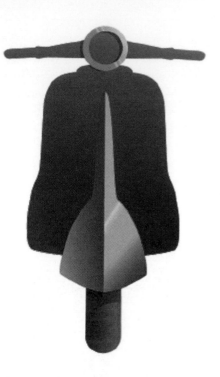

Kalene Rivers
Rocky Mountain College of Art and Design

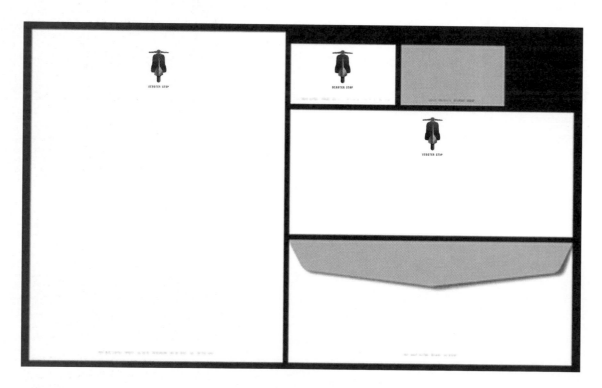

Thurston Kloster
Concordia University—Nebraska

Jason Berry Jason Bromm

Graphic Designer Marketing Specialist
phone: 402 741 5500 phone: 402 643 5555
4121 North 7th Street 2504 South 4th Street
Lincoln, Nebraska Seward, Nebraska
68002 68434

JB61044@Alltel.net

Artisan Creed Inc.

Jason Berry and Jason Bromm
2504 South 4th Street
Seward, Nebraska 68434

Thurston Kloster
Concordia University—Nebraska

Jason Berry Jason Bromm

Graphic Designer Marketing Specialist
phone: 402 741 5500 phone: 402 643 5555
4121 North 7th Street 2504 South 4th Street
Lincoln, Nebraska Seward, Nebraska
68002 68434

JB510440@Alltel.net

Collateral Cards

Successful marketing strategies include ways to extend short encounters into long-term relationships. *Wooing* might have been the word in the nineteenth century. Keeping the customer informed, entertained, and eager might be more contemporary. Involving the customer in the life of the company and treating her as if she were part of the family is the plan. Special-event announcements, promotions, expansions, introductions of new product or service lines, birthdays, thank-you's, or even "we're moving" cards are the method. The important thing to remember here is that this strategy works best if it is not perceived as a marketing plan in the first place. Avoid a no-holds-barred assault on the privacy of the customer's mailbox.

How would you woo a recalcitrant teenager, or a hopelessly shy and sensitive homebody, or an angst-ridden misfit? Affectionately, honestly, and consistently. Help your client woo his customer base in the same way. In this case, exhilarate all the senses, but do not overwhelm. You can achieve most of this through your stock choice. Touch can be stimulated through unfolding, unwrapping, and assembling. Hearing can stimulated by opening and engaging the materials. Smell can be stimulated by chemical treatments of the paper. Taste is not particularly relevant, although I have seen some very tasty promotionals that included chocolate bars and candy kisses. A lot can be communicated with food; it is a generalized metaphor for sex, and sex still sells!

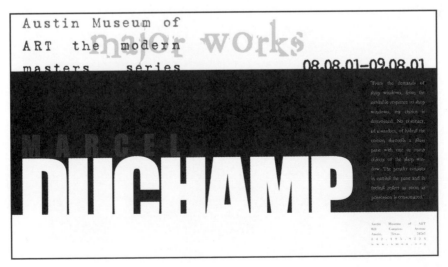

Thomas Keeley
Tunxis Community College

Sight is, of course, our strongest suit. However, in most instances you will probably be restricted to spot-color solutions. These kinds of free reminders tend to come with a low budget. Rarely will you get to add photography and run in 4 over 4 process color—but even if you do, the image should take third place to the stock and the type, in that order. The focus of the experience should be on the customer. Let this be an internal experience so your client's customer will feel more like family and less like an object. Take advantage of this essentially graphic moment! Be sure your type calls attention to the tactile beauty of your stock, so that opening the collateral piece is fun, mysterious, seductive, and celebratory. Your type should take advantage of the shape of your card by anticipating and directing the eye's movement around, through, and over the planes and edges.

No doubt copy will be supplied; with luck, it will be short and sweet. However, there may be boxes to check, lines to fill in, stamps to affix, and dots to connect, along with a multitude of other informational and regulatory items supplied by the marketing department. If you cannot convince anyone to remove these invasive pretensions at interaction, then amplify them. Consider them opportunities to enhance the customer's physical involvement with the piece. Make the game fun and unpredictable: use oversized and undersized type; add color and outlines; create 3-D effects and fields of texture and color.

Generally, designers do not have a lot of control over copy, but in this case it is essential that you exercise as much discretion as possible with the verbal messages your collateral cards carry. Work closely and patiently with the source of

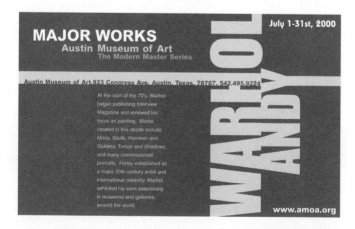

Jennifer Jacobs
Tunxis Community College

the copy. Remember that this wordsmith has a lot at stake in the copy and considers what you do a method of conveyance, not a medium of communication. Strip it down to essentials. Make it emotive, poetic, or mysterious. Be prepared to indulge, coddle, and explain in great detail why you need to remove, shift, or reduce copy. Try to get the conversation onto the field of intentions and goals and do not argue over the words themselves. Collaboration is the name of the game; it builds friendships and market share! If you accept the reasons for the copy (ten nonsensical, repetitive marketing questions, requests for redundant and irrelevant personal information, etc.), maybe your collaborator will accept your reasons for having the type race, duck, roll, run, skip, jump, and dodge all over the card. If you have to compromise on type, then stick to your guns on stock. You can make up for too much copy with the tactile pleasures of your paper choices. Be sure to proofread your comp multiple times. With all the type manipulation you are going to do as you develop this piece, there are bound to be unwanted typos.

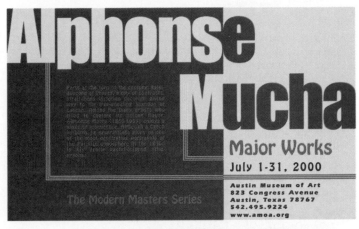

David Fuka and Petra Hromaova
Tunxis Community College

Collateral cards are great design pieces to collect. They come unsolicited to your mailbox all the time. Offers, queries, reminders, announcements, and other missives arrive every day, whether they appear out of nowhere, from some store you shopped in last year, some catalog you requested, or some workshop or lecture you attended. Collect them, both the good ones and the bad ones. Group them by informational content or just leave them in a file drawer and go through them randomly when you get this kind of job in. Look for interesting combinations of design elements, new typefaces, and oddball shapes. The Post Office has strict requirements on bulk-mail and postcard-rate sizes, but with first-class postage you can send just about any size or shape you want. Be sure to familiarize yourself with postal regulations whenever you take on a collateral-item job.

One important reason for keeping a library of collateral examples is that once you move into computer design, you can lose track of the important tactile, physical qualities of the stock. Keep your stock on hand while you design. Note how the stock affects inking. Do your second round of thumbnails on your stock

samples, and certainly use the stock you will be printing on when you do your rough. If your design changes as you progress though computer-generated design development, try out the changes on your stock samples. Keep alternating from the digital to the physical so that your final output will always retain an intimate quality of pure sensation. Go out of your way to find new paper samples and experiment.

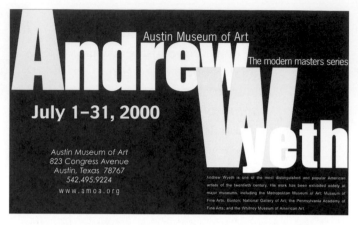

Lukasz Bagan
Tunxis Community College

When you visit your printer to discuss paper, ink, and layout, be sure to bring up questions about die cuts. These are great (albeit expensive) ways to amplify the 3-D, architectonic quality of the physical experience. Bevels, angles, rectangles, and circles translate into ramps, corridors, windows, and amphitheaters in the space of your collateral item. If you can dummy this out and make a great marketing case for the expense, your client may well let you expand the physicality of the collateral experience into three dimensions.

▲ KEY IDEAS

- The focus of collateral cards is the customer.
- Make opening the collateral piece fun, mysterious, seductive, and celebratory.
- Offers, queries, reminders, and announcements arrive in the mail every day. Collect them!
- Be sure your typography calls attention to the tactile beauty of the stock.
- Direct eye movement around, through, and over the planes and edges of the card.
- Find new paper samples and experiment.

Announcement Cards

Announcement cards are reserved for very special moments—those of excessive joy and those of unbearable sadness. They are emotionally charged and very personal. Design strategy thus tends toward strong typography, careful choice of stock and format, and diligent concern over color choices.

These kinds of cards go directly to the reader's heart. They do not promote or advertise. They do not solicit anything but an emotional response. Every design element should be crafted toward that end. If a photograph is required, it should be an emotive one. If typography is the primary motivator, a careful review of type catalogs, to find just the right face that is personal and uncommon, would be the right way to go. Spend time with stock choices and think about color. Do not rely on traditional combinations; seek your own. Learn a bit about your client's tastes in this area, and then guide them to the right design choices.

Announcement cards are often inserted into envelopes. They have a single fold and four panels. There will be a lot of graphic space to work with. Avoid the temptation to leave too much blank space or to crowd the space with exaggerated typography. Be simple and direct; use the space to its full extent, but leave room in the design for the physicality of the stock texture and the inking. Pay attention to the ways in which the typography moves the reader's eye through the card, and be sure the viewer goes through the visual and textual information in the proper order to attain the most impact emotional result. If you use an image, be sure the photograph has enough space dedicated to it and that its resolution is clear. Otherwise, do not use one. If you have to compromise on the image, you might choose a line-art illustration or a simple charcoal drawing rather than a photograph.

▲ KEY IDEAS

- Announcement cards do not promote or advertise, or solicit anything but emotional response. Every design element should be crafted toward that end.
- Be simple and direct; use the space available to its full extent.
- Design for the physicality of the stock texture and the inking.
- Be sure the viewer goes through the visual and textual information in the proper order to maximize the emotional experience.

David Correll
Rocky Mountain College of Art and Design

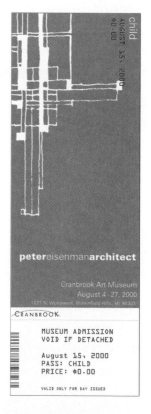 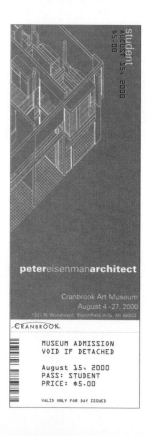 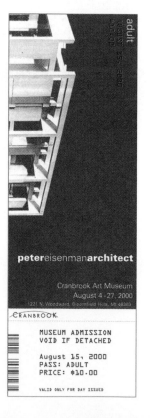

Promotional Cards

The promotional card is usually part of a direct mail campaign, supporting an advertising strategy with very specific business goals and design constraints. The art director may provide logos and photography. Text will most certainly come from the copywriters. The card itself has to fit into a campaign that dispenses just enough information to make a prospective market interested enough to follow the promotional campaign to its end—the unveiling of some product or service.

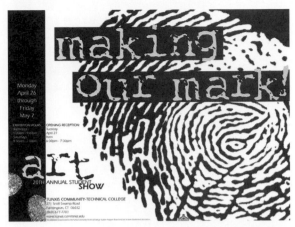

Laura McCloskey
Tunxis Community College

The approach to promo card design can be either typographic or photographic, but there is just not enough space or time (from the consumer's perspective) to do both. The hook must be one or the other: the typography can lead to the visual information of the photography, or the photography can lead to the textual information. This will create the visual dynamic that establishes the basic compositional moves.

Format adds the final dimension to the layout, but these kinds of relatively inexpensive promotions are often confined by tight budgets. This means that printing and cutting may be less than perfect; therefore, the designer would be wise to design from the center of the card rather than from the outside edges, leaving at least a 1/8-inch margin for a "safe" zone. Promotional cards can go out as blow-ins, glue-ins, or fold-ins in publications, or as stand-alones. The designer needs to know in advance how the promotional card will be distributed.

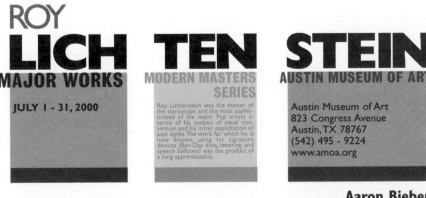

Aaron Bieber
Tunxis Community College

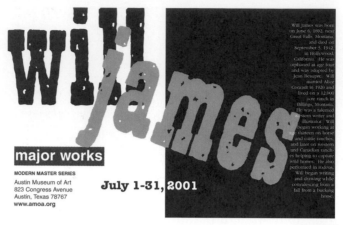

Judith Champagne
Tunxis Community College

If the photography must gain the reader's interest and hold it long enough to get to the critical textual information, it must be well crafted in relation to the quality of printing expected. If corners must be cut, use duotones or digital presses to reduce costs; do not sabotage the power of the photographic image by choosing one that requires high print quality when you know your client has to compromise on stock and inking.

If typography must carry the day, it should be direct. Choose highly graphic faces that are not commonly used. Design the card so that the type drives the reader's eye to the image. Make sure the crucial information stands out, and that the secondary information (and the tertiary information, if there is room) gets a separate type treatment. Use color to expand emphasis and to manage composition. The space will be restricted, but a judicious use of color can add a three-dimensional quality that will expand the range of the information structure.

▲ KEY IDEAS

- A promotional card often supports an advertising strategy with very specific business goals and design constraints.
- The design can be either typographic or photographic, but not both.
- Create visual dynamics that will establish the basic composition.
- Choose uncommon, highly graphic faces, design the card so that the type drives the reader's eye.
- Make sure the crucial information stands out.

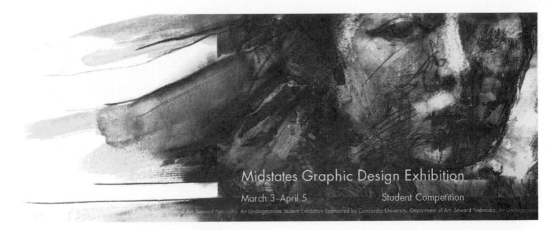

David Dolak
Concordia University—Nebraska

Invitation Cards

Every invitation is a special occasion, but not every one gets a special card. The designer must fully understand that an event requiring such a special notice inevitably brings hopes and dreams into focus; offers a brighter, better futur; or commemorates a moment of transition that can never be repeated.

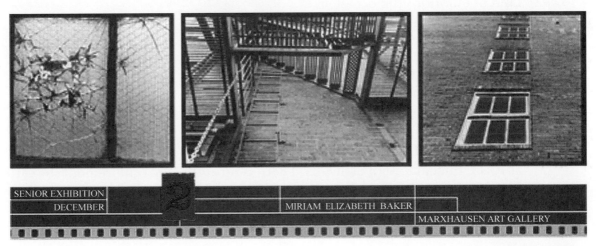

Miriam Baker
Concordia University—Nebraska

Special invitations are one-of-a-kind design opportunities. They should be as high-concept as is appropriate to the occasion. Leave imaging abstract or metaphoric, and design with the formal elements of shape, texture, color, and composition. If the card commemorates a business event, a simplicity of design honors the complexity of the moment. If it graces a personal occasion, the depth of emotions involved requires that the designer be creative with color, not image.

Type choices may involve the client. If the client is a business concern, there is probably already a typeface that identifies the company. If the card is for a personal event, then explore with your client the range and kind of emotions the occasion is intended to engender and choose a face accordingly.

This kind of card usually goes out in an envelope. The entire stock treatment must be thoroughly examined by the designer and integrated into the strategy of abstract, formal design elements. There is no automatic requirement for card and envelope to be the same stock; let the occasion dictate the range of physical production of the card.

READY TABLE
OCTOBER 21–NOVEMBER 30

PAINTINGS AND INSTALLATIONS FROM THE UNIVERSITY OF IOWA
RECEPTION AND TALK: OCTOBER 21, 1–4 PM

MARXHAUSEN gallery of art

Matthew Blackford
Concordia University—Nebraska

▲ KEY IDEAS

- Special invitations bring hopes and dreams into focus.
- Special invitations commemorate moments of transition that can never be repeated.
- Special invitations are one-of-a-kind design opportunities.
- Special invitations should be high-concept.
- Leave imaging abstract or metaphoric; design with formal elements of shape, texture, color, and composition.
- Integrate stock treatment with design strategy.

Promotional Brochures

Often the first serious design piece a small business will produce is its promotional brochure. Even established companies regularly print a promotional flyer to launch a new product line, enter a new market, or reposition themselves in an old market. Usually this piece is inserted within an advertising campaign or follows a direct-response piece. It may be the capstone of a series of product launches or the result of a major merger or acquisition. It may seek to cement a business relationship by putting the consumer in a privileged position, or the goal may be to build a reliable customer base.

The designer's first step is to find out exactly what the brochure is for and how far the promotional campaign extends. Try to clarify any vagueness of purpose if you hear, "Well, we'd like a new look" or "We're not sure what we want, maybe you can tell us." Try never to design in a vacuum. Your client may not in fact be totally clear on the purpose of the brochure or how it should fit into a promotional campaign. So perhaps you can help—and your first job during the discovery period is to ask the kinds of questions that will clarify the situation.

Questions of budget and time are important, but the answers you will get before content and purpose are addressed will be dubious at best—and they will always be the same: "Not much, and right away." This is so predicable as to be almost meaningless. If you can convince your client that your design helps achieve significant business goals, then who can predict what that's worth? Every businessperson wants to spend as little as possible, but an equally good strategy can be spending as much as is necessary to achieve a marketing goal.

The questions you need to ask are the ones that will help you design a brochure to solve the business problem at hand. Who is the market? What are their characteristics? What are their relations to the product or the company? How does your client perceive them? How do they perceive your client? How does your client want to be perceived? Do they in fact know your client and its products or services? How is your client distinguished from competitors? What are your clientís projections for the future? Finally, you need to know if the product or service works. Ask the customer relations department, the service department, and the public relations department. Ask to see the product in action or visit the service delivery site.

Now go back to budget and time. Decide on format size, folds, and stock by visiting your printer and getting a ballpark figure on a variety of choices and combinations. Then consider photography and its cost. Add a twenty percent, figure in your time, and then see if you can do the job within budget and on time.

Once you get a reasonable assurance that you can do the kind of job you would be proud of (or at least fully satisfied with) you can begin your design work. At this point you should have final, approved copy on disk so that you will not have to rekey the text, and any artwork, logos, or photographs that the client is supplying.

Determine the exact size; then the orientation of the brochure; then the compositional strategies that move the eye through the space of the brochure according to a visual hierarchy of primary, secondary, and tertiary messages. Within this structure of visual hierarchy, insert your photographs and copy; create texture, flow, and direction. Develop a grid or organizational framework that repeats graphic elements to establish a pattern. Situate within that pattern a visual story that uses emotional moments to create a believable message directed to a specific market with its own culture and reading habits. Your brochure must tell a story within the architecture of your design space.

Brochures inevitably have more than one panel. This means that transitioning from thumbnail to computer design will involve the creation of a *dummy,* a folded simulation of the brochure with the separate panels clearly marked:

front cover; inside front covers; pages 1, 2, 3; etc., inside back cover, and back cover. You will quickly see that the pages do not follow in sequence, but appear in a nonintuitive order when folded and nested. This dummy is an important guide to layout. Bring it with you when you meet with the printer.

Your design strategy, of course, depends on the client's marketing goals and flows from your research. Along with the basic elements of copy and art and the requirements of size, orientation, and stock, you will need to build a font set, a color palette, directionals (arrows, lines), shapes, and textures. These elements will be laid out on your compositional grid, with repeating items spread over multiple pages.

Create a visual hierarchy that blends the marketing goals with a dramatic story. This story will come from your research. Pay careful attention to the emotional qualities you discover in the difference between what the company is and what the company wants. Try to document the desires, needs, and aspirations you see as you trace the product or service from the marketing department to the consumer. If there are negative stories, your design strategy will have to compensate for or minimize them; no one wants a sad ending. If there are positive stories, your strategy will be to capitalize on them.

Stories are powerful opinion makers. Learn to use story structure and to treat your design as the stage upon which the drama of your characters (design elements) unfolds. Use directionals to tell your audience where and when to look. Design a stage set, using shapes to create spaces and define boundaries. Use color as you would use theatrical lighting, to create mood.

Pay particular attention to the dramatic flow from one scene (panel) to the next. Supply consistency and repetition, but add a few surprises as well. Keep your audience fixed on your design. Always remember that, just as in theater, your audience must play its part by supplying essential personal interpretations to the abstraction of your dramatic symbols. If you lose the audience, threaten their belief system, disturb or distract needlessly, they will be disinclined to fulfill their role in the performance.

▲ KEY IDEAS

- Promotional brochures are part of an integrated marketing campaign.
- Design strategy depends on the marketing goals: Find out exactly what the brochure is for and how far the campaign extends.
- Create a visual hierarchy that blends the marketing goals with a dramatic story that comes from research.
- Promotional brochures may launch a product, product line, or company.
- Promotional brochures may seek to cement a business relationship (B to B) or build a reliable customer base (B to C).

Ask:

- Who is the market?
- How does the market use the product?
- How does the client understand the market?
- How does the market understand the client?
- How is the client distinguished from competitors?
- How does the client want to be perceived?
- What are the client's projections for the future?
- Does the product or service work?

Newsletters

Newsletters are informational, motivational, and sometimes inspirational compilations of stories, facts, and announcements that promote a corporate or institutional mythology. Never assume that they are a straightforward herald or gazette. Traditionally, they do reference a newspaper-style format, with masthead, columnar organization, and advertising spaces, but this is often due to the preset templates found in layout software and a lack of design training by the staff members usually assigned to do this in-house communications job.

Newsletters are a favorite communications tool when companies grow beyond the mom-and-pop stage. They are often the catchall means of implementing internal public relations strategies. The argument for a company newsletter may be: "If only we communicated better, we would achieve efficiencies and increase productivity." Or "If only we could get buy-in to the operating strategy, all this complaining would stop and we could move on with the restructuring." Or "If we could provide a forum for suggestions and share accomplishments, we might even enjoy coming to work." Newsletters are expected to fill wide gaps in management/labor relations. Ultimately, they are methods by which the company work ethic is reified and the culture of the workplace is created.

Newsletters are typically asked to communicate from a centralized headquarters out to a dispersed and diverse population of members, contributors, or stakeholders. They help define an organizational identity. They proffer information about the short- and mid-term organizational past or future. They serve as summaries of recent events, decisions, profit-and-loss statements, fund-raising campaigns, and investment strategies. They may include personal histories as well, such as births, retirements, promotions, anniversaries, and awards. They define organizational identity by editing organizational history.

Newsletters are usually text-heavy, with monochromatic images and a columnar grid format reminiscent of a newspaper. With today's computer-generated design, however, cost considerations no longer lock in these requirements. Company newsletters can be engaging, informative, and effective communication tools. The challenge for the digital designer is to understand both the obvious and the latent purposes of a newsletter. He or she must develop a strategy that will accommodate the design flexibility and modular format necessary to produce newsletters on a regular basis, and without much foreknowledge of copy content and image quality.

One important criterion is that each edition of the newsletter, after the format is established, not require inordinate amounts of time or money. Design a template, and then be prepared to turn it over to an administrative assistant in the public relations department. There are exceptions to this, and your newsletter may become a larger and ongoing design challenge, but the cumulative changes to format, design, stock, and imaging will ultimately transform the newsletter so radically that it will become an internal magazine and serve a different purpose.

During the research phase, you will need to get as close to the top of the management hierarchy as you can, to find out who is creating the company mythology and why. Is a down-and-dirty in-house battle for strategic control going on? Is a severe downsizing, acquisition, or merger about to forever change the way the company sees itself? Have fund-raising efforts and political influence been successful? What are the local, regional, national, and international aspects of the newsletter? How will the newsletter be distributed? Are there postal requirements to comply with? What other internal and external regulatory agencies must approve the format and content of the newsletter? Who is collecting and approving story copy? Who makes decisions about content in general, and how is this done? How are images sourced? What aspects of the organizational design manual must be adhered to, and what design elements can be specific and unique to the newsletter? How and where is the newsletter printed?

During the design stage, you must choose an inexpensive stock that can accommodate the color range and image quality you plan to use. Generally, a bright white stock with a pleasant feel will do the trick. Sometimes you will be able to use a variety of stock or have cover and interior stock weights. If you have an accurate idea of the latent value of the newsletter, and if you can pitch your design to enhance that value, then you may be surprised at how much more money you get than had been previously budgeted. Ensure cost savings on future editions by making your newsletter modular and easy to update.

Modularization can be achieved by constructing a pliant but flexible grid that accommodates the different kinds of information your newsletter will carry; developing a few design elements that will repeat regularly but randomly throughout the newsletter; and creating a strict color palette and font set. The grid need not mimic a newspaper, but it must create a story space that helps the eye move in a nonlinear fashion around unrelated and discrete areas of information.

The key to structuring a newsletter is to be critically aware when you read one. You will find that you rarely read from start to finish in a linear fashion. Your eye jumps from headline to headline, seeking information that your brain needs or your heart wants. Movement is haphazard, backward and forward, side-to-side, front to back. Let your grid enhance this, not fight with it. Let your typography embrace this informational cornucopia and create spaces and areas where respite is possible. Use colors and texture to indicate when content or story changes, by creating new spaces. When the various editorial components start to come together, you will recognize a pattern that will

structure the dimensions and orientation of your modular grid. The more detailed the information about content and purpose that you gathered during discovery, the more strategic and effective your structuring process will be when you start developing thumbnails and roughs.

Many newsletters use clip art. If you want to avoid this in your newsletter, you will have to develop an inventory of images and a set of requirements for photographs to be included in future editions. This is more fun than it sounds. It gives you an opportunity to think about future readership and content. You might want to research related industry newsletters and go back about one year. If you review five or six sets of newsletters, you will probably be able to categorize enough "information types" to build an image inventory of about a hundred symbols to use over the next twelve months of your newsletter. Develop a strict photography requirement. For instance, you could specify that all photography be scanned in at 300 dpi; that color photos be converted to duotones and only blue or sepia monochromatic (include Pantone colors and percentages) will be used; that if black-and-white photographs are used, they must have brightness and contrast pushed for enhanced effect (reduce grays) and must be converted to the same blue or sepia monochromes as the color photographs. If you write each step out in detail, your newsletter will have a chance of staying the way you want it to look.

Your font set will be more self-explanatory. In most cases new copy will simply be pasted into the spaces you established on your modular, and flexible, grid. *Flexible* is the key word here: you can easily foresee how new copy will often require new text box dimensions. If you have built change into your format, you will not be on call for newsletter updates on a regular basis (use style sheets). You can reduce labor costs during the year with your newsletter template, so you can argue for more budget for stock and print quality. Be sure you create a font set that permits change and adapts to all the content circumstances you can think of. Then create a font list and style sheets and include instructions on associating fonts with content.

As you proceed from thumbnails to roughs, you will enjoy the process much more if you develop a dummy. For your rough, use markers on tracing paper and work in the color ranges you have set as your palette. Develop three or four versions (each from twenty thumbnails). See if you can combine or reduce design elements and reduce the total number of versions to two. Then proceed to computer-generated comps and develop the front and back cover, the inside front and back cover, the table of contents page, and one typical interior page.

Then mount these three two-page spreads on black illustration board for presentation. Go back to your roughs and spruce them up. Be sure to bring them along with you and be prepared to engage your client in the design process. You may need to show your client how you developed your ideas from research (have this available and organized in a strategic fashion) to rough (the whole newsletter laid out in a convincing fashion) to comp. Remember, you are designing identity and company mythology. You have entered the inner sanctum, so be prepared. Make a thorough, well-supported, clear presentation. You will take a potentially dull design job to new heights and probably garner additional projects in the process.

▲ KEY IDEAS

- Newsletters promote a corporate or institutional mythology, define organizational identity, reify work ethic, and create workplace culture.

- Newsletters can be engaging, informative, and effective communication tools.

- Research the obvious and latent purposes of the newsletter.

- Design a flexible and modular format that accommodates different types of information.

Media Kits

Media kits vary wildly in size, shape, and budget. They are made up of complex, layered, and differentiated kinds of textual and pictorial information. All this adds up to multivariate design strategies: simple compilations; complex 2-D solutions; complex 3-D solutions; multimedia kits; and special editions.

To start with, realize that all media kits are small, printed packages that convey the range of products and services that make up a company or a corporate division. They offer information about company capabilities, industry and company directions, and financial and investment opportunities. They demonstrate position strength, market share, fiscal health, and organizational vitality. They are usually directed to business decision makers, not to consumers. These kinds of business people tend to have little time and even less patience for distracting gimmicks; also, they are visually sophisticated to the point of saturation. You have got to get them interested quickly, deliver on the implicit visual experience, and get them to the crucial information without a lot of fluff.

The marketing department that employs your talents may well specify the exact content of the media kit. If this is so, you are lucky. If not, you will have to meet with senior staff and go over every piece in the kit. This might include a cover letter from the CEO, a high-quality capabilities brochure, a product catalog, management biographies, market demographics, sales and industry trend analyses, charts, and diagrams. There will be a business card and additional collateral material to provide names and procedures for getting back in touch concerning investment, strategic alliances, and cooperative arrangements. These are essentially business-to-business starter kits. You might offer or give away a novelty or promotional item to add a personal touch. Even business-to-business relations are person-to-person relationships. It is important to determine at what point in this evolving relationship the media kit comes into play and what marketing pieces preceded it.

Once you have established content, shape and size will follow. At this point budget issues should be clarified. Design begins after a quick trip to the printer for consultation and suggestions concerning stock, ink, photography, and layout. It is important to find a printer who has experience with folding and gluing or who works with a bindery that can estimate the costs to finish your media kit, so that you can secure budget approval.

A simple compilation kit is based on a standard folder with one or two interior pockets in heavy card stock. Spot colors (when photography is absent) provide a full range of vibrant color choices and ensure consistency over multiple products. Referring to the company design manual will save time and negotiations. But remember, hundreds if not thousands of new colors and inks come onto the market every year, so you may need to expand from the manual's restrictions. This depends on your relationship with your client. If it is a new client, you may need to go slowly; if you have already established your design credentials, you can push the envelope. In developing your thumbnails and roughs, you will want to purchase some ready-made folders, take them apart, and measure panel sizes, folds, and glue areas. Be sure to check postal regulations and envelope sizes before you present design strategies. You may get what you wish for, only to have to reduce your profit on the job because of the unexpected costs of nonstandard sizes.

Complex, two-dimensional strategies are a step up from simple kit solutions. Here stock choice, die cuts, nonstandard sizes, and six- or eight- color printing add visual depth, production value, and tactile enhancements. This says a lot about the company and its ability to fund such outreach. It may imply desperation as well, so think about the receiving end of the communication equation. The defining question is "Do the graphic enhancements convey the

story more efficiently, make more of an impact, and reinforce the desired qualities?" If the answer is yes, then by all means present your case.

Your design should treat the kit cover as a showcase. It should be an enticing, exciting visual and physical experience. Die cuts form frames; vellum creates atmosphere; half-pages preview and tease; repeating graphic elements tie the kit components into a comprehensible whole. Three-dimensional strategies expand your graphic design architecturally; novel stock, pull tabs, and pop-ups mean more consumer interaction with your kit. Interior spaces can hold product samples and novelty items.

Multimedia Kits

Multimedia kits are a variation of media kits that can be either a mere rework of an old theme or a truly new approach. If you simply add a promotional orinformational CD-ROM to the collection of items already present in the media kit, expecting that the inclusion will automatically position your client as a high-tech player, you have underestimated the power of multimedia. Rather than watering down the "new-tech" experience, include some collateral item that refers the consumer to your client's Web site. If the entire kit is a visual and physical prelude to the CD-ROM, if the packaging and design serve as a symphonic introduction to the moment when the busy executive inserts the CD into her computer and bathes in the complexity of an impressive presentation, then you have taken full advantage of this new medium! This means that the other pieces in the kit should foreshadow and echo the multimedia experience and direct the viewer to it. The entire experience of the informational and promotional material in the kit should point to the multimedia presentation.

Special Edition Kits

Special editions celebrate. To do this effectively they must focus. When we celebrate, we need to know why, specifically, so that we will know the appropriate limits and protocols governing our celebration. A special edition media kit might refer to a specific, breakthrough product, a monumental change in organizational direction, a realignment of business interests, or entry into a new market.

All large events are complex, collaborative efforts. This may be a good time to showcase partnerships, to display the company's timeline of growth and achievement, to remember founders or celebrate department managers. Celebrations are all about people, time, and place. The successful special edition media kit will anchor the company in the past while describing future as a *fait accompli*.

A special edition media kit will embody the company culture and mythology. Design elements must refer both to the company's history and to its future; know the company's history and the dramatic record of its growth, including challenges and obstacles. Get personal histories when you can; people make up the pantheon of company greats. The graphic design over the whole time period of the company's development will indicate social and cultural trends and will give you ideas about how to use color, texture, and typefaces as you develop your design strategy. Research stock photography houses for historical shots of your client company. By locating your client in time and space, you can tell a story of heroic proportions. If your company is young, use personal histories, or chart the future as if it were history. Pose questions and supply answers visually and in the copy. Use exciting new colors and printing methods.

Once you find the essential ingredient—the specific cause for celebration—your special edition media kit will begin to craft itself. Your job will be to keep it succinct so that it does not detract from the party and yet reminds everyone involved that tomorrow we go back to work, inviting the kit recipient to join in as the client moves on.

▲ KEY IDEAS

- Media kits are small, printed packages that convey the range of products and services from a company or a corporate division. Media kits offer information about company capabilities, industry and company directions, and financial and investment opportunities.

- Media kits demonstrate position strength, market share, fiscal health, and organizational vitality.

- Media kits are usually directed to business decision makers, not consumers.

- Research the company's history, including challenges and obstacles; get personal histories; research graphic design trends over the time period of the company's development; and research stock photography houses for historical photography.

- Locating the client in time and space can tell a story of heroic proportions and attract clients.

Annual Reports

Annual reports are the pride and joy of a chief executive officer (CEO). Get to know this person well, and your annual report project will go smoothly. Although you may not get a personal interview (but you should try), you can find out a lot by interviewing department managers, or simply by analyzing previous design work. Last year's annual report is a good place to start. Be sure to review annual reports of other companies throughout the industry as well.

Annual reports are typically reports to the shareholders on the financial health of the corporation over a given fiscal year. They are subject to high degrees of regulation by the Securities and Exchange Commission and must contain detailed financial information. Charts, diagrams, and related visual explanations of financial data may accompany this required information, but it must be there in plain English as well. This is not the place to get creative. Classic fonts, a predictable grid, typographic clarity, and refined presentation are reassuring to stockholders, investment brokers, and financiers.

However, in the past few years annual reports have presented new challenges, in part because today so many Americans own stock. This has a profound impact on annual report design. Contemporary annual reports have to reify the corporate image and positively contribute to branding. They are corporate identity pieces, even though the target market is a part owner of that identity. Annual reports serve as a form of corporate promotion: They remind stockholders of the breadth and scope of the corporate entity; they tell stories of success and predict future trends; they reassure and inspire pride; they can stimulate reflection and anticipation.

Annual reports must represent a business from a personal vantage point, as well as from a regional, national, and international point of view. They must touch the small investor who owns fifty shares and only knows long-term investment strategies. They should transport that investor into the global maelstrom of geopolitical markets. They must position the corporation as both a personal friend and a world leader in its industry.

As in any significant design project, the prerequisites for success are a sound knowledge of the task at hand, a good idea of copy and due dates, examples and analyses of past projects, and a clearly articulated set of goals that the current project must achieve. Without them there are no ground rules, no limits to your design possibilities, and no standard by which to gauge design decisions.

Assuming you have these essential ingredients, the next step is design development. Focus on the explicit and latent messages to be included, and then establish a visual hierarchy and order in response to those messages. Next, decide on the different forms of presentation that must function as an integrated whole within the report and determine the overall feel, by choosing font sets and color palettes. Create a project timeline for copy, design, and production. Develop the photo look and secure the photographer. At this point you can submit a detailed budget proposal.

As with all multiple-page documents, you will need to make a detailed dummy and consult with your printer on the most efficacious layout and format to achieve your design goals. You should develop "chapters" that combine similar kinds of information (the requisite financials, for example, or the introductory messages from the board of directors, the CEO, CFO, CIO, and COO) and invent creative strategies for each design area and sub-area, as well as an overall look. You will need to discuss paper weights, folding and binding issues, and in-line color problems. Find out all you can about how your design should come together in the real world of paper and ink before you start laying out an annual report.

Develop templates and repetitive yet variable design elements to serve as visual locators. This may be your page numbering system, an internal color code, or other symbols and layout strategies that will help the reader find his or her way through the annual report. Changing paper stock and tactile sensations, creating voluptuous break pages, and changing the photographic approach are excellent ways to help locate the reader. Use your fonts to establish a hierarchy of textual importance and to draw attention to information. Let your typography help the reader navigate through the information by creating copy breaks, section headings and subheadings, clearly defined areas of body copy, and pull outs. Create a visual strategy of typefaces, font families, and line weights to enhance meaning and direct readers' attention.

Keep photo manipulation, layering, and special effects to a minimum. When you use them, be sure they further your visual message and do not just decorate a weak spot in your design. Corporations generally can maximize profits only by minimizing costs. When they have to spend, they spend on natural and human resources, real estate, and technology. Annual report photography can be a good way to reassure stockholders that spending was done appropriately, achieving efficiencies and maximizing investment. Resist the temptation to transform a multimillion-dollar communications facility into a kaleidoscope of colored wires, motion blurs, and metallic colors with highly

reflective lighting treatments. Your photography should be evocative, but of the corporate story, not the photographer's love of light.

You should consider stock photography, especially if your corporation is spread out in multiple sites located in different regions or countries. Be sure you understand the diversity of interests and cultural and social attitudes involved when you attempt to represent the range of company activities and personnel to the stockholders. Select stock photography to create a visual overview of your corporation's varied interests, saving your location photography for up-close-and-personal shots of staff, facilities, and equipment.

Product, architecture, and portrait photography involve different skill sets and different photographic equipment. You may need to develop alternative photographic approaches with different image makers to achieve the effects you want. Be sure you have thought through the photo look you want to incorporate into your overall design. Let your photographers make suggestions. Like your printer, you depend on your photographer's expertise, sense of excitement, and commitment to the project. You will get better photography if you are open to suggestions.

You may find that photography combines well with illustration in an annual report. The handmade look of illustration often conveys a very personal and intimate message. This might be a good way for the senior officers to speak to the shareholders. Commissioning an illustrator is much like hiring a photographer. You should involve your illustrator in your project goals and design decisions, and then ask for input and suggestions. Color palettes are important to specify, as is the need to translate the illustrative work from the physical world of paint and canvas into the digital realm and then back out to ink and paper. Color range and delicate nuance are subject to a certain amount of degradation in this process, so hire an experienced illustrator and familiarize him or her with your production specifications.

Finally, you will need to develop some project management skills. A calendar in plain sight in your studio is a start, and project management software is available if you prefer to keep all your records in your computer. You'll want to develop a detailed timeline of due dates, major meetings, reviews, signoffs, approvals, suppliers, and pay-outs—and be sure you meet these dates! If you do not, you need to know why and how to adjust the rest of the schedule to compensate. Whatever slippage you build in will be used. If you do not build in any time for major errors, you *might* get lucky, but you will probably live to regret it. Reminder: Once you construct your timeline, follow it and amend it as necessary. Keep it as a record of your time management skills and as an anecdotal record of the project for future reference.

▲ **KEY IDEAS**

- Annual reports are reports to shareholders on the financial health of the corporation over a given fiscal year. They are subject to government regulation and must contain detailed financials.

- Annual reports build corporate image; contribute to branding; tell stories of success and predict future trends; reassure and inspire pride; and stimulate reflection and anticipation.

- Focus on the explicit and latent messages to be included; establish a visual hierarchy and order in response to those messages.

- Create a visual strategy of typefaces, font families, and line weights to enhance meaning and direct attention.

- Keep photo manipulation, layering, and special effects to a minimum.

- Understand the diversity of interests and cultural and social attitudes to be represented to stockholders.

- Develop a detailed timeline of due dates, major meetings, reviews, signoffs, approvals, suppliers, and payouts.

Branding and Identity

Branding refers to the cumulative effect of strategic positioning through visual communication. This used to be called *brand recognition,* an advertising and marketing phrase that refers to the consumer's level of knowledge about, and trust in, a line of products or services. Branding acknowledges that consumers identify product with producer, and that consumer loyalty is to a company. The relationship enables the company to launch new products with a guarantee of at least some initial interest.

This relationship, like all relationships, is built up over years of successful use of products and services. To support and further brand loyalty, many companies have a customer service division to hear complaints, issue refunds, generate promotional gimmicks, and collect information about customer dissatisfaction. There may be a public relations department overseeing this effort, the primary function of which is to generate good press about the product lines and to deflect any negative attention from whatever source.

The idea of brand loyalty, in the strict advertising sense, is a bit outdated now that markets are consumer-driven. Marketing divisions have to come to respect purchasing patterns and recognize that consumer choice often reflects lifestyle choices based on deep commitments. Concerns other than need or desire may motivate the consuming public. Larger issues such as conservation, public good, cultural identity, and political positions now influence consumer spending.

Branding identifies the corporate culture and advances its appreciation in the consumer market. Branding is about building relationships through emotive and suggestive approaches combined with visual and typographic communication of essential information. Branding creates consumer consciousness, rather than brand recognition in the old sense of the term. Branding is a delicate and interactive relationship between the two sides of the communication equation.

Many of the projects previously discussed in this chapter contribute to a branding campaign. The most important, of course, is thorough research that focuses on the methods of structuring a relationship between client and consumer. The consumer is not a market to be targeted for financial or emotional conquest, but is a partner in business. What drives you crazy in your personal relationships may translate directly to a branding campaign. Think about the attributes of your ideal partner. Do you prefer consistency or spontaneity? Collaborative projects or an individualistic approach to productivity? Quiet moments punctuated by raucous distractions or an even-keeled, relaxed pace? In most cases, these are not really either/or choices, but an amalgam of complex responses to a variety of scenarios. More often than not, the answer to these kinds of choices is, "It depends"—it depends on the time, context, personalities involved, circumstances, and so forth. However, as a point of departure, you can design according to your self-knowledge and your knowledge of your client company's public.

Develop a compositional approach that can travel across a variety of formats and products, from novelty items to packaging and from display installations to letterhead. Your primary and secondary design elements will need flexibility and survivability as well as communicative and emotive power. They must accommodate a wide variety of design spaces. Develop many thumbnails to be sure your strategic approach will "carry" across different media and different formats.

Color and font choice will be the primary elements that create emotional response in the branding campaign. Image will vary according to product and niche market. Images speak loudly, so they must address specific audiences. Basic design elements are less specific, and can have greater appeal across a wider audience. They must be created out of a more universal language.

Focus groups and testing are good strategies to be sure you are stimulating the appropriate reactions. Use them to analyze font choice, color ranges, and spatial and compositional relationships. The last thing you want to do is approach branding as a "system" developed only from your client's preferences or your personal guesstimates. These inevitably depend on vague recollections of other branding campaigns or insensitive application of design prescriptions. Informed intuition and substantive innovation never derive from anything but real, working knowledge about the job at hand.

Perhaps the most effective way to initiate and build a useful relationship with the consumer is to create a visual environment that will affect and enhance that very endeavor. What ingredients are necessary to create and sustain such a relationship? On what basis do you want it formed? What short- mid-, and long-term benefits will be realized? Build in surprises and drama as well as consistency and logical presentation of information. Your visual hierarchy must be flexible and adaptable to specific format requirements. In the annual report you may use a traditional grid pattern with highly formatted pages, and your packaging campaign may repeat this approach in three dimensions. However, your Web site and broadcast graphics may create a less predictable visual environment of colorful transitions and explosive fonts and appeal to a different market.

You will need to know your client's expectations as the campaign unfolds. There may be quantifiable expectations in terms of regional sales, responses to direct mail pieces, new leads, or secondary measures of company recognition solicited through focus groups. Be sure to work these points into the campaign timeline and to develop alternative scenarios for different levels of consumer response.

Along this timeline, place new product releases and their related advertising campaigns. Figure in the public relations strategy and the potential effect of well-placed press releases and public events. Division decision makers and as many department managers as possible should be involved in the creation of this timeline. It is best to do it interactively. Let the departments develop their research and reports. Bring them into the fun of creative development. Find ways to help them contribute and then use their contributions. After all the ideas are out on the table, look for economies of scale, opportunities for collaboration and partnering, and potential moments for cumulative change.

Now break your campaign down into its elements: the kinds of design approaches needed, the design products required, contingencies, special events, and related items. Create a budget and allocate the necessary resources. Decide on photography and plan ahead. Assign responsibilities and then start design development.

After the major design products have been developed in rough form, bring your team back together and rethink the campaign. Analyze each design piece in terms of the campaign, then the campaign in terms of the pieces. You may find breakthroughs or unexpected design opportunities. The cumulative effects of these design adjustments may require the strategic campaign to undergo some enhancement or fine-tuning—or maybe some major adjustment. Include the time for this important step in your timeline, then take it to focus groups for responses that can be quantified.

Securing new approvals should not mean starting from the beginning. It may mean scaling back now that all the pieces, and the entire budget are being scrutinized. Know what you can live without, or how to reintroduce it as your campaign unfolds. Have your design team rehearse its presentation.

Now that you have set your campaign in motion, be sure you have built in design reviews at the crucial moments when quantifiable responses are to be measured. Nurture the campaign to be sure it survives and adapts. Develop caretakers on the client side and constanly increase their involvement in the project. As the campaign unfolds and the branding takes hold, take a deep breath and move on to your next project.

▲ KEY IDEAS

- Branding refers to the cumulative effect of strategic positioning through visual communication.
- Branding acknowledges that consumers identify product with producer, and that consumer loyalty is to a company.
- Branding identifies the corporate culture and advances its appreciation in the consumer market.
- Branding builds relationships through emotive and suggestive approaches.
- Create a visual environment that will affect and enhance such an endeavor. Build in surprises and drama as well as consistency and logical presentation of information.

Ask:

- What ingredients are necessary to create and sustain the "life" of the relationship?
- On what basis do you want it formed?
- What short-, mid-, and long-term benefits will be engendered?

Kalene Rivers
Rocky Mountain College of Art and Design

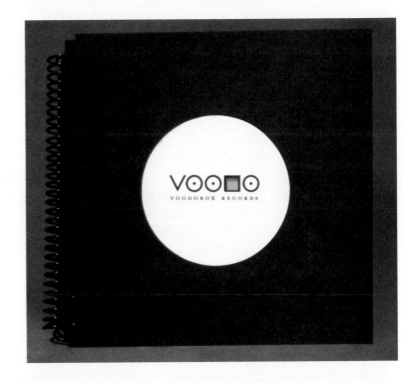

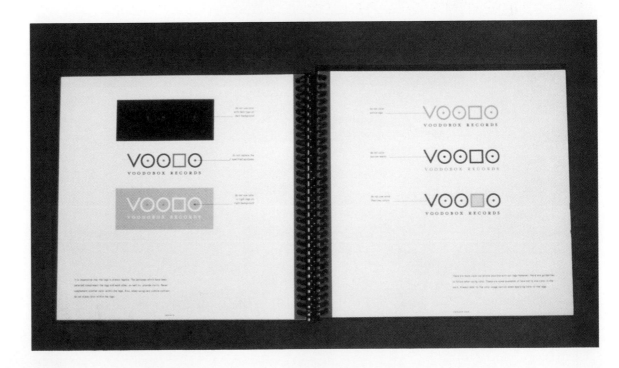

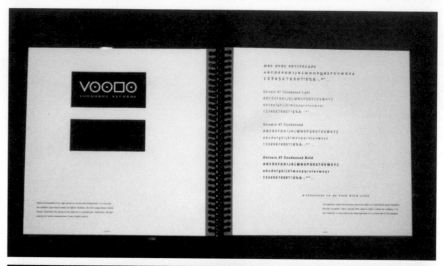

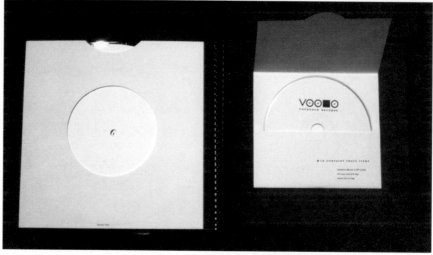

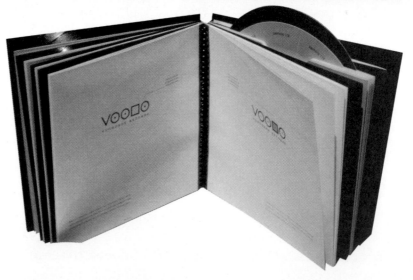

Professional Perspectives ◆

Lisa Graham
Associate Professor
University of Texas at Arlington

Branding Essentials

Branding has been called one of the most important marketing concepts in the commercial world. Through the development of a brand identity, a company can establish an image, evoke emotions, and place itself within a culture. When you think of IBM, you think of stable business technology. When you think of Nike, you think of athletic energy or the commitment to "Just Do It." When you think of Levis, you think of comfort, informality, and all-American appeal.

What Is a Brand?

A *brand* is a name, logo, design, message, or other proprietary feature that is intended to mark a company and its products as being clearly unique and different from its competitors and their products. A brand identity includes the name, logos, design, positioning, associations, and personality of the brand. A good brand identity builds positive associations with the company in the customer's mind. A positioning statement, in one phrase or sentence, tells what business the company focuses on and evokes positive associations with the brand. "You're in good hands with Allstate" or "Built Ford Tough" are both positioning statements that define the quality and values of the companies and, in a single brief statement, imply how their services and values are different from their competitors'. This is important because a brand leader can sustain a price point up to 40 percent higher than its closest competitor.

Central to the successful establishment of a brand is the concept that if you place a positive message about your company's products, services, and values in front of consumers for a long enough time, they will think of your company when it is time to buy. Branding campaigns use a wide variety of formats and media, from magazine ads to billboards to television to Web banners. Repetition is key. Conventional advertising wisdom says that a positioning message is not effective until the prospective customer has seen it at least ten times. It is human nature to buy brands that are recognized. But be warned, the company service and product must possess value beyond the implied.

How Is a Brand Created?

The first step involves extensive research of the market and the competition. Some questions to ask are:

Who is your market?

What does your market think of you, and how can you provide a service or a product to them that they want?

Who is your competition and what makes them appealing to your prospective customers?

How much are competitors charging for their products and where are those products distributed?

The second step focuses on the development of a marketing strategy by defining the objectives of the brand. To clarify marketing strategy, ask these questions:

Will the brand represent a single product, a product line, or the entire company? What values should be associated with the brand? What desired image do you want the brand to project? For example, the look and style of the brand might convey quality, dignity, playfulness, reliability, or some other brand characterisics.

How will the brand be distributed? Will it be distributed through a boutique, online, wholesale, direct, or some other distribution method? What is the proposed price, and how can the brand appeal justify the price?

The third step is one of developing the creative strategy. A name and positioning statement must be invented. The name should be memorable, appropriate, and express the spirit of the brand. Depending on company requirements, the name might also have to fit in with any existing company names. The list of prospective names must be researched to determine if they infringe on any other existing names; are offensive in another language; and, if necessary, are adaptable to international marketing. Likewise, translations of the positioning statement must be checked and double-checked for offensive or double meanings. How does the positioning statement reflect the overall look and feel of the brand, and does it present the unique benefits and values of the product?

What type, color, and images can support the appeal of the brand? Does the design of the brand work in diverse presentation formats? Does it work in one color in a newspaper as well as full color in a Web advertising banner? Once a visual identity for the brand is established, a plan for consistent usage of the brand should be outlined and distributed to all involved in the project, in the form of a standards manual. A standards manual details the use of the logos, colors, images, and other graphic elements across a wide variety of applications. It defines how the brand should be placed on items ranging from product banners to company vehicles.

chapter two

Entertainment Design for Film, Theater, and Music

In a sense, all design is entertaining, but entertainment design is a particular approach to graphic communication in support of the arts of music, film, television, and theater. It is highly interpretive and suggestive. It remains abstract while hinting at the narratives of the art form, whether it is to be projected on screen or performed on stage. The designer must reinterpret the story using the elements of design: type, image, and composition. A full exploitation of the graphic space necessitates a flamboyant, memorable design strategy that has the vitality to compete in the visual environment that is entertainment, while retaining an accurate message and attracting an audience.

Anna Stellitano
University of Florida

Talia Johnson
University of Florida

One-Sheets and Film Posters

One-sheets are, typically, small (usually 8 1/2" × 11") versions of what will become the film poster. They are used to promote the film during its development stage. As the main talent involved in the film (actors, director, cinematographer) is attached to the project, the film producer will begin raising money. The advance information kits that go out will include abstracts of the story, a synopsis of the intended treatment, biographies of the major talent, and financial information. A *one-sheet*—a small poster that visually describes the film and indicates the major talent attached to it, often enhances this kit.

David Woodruff
SUNY Buffalo

The one-sheet must make the movie stand out from all the other investment kits being pitched by seasoned promoters, tell the story of the film accurately, intrigue the reader, and please the senses. The designer will need to create an impressive piece aimed at a visually sophisticated but overstimulated market. To this extent, the film one-sheet and the film poster share common challenges. The poster, however, will require a full listing of the major talent (this is negotiated down to point size and order with the producer) and will have to function effectively at various sizes from tabloid ad to billboard.

The first step is to thoroughly understand the film. If a trailer has been made, ask to see it. If the director has been attached, view all the previous work by that director that you can find. Interview the producer and get a feel for where the investment campaign is going. Read the script and discuss its main points, innovations, plot twists, and subtleties. If the film is an adaptation from literature, read the source. If it is set in a historical time period, research all you can about the period, view other films staged in that time period, and pay attention to the costumes, set design, and props. Go to museums to get a first-hand look at pieces from that period. If it is set in a special location, visit that place (if you can), research it visually (if you cannot visit), read the script again in the setting, and get a taste of the local geography, color, and tempo of life there. Take your lead from the script and an intimate knowledge of the territory, whether historical, geographic, or psychological.

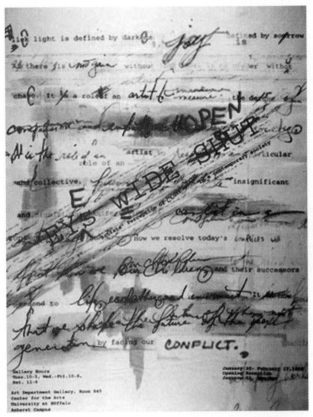

Mary Beth Woiccak
SUNY Buffalo

Film differs from theater in many ways, of course, but the primary difference for design concept is that in film everything must be supplied visually; theater works by asking the audience to "fill in the blanks." Theater requires active participation in the make-believe. Film is, in a sense, a more passive medium for the audience.

"Lights, camera, action" is for the director. The designer must satisfy "set, characters, and plot." These should be apparent in the one-sheet. Who-does-what-to-whom-and-why must be infused into the promotion package—but this is entertainment design, and therefore the facts must be combined with intrigue and seduction as appropriate to the mood and genre of the film. This must be done with a flair and affect that parallels the language of the movie.

Once the design strategy is developed, special attention must be paid to typeface and color. The typeface must convey setting, mood, and pace. Color will be used to draw attention and to create an overall mood. One-sheets and posters are "read" at two levels. One is the factual information: the title; the cast, writer, director, cinematographer, and other talent; the tag line that stimulates interest; and supplementary information such as critical acclaim or story synopses. The other "read" determines appeal and creates interest by hinting at major plot points of conflict, romance, and resolution. Typography conveys mood and pace as it incorporates the factual information. Pictures and textures affect the reading of place, plot, and drama. The overall composition should set the film apart from all the others of its kind competing for audience or investors.

At least three or four typefaces that work together should be used to achieve a unified typography for the project. Type should be used to set design areas apart

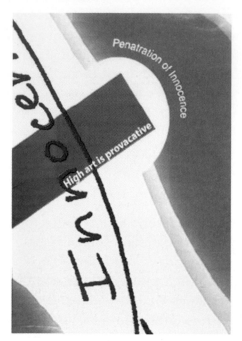

Mary Beth Woiccak
SUNY Buffalo

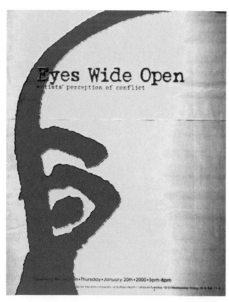

Stephen Turner
SUNY Buffalo

and to create spaces within the overall design where the requisite factual information can appear without compromising design strategies. Particular attention should be paid to the typeface for the title. It must be memorable and evocative. Embedded in the choice of display type are the designer's decisions about mood, place, and pace. Is it an action-packed shoot-'em-up set on a Mars space station in 2050, or a light, romantic comedy set in medieval France? The title and its placement in your composition will make or break your design.

Your imaging should reflect the microcosm of the film: its characters and their relationships, its setting and time in history, and its filmic texture. The last element, filmic texture, refers to the director's vision; it refers to the way the film uses color, light, and tone as realized by the cinematographer and editor and the lasting impressions the film creates. It creates the mood you share when you leave the theater and go out for that cup of coffee to discuss its meaning. Or the feeling you have when you go for a walk, after the show, down a dark, damp street to reflect on how the movie parallels your life. It is the filmic texture that you must build into your design of the film's promotion, because it constitutes the distinct quality of the film and may make the difference between success and failure at the box office. Every film has one: the designer's job is to find it, describe it, and then infuse the graphic space of the one-sheet and poster with it.

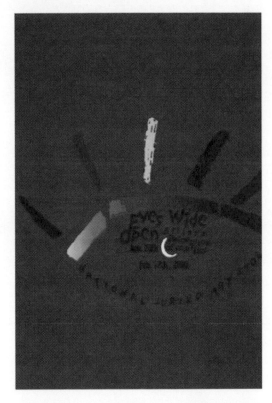

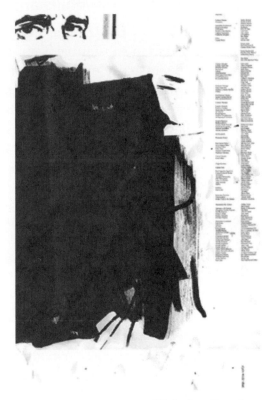

Wan -I Lai
SUNY Buffalo

Nicholas Bartlett
Concordia University—Nebraska

Film one-sheets and posters should always be printed on high-gloss coated stock for your portfolio. If possible, have full-size Iris or Fiery prints made of your film posters. Their impact is substantially enhanced by the depth of color that high-resolution prints can offer and by the scale of a full-sized print.

▲ KEY IDEAS

- Understand the film: watch the trailer; read the script; research the time period
- Facts must be combined with intrigue and seduction as appropriate to the mood and genre of the film.
- Design must parallel the language of the film.
- Identify the filmic texture and infuse the graphic space of the one-sheet and poster with it.

Theatrical Handbills and Posters

Design for the theater differs from deign for film in substantial ways. Theater has been an active expression of the hopes, aspirations, and conflicts of our culture for thousands of years. Theater is spectacle: real people doing real things, not stunt people and computer-generated special effects. Theater is accessible, whereas film is grand. Theater needs big actors; film needs big sets. Theater is here and now; film is forever.

In theater, the audience uses imagination to fill in the missing specifics of time and place and to establish context. This active and willing participation of the theatergoer establishes the primary strategy for design for theater. Theatergoers actively respond to abstraction, implication, and metaphor. The designer can use partial imaging, linear breaks, and textural overlaps to abstractly represent the story and its characters. The decisions on what level of abstraction is required to illustrate the main events, re-create the drama, and stand out in the crowd must reflect the stage director's interpretation of character, story, pace, and staging.

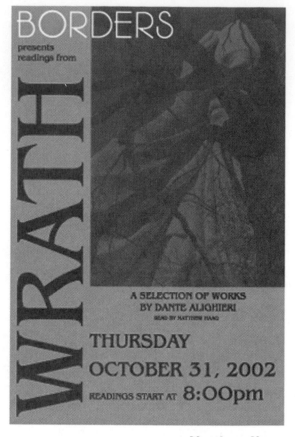

Matthew Haaq
Arkansas State University

Theatrical design often incorporates illustration with innovative stock choices. Textural physicality is a distinguishing characteristic of theater and should be reflected in design choices. Collage and montage are often used to imply missing components of linear time and historical place in theater and can be used to advantage in your graphic design. Experiment with new stock and with new hand tools to create innovative but relevant effects.

The handbill is not used as much today as it was in the past, but small promotional items, such as announcement cards and flyers, are often left in local coffee shops and bookstores hawking upcoming theatrical events. The handbill is a variation on this kind of announcement. The handbill is in many ways a small poster for the play. It does, however, have the distinct advantage of being both

more portable and less constrained by traditional size formats. The handbill can be any shape and size. It should incorporate innovative stock choice, hand-tooled illustrations, and important information such as title, playwright, theater, performance dates, phone, Web site address (URL) and so on.

The handbill should have a presence achieved by the texture, heft, and feel of the stock. This design choice must reflect the content of the play and the playwright's interpretation of the material. It must celebrate the unique characteristics of the event and must remain true to the theatrical experience. After you have conceptualized your design approach, hire an illustrator or printmaker who knows—and loves—paper. Solicit input and discuss how color and line will work on different stock choices. Think outside the box: consider handmade paper, exotic paper, and found objects. Then check with your printer to see if your innovations can be realized.

The handbill design must, like a logo, be scaleable, from small, portable pieces that can be distributed around town to large posters that adorn the theater itself. It may have to move from paper to cloth for merchandizing on banners and tee-shirts. Discuss the entire design campaign with the producer before you finalize design decisions. Develop contingencies, add-ons, and ideas about novelty items.

Your type choices embody your design strategy. Theater is a literary form and its market is comprised of sophisticated readers. Choose type that can convey important information while suggesting the playwright's approach to the material. Display type, grunge type, Old Style, moderne … each of these typeface categories creates its own reading space and can enhance your metaphors, your references, and your illustrator's hand.

Unless you fancy yourself an illustrator, do not attempt to create images in drawing and painting media yourself. You can, and should, draw up your ideas as thumbnails to be sure they will work within an overall design concept and then present them to an illustrator for further development. Illustrators know how to create realistic, impressionistic, or abstract drawings that can convey the richness of three-dimensional form, cast shapes into emotive narrative, or bring out the drama of a piece. Their world is one where image derives from text. In the same way that you would defer to your photographer's decisions for your annual report, let your illustrator help you craft images with rich lines, shapes, and textures that can survive scanning at the highest resolutions possible and that will perform brilliantly with your stock.

▲ **KEY IDEAS**

- Theater is spectacle, but theater is accessible.
- The theater audience supplies imagination to establish context. Theatergoers actively respond to abstraction, implication, and metaphor.
- The level of visual abstraction in your design must reflect the stage director's interpretation of character, story, pace, and staging.

Theater Programs

Theater programs provide an explanatory interface between the theatergoer and the cast. They enrich the theater experience by offering insight into the people and passion of the stage. They transform the staging into real people, delineating the art of performance within a spectacle of characters, costumes, and sets. Theater programs announce, project history and personality, and serve as mementos of the theatrical experience. They add reality to the make-believe, underscoring—indeed, reaffirming—the pretense.

The interiors of a theater program offer a good exercise in typography, in that great amounts of information are stuffed into a relatively small space and in accordance with a rather prescribed treatment. The decisions about typefaces, type treatment, and layout will challenge all but the most callous of graphic designers. The interior spreads of a program can enhance the careful balance between reality and illusion that theater negotiates.

Of particular interest are the opportunities for small, incremental instances of design organization that the overstuffed theater program offers. Creating repetitive design elements, such as borders, edges, lines, page numbers, headings, and layout grids, can enhance the reading experience and add to the fun without distracting from the play. These elements can add humor, supply additional biographical information, or set historical tone. Sometimes design can be most effective in the details!

The theater program cover is a design challenge unto itself. Within the confines of the format and layout, anything goes. Theater and its spectacle thrive on outrageous exaggeration. Poetic reference to the poignancy of the play, the main characters and plot points, historical period, and other staging devices serve as vehicles for the dynamic imagination of the playwright and the producer.

The program cover may continue the design strategy of the theatrical hand-bill or other promotional materials, or it may take a totally new departure. The program cover can reference theater content photographically, through illustration and collage, or through typography and color. By summing up the play through metaphor and illusion, the program acts as a record of the the-atergoer's experience. It becomes a personally meaningful object that recalls a very specific and perhaps highly idiosyncratic interpretation. The theater program is both an introduction to the spectacle and a crystallization of the experience.

One great design advantage, of course, is that the reader of the theater program is already in his or her seat. The promotional value of the program is usually restricted to a back-cover advertisement, either for a product or service or for another theatrical event. The front cover is free to set the tone.

This is not the time to simply transpose the handbill into the size and for-mat of the program. Although the designer may feel the need to offer visual consistency by using elements of the handbill, its size and stock specificity should preclude its use as the program cover. Remember: the program cover introduces the theatergoer to what is about to occur. It builds on the viewer's expectancy. It fills a void that transports the theatergoer from the familiar, work a day world outside the theater to the fantastic physicality and immediacy of the moment at hand. It must inform and intrigue while it fills the audience with expectation.

▲ KEY IDEAS

- Theater programs provide an explanatory interface between the theatergoer and the cast.
- Theater programs add reality to the make-believe and reaffirm the pretense.
- Theater programs can become personally meaningful objects that are very specific and perhaps highly idiosyncratic interpreta-tions of the events of the day.
- The theater program is both an introduction to the spectacle and a crystallization of the experience.

Entertainment Advertising: Film and Theater

The primary difference between entertainment advertising and product advertising is that in entertainment advertising the viewer is not explicitly told to do something. The copy will consist of the title of the work, the principal contributors, and information on how to experience the work. Rarely is there an instruction such as "buy this CD" or "see this film," although there may be critical acclaim or some other form of testimonial that suggests or proclaims that the entertainment piece is worth the price of admission. Copy is generally center aligned and follows other prescriptions for typographic styles. Point size, for instance, is often negotiated when the main talent signs on to the project. These conventions are immediately recognizable and the format is strictly adhered to. They will be provided by the client.

Entertainment advertising will derive from the film or theater poster. The film poster, converted to a newspaper ad, will have to carry additional information, such as where the film will be playing, the schedule of shows, the dates of the run, and so forth.

This is not, however, a simple conversion of a color poster to a grayscale newspaper medium. To simply convert a delicate, layered, full-color poster into a grayscale advertisement is a recipe for disaster. Grayscale requires more attention to the planar characteristics of the images, and to subtle transitions. Images must be able to survive a loss of detail and still convey the visual message. The composition should be considered as a series of intersecting planes and layers that retain the visual order and meaning of the poster. The film poster may require serious reworking to survive the trip from color to black-and-white.

David Correll
Rocky Mountain College of Art and Design

To further complicate things, it has become common for film and theater advertisements to carry at least some color. Obviously, this color is different from what you can expect from a four- or six-color print job on high-quality, coated stock. Newspaper pulp can reproduce color only within certain ranges. Color tone must be considered carefully. A whimsical addition of spot color can confuse the eye and detract from the overall texture of the ad. Nevertheless, color in this case can serve effectively as a navigational aid, guiding the eye as it moves from the primary to the secondary to the tertiary messages. Use it as frames and as planes, or to create three-dimensional effects and to activate graphic spaces within the ad.

The visual pace of the ad should match the pace of the film or play. Typography will be the first site of visual engagement and must drive the advertising home. Have it dominate the ad, followed by a strong visual that sets historical or geographic context or reinforces psychological mood or dramatic tone. Color can be used to augment the effect of typography, but it cannot replace a well-designed typeface. Your faces should create transitions and provide navigational guides, using both positive and negative space to catch and captivate the eye. Navigating through the space of the ad, the eye will wrap around and through the image as it reads the type. The goal is to have both the image and the type function as one message of exuberant pleasure.

▲ KEY IDEAS

- The visual pace of the ad should match that of the film or play.
- Typography will be the first site of visual engagement and must drive the advertising home.
- Type dominates the ad, followed by a strong visual that sets historical or geographic context or reinforces psychological mood or dramatic tone.
- Color can be used to augment the effect of typography, but it cannot replace a well-designed typeface.
- Typefaces should create transitions and provide navigational guides using both positive and negative space to catch and captivate the eye.

CD Mini-Magazines, Labels, and Tray Sheets

Compact disc (CD) inserts are mini-magazines. They are the depictions of a music story. They supply visual information about the process of music creation, either by depicting the influences of time, place, mood, and experience that contributed to the musical arrangement or by depicting the people and circumstances of the recording. CD inserts add physical dimensions and context to the sensory experience of listening to the music. The CD mini-magazine contains lyrics and band information supplied by the producer or manager. Images may be supplied from the band's archives or may be shot specifically for the CD release.

The CD insert should not try to duplicate the music, but rather to supplement it by reference to the physical context in which the music lives. People, places, time periods, instruments, audience reaction, sources of inspiration, and mood all contribute to the art and craft of music. Illustrative references help the audience experience the music the way the artists intended it to be heard by providing a commonality that only the visualization process can achieve. The appreciation of music is an interior phenomenon, different for each person. The actualization of the sound experience in visual form provides a common starting place for the artists' intentions to be shared by the audience. Is the music purely entertaining? Does it offer a moral or spiritual lesson? Does it refer to an historical event? Does it supplement the visual experience of a film? The answers to these kinds of questions informs the "story" of the CD magazine. Images should be selected or created to present this story to the intended audience.

It is important to remember that the function of a CD insert is not primarily that of promotion. In most cases the CD has already been purchased before the insert is accessible. This design project offers an opportunity to investigate the complex translations of meaning between the music media and the sensory experience. Be sure to keep the design lower keyed than the music.

Develop the story with the artists whose work you are packaging. Get to know them and their approach to music, their sources of inspiration, and personal quirks. Pay attention to the colors that surround the band members and that supply tone to the music.

Search out design elements that can be repeated throughout the magazine, creating a rhythm over the pages. These may be framing devices, image distortions, or special effects. They may be directional indicators such as arrows or dotted lines, boxes, small icons, textures, or patterns repeated in predictable or unpredictable ways, enhancing visual information or activating viewer awareness and sensitivity to certain areas of page information.

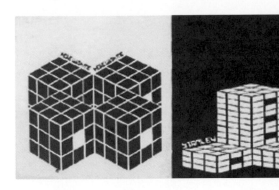
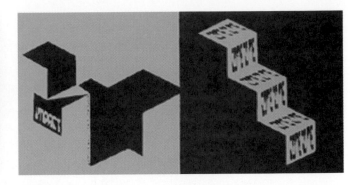

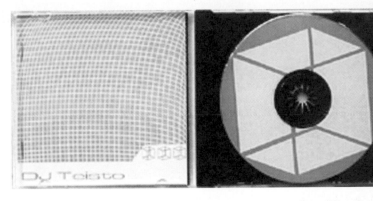

Jennifer Brown
Briarcliffe College

Photography will be the principal means of imaging. You will create image-environments that contribute to the overall CD insert story with the photographs you take, photo art-direct, receive from the band, or buy from a stock photo house. The important rule to remember is to craft the story line first, then seek the photos. Otherwise you will end up with literally thousands of possibilities and no editorial reason to accept or reject any of them. Keep to the story, once the artists and promoters approve it.

Your CD insert will invariably contain at least some text, and perhaps a lot of text. Certainly there is copyright information, arrangement information, perhaps band member biographies, and often the lyrics. The extent of the copy will depend on you and on your client. Its place within the CD insert and its relation to the visual story and the layout are your concern. The copy must reinforce and support the story and the design elements. Typeface, point size, color, and placement will activate new areas of each page and can

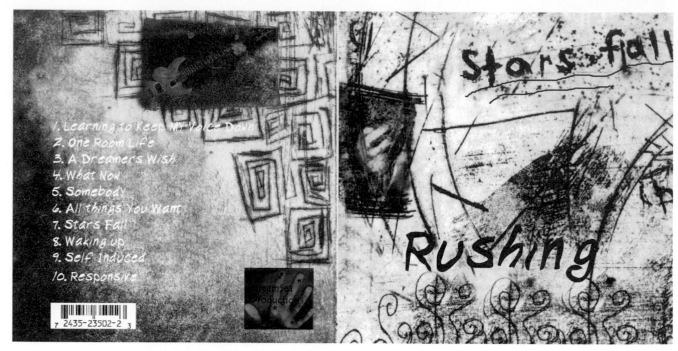

1. Learning to Keep My Voice Down
2. One Room Life
3. A Dreamers Wish
4. What Now
5. Somebody
6. All things You Want
7. Stars Fall
8. Waking up
9. Self Induced
10. Responsive

7 2435-23502-2 3

stars fall

Rushing

Jamie Burkhalter
Southeastern Louisiana University

serve as complements and counterbeats to the imaging. You may decide to allocate all or most copy to a designated area so that the reader can review lyrics and arrangement information as distinct from the pleasure of joining the artists in the virtual space created by the visual narrative. Organization is the key, whether the copy is interwoven with the imaging or whether it resides in a separate section. Plan the pacing—the shift from "reading" the image-story to reading the copy—so that it emphasizes the mood required to enjoy the sound.

The CD label and tray sheet offer additional design opportunities to extend the look and feel of the CD insert. They may extend the narrative and visuals of the CD insert or may borrow only some of the design elements from it. They can also offer a different visual experience that helps the transition from the world of the mini-magazine to the world of the musical experience.

▲ KEY IDEAS

- Although music experience is a subjective experience, the translation of a sound experience into visual form provides a common starting place for the artists' intentions to be shared by the audience.
- CD inserts offers an opportunity to investigate the complex translations of meaning between the music media and the sensory experience.
- CD inserts are the depictions of a music story.

The answer to these kinds of questions inform the "story" of the CD magazine:

- Is the music purely entertaining?
- Does it offer a moral or spiritual lesson?
- Does it refer to an historical event?
- Does it supplement the visual experience of a film?

Concert Poster

Promoting live music events is a combination of imaging the music group, the musical experience, and the setting. The musical experience, especially if crafted for the specific setting, should drive the design strategy. The group, concert theme (if any), and the location should drive the typography. Concert posters can build upon and reinforce name recognition and presence in the music industry. Many of the methods and practices of branding might be considered in developing a poster campaign for a tour. Even if the group is not a major force, you can still image it so that your poster generates enough general interest to drive people to find out more about the band, purchase its CDs, and wear its merchandising.

The poster should foreshadow the rhythm and physicality of the concert. Branding the group by promoting its unique sound is a labor of poetic imaging, using eye-catching color framed by innovative type design and enhanced by novel paper choices and printing techniques. Spot varnishes can

help create three-dimensional effects, while pulp stocks, textured finishes, and odd paper choices can create innovative printing artifacts and unpredictable inking. The music poster must often stand out in places where visual and auditory pleasure seekers find unique respites from the boredom of the quotidian world. These posters are usually meant to be seen by those whose lifestyle is attuned to the night. They speak of the physicality of sound.

▲ KEY IDEAS

- The concert poster promotes live music events by imaging the music group, the musical experience, and the setting.
- The musical experience should drive the imaging strategy; the group, concert theme, or location should drive the typography.
- The concert poster should foreshadow the rhythm and physicality of the concert.
- Concert posters speak of the physicality of sound.

Jason Disalvo
Metropolitan State College

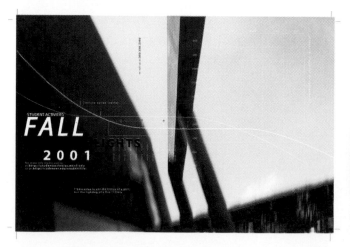
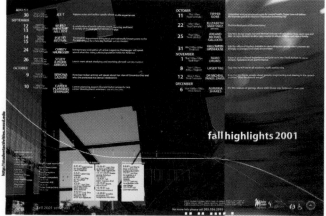

Music Advertisements

The music ad, like the film ad, has to survive in the black-and-white world of newsprint, with an occasional venture into full-color magazine formats on coated stock. Design in color and in black and white for this project, developing imaging and typographic treatments that visualize the physical presence of the performing artists and the message of their work. Develop a three-dimensional effect through your typographic treatment or through image layering so that the eye is teased into the graphic space of the ad.

Music transports each listener to a different realm of pleasure, and your advertisement should stimulate wide appeal and individual interpretations. Let the concert begin with the ad; announce its feel and its tempo; let the viewer feel the sensual pleasure of penetrating rhythms. Image with very physical references surrounded by delicate type; or strike boldly and audaciously, using your type to transform edges and borders into vaporous swirls of information. Develop a compositional structure and then break it, unexpectedly and resolutely. Remember the visual tastes of your target market, and then offer them an impulsive treat.

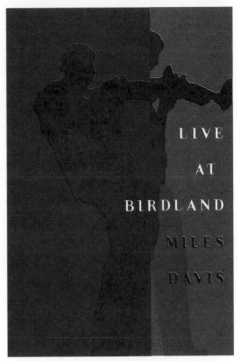

Jason Disalvo
Metropolitan State College

▲ **KEY IDEAS**

- The music advertisement should stimulate wide appeal and individual interpretations.
- Identify and use the visual tastes of the target market.
- The music ad has to work in grayscale on newsprint and in full-color formats on coated stock.
- Create imaging and typographic treatments that visualize the physical presence of the performing artists and the message of their work.
- Develop a three-dimensional effect through your typographic treatment or through image layering so that the eye is drawn into the graphic space of the ad.

Gallery Announcements

Gallery announcements were one of the earliest forms of modern graphic design. In the mid-nineteenth century, Paris Impressionists often advertised their innovative exhibitions by creating posters and affixing them throughout the less-than-fashionable *quartiers*, along narrow streets, near local produce and flower markets, adjacent to lively bistros where the intellectual life of Paris surged beyond the confines of the formerly permissible. These artists often advertised their own work by using

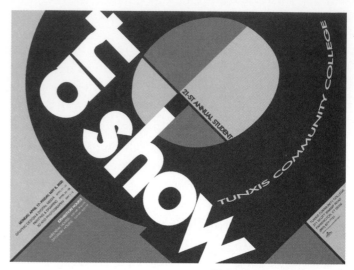

Kazimiera Cichowlaz
Tunxis Community College

their own stylistic devices, developing an early link between graphic sensibilities, mass marketing, and deeply personal artistic expression. This tradition lives on in today's gallery announcements, whether they are shows of the most novel of artistic explorations or exhibitions of a more traditional nature.

The gallery announcement frames the experience not of making the art but of consuming it. Gallery goers are often unfamiliar with the artists or their works. A sense of excitement and surprise is intrinsic to every gallery event. The announcement helps to prepare and frame the potential patron's participation in the artistic process. It must assure that the work is worth investing in, even if the artist is still unknown. It must connect the work to a tradition of works, using historical references and thematic clues. The announcement must form links to artistic methods, processes, and philosophies so that validity and value are acknowledged even as experimentation and innovation are reaffirmed.

The image must refer to the art works and will often be supplied by the gallery or the artist. The type should boldly, but simply, reinforce the individuality of the artist. Composition creates spaces of visual engagement, transition between the design elements of image and type, and sets the borders of graphic interplay.

A gallery is known for its artists, its investment opportunities, and its ability to attract art works of stature. The gallery announcement, while showcasing a specific artist, also brands the gallery, its director's aesthetic preferences, its roster of artists, and its role in the art scene. Although the announcement may be about a specific exhibition, it also presents the gallery to a particular

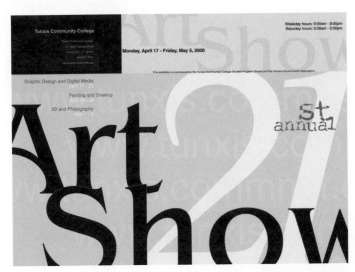

Charles Theobald
Tunxis Community College

public. This is much like a corporate advertisement, which, while showcasing a specific product, also images the corporation that manufactured it. The similarities are worth paying attention to.

Become familiar with the local art scene. Find out about the gallery's position and reputation. Is it a cutting-edge gallery whose design image must refer to the controversial and the novel, or is the gallery one that attracts patrons who need more reassurance—and less risk—in the future value of the pieces they intend to purchase? Visit the gallery and get a sense of its living reality and the people it attracts. Is it a quiet, hushed, atmosphere of leather, mahogany, and brass, or is it a raucous environment of intense energy, student fashions, and industrial-loft architecture? Find ways to connect the architecture of the gallery space to the architecture of the graphic space, and fill it with the appropriate design elements. Look for instances of luminosity and at the way light transitions through the spaces. Let the gallery light and the light of the art works dictate the color space of the announcement. Argue for full color when it is necessary and for duotones, monotones, and high-contrast black-and-whites when the atmosphere calls for them. Notice the edges of spaces and the physical transitions between exhibition space and sales space. Search out the details of the spaces: the lavatory fixtures, stairway banisters, the patina of wood and metal surfaces, and the textures of stone. Bring the physical space of the gallery into the announcement through graphic gesture. Every art work needs a home.

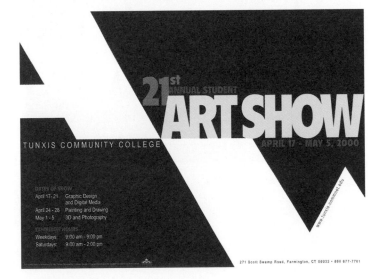

Betsy Sargent
Tunxis Community College

▲ **KEY IDEAS**

- The gallery announcement frames the experience not of making the art but of consuming it.
- The gallery announcement must acknowledge value while reaffirming experimentation.
- The gallery announcement presents the gallery to a particular public.
- The gallery announcement creates a business identity that is site-specific.

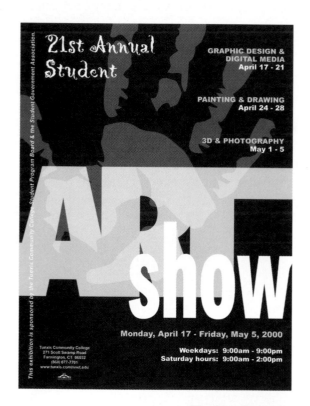

Cinthia Gorman
Tunxis Community College

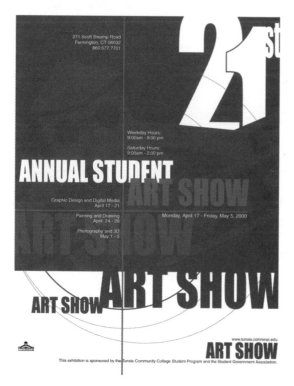

Alberto Bonello
Tunxis Community College

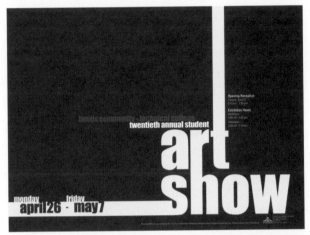

Scott Magrath
Tunxis Community College

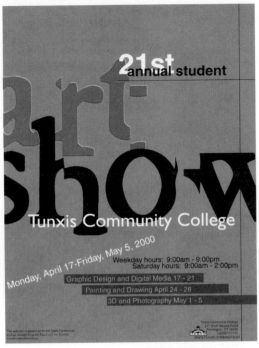

Theresa Stevens
Tunxis Community College

Small Graphics: Tickets

Ticket design is an underappreciated opportunity. These pint-sized projects can be powerhouses of design ingenuity. They can speak volumes—in whispers. Tickets grace diaries and serve as mementos of important events. They can amplify the evening's entertainment by calling attention to its special significance; dignify an anxious atmosphere of expectation by offering a brief moment of bemused sharing; and prompt a quiet meditation on the distinct value of exquisite detail.

Anthony Lupo
Briarcliffe College

Elizabeth Todari
Briarcliffe College

James Russo
Briarcliffe College

Tickets fulfill, at the very least, an accounting function by helping to compare the number of tickets issued to the box office receipts and the cash in the till. Tickets are also becoming a part of the market research arm of event planning. Bar codes permit the embedding of personal information as well as access to financial accounts. Tickets can now include, for example, $100 of food and beverage credit or other perquisites, and can be used to solidify and build business relationships. The sales agent can be identified, thereby indicating consumer patterns and purchasing habits. There is a predominantly functional utility to tickets that must be taken into consideration in the design. However, this functionality does not preclude the opportunity to address one of the defining realities of our profession: "Design is in the details."

Granted, space is limited, and creating complex arrangements of design elements and graphic space is problematic, but you can still embellish this small space with a sense of moment and import. Design strategies can make direct references to the characters who are about to take the stage or special moments in the story that is about to unfold. Your strategies can be somewhat tangential to the entertainment event, referring to the possibilities for special personal relationships that can develop out of a shared experience. They can be outrageous or insouciant, playful or romantic. They can incorporate abstract symbols, whimsical colors, and bizarre shapes. They can refer to historic context, use novel typographic treatments, or carry impertinent messages.

▲ **KEY IDEAS**

- Small entertainment design projects can be opportunities of design ingenuity, moment, and import.

- Small graphics can run from a direct reference to the characters about to take the stage to special moments in the story about to unfold.

- Small graphics can be tangential to the entertainment event and make reference to the possibilities for special personal relationships that can develop out of a shared experience.

- Small graphics can be outrageous or insouciant, playful or romantic.

- Small graphics can incorporate abstract symbols, whimsical colors, and bizarre shapes.

- Small graphics can make reference to historic context, use novel typographic treatments, or carry impertinent messages.

Large Graphics: Billboards

Outdoor advertising is a specialized form of promotion. The billboard is made to be enjoyed at a variety of scales, speeds, and perspectives. We can zoom past it at 75 miles per hour, seek shade under it, observe it from straight on and from acute angles, laugh at its exaggerated size, be offended by its licentious pretensions, or ashamed by its overt hubris.

Outdoor ads create their own local visual environment along highways and in urban areas. They offer the opportunity to push the digital medium to its full potential, using its three-dimensional capabilities to create the fantasy of monumentalism. Billboards create a sense of presence by their size alone, and if taken for what they are—gargantuan icons to a consumer age—they can convince by laughing at themselves. Their exaggerated pseudo-reality is entertainment. This is their strength and their limitation. They are their own landscape in a virtual world.

Theresa Stevens
Tunxis Community College

Outdoor ads create unprecedented opportunities for transforming the static into the dynamic, using scaleable shifts in optical illusion, expansive typographic and digital imaging strategies, and assemblage and montage techniques. Color merges with spatial construction. Content becomes confused by the limited exposure afforded by a passing vehicle. Image is consumed before typography is recognized.

With the monumentalism of the format and the ability to add three-dimensional objects, the graphic opportunities are almost limitless. The key is to avoid designing at a smaller size and then increasing size to fit the format. Start with a full-sized concept and then develop the design in sections. Think monumentally, and take full advantage of the visual dynamics at the site. Look

for lines of sight; create floor and ceiling horizons, add verticals that provide for visual access and transitions across graphic space. Let the message take full presence in the landscape by effectively framing the image within the dominant visual geometries.

Most outdoor ads fail simply because the message is too small. Once you have defined the concept in ways that fit the oversized scale of billboards, work to develop a composition of distinct spaces whose graphic contribution is unambiguous in the structure of the ad. Avoid overcrowding the content space.

Typography must be monumentalist as well. Study display-type structure, paying particular attention to the impact of the negative space as your type looms large. Use the typography to build the compositional space of the ad. Your type must frame image spaces and reinforce the boundaries of the billboard itself. When feasible, have your typography play off the sight dynamics of the site so that attention is directed to the entire content space and not to the image or to the type separately. If the site functions dynamically with the ad, your content will be framed by the local environment and will be read as a whole.

▲ KEY IDEAS

- Billboard advertising is consumed at a variety of scales, speeds, and perspectives.
- Billboard advertising creates a local visual environment. Use the visual dynamics that frame the image within the site geometries.
- Billboard advertising uses three-dimensional capabilities to create monumentalism.
- Billboard advertising's exaggerated pseudo-reality is entertainment.

Professional Perspectives

Elzbieta Kazmierczak,
Assistant Professor
SUNY Buffalo

Poster as an Art Form

The poster documents and reflects history by participating in the creation of a pictorial chronicle. Posters serve an important communicative function, as they preserve the texts of a culture and document ideas, values, and information. Posters can be heralds of events to come, and they are a common medium of advertising.

Project Launch

If the poster is to fulfill its persuasive and informative functions, it has to be highly perceptible and understandable in fast-paced, high-traffic public spaces such as streets, underground stations, terminals, and hallways. The artistic forms of posters must transcend geographic, cultural, and chronological distances if the posters are to function cross-culturally. Posters should evoke universal and desired emotions through the use of graphic metaphors and symbols. Poster design allows students to experience the expressive impact of image-text designs in a large format.

The poster is an ephemeral carrier of information. It has a brief moment of existence intensified by multiple copies. Its time expires when it gets worn out or becomes outdated, yet some posters survive. These are the posters that, along with other forms of artistic expression, add the value of an authentic experience to that of the subject by means of artistic form. Those posters are preserved and become part of a cultural heritage.

My approach to the poster as an art form challenges its function as a means for the communication of information. Defining conceptual and formal guidelines for assignments, I expect students to convey information through highly subjective and individualistic design solutions that transform the design process into artistic experience, as opposed to merely a factor of commercialism and common taste.

Project Research

Students designed posters for movies, documentaries, or art exhibitions: sequences or collections of images that were visual expressions of artistic viewpoints of other communicators. Students were asked to overcome the desire to copy the style or the look of analyzed images and derive their own conceptual and, subsequently, visual interpretations of the content.

At the beginning of the semester, students read an article by Ed Bedno, "A Program for Developing Visual Symbols," in *Visible Language* 4 (Autumn 1972), 355–63. This article provides a systematic, step-by-step method for visual concept/symbol development. It proved successful for overcoming visual clichés and conceptual stereotypes. Students were also given readings from the book *Muzeum Ulicy: Plakat Polski w Kolekcji Muzeum Plakatu w Wilanowie* [Street Museum: Polish Posters from the Collection of the Poster Museum in Wilanow], (Warsaw, 1996). Students were exposed to dozens of examples of outstanding international posters, especially posters from the Polish School of Poster Design. Presentations of outstanding posters were augmented by lectures and readings on the cultural and political contexts that stimulated the growth of metaphoric approaches to poster design in Eastern Europe.

Project Development

Students engaged in systematic decoding of images to learn how to recognize and understand graphic strategies used to convey meanings. Students were given a set of poster design "tenets" according to which their posters were examined:

- A poster expresses a compact semantic structure of the message by way of a closed artistic structure.

- A poster contains mutually codependent pictorial and linguistic messages.

- Pictorial and linguistic codependence constitutes the essence of the poster.

- A poster must reflect idiomatic relations, the expression of which requires a complex verbal statement.

- Artistic form should be sufficiently archetypal or transparent to avoid misinterpretation.

- A poster represents a reality that is contrary to the common perception of the senses.

- A poster is perceived as an image, including purely typographic arrangements.

Students were also provided with a set of design guidelines to be considered during the design process:

- Use conceptual and graphic shortcuts.

- Be synthetic and depictive as opposed to descriptive.

- Make a conceptually strong visual idiom.

- Be metaphoric and imaginative.

- Embrace the rational and emotional.

- Express unthinkable and sublime.

- Reach out to archetypes and universal meanings.

- Be minimalistic but not simplistic.

Students were required to research and analyze their subjects using concept maps from which they developed matrices of juxtaposed concepts and related icons. At this stage of the design process, students had to develop multiple versions of the brief text that would capture the focus or essence of the student's interpretation of the subject. Subsequently developed thumbnail sketches were examined in relation to the concept maps.

During the class review, compositional and strategic recommendations were made for the advancement of sketches. This second review of sketches usually provided enough feedback for students to move toward the development of compositional sketches. Students were then asked to determine the placement of and typeface selection for the text. Text had to include a title of the given subject and original, interpretative copy developed by each student. In most cases, the student's copy functioned as a subtitle or a motto appearing on the poster.

Students were encouraged to mix techniques (e.g., to blend electronically derived elements with traditionally drawn or painted elements and the analog manipulation of images). When a highly textural line quality was desired, students used their small compositional sketches as actual material for further elaboration of the final project.

Project Outcome

The method of mixing media to merge traditional and digital techniques resulted in a wide range of individual artistic styles during the semester-long practice of poster design. Thus, we managed to avoid the sterile and uniform look of electronically generated visualizations. By mixing media and techniques, students were able to develop a sensitivity to and an understanding of the wide range of emotional and graphic expressions possible with variable line strokes.

In the long run, the experience with the large format and minimalist, yet concise and conceptually condensed, approach to poster design as a form of artistic expression stimulated "outside-the-box" solutions to other design projects.

chapter three

Advertising and Promotional Design

Today's advertising designer has the opportunity to extend advertising campaigns over multiple media, develop a corporate brand, and image diverse product lines for countless niche markets. Advertising still generates tremendous amounts of work for the graphic designer, who now functions as an integral member of a team of creative professionals. Many graphic designers find their first jobs in advertising.

Advertising Concepts

Since the 1970s, one of the guiding principles of advertising design has been the primacy of "The Concept." The ad concept functions in ways similar to those of story structure in film. It is the focus and measure of all the individual components that go into the final visual presentation. It must be delivered quickly and efficiently. Imaging, copy, typeface, and graphic organization all must work cohesively to ensure that the message gets across.

The advertising concept must be presented and understood in individually compelling and effective ways. This means that imaging and tagline must function simultaneously and harmoniously, and that every graphic element must drive home the point of the ad concept in ways that reflect the desires and preoccupations of the target market.

Successful advertising design offers a solution—via the product or service—to problems of comparative value. In approaching advertising design, ask: "What obstacles impede or hinder the use of this product or service?" The obstacle may be historical, cultural, emotional, physical, or financial, but the question must be addressed by the design strategy. During the research stage, the advertising designer will focus on the benefits of the product or service and the impediments to its use by the target market. This means identifying the market,

its operative value system, and the challenges it faces in achieving those values. Advertising design is about visualizing the human drama and offering solutions to the dilemmas facing a group of potential users in a visual language that communicates believability in tangible ways.

▲ KEY IDEAS

- Advertising design offers solutions to problems of comparative value.

- Advertising design is about visualizing the human drama.

- Advertising design communicates in a visual language of believability.

- Imaging, copy, typeface, and graphic organization all must work cohesively to ensure that the message gets across.

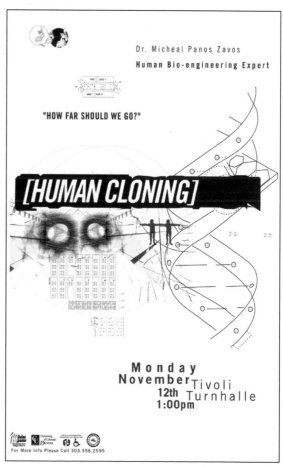

Jason Disalvo
Metropolitan State College

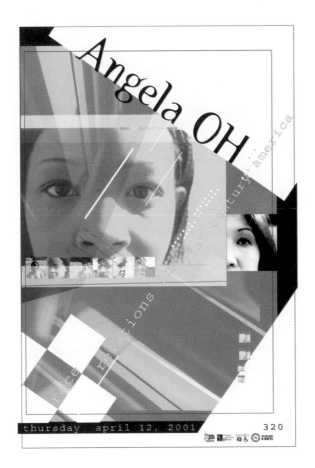

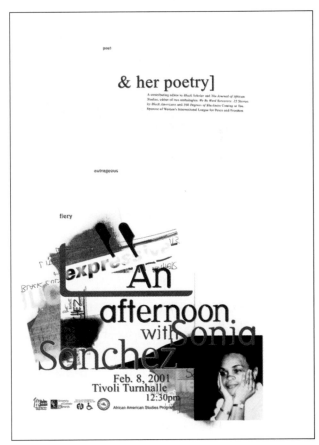

Jason Disalvo
Metropolitan State College

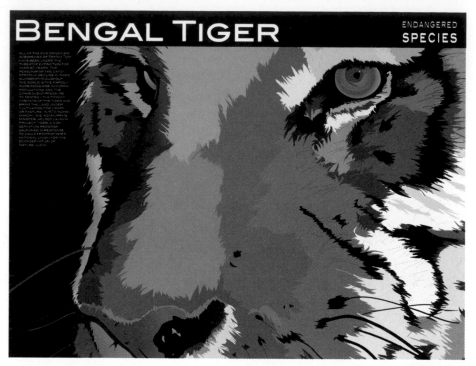

Jeremy Maendel
Tunxis Community College

Advertising Campaigns

Most successful advertising requires an integrated marketing campaign. Special events and one-of-a-kind offerings, of course, have a time limitation, but most advertisements must fit into a sustained effort over a variety of media, directed to diverse markets. It is always a good idea to think strategically, situating your individual ads within a broader campaign that evolves over time. Address some best-case/worst-case scenarios in advance; scenario planning can help optimize response to changing market conditions.

Recognize that a successful advertising campaign itself may affect market conditions. Competing firms will respond with their own advertising and marketing schemes, compounding the changing conditions. Advance planning for the unfolding of the advertising concept, in response to both predictable and not-so-predictable market changes, encourages creative consistency and brand stability. This in turn may increase market share, the ultimate goal of advertising and marketing.

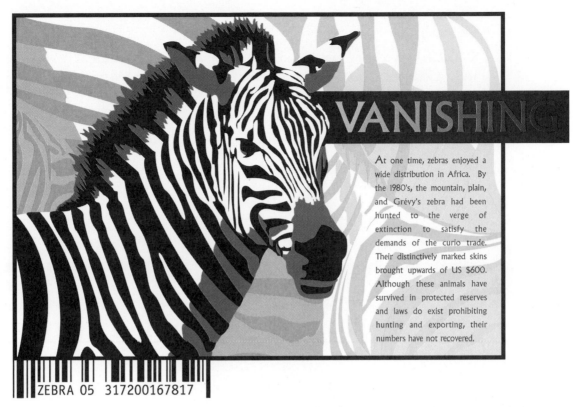

At one time, zebras enjoyed a wide distribution in Africa. By the 1980's, the mountain, plain, and Grévy's zebra had been hunted to the verge of extinction to satisfy the demands of the curio trade. Their distinctively marked skins brought upwards of US $600. Although these animals have survived in protected reserves and laws do exist prohibiting hunting and exporting, their numbers have not recovered.

ZEBRA 05 317200167817

Laura McCloskey
Tunxis Community College

The campaign should be thoroughly researched, budgeted, and planned. Diverse media, reinforcing themes, and short-, mid-, and long-range goal clarification should be thought through. Seasonal variations, special events, discounting schemes, publicity and public relations, and spinoffs must all be addressed. Practical issues such as consistency in look may mean shooting every conceivable photo session early in the campaign, so that availability of set and model will not hinder future production. Ordering stock in bulk and reserving time in printing schedules should be considered.

How will the advertising concept evolve? In this era of immediate response to consumer desire, it is important to build feedback loops into the campaign so that the design strategy can remain fresh and responsive to changing markets. The think-tanking that can take place during these creative planning sessions is one reason why the advertising industry attracts some of the most talented creatives in the world today.

▲ KEY IDEAS

- Successful advertising requires an integrated marketing campaign and a sustained effort over a variety of media, directed to diverse markets.
- Successful advertising builds feedback loops into the campaign so that the design strategy can remain fresh and responsive to changing markets.

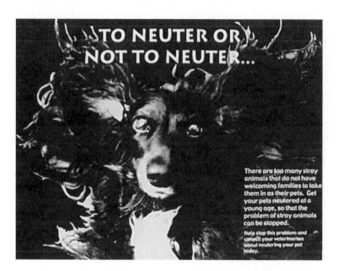

Naomi Smith
Briarcliffe College

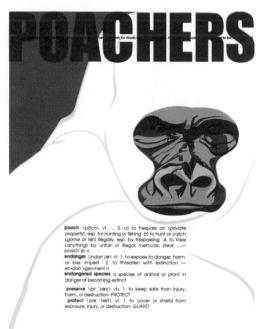

Pamela Lence
Tunxis Community College

Lifestyle Ads

The first step of any successful lifestyle advertising campaign is to develop a concept—a strategic approach to promote the product or service to a specific market in simple, direct, and effective ways. This involves developing a before-and-after scenario that clarifies the needs addressed by the product and the benefits attained by using it. These may be attitudes, values, behaviors, or preferences, but they should be clearly—and personally—identified. It is from this before-and-after scenario, together with market and product research, that the advertisement's message and chief design elements will flow.

Ads have three primary messages: the tagline, the image, and the body copy. The image must place the viewer in the ad. This strategy involves creating imagery that helps the viewer identify with the concept. Create a visual identity in which viewers can see themselves when the product is used. For lifestyle advertisements, this will be an imagery of action and setting. It is important to establish use in context by creating a short visual narrative.

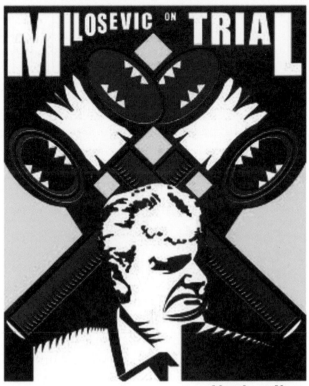

Matthew Haag
Arkansas State University

This approach may depict an interior context (mood, feelings) or an exterior one (action, diversion), but it is important to remember that the context acts as the "glue" in the before-and-after scenario. Imagine an advertisement for a sports watch of supreme precision. It is used to help a skier make crucial decisions during a competitive descent. Without the precise information provided by the watch, the skier will lose the race. Remove the ski slope or the intent look of the racer's eyes fixed on the approaching field of moguls, and the advertisement loses all its meaning—we are left with just another expensive watch with a lot of dials and numbers. No story, no context … no identification. The lifestyle ad must incorporate a personal strategy, a story about people using the product or service. Linking the skill of the skier and the precision of the watch can work so effectively that we do not even question how the skier might find occasion to glance at his timepiece during a giant slalom!

The tagline must underscore the narrative and the context, and the chosen typeface should complement both the interior and the exterior context (if both are present). Body copy may be of secondary or even tertiary importance, and typeface choices should indicate whether there is a hierarchy of information. The more directly the viewer can get to the advertisement's concept and context, the more memorable the ad will be. Body copy should be part of the overall design strategy and function as a supportive compositional element, but it should not interfere with the ad concept or the construction of the visual context. Usually all copy—both tagline and body copy—will be supplied by the copywriters or by the client's internal public relations/marketing department.

Composition must enhance the concept by framing an exterior context or by sustaining an interior one. An exterior setting will be obvious; an interior setting may be more ephemeral. Framing devices include treatments to base or overhead planes and to horizontal and vertical transitions that help create the three-dimensional perspective. Compositional strategies that can enhance emotional contexts include innovative orientations that break the rectangular grid of the page and special effects such as layering, variations in opacity, and lighting that establishes mood.

▲ KEY IDEAS

- Develop a concept: a strategic approach to promote the product or service to a specific market in simple, direct, and effective ways.

- Create a before-and-after scenario that clarifies the needs addressed by the product and the benefits attained by using it. The advertisement's message and chief design elements come from this scenario.

- Create a visual identity in which viewers can see themselves when the product is used.

- Establish product use in a value-laden context by creating a short visual narrative.

- The lifestyle ad must incorporate a personal strategy—a story about people using the product or service.

Technical Product Ads

"Know your product" is always a good rule of thumb in technical product advertising. A product must be showcased in context, so it is a good idea to know how and where the product is used. Although technical product ads are chiefly about products, people may be featured to contextualize the use or benefits of the technical product. Often, however, the product will have to speak for itself.

Consider the product in its use context. The requirement for prompting a purchase is the belief in the consumer's mind that the product can achieve his or her goals. The specific conditions under which those goals might be achieved is not the subject of the ad; only that the product can, under the right conditions, achieve that end. The contextual conditions, whether they are people, landscapes, or interior situations, must all contribute to the reader's belief that the product can achieve its stated goals.

Humor is a powerful communicator, so an ad strategy can develop from humorous conditions that impede or inhibit attainment of the reader's goals (such as a technical product that requires electricity showcased in a natural setting far from any electrical power). In this case, the tongue-in-cheek approach is used to establish a personal contact with the reader and to avoid having to discuss the product directly. This strategy has its risks, especially if the product is not well known, but it highlights the overarching requirements that the advertising concept be present, be reinforced by all design elements, and be delivered as directly as possible.

The advertising design strategy should seek to enhance the product design, not overshadow it or compete with it. A product is designed or engineered with materials, textures, colors, and shapes. These elements can fit harmoniously into your advertising design. The typography and composition will integrate the design of the product with the advertising design. The product design may say "Use me," but the advertising design must say "Buy me."

A setting must be established to showcase the product's benefits in either a literal or a metaphorical fashion. These advantages must reflect the desires of the target market and must derive from solid market research about the consumption patterns, hopes, dreams, and daily activities of this group. Mixing too many different niche markets into one target market is false economy. As the ad tries to accommodate the diverse consumption patterns, it will play to the lowest common denominator and lose its vitality. Theoretically, every individual should have an advertising campaign written exclusively for him or her.

Body copy will be primarily descriptive, highlighting the advantages of the product or service in explicit ways and telling the reader how to procure the product. This last part is crucial. If your ad is to be successful, it must tell your readers what to do—that is, it must create some behavioral change. While the imaging, tagline, and typography explain why the reader should use the product or service, the body copy must reinforce this concept by explaining how to purchase it, in the most explicit way appropriate to the ad concept and the target market's consumer habits.

▲ **KEY IDEAS**

- Know the product.
- Showcase the product in context. The contextual conditions must all contribute to the reader's belief that the product can achieve its stated goals.
- Tell the consumer what to do; create a behavioral change.
- The advertising design strategy should seek to enhance the product design, not overpower it.
- The product design may say "Use me," but the advertising design must say "Buy me."

Pharmaceutical Ads

Pharmaceutical products are not particularly designed, nor are they about personal fulfillment. They are about reestablishing normalcy—getting back to full health. The main goal is to re-create a former condition. Therefore, the pharmaceutical advertising strategy must be slightly different from that of the lifestyle or the technical advertisement.

Because the benefit of a pharmaceutical product is restoration of health, the ad must reference an idealized condition. The benefits highlighted in pharmaceutical advertising, though extremely personal, cannot be represented in highly individual ways. They must be presented as universal and attainable conditions. Pain and disease are not good motivators. Pharmaceutical ads can image idealized conditions only by conceptualizing idealized desires.

These might be love, family, happiness, peace, and so on. You can see that these values or ideal conditions might differ from one person to the next, so the advertising imagery often accesses natural imagery such as landscapes. The implicit reference to Mother Nature suggests a nurturing, natural healing that has appeal. This can be appreciated as an idealized concept. Another way to image an ideal condition would be to use abstract design elements, such as light or texture, to create an interior tone that reflects the condition of generalized health. Ideals and implied universals such as cleanliness, happiness, and peace might serve as points of reference in developing such a design strategy.

Some pharmaceutical product ads image the active methods of healing that the product offers, as a secondary level to the descriptive copy. Scenes of antibodies attacking diseased cells can often be found in such ads. This image references another narrative of pharmaceutical lore: the battle between the ideal and the diseased condition, with the medical industry supplying the weaponry to achieve perfect health.

The emotive aspect of health and healing may also be used to reference an idealized concept. Personal struggle, perseverance, and individual victory over the depleted or diminished conditions can be showcased through personal testimonials or abstract images that imply strength and determination. Along with idealized health go notions of idealized bodies. Beauty can be a powerful motivator in pharmaceutical ads. Imagery can reference literary devices such as the metaphor, allegory, and simile to establish both personal and ideal form.

Pharmaceutical ads will be copy-heavy. This industry is highly regulated and must stipulate disclaimers, ingredients, possible side effects, co-use warnings, and so on. The copy will come from the client or from an advertising copywriter who specializes in this kind of product. The pharmaceutical advertising designer will have to develop a typographical structure that is flexible enough to be used at many levels of copy.

The typographic treatment must convey truthfulness and inspire confidence in the product while reinforcing the advertising concept. The typographic structure should guide the reader through the copy, calling attention to specific aspects by using highlights, pull-outs, graphs, and other information design tools, both to reinforce the advertising strategy and to convey essential information.

▲ **KEY IDEAS**

- Pharmaceutical advertising is about getting back to full health, so it must reference an idealized condition.
- Pharmaceutical advertising must present universal and attainable conditions.
- Pharmaceutical advertising can image idealized conditions by conceptualizing idealized desires.

Magazine Ads

The first step in developing a magazine ad is to call the magazine for its advertising specifications—even if the client provides them. Double-check. It is worth the time and effort, and it is easy to do. At the very least you will confirm the client's information. You may, however, find a number of alternative sizes for the same or similar prices that will afford you better orientation, better page presence, or a consistency that can reduce costs over the campaign. Information is power, and the designer needs all the information he or she can get in the high-risk and fast-paced world of editorial advertising design. The next step is to acquire the magazine media kit. This kit will provide, in addition to ad sizes and prices, important demographic and market information.

Once size and production specifications are determined, research and design development can proceed hand-in-hand to arrive at a fully executed comp. Essential to production will be image quality and production methods of scanning photography. Some printers ask for low-resolution scans and original art so that they can drum-scan (a very high-resolution, professional process) the work and place it in the ad. Other magazines expect high-resolution images to be supplied digitally along with the layout.

Production requirements for all files should be finalized in the initial stages of design development. Approval procedures, timelines, and the logistics of the art (photo shoots and personnel, copywriting and proofreading, illustration specifications), as well as copyright and contract issues, submission and production dates, and printing schedules, should be made known to the entire creative team and strictly enforced by the art director.

Connie Ueng
Brooks College

▲ KEY IDEAS

- Call for advertising specifications.
- Consider size, orientation, and page presence.
- Study the important demographic and market information supplied in the media kit.
- Production requirements for all files should be finalized in the initial stages of design development.
- All procedures and schedules should be available to the entire creative team and strictly enforced by the art director.

Newspaper Ads

The initial steps for newspaper ads are similar to those for magazine ads: get the advertising specifications and the publication's media kit. Ad size, point size for type, border, lines-per-inch and dots-per-inch requirements, and output requirements should be known before design begins. Due dates for concept approval, copy approval, photography, proofreading, final approval, and delivery must be agreed upon by the designer and the client so that everyone involved in the project is working with the same timeline. When the eleventh hour approaches, you want to be sure the client will give the project high priority so that approvals and fine-tuning can be accomplished efficiently and productively while still leaving you time to make corrections, finalize the ad, and get it to the newspaper on time.

Typographic treatments should take advantage of the graphic space of the ad and the opportunities for the interplay of positive and negative space available in the black-

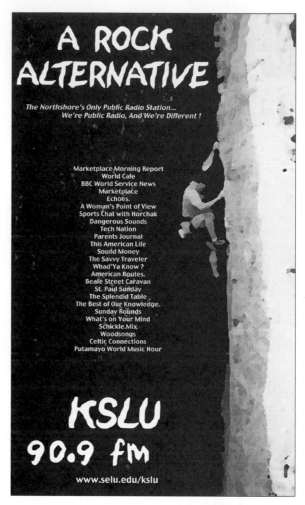

Mark Landry
Southeastern Louisiana University

and-white format of most newspaper ads. Your newspaper ad must compete effectively with the adjacent ads and within the ad space of the page. Be sure to discuss the tonal range of grayscale available to you with the production department of the newspaper. There may be 256 shades of gray, but the newspaper you are working with may not have more than three effective tones: 100%, 80%, and 60% black. Any other variation will be lost. This limited range will affect your image and your typographic space by limiting detail and tone.

Newspaper display ads generally offer large advertising areas and can reproduce photographic detail. They may be able to carry some spot color too. They can function in your campaign as a cost-effective version of your full-color magazine ad. The display ad will often break the columnar restrictions of the standard newspaper ad. Quarter-page, half-page, and full-page ad spaces and their various orientations (vertical, horizontal, special) will be available. Each will affect the graphic space differently, requiring new imaging and typographic treatments.

Use caution in employing display ads as the black-and-white versions of full-color ads. When production values permit this transformation, it is crucial not to simply convert a full-color ad to grayscale. The planar effects and layering of light in black-and-white images differ radically from those in full-color photographs. The black-and-white translation exaggerates the emotional tone and expands the dimensional space of the design. Color adds context, reality, identification, and personality to images, but it lacks the depth of emotional range and the graphic space of light that black-and-white photography offers. To simply translate color to grayscale is to miss an opportunity to access the dynamics peculiar to black-and-white imaging, which can greatly expand the range and impact of an advertising campaign.

Display ads can be very costly because they are effective communicators. Target readers go to display sections for information, and those advertising spaces permit the full promotion of products and services. Mistakes are expensive in actual charges, lost opportunity, and reputation damage. Know your specs thoroughly before venturing into display ad markets.

▲ KEY IDEAS

- Get the newspaper's advertising specifications and media kit.
- Display ads are expensive: know the specifications and investigate ad size and orientation options.
- Use display ads as the black-and-white versions of full-color ads only with caution.
- Discuss the tonal range of grayscale with the production department of the newspaper.
- Typographic treatments can take advantage of the interplay of positive and negative space.

Professional Perspectives

◆

Doug DeVita
Instructor
Fashion Institute of Technology, New York
The Katharine Gibbs School, New York

The "Think" System

In the musical *The Music Man,* Professor Harold Hill is a traveling salesman, roaming the Midwest selling boys' bands to the citizens of small-town America. He has a revolutionary method of teaching the children how to play their instruments—something he calls the "Think" system, whereby all one has to do is think a melody to be able to play it.

Of course Hill is a fraud, and is usually able to skip town with the residents' money before he is found out. In due time he gets caught, but to everyone's surprise, his bogus "Think" system actually works! The children play—in a fairly terrible but recognizable way—"Minuet in G," and the townsfolk, thrilled that their children have created something out of nothing, are satisfied that they have gotten their money's worth.

Though I am an instructor of conceptual thinking in graphic design and advertising, I do not actually advocate the idea that if you "think" a good design or strategic selling concept you will eventually achieve one. However, I do advocate the good old-fashioned idea of thinking before ever setting pen to paper (or mouse to screen).

 Why bother doodling for hours and hours when Photoshop and Illustrator can give you such neat effects almost instantaneously? Why bleed yourself dry searching for an original, strategically sound idea for your client when they, and your nervous account executives, are just as happy with ideas that have worked many, many times before?

Perhaps the following anecdote may serve as an answer. I remember sitting in a meeting once when I was an art director at the direct response division of a large, venerable ad agency in New York. A very big, agency-wide presentation was being given to one of the largest clients on the agency's roster. When the time came for the creative presentation (after an admittedly weak presentation

from the account side), the creative director proceeded to give a outstanding show, presenting gorgeous work done by the agency's hot new team of the month and several dazzling sample reels by the hot new commercial director of the month.

It was quite a show, and it was also quite a while before the clients realized that they had never actually seen an idea to sell their product—just examples of beautifully designed but strategically empty work. (The agency, by the way, is still in business, but in a drastically reduced form—from nearly 1,200 employees on 10 floors, it has shrunk to fewer than 100 employees on a single floor. There may be a correlation here.)

When push comes to shove, no matter how trendy it is or how "up to the minute" it may look, a "glow" around type is *not* a concept unless there is a clear reason to have it. No matter how funny a technologically enhanced talking animal is, it is not a concept in and of itself, especially if the technique is used repeatedly to promote everything from pet food to carpet freshener to fast-food restaurants. It is simply the hot new thing, soon to be supplanted by another hot new thing that is amusing a couple of times … until the next hot new thing pops up. Just because we *can* do it doesn't mean we *should* do it, nor is it a substitute for fresh, original thinking. Original thinking is not easy, nor does it come fast. Knowledge of current trends in design is a good thing to have, but the truly successful designer can take the hot new thing and transform it into the hot thing that serves the client.

The 1960s saw a revolution in the way advertising is created, with a model that is still being used today: the concept of teamwork. Writers and art directors, along with their account partners, work together to create the concept. In a truly great team, each branch supports the other and no one really knows who did what, but the resulting work is fresh, original, and on target.

Truly great teams are rare, especially in economic down times when panic tends to rule the day and all that matters is pleasing (i.e., keeping) the client. I personally only been involved with only two completely successful creative/account partnerships in my career thus far: at Grey Direct in the late 1980s, working on IBM, and at J. Walter Thompson in the early 1990s working with Kodak. In both instances, the account teams forged strong relationships with the clients, utilizing the reams of market research provided by the client (and sometimes augmenting with reams of their own research) and working with the clients to come up with the smartest strategy possible.

As strong as the relationships they forged with the clients were the relationships they forged with the creative teams. There would be several lengthy, in-depth meetings with the account teams while they were preparing their briefs for us, and in the meantime we would be doing our own hands-on research. In the case of IBM, we were attending classes (and getting paid to do it!) to learn the latest programs they were developing; in the case of Kodak, we were having even more fun using the cameras, film, and (in one special project) a CD player they had developed that allowed one to store photos on a compact disc and view them on a television screen. (Up-to-the-minute then: positively primitive now, not even 10 years later!) In addition, there were many trips to each respective agency's library (and that included watching endless reels of old commercials) and that bastion of information (still), the New York Public Library. Very often, the oddest bits of information opened doors to really neat thinking. For instance, just glancing through an original edition of Lewis Carroll's *Alice's Adventures Underground* led to a very well-received project for IBM: the basic concept of consumer confusion as to what the burgeoning PC market was all about was based on Alice's confusing adventures.

The most rewarding part of it all was that the lines of communication were always open among the creatives, the account teams, and the client. No one worked in a vacuum, each partner's input was valued, and the work spoke for itself (and in the case of Kodak, won awards). And it was all based on good, deep thinking before any other work was attempted.

Of course, there are teams that do not work as well together: creatives who believe they are God's gift to advertising; account executives who use the Cut and Paste buttons on their computers to recycle old strategies; clients who bark out orders based on personal preference and without any apparent long term goals for their product.

In a way, the technological advances that have quickened the pace of contemporary life have contributed to this phenomenon. It is much easier to cut and paste an old strategy that worked before than to rethink and retool. Direct mail, cable, the Web, spam e-mails, and Flash banners have made advertising more intrusive than ever: clients see something that tickles their fancy and they want to use it themselves, whether or not it works for them. But no matter how advanced the technology, nothing substitutes for the original computer, the brain. As Harold Hill beseeches to his band members when called on the carpet: "Think, men, think!"

chapter four
Editorial Design: Books and Magazines

Stephen Sanderson
Metropolitan State College

The alignment of design elements along a perpendicular set of divisions defined in relation to the size and orientation of the page (the editorial grid) is the structural requirement of editorial design. In part, this corresponds to the modular arrangement of advertising and text that form the basis for editorial design layout.

The editorial designer should experiment with the grid structure to develop innovative approaches to its insistent uniformity. The grid can be modulated within its own structure to create rhythm and contrast; it can be reoriented at angular relationships to the dominant directions for emphasis and counterpoint. It can be expanded in multiple directions and across textual boundaries to enhance content or accommodate visual hierarchy.

Book Cover Design

As in any design project, thorough research establishes a sound starting point and offers an opportunity for ideas, strategies, and design elements to come into play and go through an initial edit in the rough. The contents of the book must be understood, and the methods of literary engagement by the prospective readership must be examined. Simple ways to do this research include a trip to the local bookstore to review the forms of visual communication currently utilized to reach the market.

Find out whether the project is a redesign of existing editions or a brand new design for a new text. What are the publisher's current design preferences? Is this book intended to fit into an existing series, or is it a stand-alone text? Is the publisher entering new literary territory or building on past success?

What design guidelines are to be followed, and where can design innovation take place? Are there publisher logos, bar codes, and other regulatory marks to include? Does the publisher have an identity in this literary genre; does the author? Knowing where design innovation is called for and where prior design decisions must be maintained will save a lot of time.

A book cover shares a number of primary concerns with entertainment design projects in that it is design for a preexisting creative product. The emotional and philosophical nuances of the text should not be overshadowed by the cover design. The cover should be a gateway into the tone and content of the text.

Reading is essentially a private time, and the cover design must offer the potential reader the prospect of pleasure that accompanies the literary experience. The design strategy should grace the personal relationship. It should hint and imply the literary content through methods appropriate to the readership. The book cover creates a visual frame where text and image come together to promote a set of ideas. In the clamor of bookstore display, the book cover offers a respite from the chaos of competing voices.

▲ **KEY IDEAS**

- A book cover is design for a preexisting creative product.

- Reading is essentially a private time, and the cover design must offer the potential reader the prospect of pleasure that accompanies the literary experience.

- The design strategy should hint at the literary content through methods appropriate to the readership.

- The book cover creates a visual frame where text and image come together to promote a set of ideas that act as a gateway to the tone and content of the book.

Trade Books

Trade books are single-focus books that provide information about specialized activities, skills, and industries. Their success is dependent on the expert advice and reviews proffered in the editorial content. Readership of trade books are distinguished from others by their interest, experience, and level of proficiency. The successful trade book cover will use and enhance distinction of this readership. This calls for content-related layout, specialized typography, unique imaging, perhaps a striking format or stock, and an appropriate color and tonal range. Design reference must showcase the tools and technologies of the specialized trade, but more importantly must underscore the specialized talent, attitudes, traditions, and codes of the given field or subject. The initiated will recognize the unique forms of their trade.

The cover should hint at the arrangement of ideas and images of the interior, setting up the editorial themes right from the beginning. Rarely is the interior information all that different from material that has already been written about

the specialized trade. It is the editorial slant, the range of content choices, the thematic organization, and the quality of imaging that distinguish this text from the others. The cover can set the tone for this by highlighting the unique intellectual and emotional range of the book. It will help the potential readership to self-select, based on degrees of initiation into the trade. Is the book for beginners or experts? Is it a gift from the novice to the expert, or vice versa?

Once the design strategy has been elaborated into design elements and compositional scheme, and the illustrations and photographs have been secured, it is time to concentrate on the visual tone. The dynamics of interaction between the design elements can be muted or exaggerated by slight revisions to the visual hierarchy. The production value can be furthered by crafting dimensionality and an architecture of graphic space through inking techniques and stock choice. Consider how each design decision affects the visual environment and adds to the strategy of distinction or to the overall tone of the work. Choose photographs that reinforce the organization of graphic space.

▲ KEY IDEAS

- Trade books are single-focus books that provide information about specialized activities, skills, and industries.
- Trade book covers showcase specialized tools and technologies and underscore specialized talent, attitudes, traditions, and codes.
- Trade book covers help the potential readership self-select.

Showcase Books

Showcase books are intended for a wide readership. Generally, they have high production value and are oversized. Their high production cost is amortized over a wider potential sales market than that of more specialized texts. From a design point of view, covers for showcase books must be both highly visual and widely understandable. They should indicate the structural format (grid) of the interior. This prepares the reader, sets a high tone for the information design, and offers a frame for the content that justifies the cost.

Showcase books may tend toward specialization, as trade books do, but they will be oriented to a wider and less expert readership. The tone of a showcase book cover design is not one of exclusiveness but of inclusiveness, albeit with a high production value and a dramatic finish. The successful showcase book cover design depends on a strong, narrative image and bold, but appropriate,

typography that locates the contents of the book in time and place. The specificity of the showcase book design is its method for wide appeal in a segmented marketplace: the more specific the design elements, the wider the impact. Mystery here is counterproductive. Straightforward composition that introduces the interior grid and high-concept typography that reinforces the dramatic content of the cover image are the way to go.

Format is crucial to the showcase book cover. Oversized books are common and these larger-than-usual dimensions create a large graphic space. This may suggest a monumentalist approach, combined with small areas of intricate design dynamism. Monumentalism requires a strong graphic sensibility and effective use of positive/negative space to create shape, depth, and dimension. However, it is important to ameliorate the potentially overbearing aspects of monumentalism by creating small spaces that are charged with typographic dimensionality. The large space of the oversized book offers a number of places to do this that can enhance marketability.

▲ KEY IDEAS

- Showcase books are intended for a wide readership, so showcase book covers are inclusive.
- Showcase book covers have high production values and a dramatic finish.
- Showcase book covers combine strong, narrative image with bold typography that put the contents of the book in context.

Juvenile Books

Juvenile literature comes in many shapes and sizes. A successful cover strategy depends on analysis of the intended method of reading. Will the book be read to the child by a caretaker, or will children read it on their own? The answer initiates a series of questions concerning the primary outcomes of the reading experience (parental bonding, entertainment, stimulation of reading interests and skills). Only the author and publisher know the answers to these questions, so they are the place to start your design research. Through additional research, try to gather information about the primary decision maker in the buying scenario. Is it the child, the parent, a friend, a grandparent?

Making the book stand out among the thousands of other and similar books in the juvenile section should be the second goal. The first is, of course, offering an appropriate gateway to the reading experience. The juvenile book

cover designer needs to do some intensive research on the imaging and reading habits of children as they pertain to the specific editorial content.

Size and shape are important aspects of cover design, as are stock choices. Make the experience a full range of sensory experience. Stimulate with touch, shape, and texture as well as with typography and image. Be consistent with the message of the book. Find out what the specific message is, and how it is conveyed through the characters and plot. Look at the historic and geographic context and see how this story differs from others in the same genre.

▲ KEY IDEAS

- Juvenile book covers refer to the intended method of reading: Will the book be read to the child by a caretaker, or will the child read on his/her own?

- Juvenile book covers refer to the primary outcomes of the reading experience: Is the book intended to further parental bonding, provide entertainment, or to stimulate reading interests and skills?

- Gather information about the primary decision maker in the buying scenario: Is it the child, the parent, a friend, a grandparent?

Special-Edition Books

The first question to ask about a special-edition cover design is "What specific aspects of the editorial content should be reinforced in this special edition?" If you can get the answer(s) to this question, you will produce a design that works! Rarely are special-edition books published simply because of a design aesthetic. Usually some promotional or marketing goal is reflected in the size and shape, as well as the production value, of a special-format book. If you can find out why the decision has been made to go with an odd-sized format or special production process, then you will know a lot about the business goals of the publisher, the intent of the author, and the preferences and reading styles of the intended readership.

Often these books are given as gifts, or are somehow imbued with a special commemorative value that exceeds (or at least supplements) the content. The special-edition book furthers a relationship, extends the heart and the hand, offers a private pleasure that speaks softly and personally. The designer must honor that emotional and personal space by letting the special-format cover also speak softly and personally. Let all the sensory pleasures of handling the book be a part of the rich gift of reading.

Use unique stock combinations to vary tone and texture. Add heft to the book through luxurious weights. Choose only the best inks, and let them convey the full range of luminescence and spirituality that is appropriate to the content. Study the best works of art you can find, in person. Consult your printer about how to achieve the qualities of lighting you want. Consider your printer your cinematographer—or better yet, get some advice from one of these true masters of light.

Use the available volumetric possibilities to full advantage, crafting space in three dimensions. Look at interior and exterior wall designs by some of your favorite architects to get ideas on how to master mass and spatial purpose. Experiment with materials, within the range of the budget and feasibility. Consider scale, and use juxtaposition judiciously to achieve an implied complexity of space. Let some of the work hide, to be revealed only by the reader's effort. Discovery and amusement should rule the day. Let reading be a pleasure, just as friendship is.

▲ KEY IDEAS

- Special-edition book covers reinforce specific aspects of the editorial content.
- Promotional, business, or marketing goals are reflected in the size, shape, and production values of the special-format book.
- What are the business goals of the publisher, the intent of the author, and the preferences and reading styles of the intended readership?
- The special edition book cover offers a private pleasure that speaks softly and personally.
- Let all the sensory pleasures of handling the book be part of the rich gift of reading.

How-To Books

How-to books differ from trade books in that they offer step-by-step information, oriented toward a specific level of expertise. This type of book tends to use a before-and-after approach or a project-based approach. This format should drive the visual organization of the book and should inform the cover design strategy.

Typography should be direct and helpful, with clear text type and an inventive display type that echoes the spirit of craft and handwork appropriate to the subject. This cover must say that the information provided within is factual, concise, and useable. The cover must convey a serious, linear method with a playful, spontaneous feel.

Think of this cover project as an experiment in duality, full of contrasts and opposites. The visual implication is that the book explores the process of getting from point A to point B. Using both points to image the cover lends believability to the process. The process is previsualized, but the starting point speaks to the prospective reader. Leave room for readers to place themselves in the picture.

Determine the main emphasis of the content. Is the book focused on assembly or building, on quantitative assessment, on technology? Is it part of a series, or could it potentially become part of one? Develop a compositional strategy that underscores the content, and leave open the possibility for modular design. Layout and type will carry the day on a how-to book cover design. Image hints at the end product and opens the text to its potential readers.

The primary effectiveness of the how-to book cover depends on reader participation and buy-in to the authoritative voice and believability imaged on the cover and implied in the interior layout and typography. It is best to leave plenty of white space to facilitate readability and within which to organize design elements. Overcrowding can be confusing and distracting, and ultimately counterproductive, to the design goals.

Sometimes there is no alternative to a crowded cover. Use typography and composition to create information layering and to activate areas of three-dimensional graphic space. Develop multiple roughs on tracing paper, lay on top of the other, and construct a three-dimensional grid that will help the reader sift through the complexity of the information. Create related information levels by using variations of typeface and point size. Be sure to use color to link design elements and tie levels of information together.

▲ KEY IDEAS

- How-to books offer step-by-step information, oriented toward a specific level of expertise.
- How-to books usually use a before-and-after approach or a project-based approach.
- How-to book covers are full of contrasts and opposites.
- Determine the main emphasis of the content and develop a compositional strategy that underscores the content.
- Leave open the possibility for modular design.

Nonfiction Books

A nonfiction book is the product of tenacious research, relentless discipline, and selfless dedication. Its cover should honor the effort of nonfiction writers and commemorate the special relationship they have with their readers. Nonfiction readers are curiosity seekers, students of the human condition, scientists of the past, oracles of the future.

The nonfiction writer's overriding taskmaster is truth; without it, the nonfiction writer is indistinguishable from the fiction writer. Truth and fact let us know the difference, and it is truth that must be designed into every facet of the nonfiction cover. Use design elements—color, line, shape, type, and image—in a straightforward fashion. No extraneous embellishment, no construction of three-dimensional illusion (except with the photographic image), no romance of tone and texture. A nonfiction cover calls for clear typographic design, a relevant color scheme, and, when an image is used, a documentarist approach to photo-story.

The nonfiction reader is often an educated researcher, and most appreciate the subtleties of human opinion. This is the key to expanding design opportunities for nonfiction covers. Working the subtlety of the writer's perspective into the design elements offers pathways into the writer's mind and helps the reader join in the pursuit of knowledge. The nonfiction writer creates a world of reality through the lens of his or her own experience. The reader knows this; the author knows it; the publisher knows it; the design should incorporate it. It is the way to reach the audience and to place them within the scholarly effort.

Caution: This design linkage cannot transverse the propriety of distance and objectivity implicit in nonfiction. To transgress this boundary is to destroy the literary genre. Fidelity and authenticity must be conveyed; the writer's tone comes in as accent and perspective, reinforcing the quiet mood necessary for scholarly pursuits.

▲ **KEY IDEAS**

- A nonfiction book is the product of research, discipline, and dedication.
- Nonfiction book covers reinforce the writer's perspective.
- Nonfiction book covers help the reader join in the pursuit of knowledge.

Fiction Books

The fiction cover should not promise more than the book content will deliver, nor should it try to overstate its relation to the work. The key to successful fiction cover design is to understand the full range of nuances in the content, and to know whether the writer or the story is to be showcased. In a certain sense the two are inextricably intertwined, but the publisher should be able to provide the necessary information concerning emphasis.

Ultimately, it is the romance of writing and of reading that is the basis for the design, linking the very private and personal act of reading with the intensely passionate art of the writer. The cover joins the two isolated acts into one, with one purpose and in one form. It completes each half, consummates two desires, and reaffirms two hopes.

Fiction book cover design, when it showcases the author, builds its design strategy on typography. When it showcases the text, it builds its design strategy on image. However, neither is mutually exclusive of the other. Typography that showcases the author may well include special effects, three-dimensionality, and other forms of typographic imaging. These can call attention to the book title and author's name and imbue them with a color, tone, and texture that tell a latent story about the personal characteristics of the author as well as an explicit story about the content of the fiction.

Image can be constructed with type or other basic design elements such as line, shape, or color; you are not restricted to photographic or illustrative treatments. Die cuts, embossing, and other interesting uses of negative space, as well as special inking effects and innovative stock, can all contribute to successful fiction cover design.

The fiction cover must offer an enchanting and exuberant entry into the story. It must set tone, time period, and place; introduce characters and plot points; and hint at story resolutions. This means the fiction cover designer must become expert at metaphor and visual abstraction, using design elements to convey mystery, romance, intrigue, horror, tragedy, comedy, and sensuality. Command of the genre and subject matter, and knowledge of the characters and their struggles, help the designer to use the tools at hand (typography, image, color, stock, line, shape, and texture) to convey the author's message and distinguish this particular book from other works.

Consider the entire design an image, and illustrations or photographs, as ways to activate graphic spaces by counterbalancing type and design elements. Composition will drive the fiction cover design. Typography will supplement the composition, using line and color to advantage. Integrate the full range of design into an architecture of graphic space; create walls, doorways, and windows. Encase the points of transition, access, and egress with a roofing scheme that adds drama and direction. Consider framing devices and areas of conflicting texture; build mass out of light and color.

Copy requirements may drive design decisions in some areas of the cover. Save room for the requisite bar codes, "about the author" blurbs, and critical acclaim. Be sure that you retain design integrity as you adjust design details.

▲ KEY IDEAS

- Fiction book covers reflect the full range of nuances in the content.
- Fiction book covers showcase either the writer or the story.
- Fiction book covers celebrate the passion of writing and the romance of reading.
- Fiction book covers offer an enchanting and exuberant entry into the story.
- Fiction book covers set tone, time period, and place, and hint at story resolutions.
- Fiction book covers use typography, image, color, stock, line, shape, and texture to convey the author's message and distinguish the book from other works.

Book Interior Design

Interior book design organizes the information inside the book in a clear, accessible, and inviting way. There is little need or call for bizarre arrangements of text and image that detract the reader's attention and impede the reading experience. The interior design should facilitate and complement that experience.

The reader must be able to navigate the textual information at all times. Crafting location signs, an effective grid, and a unified relationship between text and image offers the reader a safe visual environment. Information should be presented in an understandable order, where pullouts and special sections enhance through predictability and where images are integrated within the information structure to illustrate text. Successful interior design will create a reasonable information structure that corresponds to the goals of the text and the reading sophistication of the market. After the structure is established, design elements should be developed that will reinforce that structure.

Miriam Baker
Concordia University—Nebraska

Design elements will include, first and foremost, a columnar grid structure. This is highly dependent upon format and size, amount of text, and type of book. Much of this direction will come from the publisher, who will have budgeted these kinds of limits in response to sales projections. However, within the publication budget, the designer has basic typographic decisions to make, such as typefaces, point sizes, text column length, and column placement. After the basic grid structure has been developed and the text flowed into the column arrangement for at least a sample chapter, additional navigational elements must be developed. These can range from a simple page numbering system to complex headers and footers, tabs, and other dingbats that indicate where the reader is located within the chapter, section, and volume.

Melissa Adkins
Concordia University—Nebraska

Nicholas Bartlett
Concordia University—Nebraska

The grid structure and information organization must position any photographic or illustrative images in ways that will ensure a smooth transition from reading text to picture. Flexible grid structures should be developed for text-only sections, text/image portions, and text/pullout spreads. Design elements should be crafted so that some are common to all spreads and some represent distinct variations of a standard. A typeface and point size format should be created for each segment of the grid structure. Place actual text and image into the structure, make refinements and adjustments, and then step back to review all the details within the overall grid; then make more refinements. Flow the text and images into the structure, chapter after chapter, making additional refinements and adjustments. Step back and review the entire compilation, adjust it as a whole, and then go back, page spread by page spread, to finalize the interior design.

This process of detailed refinement and adjustment, coupled with regular reviews of overall structure, is similar in every type of interior book design. However, the kind of text and readership for a given book will impact design decisions on grid structure and design elements. Of course, the designer's decisions are informed by personal preferences, training, and experience.

▲ KEY IDEAS

- Interior book design organizes textual information in a clear, accessible, and inviting way.

- Interior book design creates an information structure that corresponds to the goals of the text and the reading sophistication of the market.

- The grid structure must allow the reader to navigate the textual information at all times.

- The grid structure must ensure a smooth transition from text to picture.

- Flexible grid structures should be developed for text-only sections, for text/image portions, and for text/pullout spreads.

David Dolak
Concordia University—Nebraska

Fiction Books

The fiction book enjoys a special and intimate relationship with its reader. The act of reading fiction transports the reader a new and personal world, full of abstraction and mystery. One never knows what is around the corner, and the suspense and surprise are part of the emotional experience. Textual construction is an incredibly powerful art form, but it requires a lot of work on the part of both author and reader. The interior design of fiction books should not interfere with this work. Fiction interiors should not try to compete with the visual pictures that the text and language stimulate in the mind's eye. Distracting grid structures, unnecessary color schemes, and effusive typeface choices all serve to destroy, not enhance, the reading experience. Illustrations and photographs are basically not necessary, except perhaps for the juvenile market. There may be instances when an author or publisher requires illustrations for a work of fiction as enhancements or flourishes. These should be kept away from the text and relegated to chapter breaks or introductory pages.

Miriam Baker
Concordia University—Nebraska

Typefaces should be clear, to facilitate reading, but not boring. Generally speaking, all text typefaces should be serif faces. The choices should work laterally as well as literally, tying text together and making it easy for the eye to travel across all those characters. The typeface should work at various point sizes and produce a uniform flow at each point size used. A secondary typeface should be developed to complement the text. This can be used to accentuate the different parts of the text such as chapter headings, page headers and footers, page numbers, and the like. Even small breaks in text flow can help orient the reader.

Do not cramp the text, but frame it with the margins so that the eye can both move across the text and be constrained to the page. Stock and typeface color choices should be subtle and easy on the eye. Variations of black, or black with one color, can be effective ways to separate text from headings. Brilliant white may be hard on the eyes; a light cream or an off-white can offer more range in color choices and provide an easier background for reading.

▲ KEY IDEAS

- The fiction book transports the reader a new and personal world, full of abstraction and mystery.

- Fiction interiors should not interfere with the writer's art of textual construction, nor compete with the pictures the text stimulates in the mind's eye.

- Fiction interiors should provide an unobtrusive plane of engagement between writer and reader.

Technical Books

Technical books are primarily explanatory and descriptive. They will be filled with charts, graphs, technical illustrations, and photographic images. They are a study in information design. The grid must be expansive and flexible, and the designer must work closely with the author and publisher to ensure proper visual interpretation and correct design emphasis. The text may, in fact, be secondary to the pictures and illustrations. Certainly there will be various types of textual information: from body copy to pictorial captions, from breakout sections and inserts to chart and graph descriptors, from chapter and section headings to page and section numbering schemes. An open grid and a wide typographic approach are requisites to successful design of a technical book interior.

As color plates are almost essential to the technical book, stock will generally be glossy and brilliant white. This kind of stock holds colors better than a textured paper, and it is more economical for the publisher. This gives the designer a wide range of color choices to use along with the information design structure. However, too much color can be confusing, so let the illustrations and photographs drive the color, using additional color in charts, graphs, lines, and text boxes that complement the dominant colors of the images on the page. Set a tone and create drama through careful use of colors that carry an emotional range as well as a pictorial range. Otherwise you may end up with a many-hued spread that confuses, rather than one that draws all the elements together to create a comprehensive explanation that inspires, incites, or illuminates.

The text/image grid should frame the reader's experience right from the very first page. The table of contents will outline the information design and introduce the primary navigational tools, but the very first or second spread should introduce the full range of the grid. Information design will be successful only after the reader has recognized it as a pattern within which certain kinds of information repeatedly appear in predictable spaces. The sooner this happens, the more quickly the reader will take in the full scope of the information presented.

▲ KEY IDEAS

- Technical books are explanatory and descriptive.
- Technical book interiors are filled with charts, graphs, technical illustrations, and photographic images.
- Technical book interiors are a study in information design.
- Technical book interiors must ensure proper visual interpretation and correct information.

Educational Books

Educational book interiors are highly market-dependent. The differences among the juvenile educational book market, the educational book market for teenagers, and the college book market are substantial. However, this is basically a difference of degree rather than of kind. Every group needs to identify with the content and presentation of the information; otherwise, little education will be accomplished.

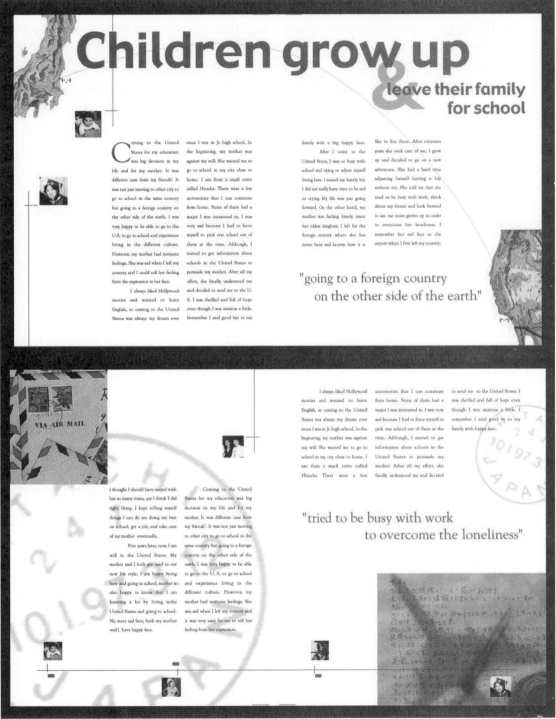

Children grow up
& leave their family for school

Coming to the United States for my education was big decision in my life and for my mother. It was different case from my friends'. It was not just moving to other city to go to school in the same country but going to a foreign country on the other side of the earth. I was very happy to be able to go to the U.S. to go to school and experience living in the different culture. However, my mother had intricate feelings. She was sad when I left my country and I could tell her feeling from the expression in her face.

I always liked Hollywood movies and wanted to learn English, so coming to the United States was always my dream ever since I was in Jr. high school. In the beginning, my mother was against my will. She wanted me to go to school in my city close to home. I am from a small town called Hitachi. There were a few universities that I can commute from home. None of them had a major I was interested in. I was very sad because I had to force myself to pick one school out of them at the time. Although, I started to get information about schools in the United States to persuade my mother. After all my effort, she finally understood me and decided to send me to the U.S. I was thrilled and full of hope even though I was anxious a little. I remember I said good bye to my family with a big happy face.

After I came to the United States, I was so busy with school and trying to adjust myself living here. I missed my family but I did not really have time to be sad or crying. My life was just going forward. On the other hand, my mother was feeling lonely since her oldest daughter, I left for the foreign country where she has never been and known how it is like to live there. After nineteen years she took care of me, I grew up and decided to go on a new adventure. She had a hard time adjusting herself having a life without me. She told me that she tried to be busy with work, think about my future and look forward to see me more grown up in order to overcome her loneliness. I remember her sad face at the airport when I first left my country.

"going to a foreign country on the other side of the earth"

VIA AIR MAIL

i thought I should have stayed with her so many times, yet I think I did right thing. I kept telling myself things I can do are doing my best on school, get a job, and take care of my mother eventually.

Five years later, now, I am still in the United States. My mother and I both got used to our new life style. I am happy being here and going to school, mother is also happy to know that I am learning a lot by living in the United States and going to school. No more sad face, both my mother and I have happy face.

Coming to the United States for my education was big decision in my life and for my mother. It was different case from my friends'. It was not just moving to other city to go to school in the same country but going to a foreign country on the other side of the earth. I was very happy to be able to go to the U.S. to go to school and experience living in the different culture. However, my mother had intricate feelings. She was sad when I left my country and it was very easy for me to tell her feeling from her expression.

I always liked Hollywood movies and wanted to learn English, so coming to the United States was always my dream ever since I was in Jr. high school. In the beginning, my mother was against my will. She wanted me to go to school in my city close to home. I am from a small town called Hitachi. There were a few universities that I can commute from home. None of them had a major I was interested in. I was very sad because I had to force myself to pick one school out of them at the time. Although, I started to get information about schools in the United States to persuade my mother. After all my effort, she finally understood me and decided to send me to the United States. I was thrilled and full of hope even though I was anxious a little. I remember I said good by to my family with happy face.

"tried to be busy with work to overcome the loneliness"

Ritsuko Nakane
California State University—Northridge

The juvenile market often relies on pictures to present content. The pictures will reference moments with which the child is familiar. The illustrations or photographs will serve as a secondary—or even primary—conduit for educational information in relation to the text. These images can underscore and call attention to the crucial interrelationships of the information described in the text. This brings the text to life, helps hold the child's interest, and improves information retention.

The image, then, should represent a break from the reading of text and signal the user to start reading visually. The grid should transform; typography should modulate; color range should shift. There should be an apparent and even startling shift from one kind of thinking to another, from text reading to image reading.

Typography for the juvenile market must be engaging but not condescending. The typefaces should be pleasant and easily accessible, not glaring and animated. Reading cannot substitute for television, nor should it try. It is different, and the educational book for the juvenile market should encourage the specific activity without reference to the other.

Teenagers want nothing more than to fit in and know what is expected of them, although they seem to do everything to thwart this goal. Identification is the key to design for the teen market. Research teen preferences thoroughly, as they change radically and frequently. Look at current teen material; conduct focus groups and find out what kind of text/image relation is appropriate. Because teens like order, the grid can convey text information through a straightforward, columnar organization. Use images to activate other spaces, to intrude on the text, and to add dynamism by breaking the grid in a seemingly chaotic yet internally regulated pattern.

Typefaces must be dynamic. Teens seem to speed-read. They pretend not to comprehend, but that is often only because they lack certain communication skills. Wordsmithing comes from exposure to educational reading material and from using and adapting that material to various social contexts. The interior design for the teen market facilitates access to information by isolating approaches to its consumption, setting clear breaks and designing transitional areas as areas of primary interest.

By the time the educational book market reaches the college crowd, the separation of text and image has been fully realized. No longer is image supplementing text to highlight important information; no longer is image intruding into text to create dynamic boundaries and transitions where the primary

"read" takes place. Now text and image are separated and codified into different realms of thinking, with the verbal privileged over the visual. The approach to adulthood is nearly complete—that is, except for the current generation of highly sophisticated visual storytellers, who are gravitating toward design and visualization fields at unprecedented rates.

▲ KEY IDEAS

- Educational book interiors are highly market-dependent, and move from image-focused to text-focused through the markets of juvenile, teen, and college.

- The juvenile market often relies on pictures to present content. The grid should represent a break from the reading of text and act as a signal to start reading visually. There should be an obvious shift from one kind of reading to another.

- Book interior design for the teen market facilitates access to information by isolating approaches to its consumption, setting clear breaks, and making transitional areas of primary interest.

- The interior grid for the college market fully separates text and image into different realms of thinking, with the verbal privileged over the visual.

Special Edition Books

Special-edition interior design has to acknowledge the fundamental gift of reading, honor the art and craft of the author and the integrity of the material, and reach out to inspire wide ranges of potential, although definitely segmented, readerships. It is like wrapping the most precious present you could think of to give to your most intimate friend.

Special editions integrate elegant use of columnar grids, which vary in length and number of columns, with images within a pictorial system that serves as an appropriate pedestal for the photographic art. A special-edition interior offers a limited but rich tonal range and high production value.

The place to start is book size and photo editing. These choices will determine the area you have to work with, the number of pages, and the sequence of images. Then choose a range of font families and point sizes that highlights and showcases the images, but also enhances reading of the text. Differentiate between body text, headings, and picture captions.

Next, develop a range of spreads that enhance the different approaches to pictorial and textual information. Create a use pattern for the different spread structures. Flow text and image to test one section; refine, expand, and develop a typographic treatment that highlights the grid, underscores the textual information, and ties image to paragraph. Develop a textured rhythm in the text by using varying point sizes and leading. Echo this rhythm in the placement of images.

After the design decisions are made, investigate the various costs of stock and inking. Find the best combination for the images you will be using and the effects you want to incorporate into the design. Design every aspect of the physical and emotional experience of reading. If you are unfamiliar with the content, do as much research as it takes for you to feel comfortable with it. Steep yourself in the historical and geographic context of the material. Read everything you can about the time period; listen to its music; discover its contributions to the present and its links to the past. Make it personal. Let images come and go in your mind's eye. Breathe deeply of its scent, and then begin the work of structure and organization.

▲ KEY IDEAS

- Special-edition interiors acknowledge the fundamental gift of reading, honor the art and craft of the author and the integrity of the material, and reach out to inspire wide ranges of readerships.

- Special editions integrate an elegant use of columnar grids which vary in length and number of columns within a pictorial system that serves as an appropriate pedestal for the photographic art.

- Special-edition interiors take a limited but rich tonal range and high production value.

Professional Perspectives

William Wolfram
Professor
Concordia University—Nebraska

Grids or No Grids: Working From Chaos to Structure

A *grid* is a series of nonprinting vertical and horizontal lines that break the page into repeated units and establish a structure for placing titles, text, graphics, and other page elements. This has been a popular approach to organizing page layout for more than thirty years because decisions on placement are easily made. This approach also translates well to the computer, with its nearly one-point-square pixel that facilitates the use of vertical and horizontal guidelines.

It has been written that it is easier to add diversity to order than to add order to freeform on a page layout. For many graphic designers, this is certainly desirable, and therefore the grid system is very useful; for others, though (or at certain times for most), this dictum can certainly be questioned. Working from chaos is an acceptable, proven fine arts approach. The graphic designer, however, should ask whether the grid system should be used in all page layouts, and if or when it becomes counterproductive.

Indeed, grids—along with master pages, style sheets, and other unifying tools—are essential for good design of publication pieces. They promote understanding and appreciation of well-constructed page composition. However, as these fundamentals are taught, a tightness or rigidity often develops in student layouts. Such work can look contrived, unimaginative, and overly cautious. Occasional assignments with limited or no required grids or blueprints can counter the typical, hyperorganized guidelines usually given with most assignments, thereby encouraging students to break out by plying their acquired fine art craft on the computer as they would with nondigital media.

Research

The designer's role is not only to develop a visually pleasing spread, but also to interpret the content of the material that is placed on the pages. Before designing a spread, one should read the text carefully, noting especially any statements in the body text and subheads that highlight the theme of the article. The artist should do additional study on the subject of the text if it is unfamiliar to him or her.

Design Concerns

The designer should "play" with form, color, and texture, trying to interpret the article's story. One's intuition becomes the most important guide for a time. Be flippant for a moment. Advice should not be authoritative. Try creating different textures using various scanning techniques. Draw forms with charcoal or graphite. Combine these in Photoshop with other created or photographed textures and shapes. Explore with the computer, but stay away from filters (the nemesis of the young computer artist) and other program devices that shortcut or preempt the artistic process. Explore various layout ideas in a pagemaking program.

Type in text to see how it relates to the graphics. Think texture when selecting a typeface. What kind of type texture complements or counterpoints the graphics? One or two faces are enough. Serifs are often a good contrast to grunge. Consider cursive, hand-lettered alphabets. Spell-check all text—and then have someone else proofread it again, if possible.

The layout will now require structure. The essential elements of good page design should be reviewed before proceeding further on the computer. Grids, balance, use of white space, emphasis, unity, and other canons of composition must be understood before wise aesthetic decisions can be made. Place guidelines over the visual exploration that has taken place. Look for patterns and repetitions. Build a blueprint over the spread. It is also helpful to remember that horizontal grid units should be divisible by the leading dimension. Push the graphic and type elements around so that some of their parts hit the blueprint. Look at the white spaces. Consider their shapes, sizes, placements, and number.

When building structure on chaos, consider unifying elements. Applying a grid system will be useful, but so will repetition of color, form, and texture; these aid in bringing the pieces into a unified whole.

Conclusion

There is a built-in risk when working from chaos to structure. In the final version, visual disorder will likely occur if the graphic artist does not appreciate and understand page layout fundamentals. Therefore, it is important to review principles of page composition during the later stage of such an assignment. However, designers with basic graphic design skills usually will perform beyond expectation and return to doing more creative page designs even with later assignments that are more traditional.

Catalog Design

The catalog brought consumerism to rural America. It offered a range of choice, good prices, and a way to escape the restrictions of rural life. Television then increased the need for high-end consumer catalogs with rich visual content. These catalogs offered new standards for measuring personal success and identity. They also continued to offer practical goods at practical prices. They combined the mundane with the fantastic, making each more palpable.

The catalog designer must keep this duality in mind. The catalog is an exercise in information design and straightforward consumerism; it is also a product that entices, transports, and stimulates. A list of products and product descriptions, prices, sizes, and stock numbers is offered. Ordering procedures and customer service agreements are clearly stipulated. But in addition, novel standards of behavior, dress, and comportment are introduced. The products are enticing because they are necessary, but they are also seductive because of the context in which they appear. The promise of complete autonomy and anonymity increases the fantasy and stimulates the consumer appetite. No salesperson will look disapprovingly; no embarrassing moments will be suffered in public; no one else will ever know the consumer's secret tastes.

▲ **KEY IDEAS**
- Catalog design is an exercise in information design and straightforward consumerism.
- Catalog design entices, transports, and stimulates.
- Catalogs combine the mundane with the fantastic, making each more palpable.

Fashion Catalogs

Certainly the most common sort of consumer catalog is the fashion and accessory catalog. One of the first catalogs to bring "big city" choices to rural America was the Spiegel catalog, which offered up-to-date fashion choices at relatively low prices. By avoiding the overhead of retail outlets, savings could be passed along to the consumer.

Catalog shopping was a new way of doing business. There was no human involved to personalize the transaction, so in catalogs the personal touch is absent. The catalog itself had to image the company and offer the buyer a belief structure that lent value to the transaction.

Creating and reinforcing this belief structure is still a fundamental requirement in catalog design today. The catalog must establish the company and the product lines in the superlative: the most authentic, the most functional, the most valuable, the most exotic, and so on. This positioning is especially true for the fashion catalog.

The catalog begins with a concept that unifies all the design elements—and all the fashion products—into a comprehensive image that meets high standards of authority, fantasy, and practicality. The products will be used in a context, whether a practical or an imaginary one. Therefore, the strategic approach for the catalog design must address the issue of context and use it to create an underlying structure that will support the other design choices for photography, color palette, typography, composition, stock, and shape.

Context can be established with a narrative approach, telling a short but poignant story to showcase the products. It can be created with a purely visual structure that situates objects in spaces and creates patterns, rhythms, and tone. Or it can derive from a series of dramatic moments that have no narrative relationships but are connected by the product line. The concept/context relationship that connects the products and establishes the authority and identity of the company will direct the basic photography and design choices.

Fashion catalogs are especially sensitive to the quality of the photography. Photography creates color and mood, and it can make or break the consumer belief in the fashion product. If consumers cannot imagine themselves in the product, the photography has not been successful. If the photography does not create a context and tone, it is not successful. If it does not fit into the overall design strategy that connects the products to the House, then the photography is not successful. Perhaps second only to a food catalog, in a fashion catalog almost everything rides on the photography, and the photography is only as good as the photo-art direction.

The designer must know, in great pictorial and emotional detail, what the design strategy is and be able to convey it pictorially to the photographer. Then the designer must step back and let the photographer interpret the vision. The photography cannot be a mechanical version of the design strategy. It is not a recording of product, but an imaginative interpretation of setting and creator of mood. This is especially true in a fashion catalog, where the use of models will create a method of emotional identification for the consumer.

It is imperative to review photography portfolios and to get recommendations from trusted colleagues when choosing a photographer. It may not be necessary to hire someone who has already created the specific look you want, but it is imperative to hire someone who has treated light and achieved tonal ranges in just the way you expect them to be handled in your catalog. Be sure that the photographer you pick can work well with your creative team. When you find a good match, do a trial run. Then move on to the fashion shoot, giving increasing amounts of authority and design control to the photographer. If you have established the ground rules correctly, the photographer will bring you increasingly into the decision-making loop on questions of photographic mood, tone, emotion, and, above all, lighting.

Typography must underscore the photographic mood while referencing the identity of the fashion house. The products displayed will only be valuable this season; the house must appear to last forever. While fashion trends come and go, the house establishes itself as a leader in the creation of trends and thus reinforces consumer belief in its products.

▲ KEY IDEAS

- The catalog begins with a concept that unifies all the design into a narrative context.

- Context can be established with a narrative approach—telling a short but poignant story.

- The narrative context can be a visual structure that situates objects in spaces and creates patterns, rhythms, and tone.

- The narrative context can be a series of dramatic moments that have no narrative relationships but are connected by the product line.

Consumer Product Catalogs

The consumer product catalog presents a related set of products, organized according to a utilitarian system. There may be a set of related activities, such as "Outdoor Recreation"; one specific activity with seasonal restrictions, such as "Gardening"; or a range of activities, such as "Pest Control for the Small Gardener."

The product catalog has to present a clear hierarchy of information. A catalog should have a number of wayfaring devices and navigational aids, a strong format, and a composition that reiterates the organization of information. Nooks and crannies of graphic space should be allocated to supplemental material. Even the smallest catalog should have a clear grid structure, which will organize the text in columnar format and arrange the images in an easy-to-follow and easy-to-read format. Stock and type should be straightforward, with decisions made on the basis of clarity and production value, strong communication, and product enhancement.

However, none of this organization will have any strength if the authority and identity of the company offering the catalog are not fully imaged. No product can stand without its manufacturer, related products, and customer service. All this goes missing from the impersonal world of catalog consumerism unless it is specifically and intentionally interwoven into the design strategy. Pullouts should include letters from satisfied buyers, expert testimonials, and other items that increase credibility for the manufacturer and the product line. Be sure to incorporate the company branding strategy into the design of the catalog, using the colors, logo, and approach of the company's letterhead, advertising, and annual reports.

High-quality photographs must fully document the product while they place the viewer in close proximity to the experience of using that product. Each photograph should enhance a particular detail, show a technical system, or offer a use context for the product. Full-product shots with no background do not. If you are buying stock photographs or using some that were taken previously for some other advertising campaign, then crop and digitally enhance these photographs to achieve your design goals.

▲ KEY IDEAS

- The product catalog must have a clear hierarchy of information, presented in an easy-to-read and easy-to-follow grid structure.
- Stock and type decisions should be made for clarity and production value, strong communication, and product enhancement.

Technology Catalogs

Today hi-tech is so fashionable as to rival the entertainment industry. This conflation of the entertainment and technology industries has conferred celebrity status on technology. Our limitless faith in the possibilities of technology, and our deep belief in its power to shape our future in any fashion we choose, require that a technology product catalog have its own unique design strategy.

Design research should include a review of the kinds of magazines the target market reads, the market's spending patterns, disposable income, vehicles, and activities. Relations to cultural institutions, religious organizations, and entertainment activities should be identified. An assessment of this information will give the designer a general overview of the depth and breadth of the target market's current level of faith in technology. It is important not to assume that you know your target market's comfort level with technology, and not to develop a design strategy based only on your client's faith in its own products.

The answers to research questions will point the way to your design strategy. Then you will need to assess your strategy in light of your client's budget. Photography has to fit both your strategy and your client's budget. Avoid stock photography if you possibly can in this case, or find your own source. Stock photography in this field seems to circulate rapidly through the design community. Once a hi-tech shot becomes recognized, its use value for your specific project is compromised.

The primary design choices will define the shape and size of the catalog itself, its range of materials and stock choices, and its approaches to color and typography. The catalog can take many different forms, from a "standard" glossy, multiple-page, staple-bound catalog to a mini CD inserted in a multi-sided presentation case with mini-magazines, promotional novelties, and lush 4" × 6" chromes.

Type can be used to offset the dominance of the high-content, high-color product shots. It may be that an Old Style typeface will provide just the right amount of relief from the hard edge of the technical aesthetic. Techno and grunge fonts are intriguing for a high-tech product catalog, but they are generally difficult to read. Integrate headline and body copy, and use different typefaces to achieve different results.

The color palette should be strong and pervasive, letting light flow through the catalog in novel ways that highlight the products and help structure reading patterns. Metallic inks are not required, but special effects that parallel their ability to reflect light and illuminate detail is helpful. The creative use of spot varnishes can add three-dimensional "pop."

The high-tech catalog should have at least one special section or one special treatment that distinguishes it from other catalogs. The special treatment can come from the visual story or from the products themselves. A pop-up, a die cut, an insert, or an interesting use of a novel stock can make your catalog stand out from the rest of the pack. New color combinations, novel typography or a new typeface, or the judicious use of bizarre design elements can extend the reach of the catalog and enhance the emotional relationship the consumer develops with the products. Visualize the use of the product, and then design from that special vantage point. It will associate the buyer with the product and help make the sale.

▲ KEY IDEAS

- Technology today has near-celebrity status.
- Design research must identify important characteristics of the target market: spending patterns, disposable income, recreational preferences, and relations to cultural and religious organizations.
- Know the target market's comfort level with technology.

College Catalogs

The college catalog sells a set of experiences that are associated with past traditions and future hopes. There is no product per se, but there are the various courses, majors, and degree programs that form the basic "product line." These are supplemented with additional product lines such as athletic activities, student services, and special activities available within the geographic region (beaches, ski resorts, museums, and so on).

College catalogs are highly regulated. There are both state and federal regulations concerning content and presentation of data. Accrediting agencies also have high expectations for the value and validity of a catalog. The college catalog designer must be aware of all these regulatory agencies' requirements. There is often a college officer in charge of the project who should be able to supply the required information.

Shape, stock, and photography are as important in this kind of catalog as in others. However, this catalog sells in different ways and to different audiences. The first distinction is that the college catalog must be directed to the potential college student, even though that is usually not the person who is paying for the education. Secondly, very few people want to think of this catalog as a product catalog, even though that is, increasingly, what it is. They want to see a set of experiences, of moments of intense person-to-person interaction. College is a place where the dreams of students and their parents are made real.

Photography, shape, and stock should reflect to the way the college views its learning environment. High-gloss, large-format catalogs with stock photography and high energy seem to equate the college experience with fast-paced, twenty-first-century business concerns; small-format compendiums of information with no photographs simply say that this year will be much like any other year in a two-century-old tradition.

Somewhat like a corporate annual report, the college catalog will have distinct sections. The central focus is, of course, the college programs, majors, and curricula. Next in importance are administrative sections, including financial aid and student services; then faculty; and then course descriptions and the like. Some colleges relegate the sections of lesser import to inexpensive stock, and use a better grade to present information of greater importance. Some colleges use full color throughout, and others will confine color to a middle folio of 8, 16, or 32 pages.

The designer must work with all the pieces and build a composite of information, presentation, and personality, while complying with regulatory requirements, and reaching all the potential markets of the college. A straightforward approach to stock, section separators, color, and photography can go a long way toward both organizing vital information and presenting it in ways that appeal.

College catalogs are copy-heavy. Set up the copy approval processes in advance. Determine how many rewrites are permitted, when they are due, and who has final signoff authority. Plan on last-minute changes—some of which will be major—and develop a strategy to handle them. Get the photographic treatment approved by the college before you contract with any photographer. Approach the format and cover design as a separate project and get approval on this first. The interior will flow from the decisions on the cover design.

Typography must be flexible and organizational. Develop an approach to type that will give you at least four levels of information categories, and a color palette that can reinforce your photography and enhance your section separations. Develop navigational aids and a consistent information organization that help the readers find their specific areas of interest within a cohesive whole. Create a visual surprise once in a while that wakes the reader up and appeals to the youthful fun of the college experience.

▲ **KEY IDEAS**

- College catalogs are highly regulated. Know the applicable requirements.
- The college catalog is not considered a product catalog, even though that is increasingly what it is. It must present a set of experiences and moments of person-to-person interaction.
- The designer must build a composite of information, presentation, and personality.
- College catalogs are copy-heavy. Typography must be flexible and organizational.

Seth Boggs
Concordia University—Nebraska

Connect with the Non-Connected?

Multi-faceted diversity makes up the mosaic of the mission field in which our churches live, move, and now have their being today. The start of the 21st century has caused the church to fall to its knees and repent for its inability to effectively reach out to the multitude of people who surround our auspicious buildings and dwindling communities. Although a few churches continue to experience growth and vitality, the majority of congregations across America are asking such question as: "If it worked in the past, then why isn't it working now?" "Why aren't our children connected to a congregation?" "How do we go into our neighborhoods to proclaim the Gospel and make disciples when no one is interested in listening?" "Where have we gone wrong?" "What are we to do?"

In a very recent presentation, Bob Lagon of Church Resource Ministries shared that during the past fourteen years all Protestant denominations declined by 9.5 percent, a loss of 4,498,242 people, while the population of the United States increased by 11.4 percent, a gain of 24,153,000 people. In the past 50 years, evangelicals have failed to gain an additional two percent

Bachelor of Fine Arts Program

CONCORDIA UNIVERSITY offers the bachelor of fine arts degree in studio art, K–12 education, and graphic design.

The bachelor of fine arts degree is the initial professional degree in art or design. Its primary emphasis is on the development of skills, concepts, and sensitivities essential to the professional artist or designer. In any of the roles as creator, scholar, or teacher, the artist or designer must function as a practitioner who exhibits both technical competence and broad knowledge of art and history, sensitivity to artistic style, and an insight into the role of art and design in the life of humankind. Evidence of these characteristics and potential for their continuing development is essential for the awarding of the bachelor of fine arts degree.

THE PROGRAM:

The following program structure has as its emphasis the preparation of the professional artist or designer, whether that role is commercial artist, studio artist, or artist teacher.

General Education	51 hours
Common Core: (including foundations and art history)	30 hours
I. Foundations	21 hours
Art-103 Drawing	3
Art-145 Digital Photography Manipulation	3
Art-203 Two-Dimensional Design	3
Art-205 Three-Dimensional Design	3
Art-210 Intermediate Drawing	3
Art-213 Advanced Drawing A	2
Art-214 Advanced Drawing B	2
Art-215 Advanced Drawing C	2
II. Art History	9 hours
Art-271 Art History I	3
Art-272 Art History II	3
Art-273 Art History III	3
III. Art Theory	6 hours
Art-370 Studies in Art (course is to be repeated three times)	2 hours

This two-hour course is offered three times and will have a sequence of different topics offered each year for third and fourth-year students in the disciplines of art criticism analysis, and aesthetics. This sequence will be required of students in the BFA studio and BFA art education programs. Graphic design students are not required to take these six hours.

In addition to the common core and art theory courses each BFA program will require the following courses bringing the total of each major to 75 hours.

BFA STUDIO ART: Art-141, 223, 235, 243, 315, 325, 499, nine hours of advanced study in one studio area, art electives to bring the major to a total of 75 hours.

BFA ART EDUCATION: Art-190, 223, 235, 243, 301, 315, 325, 345, 499, Edu-377, nine hours of advanced study in one studio area, art electives to bring the major to a total of 75 hours. The required education courses for the BFA in art education will be identical to those required for the K–12 BA art major.

BFA GRAPHIC DESIGN: Art-190, 280, 303, 320, 351, 352, 365, 407, 451, 452, 489, (six hours from 223, 235, 315, 325), CTA 241, art electives to bring the major to a total of 75 hours.

COURSE DESCRIPTION:

Note: Not all courses will be offered in any given term, semester or year. (Consult your academic adviser for projected schedules.)

Art-101 Fundamentals of Art (3)
An introduction to art. Emphasizing production of art through the exploration of design elements and principles: interpretation of art through cultural and historical context; investigation of nature and values of art. This course is intended for students with limited or no previous art experience.

Art-103 Drawing (3)
Foundation in the basic perceptual, expresive and design aspects of drawing; use of various black and white media and diverse subjects.

2001–2002 Academic Calendar

SEMESTER I, 2001–2002

Monday, August 27	First day of classes
Monday, September 3	Census date
Friday, September 14	Tuition and fee payment deadline
Friday–Sunday, October 12–14	Fall Break–No classes
Wednesday, October 17	Mid-Semester (Classes Meet)
Wednesday, October 17	Deadline for removal of incomplete grades
Saturday–Sunday, November 17–25	Thanksgiving Recess
Monday, November 30	Deadline for Withdrawal
Friday, December 14	Regular classes end
Monday–Thursday, December 17–20	Final exams
Thursday, December 20	Semester ends

SEMESTER II, 2001–2002

Monday, January 14	First day of classes
Monday, January 21	Census date
Friday, February 1	Tuition and fee payment deadline
Tuesday, March 5	Mid-Semester (Classes Meet)
Tuesday, March 5	Deadline for removal of incomplete grades
Saturday–Monday, March 23–April 1	Spring Recess
Friday, April 19	Deadline for Withdrawal
Friday, May 3	Regular classes end
Monday–Thursday, May 6–9	Final exams
Saturday, May 11	Commencement

MAY TERM, 2002

Monday, May 13	First day of classes
Friday, May 31	May Term ends

SUMMER TERMS, 2002

June 10–26	First Term
June 26–July 12	Second Term
July 15–31	Third Term

CHARACTER

CONCORDIA UNIVERSITY opened its doors on November 18, 1894, with one professor, a dozen male students and a three-year high school curriculum. Concordia has since grown into a fully accredited, coeducational university which has granted degrees to more than 20,000 students. Concordia-Seward is one of 10 institutions belonging to The Lutheran Church–Missouri Synod's Concordia University System.

STATEMENT OF MISSION AND COMMITMENTS

CONCORDIA UNIVERSITY, owned and operated by The Lutheran Church–Missouri Synod, is a coeducational institution of higher learning committed to the Christian growth of its students. Concordia students will receive an excellent, holistic, Christ-centered education and be prepared for servant leadership to the church and world.

This goal is accomplished through degree programs in professional education and the liberal arts. In addition, Concordia's faculty, staff and students are committed to service to the church and community and to scholarly activity and research. These programs and activities are set forth in an explicit value system that has as its core faith in Jesus Christ as the Son of God and only Savior of the world, commitment to the Holy Scriptures as the communicator of that faith and commitment to the Lutheran Confessions as exposition of the Scriptures. Concordia's programs promote intellectual, emotional, physical and spiritual growth. They nurture religious commitment, enlarge social and cultural understanding, provide insights for Christian action in the world and facilitate the ability to communicate effectively.

SETTING

CONCORDIA'S CAMPUS covers nearly 120 acres and features more than 20 academic and service buildings. Because Concordia draws the majority of its students from outside Nebraska, residence hall living and student activities play prominent roles in shaping students' total educational experience. Concordia has nine residence halls, a student center, athletic fields for intercollegiate

Seth Boggs
Concordia University—Nebraska

Magazine Design

The Masthead

The masthead has to announce the name of the magazine, convey a distinct approach to the content, and target a niche market. A masthead must tell the reader what the magazine stands for, how the magazine sees itself, and how it wants to speak to its audience. A masthead demands new and exciting typography. It includes the name of the magazine as well as supplemental information such as volume and number, month, price, or a secondary tagline. Both letterforms and colors must be considered. Sometimes the two are inseparable. Flexibility is always optimal, so go for the changing color option when you can.

The next step in designing a masthead is to decide on the extent to which it will be integrated into the cover design or separated from it. If it is fully integrated into the cover design, it should drive the cover, with illustration or photography becoming secondary elements. The masthead will direct readers

through the composition of the cover by creating a visual hierarchy that starts with the masthead itself.

If the masthead is less integrated with the cover design—if it sits in a sidebar, or across the top of the cover—then its presence should frame the cover, serving as a pointer to the cover content and offering a feel distinct from that of the cover illustration or photograph.

Editorial content is ultimately what people buy in a magazine. The masthead promises that the readers have made a correct decision in choosing this magazine—that those who seek its particular content will be pleased.

▲ KEY IDEAS

- A masthead must tell the reader what the editorial content stands for, how the editorial content defines itself, and how the editorial content speaks to its audience.
- The masthead reinforces a purchase decision.

The Editorial Spread

Most magazines are organized around a set of interior spread formats. These are the grid structures within which the editorial content, advertising, and design will be housed. The columnar, predictable structure of a grid is especially helpful in measuring type and assigning advertising space.

The three main spreads are (1) the table of contents; (2) the prime editorial story spread; and (3) the secondary editorial spread, where stories are completed and ads are run. The prime editorial story spread receives most of the attention. It typically uses photography to extend the editorial content. The secondary spread can include photography, but it will usually be in the advertising space.

The table of contents also offers a guide to the design and layout of the magazine, along with a letter from the editor or some topical column. The table of contents is often overlooked by readers, who flip through magazines until their eye is caught by an interesting photograph, but it is still an important part of the overall design strategy and should be considered an important design opportunity.

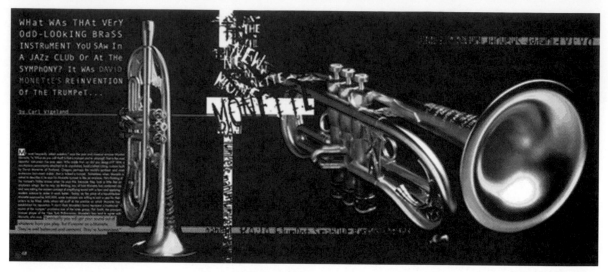

Chris Barron
Metropolitan State College

The most common way of "reading" magazines is akin to surfing the Web or channel surfing with a remote control. Content is scanned. Eyes dance across the pages. Catching the eye of the magazine surfer is the job of the editorial spread. It must tell a story at a glance, and successfully entice the reader into the content.

▲ KEY IDEAS

- Magazines are organized around a set of interior spread formats. These are the grid structures within which the editorial content, advertising, and design are housed.

- The three main spreads are the table of contents, the prime editorial story spread, and the secondary editorial spread.

- The most common way of "reading" magazines is more akin to surfing the Web or channel surfing with a remote control.

- The editorial spread must tell a story at a glance.

Editorial Spread: Sports

The sports spread must tell a story with pictures long before it tells it with words. The drama of the sports story is conveyed through photographs

supported by headline and body copy. The purpose of the sports spread is to mimic the action of the game and/or personalize the play, creating a visual mechanism that will let the reader identify with the passion, drama, and outcomes of a competitive contest.

The initial visuals should be large enough to be dramatic. The small, emotional close-up comes later in the story when the characters are in place. The sports spread builds on the play even if the outcome is the focus. The photographic story is about the unfolding events and persons involved. The reader wants to feel the emotion of sport. There are heroes in sports, and readers project themselves into these persons' constructed lives as represented through the words and pictures of the designer. In Western traditions this has been a subject of some of our most cherished stories since Homer. Sports and sports legends are the embodiment of exemplary behaviors, strength of character, and sound personal habits (whether factual or inverted).

Typography should be predictable and straightforward. It should reinforce the story by carefully and subtly replicating the rhythms and pace of the event, through judicious use of kerning, leading, point-size choices, and color variations. A classic, easy-to-read typeface should be chosen, with one or two secondary typefaces that enhance and provide counterpoint for the main typeface.

▲ KEY IDEAS

- The sports spread mimics the action of the game and personalizes the play.
- The sports spread lets the reader identify with the passion, drama, and outcomes of the competitive contest.
- There are heroes in sports and the reader projects him or herself into their constructed lives as represented through the words and pictures of the designer.

Editorial Spread: Fashion

The fashion spread must stimulate consumer desire. The designer must create a visual context that permits viewers to project themselves into the graphic architecture of the editorial spread. As previously noted, one way to do this is to use visual metaphor and simile. When essential but obvious parts of the photograph are missing or obscured, the viewer can "fill in" and complete the

visual message. Layering, typography, and inking, as well as format and die cuts, can be used to effect this strategy of enticement. Other strategies include the use of direct messaging via the copy; less direct methods use nostalgia, sexual fantasy, jealousy, or some other emotion to draw the consumer into the fashion spread. The fashion spread set dresses the editorial content, integrating it into the physical space of the graphic design.

Typography should create perspectival spaces—points of view—from which the viewer can gain access to the rich visual information of the photograph. Bold graphic type can offer a new view of the action of the photograph. Graceful, Old-Style letterforms can change the tempo and refer to bygone times, setting up an interesting tension of opposites if the photo has a contemporary, gritty feel to it.

Color can expand the emotional range of the photography, make hinting references to past and future, help establish context, and direct the viewer through the visual hierarchy of the spread. Large areas of black or of white can frame the photography or offset a splash of color, changing the visual pace.

If the fashion photographer has caught the story, then the designer need only reinforce it and create a graphic space for it to come to life in.

▲ KEY IDEAS

- The fashion spread stimulates consumer desire.
- The fashion spread creates a visual context that permits viewers to project themselves into the graphic architecture of the editorial spread.
- The fashion spread set integrates editorial content into the physical space of the graphic design.

Editorial Spread: News

The news spread must convey the strength of truth and the directness of real life. A discernable grid and the power of modern typefaces will add to the truth value and enhance the drama. Tones should be a full 100 percent. Type should be direct and extremely legible. Composition should keep the reader on the page and formalize the visual structure by reinforcing the horizontal/vertical grid that contains the copy. Design elements should help the reader follow the copy and direct the eyes from text to image in a predictable and informative way. Photographs should be dramatic.

Nicholas Bartlett
Concordia University—Nebraska

Melissa Adkins
Concordia University—Nebraska

Design elements should manage the visual hierarchy. If the image is central to the story, its presence should be affirmed and the viewer directed to its visual information first, then to headline, then to copy. If the image is supplemental to the news story, it should be put off to the side of the copy and its secondary role indicated by a change in design treatment.

Display typefaces and other ornamental flourishes should be avoided. It is, however, possible to use highly layered typography to create a visual context for "the news" and to simulate the complexity of intersecting stories. Not all news is straightforward. Type and/or image can be developed within the grid structure to call attention to conflicting points of view.

▲ KEY IDEAS

- The news spread must convey the strength of truth and the directness of real life.
- The news spread formalizes the visual structure by reinforcing the horizontal/vertical grid that contains the copy.
- Photographs should be dramatic. Design elements should manage the visual hierarchy.

Editorial Spread: Art

The editorial spread that showcases works of art must keep design in the background and the art in the foreground. The design of the spread creates tone, rhythm, direction, and context for the photography and text. In this particular case, however, the graphic design does much more: it functions much like a pedestal or a frame and provides the reader with a strict demarcation between art and commentary.

Typography must be appropriate to the content and to the structure of the editorial grid. It can override the grid to call attention to issues or details, but it cannot ignore the grid. It should be helpful to the reader, although not necessarily in a literal way. It should guide the eye and open the mind. It certainly should not compete with the art, but it should expand the reading experience and introduce the dynamic conditions that establish a context for the art works.

Photography should be nothing less than excellent, with rich tones and highly crafted lighting. However, it should depict the art works as they are, *in situ*—no need to obscure the works. Generally speaking, the readership of an art magazine wants information. The editorial art spread should fulfill their desire.

The color range has a significant impact on tone. Color can be used as a design element, gracing the grid and helping to establish visual frames. It can be used to call attention to pullouts and information bars that expand and extend the reading. Used sparingly, color can accent a transitional moment from text to photography or from concept to concept.

Color can also be used to expand the visual experience of light and space. Design elements can be used to tie the luminescence of the photograph and its planes of light to the grid structure of the editorial composition. This can extend the light captured in the photograph into the graphic space of the page. This strategy should be decided upon during design development and brought into the photo art direction. Draw the architectural elements of the photographic space into the graphic space. The planar integration of the photography, art, and graphic design, as they intersect the grid of the text, can add physically to the reader's experience.

▲ KEY IDEAS

- The art spread keeps design in the background and the art in the foreground acting as a pedestal or frame.
- The art spread provides the reader with a strict demarcation between art and commentary.
- Design elements tie the luminescence of the art photograph and its planes of light to the grid structure of the editorial composition.
- Draw the architectural elements of the photographic space into the graphic space.

Editorial Spread: Special Interest

A special-interest editorial spread must take the character of the magazine to an exaggerated level. If it is a nature magazine, the visually rich treatment of the natural environment must make the Garden of Eden seem boring in comparison. If it is a sports magazine, we should hear the clash of Titans. If it is a magazine dedicated to collecting, we need to visually experience the rarest, the most precious, and the costliest examples. If it is scholarly, only the most exemplary research on the timeliest of issues can grace the editorial spread.

Design strategy and typography will flow from the textual content. Color palette and stock choices will enhance and complement the photographic content. A grid structure should be used only to the extent that it helps

Kenneth Behnken

How Can Congregations Connect with the Non-Connected?

Multi-faceted diversity makes up the mosaic of the mission field in which our churches live, move, and have their being today. The 21st century has caused the church to fall to its knees and repent for its inability to effectively reach the multitude of people who surround our auspicious buildings and dwindling communities. Although a few churches continue to experience growth and vitality, the majority of congregations across America are asking questions like: "If it worked in the past, why isn't it working now?" "Why aren't our children connected to a congregation?" "How do we go into our neighborhoods to proclaim the Gospel and make disciples when no one is interested in listening?" "Where have we gone wrong?" "What are we to do?"

In a recent presentation, Bob Logan of Church Resource Ministries shared that during the past 10 years all Protestant denominations declined by 9.5 percent, a loss of 4,498,242 people, while the population of the United

States increased by 11.4 percent, a gain of 24,153,000 people. In the past 50 years, evangelicals have failed to gain an additional two percent of the American population. Chip Arn reported that not one county in America has a greater churched population today than it did 10 years ago. Today the United States of America is the third largest mission field in the world, with 100 million non-connected (unchurched) Americans. In February of 1999, George Barna reported that one out of three adults in America is unchurched. As a result, the United States has become a nation to which, 50 years ago, every Christian would have felt compelled to send missionaries. Bill Easum, a church consultant, has estimated that three out of four established churches will close in the next 30 years unless they transition into "doing church" differently. In the United States, the non-connected out-number the connected. In accord with our Lord's command to "make disciples of all people," we must ask, "Who are the unconnected, and how do we reach them with the Gospel of Jesus Christ?"

Who are the Non-connected?

If we are to use the word, diversity, to explain the make-up of the United States, then we must quickly add that it is a multiplicity of diversi-

ties. In order to grasp the beauty and density of this colorful mosaic, we need to take a brief look at the individual pieces.

Diversity of Cultures. As a result of war, famine, and seeking better living conditions, millions of immigrants and refugees have made their homes in the United States. People from Asia, Africa, South America, Mexico, Europe, and many of the island countries, like our ancestors, now call the United States home. They bring with them their cultures, their languages, their food, their forms of dress, and their religions. Some come from cultures with written language, while others are only oral communicators. Our Western culture—its food, dress, language, and religion—is so strange to these newcomers as their cultures are to us.

The Christian looks at these newcomers and asks, "How do we connect those who are non-connected with the Body of Christ?"

Diversity of Generations. George Barna, a church research specialist, reminds us that there are five generations in America who hold distinct differences in regard to specific areas of life, such as: "Authority—older Americans accept it, Boomers want to control it, and Busters ignore it. Contradictions—elder citizens ignore them, Boomers strive to solve them, and Busters appreciate them. Life from—seniors worry about being useless, Boomers fear being out of control and powerless, while Busters are troubled by emotional abandonment. The list could go on, and we could add two generations after the Boomer generation. Even different

generations living in the same household have difficulty understanding each other.

Christians look at diverse generations and ask, "How do we connect with the non-connected?"

Diversity of Class. The United States is experiencing an ever-widening gap between the haves and the have-nots. In the United States, one percent of the population owns 42 percent of the wealth, double that of what it was in 1978. Class has become, in our culture as in others, a greater line of demarcation and division than culture or language. Today it is what one has, not a matter of cultural background, that determines where one can live. As Christians we understand that with Christ there is no distinction between classes.

The Christian looks at class diversity and asks, "How do we connect with the non-connected?"

Diversity of Religions. As people from across the world unpack their belongings on the shores of the United States, they also unpack their gods and religions. One needs only look at bookstore displays to realize the impact of the diversity of religions in the United States. The postmodern world has become a secular, pluralist world intermingling with religiosity. Buddhism, Hinduism, Islam, Confucianism, and local tribal gods intermingle with religious sects and gods of materialism, individualism, and fame, or the cult of the irreligious. How does the Gospel relate to each local religious cultural manifestation of faith without compromising the Gospel's supracultural character?

Dr. Kenneth Behnken is the director of the Center for U. S. Missions located on the campus of Concordia University, Irvine. behnkenk@aol.com

18

ISSUES WINTER 2001

19

Seth Boggs
Concordia University—Nebraska

organize the superlative themes. No structure can contain the very best of the best, so be prepared to adjust the grid structure to highlight the novel. When appropriate, use graphic architecture to create a three-dimensional space.

Typography should be simple. Use it to highlight the outstanding examples that are showcased photographically. Type can frame, point, underscore, corner, and support simply by its placement. It can be made subtle or brilliant by adjusting color and saturation. It can play an obviously secondary role as explanatory text. It can even take on a tertiary role, confined to captions or short phrases in small point sizes.

Careful consideration of the content of this visual narrative must be undertaken with the photographer. It would be foolish to rely on stock photography for this kind of spread unless there is a specialized and committed source. The whole design strategy pivots on the photographer's ability to capture the

essence of the object's particularly distinctive role in the universe of all objects of its kind. Its outstanding physical attributes will raise it to the level of "one-of-a-kind." Showcase the absolute qualities. Underscore them with quiet and subtle use of minimal copy, appropriate typeface, small type size, integrated color, and a small line or other directional once in a while just to keep the reader's eye on the page.

▲ KEY IDEAS

- A special-interest spread exaggerates editorial content.
- The special-interest grid structure should be used only to the extent that it helps organize the superlative themes; adjust the grid structure to highlight the novel.
- Use graphic architecture to create a three-dimensional space.
- Showcase the absolute qualities of the featured subject.

New Magazine Design

Now that the budget is in place, the advertisers lined up, the market identified, and the editorial content solid, it is time to move into the design development stage for your new magazine. The launch date is four months from now. Copy is in or is being written, freelance photographers are out collecting visual material, and the board wants to see your presentation of two different versions of the design.

You know the editorial strategy and the target market. You have researched all the competing magazines and know the visual preferences of your readership. The next set of questions must focus on the relationship of word and picture. Is the magazine primarily written to be read? If so, then photography is illustrative and layout must be highly structured, so that the textual information can flow to the reader in a predictable and deliberate way.

More likely than not, however, the magazine will written to be looked at, flipped through, and consumed in a nonlinear, disjointed fashion. Photography will be primary and text supportive. Photography will tell the story visually, text will reiterate. Reading will take place in a nonlinear fashion, with pages opened in no particular order and content browsed until some eye-catching phrase or picture fixes attention.

Magazine format should enhance the reader's ability to shuffle through the pages in a variety of positions and places: from dining room table to bed; from crowded train to diner stool. The format—which includes shapes, heft,

Chris Barron
Metropolitan State College

and materials—should reflect market tastes. These can range from a desire for a highly textured and physical experience with the magazine to a somewhat emotionally and physically distant relationship that nevertheless requires intellectual engagement. An art magazine will have a very different set of physical requirements than those of a travel magazine or a professional medical journal.

The next issue to be addressed is the cover, which, as we have seen, is comprised of masthead, minimal copy, and maximum illustrative impact. The cover layout sets the tone for the interior grid, introduces the principal editorial content, and identifies the magazine. The cover must state everything the magazine stands for, whether that is real-life drama, personal pleasure, object fantasy, or financial investment. Color, typography, and photography come together within the frame of the cover to make the visual statement that this magazine is different. Die cuts and half-pages are additional methods of bringing the reader into the magazine. The physical and visual structure of the layout should resonate within an appropriate range of entertainment values. Magazines are not just about information; they entertain, inspire, shock, and please.

The interior grid will have to have at least three main templates: the table of contents, the main editorial spreads, and the secondary editorial spaces that will include advertising. These three different grids should share a design strategy that creates magazine identity. This is especially required in a new magazine. Even such items as the page numbering system, column dividers, and break between articles must be conceptualized as design opportunities to help create visual structure and develop magazine identity. Attention to edges and to transitions can make the difference between a magazine that has a fully realized identity (and a chance to make a big splash) and one that is still evolving.

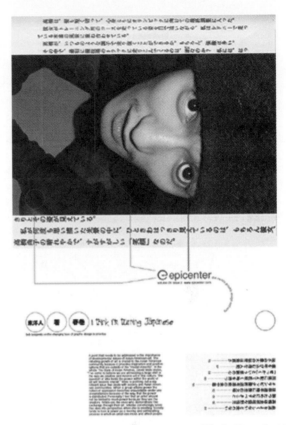

Nick Bartlett
Concordia University—Nebraska

A primary editorial decision concerns the inside cover. Is it advertising space or editorial space? If it is advertising space, what kind of ad can help establish identity? If it is editorial space, what will it contain? Is this the place for the table of contents and regulatory information? Is it the place to introduce the first editorial spread? This is valuable real estate, and more likely than not the inside front cover will be advertising space.

The magazine's position on typography should come across boldly in the first editorial spread. Many of the design elements should be introduced, although some can be saved for surprises later on in the magazine. The designer's approach to photographic content should be introduced as soon as possible, as it sets the tone for the readers' emotional experience and shapes their relationship to the editorial content.

Most magazines do not last without advertisers. Subscription income and store sales cover some operating expenses, but the advertising dollars are what help magazines make payroll and stay afloat. Editorial designers need to know how to incorporate advertisements that they have not created into their design strategy. As with photography and illustration, this art comes

from other sources; the editorial designer's role is to develop a layout structure into which contributions from other artists and designers can be incorporated—while supporting the design strategy, effectively communicating the text, and expanding the interactive experience of editorial communication. A lot to ask, no doubt, but as long as advertising is required to fund magazines, the editorial designer has to face the reality that areas of the magazine will be filled with potentially distracting messages.

Wordsmithing is not handled exclusively by the editorial department. Typography is quietly dominant in any magazine. There is a level of interaction that depends on clearly presented verbal information. Designing that relationship demands careful market and design research.

▲ KEY IDEAS

- Market: The magazine format should reflect market tastes.

 The market may require a highly textured and physical experience with the magazine or it may require a primacy in visual stimulation.

 The market may require an emotionally and physically charged relationship or one that requires intellectual distance.

- Format:

 —Layout must be highly structured so that textual information can flow to the reader in a predictable and deliberate way.

 —Reading will take place in a nonlinear fashion, with pages opened in no particular order and content browsed until some eye-catching phrase or picture fixes attention.

- Cover:

 Color, typography, and photography, taken together, within the frame of the cover, make a visual statement about the magazine readership as well as the editorial content.

- Design elements: Attention to edges and to transitions can make the difference between a fully realized identity and one that is still evolving.

- Photography: The photographic content sets the tone for the readers' emotional experience and informs their relationship to the editorial content.

- Type:
 - —Typography is dominant in any magazine.
 - —The magazine's position on typography should come across boldly in the first editorial spread.
 - —Textual interaction depends on clearly presented verbal information.
- Advertising: The editorial designer must develop a layout structure within which contributions from other artists and designers can be incorporated.

Magazine Redesign

Magazine redesign differs from magazine creation in significant ways. Identify has been established. It may be tarnished or in need of an upgrade, but it does exist. The market is already defined, and though it can be expanded, it is intimately tied to the magazine's identity. Advertisers are on board, and if ad revenue is slipping, the magazine redesign should help to get advertisers back.

The place to start is to determine how the identity can be reestablished. Do not guess. Go out and find out for yourself. Interview, conduct focus groups, and speak with all facets of the readership. Those who have jumped ship, those who have been loyal, both the aging and the young readership should all be solicited for input. Speak with advertisers and see where they have taken their media placement or why they have stayed true to the magazine. Research the competitors. Then surge forward. Do not settle for imitation or hesitant, faltering, half-hearted design moves. Create a new generation of loyal readers while bringing your current and loyal audience along for an enjoyable and perhaps long-awaited ride.

The primary agent for magazine identity during a redesign is the cover. Next in line is the interior grid structure. This structure has to be revitalized in a redesign. It is the place where the words and pictures come together. This is the place to explore the graphic space of the magazine. Develop an editorial signage system through design elements. Formulate a program of sequential spaces with dedicated uses. Develop pathways and walkways, open spaces, and enclosures. Create a landscape architecture, a garden of viewing pleasure, with private, quiet places to read in.

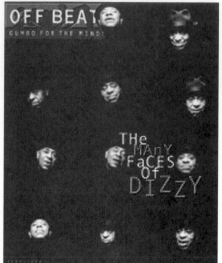
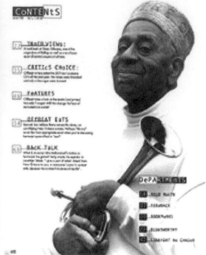
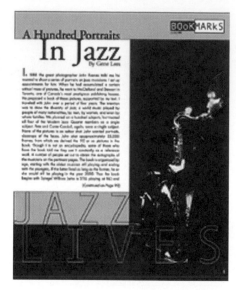

Chris Barron
Metropolitan State College

Find three different strategies and explore them in design depth. Move to one full mockup and take it back to your focus groups. Get their input; make the revisions you feel are appropriate. Your photographic approach may need redirection. Go into the most infinitely small detail (such as a page numbers) and out to a full overview, passing through the various grid structures, design elements, and color ranges. Build this time into your project timeline. Identity often succeeds or fails on design details.

▲ KEY IDEAS

- The primary agent for magazine identity is the cover. The interior grid structure is the next most important.

- Develop an editorial signage system through design elements.

- Formulate a program of sequential spaces with dedicated uses.

- Develop pathways and walkways, open spaces, and enclosures.

- Create a landscape architecture, a garden of viewing pleasure, with private, quiet places to read in.

- Identity often succeeds or fails on design details.

Jason Disalvo
Metropolitan State College

Professional Perspectives

Michele Hadjopoulos
Instructor
The Katharine Gibbs School, New York

Digital Workflow for Publications
Overview

Publication production is unique to the graphic arts with respect to the number of contributing factors. A carefully planned and maintained workflow is necessary to organize and control these factors to produce a magazine in the short amount of time usually allocated in editorial production. The workflow tracks all the elements of a page and orchestrates the people involved, using advanced technology.

A digital workflow is the sequence of events that transform original art and text into a final printed product. The ultimate objective is to maintain quality and accuracy while reducing waste and inefficiencies of materials and labor.

Participants

In the overall workflow, the three principal workgroups that need to communicate to produce a magazine are publishing, prepress, and printing. The publisher's design development workgroup is typically comprised of an art director, graphic designers, photographers, illustrators, editors, and production artists. The publisher may have a production group responsible for the printing of the magazine, which includes tracking and scheduling.

The prepress vendor or "in-house" department contacts the publisher through its customer service representative (CSR). The prepress CSR is the liaison between the publisher's production workgroup and the prepress manufacturing workgroup. The prepress manufacturing workgroup is made up of graphic artists, managers, and the scanning and proofing departments.

The printer's CSR contacts the production and prepress groups through their CSRs. The printer's CSR is the production planner, who relays information to the print manufacturing workgroup. The printer's manufacturing workflow involves platemaking, press, and finishing departments.

Scheduling/Tracking

Publishing, prepress, and printing workflows must work together seamlessly. Each participant in the workflow needs logs and job tickets for scheduling and tracking. The magazine print schedule is based on the frequency of the magazine. A monthly will have more flexibility than a weekly or biweekly, and a quarterly will have more flexibility than a monthly. The publisher and the printing plants negotiate the press schedule and determine deadlines for final files at the plant. Each magazine issue has a production schedule.

Every issue is broken down into signatures or forms. A signature folds and cuts into sections of the magazine with the page numbers in order. The page schedule depends on which signature it belongs to. The pages in the first signature to print become the priority. The publisher's production department will determine the form print order. This decision is based on the progress of ads, story art, and editing that will potentially complete the pages of the signature. Job tickets are used to track where the art edit and pages are in the workflow. *Logs* are electronic entries of the job ticket information.

Publisher's Workflow

For creation of a story layout, the publisher's workflow coordinates the work of the art director, graphic designers, editorial department, photographers, and illustrators to produce the necessary components that make up pages. Although a layout may be established, the edit may not be complete or may require modification at the last minute. The designer may have to use an approximate word count as dummy text until the edit is fit for print. Design may not have art to place until the art department coordinates with production to scan photographs or artwork. Art can change at any point as editorial content changes and develops. The design department's workflow requires "versioning" to ensure that the correct digital files are in the layout when it is submitted to production.

Production and Prepress

Advertising agencies or the agency's prepress house may supply digital files of ads to the production department. The placement of these ads directly affects the workflow schedule. For example, ads and editorial copy may end up on the same page, or each may run as a full page. Ad positions may change for different parts of the country, or they may be moved before printing if they are not appropriate for certain edit pages. These circumstances may require changing a form's schedule.

Digital files from agencies and the publisher are generally logged into the prepress department by the CSR to begin a workflow. The CSR specifies instructions from the publisher to prepress manufacturing with a job ticket. Preparing the magazine for print requires preflighting, scanning, proofing, color correction, retouching, pagination, trapping, and color separation. Each correction pass requires a revision to logs and job tickets by the CSR. To meet a print schedule, the production department must track each file's progress.

Workflow procedures depend on the details of specific publications. For example, for a high-quality publication, art and images (negatives, transparencies, photos, etc.) require scanning. Low-resolution representations of the scans are sent to layout designers for placement. Simultaneously, color correction and proofing of the high-resolution images are done. Approvals for the color scans and for completed pages may be accomplished through separate steps in the overall department workflow.

The prepress and publishing production departments communicate with the art director by providing proofs of the pages; the proofs represent what will go to the printer. Proofs confirm content and color of the final page. If there are edits, new proofs must be generated to show the change requested. Each proof must be approved before final files are sent to the printer.

It is important for publishing production to have good and ongoing communication with the printer(s). When a story changes, folios (page numbers) can change, which in turn may affect signatures. A good workflow will provide a quick solution to a schedule problem presented to the publisher, prepress, and printer.

Publishing production and prepress coordinate transmission of approved pages based on a schedule that can change. A file containing the page information is transmitted to the printer. A proof of how the page should look is also sent, to confirm once again that the page transmitted represents the latest page. When all of the pages in the signature reach the printer, an imposed file is created to make film or plates for press.

Technology

The process by which digital files are prepared, communicated, and translated includes all aspects of a workflow. In the graphic arts industry, computer platforms, software applications, and file formats are constantly evolving.

Printing technology processes are evolving to handle faster turnaround time. Designers want to be more expansive in their designs and printers need to accommodate their clients by executing the designs accurately and efficiently. Many publications are generating plates from digital files and replacing film. This change in platemaking directly affects the prepress and print processes.

The production of a publication requires a tremendous amount of communication between client and service. Procedures define responsibilities. A workflow organizes the flow of procedures. An efficient workflow facilitates a high level of communication.

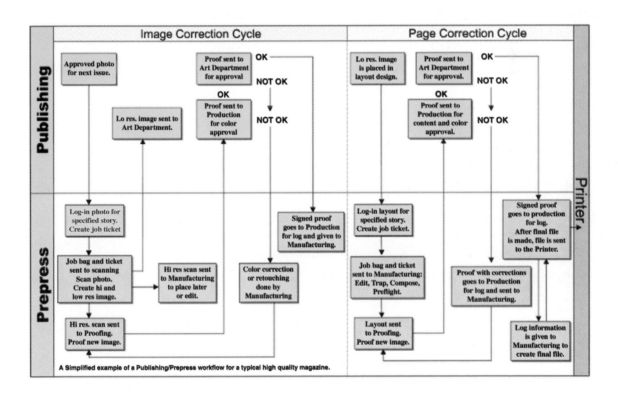

A Simplified example of a Publishing/Prepress workflow for a typical high quality magazine.

chapter five

Information Design: Directional, Instructional, and Quantitative

Information design concerns the visual presentation of quantitative data. It incorporates symbol systems that refer to temporal, physical, and geographic properties as determined by units of measurements, statistics, and other relational factors. Information design offers a context within which to access and assess the construction of visual reference points, guidelines, and information that signal appropriate goals and behaviors for diverse consumer markets.

Information is contextualized by the way it references scales of meaning. Legends and keys transform the information design into a code. The language and grammar of information design are self-referential; it is a closed reference system. Information design is both exacting and convincing.

The key to successful information design is to understand the plurality of the audience, and to intervene in ways that increase use value to the various constituencies.

Jerod Wilson
University of Northern Colorado

Erick Weitkamp
University of Northern Colorado

Menus

Menus are part entertainment, part catalog, part branding, and part information design. Like the meal itself, a menu can be a pleasing mixture of fine ingredients brought together with the science of a measured recipe and the art of invention.

The first step in any design project is the research. In this case, that simply means taking yourself and your significant other out to eat! (It's a tough job, but someone's got to do it!) There is work to do, however. Be sure to take in the entire ambiance of the restaurant you will be creating a menu for. Watch how the customers enjoy their meals. Notice the tableware, the signage, the mood at the bar, the uniforms, and the demographics and style preferences of the clientele.

Interview the owner and mangers. Find out from their point of view what kind of people frequent their establishment. Who, specifically, are the regulars? Are the owners interested in expanding the client base? Are they redesigning the look of the restaurant? What would they like their restaurant to say about them? What kind of mood do they prefer in the restaurant?

Research the different segments of the pre-dining experience. How do the owners feel the basic information of food and price should be delivered to the customer? Do they want a lot of wait-staff interaction with the customer, or do they prefer a minimal amount of contact? Do their customers need detailed explanation of the primary ingredients of the meal, or just a basic description? Explore these choices in great detail; they will involve your client in the project and invariably generate novel approaches to it. The more you can bring your client into the

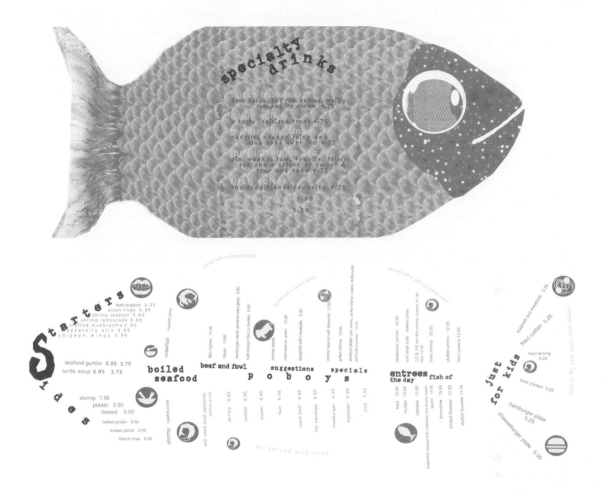

Leah Standley
Southeastern Louisiana University

exploratory phase and let ideas and questions freely flow, the more likely it is that any innovation or novel approach you undertake will be well received.

The menu is the initial moment of presentation. It must have flair and panache. It must not only appropriately and adequately present the cuisine, but also initiate eating—a very sensuous physical experience. This is a highly emotive context. The meal, and the menu that presents it, must establish an emotional tie between restaurant and customer. It should facilitate and encourage customers to share intimate conversation, and it should help foster long-term relationships, even if they are business relationships.

Menus are the quiet interlude that introduces the main events. They are the contemplative moments in which each diner assesses his or her mood,

desires, and degree of satisfaction. Menus offer a value-laden moment of introspection. They must promise and please, satisfy and stimulate the appetite.

Menus must incorporate the restaurant's theme. This may be an activity, such as a sports bar/restaurant; or a reputation, such as a place where hushed tones belie the high-stakes business deals made there. It may offer an ethnic cuisine. It may derive from the fashionable preferences of its clientele or appeal with a paparazzi effect, if the restaurant attracts stars. There is a theme to every restaurant, and it is the designer's job to find it. It may not be obvious.

Do not overlook the opportunity to incorporate the restaurant's architecture into the design strategy. This is particularly appropriate if the restaurant uses unique or compelling architectural details. If the restaurant is an architectural showcase, it will be absolutely necessary to work with the architect as the menu project develops. Three-dimensional and architectonic approaches will include the physical format of the menus (size, dies cuts, pop-ups, etc.) and the graphic space of the composition, typeface(s), and color palette.

The theme will direct the design strategy and some of the specific research activities. It will supply color parameters, typeface choices, and imaging and stock ideas. However, the two most important characteristics of any menu can be grouped into two interdependent aspects. The first includes design decisions about the look and feel, as determined by the color palette and stock choices. The second is the informational aspect as presented by the typeface(s) and graphic organization.

Meals are consumed in courses. The menu must follow the course selection. If you are not sure of the proper sequencing, check with the restaurant owner and speak with the chef. This, as well as other required copy, should be supplied by the restaurant's promotional department—which may be inside the owner's head, but has to be brought out and into your design.

The courses, selections available within courses, and ingredients of selections, each represent a different level of information. Other levels may appear in the copy you will receive as well. Perhaps the history of the restaurant or information about the geographic or historical roots of the cuisine should be included. Perhaps there is a map indicating where the ingredients come from. Nutritional information can be a compelling communicator.

The graphic space is created by the interplay of positive and negative space in the typography and through the texture, shape, and dimensionality of the stock use and cover treatment. The menu is, after all, a multiple-page document not unlike a promotion brochure, product catalog, book, magazine, or CD insert.

Miriam Baker
Concordia University—Nebraska

Soups & Appetizers

- Vegetable Samosa — 2.50
 Two crisp turnovers, stuffed with delicately spiced potatoes, peas and herbs
- Vegetable Pakora — 2.25
 Assorted vegetable fritters, gently spiced (seasoned) and deep fried
- Vegetable Cutlet — 2.25
- Chicken Chaat — 4.95
 Tender chicken in tangy sauce with yogurt, potatoes, topped with pappad
- Vegetarian Platter — 4.95
 Assorted vegetable appetizers
- Samosa Chaat — 3.95
 Samosa in a tangy sauce with spiced potatoes and yogurt
- Chicken Pakora — 4.95
 Assorted chicken fritters, gently spiced (seasoned and deep fried)
- House Special Platter — 6.95
 A fine presentation of our choice appetizers, recommended for two
- Aloo Papdi — 3.95
 Lentil crisps, cubed potatoes with freshly whipped yogurt, tamarind and mint chutney

Vegetable Soup — 2.25
 Soup made from fresh vegetables, lentils, spices and flavored with delicate herbs
- Mulligatawny Soup — 2.25
 A traditional chicken soup with subtle and mild Indian spices

Freshly Made Breads

- Roti — 1.75
 Whole wheat bread
- Poori — 1.95
 Whole wheat puffy bread, deep fried in vegetable oil
- Naan — 1.50
 Unleavened white flour bread, baked in the oven
- Paratha — 1.75
 Whole wheat multi layered bread
 - Mooli Paratha — 3.95
 Wheat bread stuffed with spiced radish
 - Kheema Paratha — 3.90
 Whole wheat bread stuffed with minced lamb and choice (Indian) spices
 - Tika Paratha — 3.90
 Whole wheat bread stuffed with tender tandoori chicken meat and vegetables

- Madras Lamb Curry — 10.50
 Hot and spicy lamb from Southern India
- Kerala Pepper Lamb — 10.50
 Spring lamb with special lentils and cracked peppercorns. Hot & spicy!
- Gosht Achari — 10.50

Rice Specialties

- Vegetable Biryani — 9.00
 A Mughlai-inspired dish of curried rice with vegetables, dried fruits and nuts
- Chicken Biryani — 9.75
 A classic Mughlai dish of curried rice with chicken, dried fruits and nuts
- Lamb Biryani — 10.00
 Curried lamb with rice, dried fruits and nuts
- Shrimp Biryani — 10.95
 White shrimp and rice in dried fruits and aromatic spices

Vegetable Specialties

- Baigan Bhartha — 8.25
 Roasted eggplant sautéed in onions, tomatoes, and green peas
- Dal Makhani
 Lentils cooked in onion, ginger, and garlic

- Palak Paneer — 8.25
 Chunks of homemade cheese in creamed spinach and fresh spices
- Aloo Palak — 8.25
 Spinach and potatoes with fresh spices
- Mix Vegetable Curry — 8.25
 A vegetarian delight made with fresh vegetables
- Punjabi Channa Masala — 8.25
 A North Indian delicacy; subtly flavored chickpeas tempered with ginger
- India Sag — 8.25
 Creamed spinach with chick peas, cooked with delicate spices
- New Delhi Kofta — 8.25
 Minced vegetables shaped into croquettes with curried sauce
- Madras Mushroom Curry — 8.25
 Spicy mushrooms with green peas and tomatoes
 - Bombay Gobhi — 8.25
 Cauliflower with potatoes, peas, and tomatoes
 - Mattar Paneer — 8.25
 Homemade cheese with curried green peas and spices
 - Aloo Paneer Masala — 8.25
 Cheese cooked with nuts and cream

Murg Curry or Chicken Specialties

- Chicken Mushroom — 9.50
 Curried chicken in onion, garlic and spices with mushrooms
- Chicken Sag — 9.50
 Boneless chicken cooked with spinach a spicy delight!
- Chicken Vindaloo — 9.50
 Boneless chicken and potatoes in a highly spiced sauce
- Chicken Tika Masala — 9.50
 Tandoori boneless chicken, in a tomato sauce
- Chicken Kebab — 9.50
 Tender chicken, gently broiled with delicate spices
- Madras Chicken Curry — 9.50
 Hot and spicy chicken from Southern India
- Chicken Jalfraizie — 9.50
 Chicken sautéed with fresh bell pepper, tomatoes and onions
- Chicken Korma — 9.50
 Succulent chicken in a rich almond and cream sauce
- Kadai Chicken — 9.50
 Chicken with sautéed vegetables & spices

Seafood Specialties

- Shrimp Sag — 10.95
 Shrimp cooked with creamed spinach
- Goa Shrimp Curry — 10.95
 Shrimp in coconut milk with mushrooms and herbs
- Shrimp Vindaloo — 10.95
 Shrimp and potatoes in a highly spiced sauce
- Shrimp Jalfraizie — 10.95
 Shrimp sautéed with fresh bell pepper, tomatoes, and onions

Lamb Specialties

- Lamb Mushroom — 10.50
 Spring lamb in curry sauce with mushrooms
- Rogan Josh — 10.50
 The perfect lamb curry, cooked with onions, ginger, garlic. Topped with almonds.
 - Lamb Sag
 Chunks of lamb in creamed spinach
 - Lamb Vindaloo
 Lamb and potatoes cooked in sharply spiced and tangy sauce
 - Lamb Jalfraizie — 10.50
 Spring lamb sautéed with fresh onions, bell pepper and tomatoes

THE CURRIED MANGO

Miriam Baker
Concordia University—Nebraska

Multiple pages permit the development of repetition and rhythm. The primary visual rhythm will be established by the repetition of design elements. Next, variations in stock, color, and texture can be identified with the different stages of the meal, marking the passage of time. Visual surprises and other enhancements to the conversation can be included as copy and as design elements. Break pages can be created to interrupt the primary rhythm and offer one of their own. Die cuts can expose portions of successive pages, creating a contrapuntal rhythm. The full visual effect can establish a pace that helps digestion and complements the restaurant ambiance.

The organization of information and visual effects must be somewhat predictable, so that the user's eye can find what it needs and the user's mind can make choices. After all, the menu is not the meal. The menu is only a prelude to the physical experience of eating, the intellectual experience of a stimulating conversation or interchange of personal thoughts, and the emotional experience of enjoyment.

▲ KEY IDEAS

- A menu is part entertainment, part catalog, part branding, and part information design.
- A menu is the initiating moment of presentation.
- A menu offers a value-laden moment of introspection.
- A menu must facilitate intimate conversation, shared secrets, and fantasies.
- A menu offers a value-laden moment of introspection.
- A menu must promise and please, satisfy and stimulate the appetite.

Product Labels

Labels come in all shapes and sizes: from three-dimensional point-of-purchase items to sales tags; from promotions for foods and beverages to product inventory codes. When they are visible, labels should be considered part of the marketing scheme. Sometimes they are purposely hidden or semi-hidden, but often they are just overlooked. To designers, labels represent yet another opportunity to enhance the quality of our visual life, to stimulate client-consumer engagement, and to ply our trade in innovative ways. The simple—and tiny—promotional stickers placed on fruits in supermarkets are but one of the ever-expanding opportunities for designers to broaden the range of possibilities for visual communication.

Labels must convey important information in a small space. Instructions for use, care, and replacement; warnings about misuse; information on nutritional ingredients; manufacturing lots; product numbering systems; and scannable bar codes are just some of the kinds of information found on labels. Product or company history, regional characteristics, related products, and other promotional information may accompany information on use and manufacture.

The first step in label design is to understand the full range of copy required and the goal(s) of the label itself. The label may be part of a larger branding scheme, or the product may be one in a series that requires a continuity of identity. The product may be innovative, and therefore the label must announce this important fact in small but noticeable ways. The format itself, as well as the material, will derive from the business goal, the copy, and regulatory requirements.

Label design must successful integrate previously established product identity and company identity. This includes, at the very least, the color palette and typeface choices that determine company identity, along with the company logo or other trademarks. On a broader scale, label design integrates design choices featured in related products manufactured by the same client.

Know the product or product lines thoroughly. Research the manufacturing, engineering, or growing processes and procedures. Find out about the component parts, the region of origin, and the kinds of people involved in manufacturing the product. Ask questions about conservation and sustainability. This information may suggest imaging, typography, color, and format.

The design strategy of the label will be to indicate, in both suggestive and descriptive terms, the contents of the packaging. The label should inspire confidence in (and desire for) the product, allude to the optimum results of its use, and appeal to the lifestyle, business, or entertainment choices of the target market(s).

Format and dimensionality offer distinct opportunities when a two-dimensional label is intended for use on a three-dimensional form. The designer must be aware of the possibility for image distortion and the tricks of viewing angles and *trompe l'oeil*. These kinds of chance events that occur when design comes into the three-dimensional world offer opportunities for humor and exaggeration that the two-dimensional world does not. Similarly, other kinds of visual accidents take place when packaging is lined up along shelves or in displays at retail stores. The repetition of design elements, the shadows and

lines cast by the packaging edges, and the exaggerations and reductions in depth that occur because of lighting or reflections offers unique challenges and opportunities. New inks and digital printing techniques offer relatively inexpensive methods to integrate lighting into your label design in ways that call attention to the product and enhance its presence in the chaos of retail marketing.

▲ KEY IDEAS

- Labels convey important information in a small space.
- The label design indicates, in both suggestive and descriptive terms, the contents of the packaging.
- Know the product or product lines thoroughly.
- Research the manufacturing, engineering, or growing processes and procedures.
- Ask questions about conservation and sustainability.

Questionnaires and Surveys

Research in graphic design is intuitive, and draws on skills of observation, reflection, and experimentation. Visual communication is not a science, nor does it have scientific aspirations. Designers focus on interpretive and emotive impressions, not hard data and measurable responses. However, there are times when such data is essential to a project—or it may simply provide an alternative view that stimulates inspiration and innovation.

Science requires that experimentation be objective and reproducible. Such objectivity may be impossible in graphic design. That means that our data need not be reducible to mathematical relations, nor must we use strict variable analysis to arrive at statistical probabilities and significances. However, knowledge of these methods of data collection and analysis are helpful, and it is always worth learning how to use them to your advantage.

There are, of course, less rigorous methods. They include interviews, observation, and familiarization with other design approaches. This is all first-person, irreproducible research, but designers do not need to build on a formal body of cumulative knowledge. What we do is, by definition, culturally constructed.

Nevertheless, it is a good idea to follow some of the steps that social and natural scientists use, to ensure that our data has value for our projects and that when we pitch our project to our clients we can substantiate our design strategies with verifiable evidence.

The first recommendation is that we take our studio working method and bring it with us into our research. Success in visual communication owes much to the interactive nature of our world. If we take only our client's viewpoint into consideration, we will inevitably produce work for which success can be measured only by the sales generated. When we bring the consumer into the equation, we situate our work in a broader cultural context of dynamic change.

Questionnaires and surveys should genuinely assess behavior, change, and decision-making. These cannot just be word-processed documents, copied onto plain bond paper and distributed to a target population. These are typographic design opportunities that derive from specific goals and strategies. Our goal is to stimulate participation.

To achieve a broad level of participation "buy-in," we need to acknowledge the value of our public and the importance of their responses. This means that we must convey our information in both manageable and appealing ways. We need to speak our market's language(s) and be sensitive to its relationship with data collection. In many cases, legal, medical, and business documents are designed to screen out participation by the uninformed. When we work in mass media, however, we want to bring data into our research from a wide audience. Therefore, we need to design research methods that are inclusive, respectful, and clear.

Our first choices come in determining compositional organization, typeface(s), and stock. Orientation, size, and mailing requirements will influence these design choices as well. It is essential that the design strategy be transparent and well defined. Will simple checkoff boxes appeal to our group's relationship with forms? Do we need to offer encouragement and space to provide more detailed and personal information? Will our stock choice say that we are high-tech, environmentally aware, high-profile, or tactile? Will our typeface say that we appreciate our audience's cultural history and their relationship to the printed word? Will it have to stand out against a background of media saturation?

Does our audience prefer tabloid-sized coated pages, small pamphlets, oversized postcards, or standard 8-1/2" × 11" forms that fold into a self-sealing envelope? Do the questionnaires and surveys have to be filled out immediately

and returned to a data collection agent on the spot, or can they be dropped into a secure receptacle later? Will they be returned by mail? Different strategies imply different relationships with our audience.

Does the organization of the questions and responses require a linear, step-by-step approach, or can the respondent move in a nonsequential fashion, answering questions here and there? What kind of attitude must the respondent take to complete the form? Must they engage the form in a prescribed, formal manner, or can they interact with the material in a less reserved way? Does it fit into their lifestyle? Does it ask them to step back from their routine and reflect on their choices? The organization of the copy and the size and orientation of the form itself will communicate your answers to these questions and establish a tonal and textural relationship with your audience. Be sure you design the one you want.

▲ KEY IDEAS

- Substantiate design strategies with verifiable evidence.
- Questionnaires and surveys should genuinely assess behavior, change, and decision-making within cultural contexts.
- Questionnaire and surveys acknowledge the value of market responses and convey information in manageable and appealing ways.
- Questionnaire and surveys create design research methods that are inclusive, respectful, and clear.

Charts and Graphs

According to Edward Tufte's *Visual Explanations,* (Graphics Press, 1997), the first recorded instance of information design in the modern sense is Jonathan Snow's "Report on the Cholera Outbreak in the Parish of Westminster," during the autumn of 1854. Dr. Snow plotted the deaths attributed to a cholera epidemic on a geographic grid of a particular area of London. He discovered that the preponderance of fatalities occurred in clusters around a specific public drinking fountain and that almost all the fatalities within the parish

could be traced to the use of that particular well. The chart, in full lithographic illustration, convinced the Board of Guardians of St. James' Parish that the well was contaminated. After they ordered the pump handle removed, the epidemic ended.

The "mapping" of information had demonstrated a causal relationship between the use of the infected well and the spread of disease. The visual presentation of this evidence convinced the civil authorities of its veracity and prompted them to take action that reduced the number of potential fatalities. Snow's illustrations saved lives!

Of course, not all information design can hope to save lives. But the challenge remains similar: the presentation of data in visually convincing ways that both accurately describe verifiable evidence and convincingly argue a point of view or a plan of action based on that evidence.

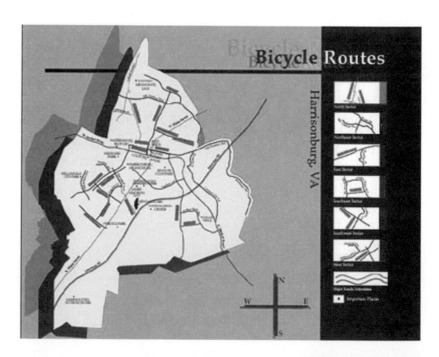

W. Stanley Conrad
James Madison University

Graphs present evidence or measurements of relationships between instances and show differences in relation to a set of assumptions. These visual analyses of data are very effective communicators. Individual instances can be presented in relation to one another and in relation to a norm. The set of possibilities is closed, and all instances are implied, even if they are not specifically represented.

Graphs tend to be vertical representations of data and interrelationships, whereas charts tend to use objects to depict quantitative information. Graphs can offer a closer visual link to the mathematics of plotting statistical data, thereby implying a more authentic relationship to the data. Charts may be more compelling: their use of drama, humor, or qualitative references permits secondary readings that can reinforce political arguments, financial decisions, or other assessments made on the basis of the visual evidence.

Although almost any arrangement of three-dimensional grids, symbols, or objects can serve as a chart or graph, the successful information designer knows that the believability of the evidence and the strength of the argument based on that evidence necessitate a context that makes sense to the viewer. As with any design project, research comes first.

Situate the evidence in a wider context. Look for the story as presented by the argument. The dramatic and historic quality of the narrative; the people, places, and things woven into the narrative; and the range of events it refers to can all suggest the design elements for charts and graphs. For instance, how would you chart the increase in the number of carbon dioxide molecules in the upper atmosphere over the past fifty years?

Production value is important in the depiction of quantitative data. Visual argument calls for color choices that are appropriate to the context, the content, and the consumer of the evidence. No color is neutral to your argument, and every color must be seen in relation to the colors around it. The choice of color palette for graphs will affect the believability of the data.

Typography is minimal, serving only to explain the general context of the data relations. Large blocks of explanatory copy should be relegated to sidebars with directional lines or other marks leading back to the appropriate portions of the charts or graphs. Typography should be reduced to describing the general unit values of the chart and graph objects. Typography that interferes with the visual depiction of data, either by calling needless attention to itself or by conflicting with the evidentiary nature of the graphs and charts, does not add value to the information design strategy.

Charts and graphs are designed to be taken in at once, with all details supporting the conclusion arrived at in the argument. Size, shape, content, and color must function simultaneously to convey the visual information. The emotive and poetic content derives from the conclusions of the argument, not from the evidentiary support. There is no meaning other than that created by the narrative content. It is this content that must be supported by the visual presentation of data. In this case, the message establishes the drama. The design plays a supporting role.

▲ **KEY IDEAS**

- Charts and graphs accurately describe verifiable evidence.
- Graphs present evidence or measurements of relationships between instances. Charts note differences in relation to a set of assumptions.
- Graphs tend to be vertical representations of data and interrelationships; charts tend to use objects to depict quantitative information.
- Graphs can offer a visual context to the mathematics of plotting statistical data. Charts may be more compelling in their use of drama, humor, or qualitative references that permit constructed readings.

Appointment Books

The appointment book aids in the planning and achievement of goals. It organizes time around tasks, which are, in turn, organized around people. It can be used for business or for personal goals. The object is to create a graphic space in which divisions of time (month, week, day, hour) can be used to record and organize the swirl of events, people, and plans that constitute the user's life. The appointment book records meetings and serves as a reminder, a planning guide, a means to visualize the use of time, and a time management tool. It can also be used as a give-away or as promotional advertising to stimulate sales or reinforce a corporate or institutional image.

The important starting place is to identify a theme that will enhance the value of the appointment book and will form a basis for structuring the design. Perhaps you have interwoven a horoscope theme or a sports calendar; maybe

you have embedded messages about gallery openings, famous persons' birthdays, movie trivia, or some other interesting facts. The theme can be abstract, illustrative, or just visually engaging. It can be part of an institutional identity program, an advertising campaign, or just entertainment. Without a theme, design elements will have no context. They are reduced to indicators of time units. Although this may seem sufficient, ignoring conceptual approaches does not make them go away. Without themes, the design elements imply primacy of the time unit rather than user value. This approach codifies an exterior value (time) without stimulating personal interest.

The project theme should drive the assemblage of design elements: fonts, colors, stock choice, illustrations or photographs, directions, and format. It is important to have the user's navigation through the different scales of time (year, month, week, day, hour) represented in the appointment book retain practical value and be easy to follow. Is the appointment book used primarily for weekday (i.e., business) events or for weekend and evening (i.e., personal) events? The answer to this will help determine format and size (desk or pocket size), materials, and space allocation per time unit.

Time management and use value will demand that moving up and down the scales of time be easy. Methods to enhance the flow of information, from hour to day and across week and month, are vital to the success of this project. Whether technology is used (such as upload and download capabilities, embedded chips, or e-paper), or whether visual elements and internal references are used, the design of the information flow across the units of time is central to the project.

The primary tools for this organization will be the internal grid system and the typography. Illustrations can tie the design together, add elements of surprise and fancy, and convey institutional or corporate identity, but scaleability across units of time will come from careful grid organization. Die cuts, tabs, half-pages, and other similar strategies can expand the grid to three dimensions, adding breadth and depth to the organizational solution. Typography must guide the user through the various scales of time, assigning certain typefaces to certain unit levels. Color can be used as well to indicate level or unit. It may well be that both type and color must coordinate in this effort to provide navigational reference points to the user at all times. Stock choice can further support this goal.

Various strategies can be employed to help make an appointment book a valuable organizing tool for the user. The theme elements identify the typical user. If the appointment book has a club theme, then the illustrations and

fun information must be directed at a young, single audience that needs far more space allocated to night hours and weekends than to business hours. Vice versa for the pinstripe, investment-banker crowd. But everyone needs to organize time and to achieve goals in coordination with others. Creating navigational tools and directional aids to effect this for diverse constituencies is the challenge of the appointment book project.

Hourly units must have enough space to write in. Monthly units must be easily accessible; weekly units must always be present. Thematic information may include general goals of time management for the user (club nights, dates, film festivals, sports events), even if the details of the appointment book become a record of obstacles in achieving these goals. Life getting in the way of fun may be the record that is ultimately left in the appointment book. This suggests a kind of "chutes and ladders" approach that might provide yet another way of organizing your appointment book.

An efficient approach to this project necessitates the creation of templates. An appointment book can include up to 365 day pages, 52 week pages, 12 month pages, or even finer scales of morning, afternoon, evening, and night pages for each day, or special weeks (vacations, holidays, trips, conferences, and so on). Rather than developing more than 400 separate pages, a more reasonable tactic is to create templates or models for each section, such as month, week, day, partial-day event, or other special section. The template approach provides many economies for this complex project.

Type choices (size, color, and primary, secondary, and tertiary typefaces) must help the viewer navigate through the information scales while indicating areas for personal notes, appointments, and commentary. Stock choices should enhance the divisions of information scales (weekday, weekend, morning, evening, break pages, tabs, and dividers, etc.). Samples can be included on presentation boards or the templates can be comped directly onto various stock. Die cuts, windows, and half-pages can be simulated without the expense of production.

The final requirement for this project is the cover. The cover introduces the theme as well as the textural aspects, color palette, and typographic strategies. It can also generate interest and hint at the advantages offered by the information organization, thematic content, and innovative approaches of this particular time, task, and event planner. The cover provides a gateway into the world of time management and task prioritization.

▲ **KEY IDEAS**

- The appointment book aids in the planning and achievement of goals.
- The appointment book can be used as promotional advertising to stimulate sales or reinforce a corporate or institutional image.
- Identify a theme that will enhance the value of the appointment book and will form a basis for structuring the design.
- Use a structure that enhances the flow of information, from hour to day and across week and month.
- Create navigational tools and directional aids for diverse constituencies.

Calenders

The calendar is a challenge for any graphic designer, not so much because it is a complicated, visually exciting project but precisely because it is not! You will not be able to invent new months or other configurations of time—but you can be inventive! The calendar itself is a physical object that sits in a physical space. It can hang on a wall, sit on a desktop, be carried in a pocket or a purse, or be printed onto a bed sheet, shower curtain, or mouse pad. Your calendar can be both an information design project and a three-dimensional product design as it incorporates the space of its environment into its design strategy.

Calendars serve many purposes. They depict an organization of time that is useful and predictable. They help us plan our tasks and reinforce our network of relationships (though reminders of birthdays, anniversaries, and other important events in the lives of our friends and loved ones). They can also help decorate an environmental space by the use of thematic material such as photographs. They can promote a business, institution, or corporation in a direct way, by depicting products or services, or in a less direct way by reinforcing an image or brand. A paper company, for instance, might use a variety of its most popular stock for the calendar and only mention its corporate name in passing.

After the preliminary research is done, start by determining size and format, typeface and color palettes, and a general organizational approach. These will

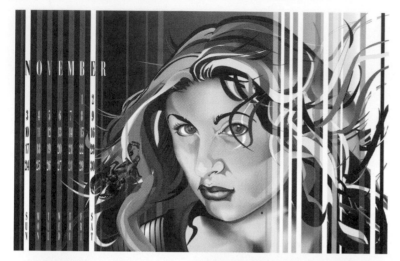

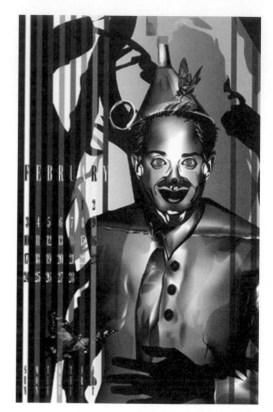

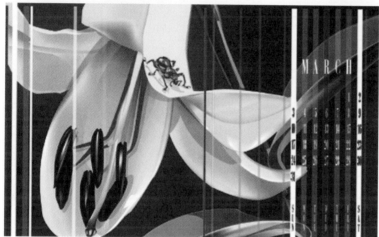

Alvina Khromova
Concordia University—Nebraska

derive from your thematic approach. For example, if it is environmental, you will need to preconceptualize the kind of environment that will "house" your design. Is it a wall hanging? A desktop feature? Is it portable?

If it is decorative, you will have to research your target consumer market. Are you addressing sci-fi buffs; techno-savvy browser babies; teenagers who need to remember all sorts of personal information about their ever-growing and highly volatile friendships?

If your calendar is promotional, you will have to research your client's strategic goals and integrate the calendar into the branding campaign. Refer to the client's design manual, and identify the business goal.

Carl Fay
Concordia University—Nebraska

Rachel Ziegler
Concordia University—Nebraska

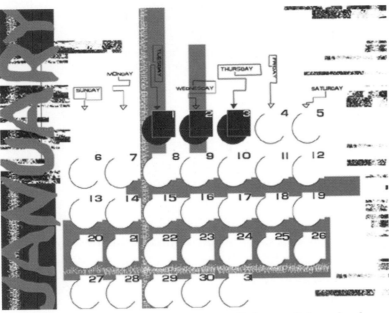

Rebecca Schnackenberg
Concordia University—Nebraska

If the calender is a design showcase, it must reflect the firm's approach to design. If the firm is has a minimalist approach, you will need to do a lot with a very limited color palette and font set, while you create innovative approaches using stock choice and environmental concerns. If the firm uses a more dramatic approach to design, you will have to create a highly stimulating pictorial strategy that tells a motivational story. If the firm specializes in signage or product or exhibition design, the calendar project might be approached as one of the firm's three-dimensional products. If the client is a new media firm, the calendar could incorporate an interactive, nonlinear strategy.

▲ **KEY IDEAS**

- Calendars can advertise products or services.
- Calendars activate an interior space by the use of thematic material.
 — If it is environmental, research the kind of environment that will "house" the design.
 — If it is decorative, research the target consumer market.
 — If it is promotional, integrate the calendar into the branding campaign, reference the design manual, and identify the business goal.
 — If it is a design showcase, research the design studio's style.

Timelines

A timeline measures the passage of time as a linear progression of events. It discards the abstraction of the calendar grid, and in its place uses pictorial elements indicating a flow of time, punctuated by periodic events. The subject of the timeline determines these events. For instance, suppose our subject is the "History of O." The invention of the wheel, the invention of zero, the construction of the Roman Coliseum, the invention of the compass, the development of the traffic circle, Pauline Reage's book, *The Story of O,* and the Wheel of Fortune could be events indicated along a linear flow of time extending from prehistory through contemporary time.

In a timeline, the relationships between the periodic events are implied. This leaves the viewer free to invent these connections, or demands that additional information be provided so the randomness of the events depicted is explained in a context that clarifies their positions along the timeline. To continue our previous example, the events mentioned have nothing to do with one another, although they all refer to a circle in some way. Explanatory text might make the relationship clear and form the basis for meaning. The timeline would then supply a visualization of that meaning by marking the relative place of each event in the flow of time over 5,000 years.

It should be clear that a timeline cannot by itself supply the meaning or explain the relative positions or relations between the periodic events depicted. An explanatory context must be supplied as well. This may be a simple key or a complex narrative. Successful timeline design will incorporate this narrative

explanation in innovative ways that complement the pictorial elements of the timeline and the compositional arrangement of these elements.

Typography plays an important role in constructing the visual context within which the timeline is read. As in all successful typography, an interesting and effective grid within which to develop both the typographic strategy and the pictorial composition is essential.

The prime visual element that will organize the compositional thrust of the timeline design will be the direction and orientation of the timeline flow. Does your timeline "flow" vertically, horizontally, or at some angle to the rectangle of the page? How can your grid of pictorial elements and type supply a secondary design strategy that complements this flow? Should you orient your design at right angles to the direction of the flow, parallel to the flow, or at some other angle? What design strategies will be most consistent with the meaning of the timeline, make it easier to access, and create the visual dynamics appropriate to the context?

These questions can be answered in your thumbnails. Make them as detailed as your drawing technique will allow. Be sure to keep the visual elements in relative proportion to each other and to the page size you will be working with. Work in monochrome in the beginning. Color may add a level of complexity prematurely. The compositional approach and the development of an appropriate grid come first.

Color will add depth and character and establish a visual context. If the timeline is part of an annual report, the design manual will mandate specific color choices. If it is part of a text, there will be an overall design strategy for color use. If the timeline is a stand-alone wall hanging or fold-out book, the range for color choice will be larger but the goal is the same: to create a visual context that enhances and supports the meaning of the timeline.

The second concern is the timeline itself. The color choice here must support the structure of the line: single strand, multiple strands, dotted lines referencing units of time, and so on. This means that the range of hues and saturation available will reference and support the meaning of the timeline while reinforcing the compositional decisions about flow and direction.

The color(s) of the pictorial elements must complement the first two choices, so that the elements both stand out from the timeline and refer one to another in ways appropriate to the meaning of the timeline. Perhaps your timeline is intended to indicate the evolutionary development of an anatomical

part. One strategy would be to use the same highlight color to indicate this part in a series of pictorial elements that were otherwise constructed with subdued hues, in keeping with an overall earth-tone approach and a timeline of multiple strands constructed with richly hued browns, purples, and greens.

An interesting alternative to a linear timeline might be a matrix with branching structures developing from a general linear movement or a complex spiraling. If the information designer has the opportunity to influence the design of the flow, then he or she must conduct some scientific research to determine an arrangement of time that conveys the meaning of the data. Although we are used to the linear abstraction of the "march of time," contemporary evolutionary theory, physics, cosmology, and social theory all point to a far greater complexity in the interrelatedness of events. Linear approaches imply a causality that is often dubious or even erroneous. Multiple branchings, spiraling expansions, strange attractors and Red Queens, fractal structures at the macro- and microscopic levels all offer interesting alternatives to linear arrangements. The information designer must work closely with the creator(s) of the raw data, the authors and editors of the explanatory text, and must bring to the table alternative approaches that convey more precise meaning and create more effective visual communication.

Edward Ludington
University of Wisconsin La Crosse

▲ KEY IDEAS

- A timeline uses pictorial elements indicating a linear flow, punctuated by periodic events.

- Construct a context that explains connections and the relation of events.

- Timelines incorporate narrative themes in innovative ways that complement the pictorial elements on the timeline and the compositional arrangement of these elements.

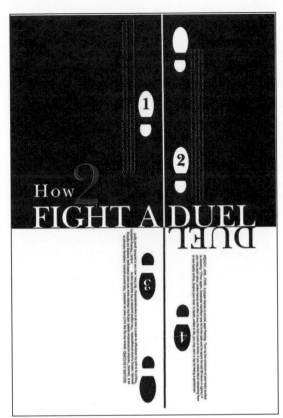

Stephen Sanderson
Metropolitan State College

Flow Charts

Flow charts derive from industry (chemical, mechanical, energy), from nature (evolution, erosion, currents), and from culture (demography, geography, economy). They distinguish units of progression and call attention to the interdependence of states of change. They map transitions and record or predict the development from one state to another.

The information designer must seek to understand the background conditions, as well as the order of discrete states, causal relations, and transitional states, in order to develop appropriate choices for orientation, format, symbol system, typefaces, and color. Historical conditions might argue for specific pictorial or typographic references. Economic conditions will affect the choices of symbol systems or key codes. Natural and industrial processes often derive from causal links to larger systems. Establishing visual reference points beyond the elements of the flow chart itself adds dimension and context.

Format, size, and orientation must take into account the use value of the flow chart. Is it part of a technical manual? Is it a stand-alone wall hanging or a pocket-sized field guide? Does it have to accommodate additional objects, such as pushpins or other markers that change position over time? Must it be inexpensively reproducible, or can it be a lavish, one-up digital print job?

Color palettes should emphasize the specific points of the flow and visually prepare the viewer for the transitional states. Breakout sections and text boxes can convey additional information about processes and technical procedures. Typeface choices should be consistent with the direction and pace of flow; secondary font choices can reinforce the contextual references.

Production value must correspond to use value. If the chart is a "how to" guide, inks and stock must accommodate rough handling and unpredictable weather conditions. If it is a specialized guide used in specialized conditions, the production value should accommodate the work environment, from pristine scientific labs to busy auto repair shops.

▲ **KEY IDEAS**

- Flow charts distinguish units of progression and call attention to the interdependence of states of change.
- Flow charts map transitions and record or predict the development from one state to another.
- Understand background conditions, the order of discrete states, and causal relations to make appropriate choices for orientation, format, symbol system, typefaces, and color.
- Establish visual reference points beyond the elements of the flow chart itself to add dimension and context.

Way Faring

Information mapping, or *way faring*, derives from cartography. The territory has now expanded from the geography of the physical world to the multidimensional world of interactive information systems. *Wayfaring design* is the creation of graphic strategies that propose navigational aids to understanding and assessment of non-linear but essentially sequential information. Way faring provides information on directional flow through systems. These systems facilitate the achievement of diverse goals while simultaneously offering alternatives.

Subway systems facilitate a myriad of user goals and offer opportunities to explore alternate routes. A highway system offers multiple means to multiple ends. Tourist books offer guidance in achieving various educational, entertainment, or business plans during travel. Directories list information that helps users make choices between competing products and services. Technical manuals facilitate the acquisition of skills.

Way faring is intended to help users navigate through a range of information. The goal is to find and use the information presented to achieve specific tasks. An intriguing aspect of this is that as users achieve those tasks, their goals may shift. The information gained may generate broader questions that necessitate larger goals. The wayfaring system, must thus plan for a developmental aspect of scaleability.

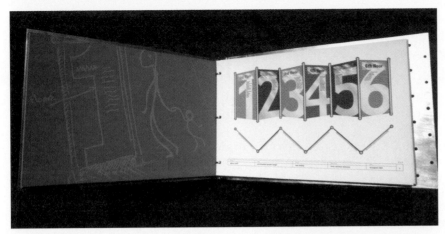

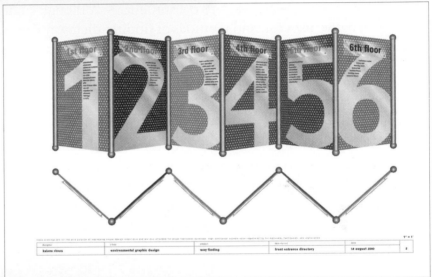

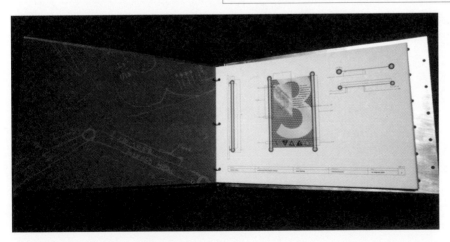

Kalene Rivers
Rocky Mountain College of Art and Design

Whether the wayfaring system is a college curriculum or a product catalog, a sequential or a nonlinear progression, a Web of alternative choices with feedback loops and successive scales of linkages, the initial starting points and initial use value must be broadly determined. If there is only one specific goal or use for the system, the project resembles a flow chart or a timeline rather than a wayfaring system. A wayfaring system must be defined from the multiple goals of its users.

The first step in designing a wayfaring system involves understanding the processes, levels, and goals represented within the system. We will use a college curriculum as an example. Students come into the system with different levels of preparedness, enthusiasm, and financial resources, yet the curriculum is set by local, regional, and state practices, societal goals, institutional history, and the will of the college's various constituencies. Although students will have many alternative uses for, and methods of finding their way through, the curriculum, graduation is a shared goal. This is a system that defines itself by its own end. Of course, student services, financial aid, and other procedures will offer feedback-loops and stop-out procedures, and some of the users will leave the system prematurely. Yet, overall there is a definable sense of progression through the system (freshman, sophomore, junior, senior levels), with changing alternatives offered at various levels (prerequisites, electives, required courses, declared majors, and competency examinations). The general goals achieved at each level can be identified (courses, grades, credit accumulation).

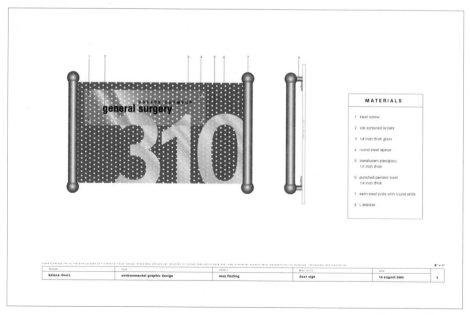

Kalene Rivers
Rocky Mountain College of Art and Design

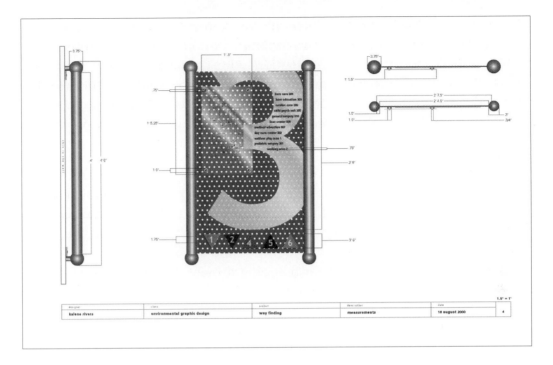

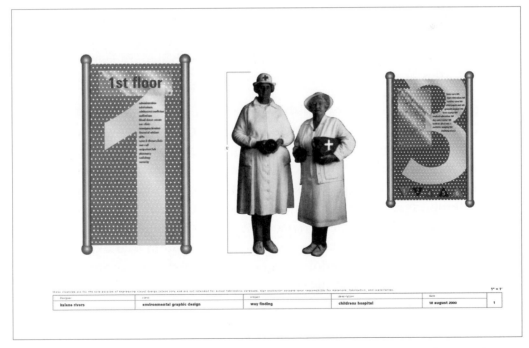

Kalene Rivers
Rocky Mountain College of Art and Design

The next step is to identify obstacles to the attainment of user goals and the solutions offered by the system. To use our example, what might impede or stop a student from attaining graduation? Alternative sequencing, scenario planning, and task management strategies have to be built into the system and indicated in the design. Links to outside systems that offer alternative opportunities and productive courses of action will reinforce the use value of the system.

The wayfaring symbol system will reflect the historical, technical, social, and cultural preferences of the user groups. If the pictorial language is beyond the life experiences of its users, the system will seem distant and ultimately be useless. The color palette and typography will form the basis of the pictorial language, but photographs and stylized illustrations, numbering systems, key codes, and other mapping devices must also convey meaning within a larger cultural environment.

One key to way faring is to let the user find his or her own way, while providing all the information and navigational tools necessary to achieve his or her goals. Consistency of "level identity" is crucial. Contextual points of reference must provide navigational reassurance. This can be accomplished by color choice, typography, and symbolic codes. Breakout sections, sidebars, and other methods for providing important information that disrupts level consistency must be developed. These design elements should be internally consistent as to color and typeface choice, placement and pictorial tone.

A structural grid must be established. This grid, in the initial thumbnail stage and again in the early stages of computer design development, may be broken out by level into a hierarchical arrangement. Be sure to trace links and connections so that these level substructures do not evolve in ways that make the project impossible to put back together. Unless your system demands an "exploded" view, you will eventually want to bring all the layers back into a single perspective so that the users can always find themselves within the matrix. Developing a grid system that expands along definable points of intersection is a good way to refine pictorial language while creating a single graphic space.

> ▲ **KEY IDEAS**
>
> • Way faring proposes navigational aids to understanding and assessment of nonlinear but essentially sequential information.
>
> • Way faring provides information on directional flow through systems.
>
> • Way faring facilitates the achievement of diverse goals while simultaneously offering alternatives.
>
> • The wayfaring system must accommodate feedback and incorporate scaleability.
>
> • Way faring visualizes the processes, levels, and goals represented within the system.

Gameboards and Games

A game project offers a good metaphor for the design process:

Game objective	⟷	Business objective
Game strategy	⟷	Design strategy
Method of play	⟷	Visual hierarchy
Game pieces and board	⟷	Design elements

The objective is the preferred outcome, in both gamesmanship and design. To achieve that objective, research, thought, and experience must be refined by practice. Various "gambits" (i.e., thumbnails) can be visualized in the mind's eye, then rejected, enacted, or refined. The objective is generally simple: to win. But the strategic approaches to achieving that end require constant refinement and development. A design strategy is a best-case scenario that always benefits from further testing and development.

The game objective is defined by cultural narratives operating within the population that plays the game. Leave room for social interaction, humor, sexual innuendo, competition, anger, jealously, and the like. Game play is a microcosm of social practices. Choose the ones you think are important, predictable, or appropriate, but leave room for unexpected scenarios.

After the objective is established, think though a number of possible principal scenarios that derive from the objective. Do not forget to research these scenarios. Find examples in history or in current events. Look for causal links, but also for less obvious interactions. Systems will transform in unexpected ways and not always where you are looking.

Having charted a number of major scenarios related to the objective, develop methods of play that will allow these scenarios to develop, mature, and achieve the game objective. Historical or geographic references are good signs for the game players. Projects of cultural significance can stimulate interest in the target market by forming thematic bonds.

Review your objectives, scenarios, and methods of play, and develop or refine game pieces and the gameboard in ways that reinforce the objective. Establish a method of play that can adapt to the main scenarios. Then further refine the game by playing it, developing sidebars and alternative strategies. Finally, develop obstacles to achieving the objectives by introducing alternative strategies, counterproductive-opportunity scenarios, and counterintuitive scenarios.

The gameboard and pieces combine two-dimensional and three-dimensional design approaches. The board itself is often a grid upon which a sequence of moves occurs in a linear fashion. There are certainly alternatives to this approach, just as there are alternatives to the grid of corporate communications and editorial design. Be sure your imaging reflects your method of play and reinforces your objectives. Navigation through, on, across, or around the board occurs according to the method of play. The pieces reflect your theme and accommodate the method of play. The board acts as the navigational structure.

Color choices, format, and typography must all be considered. They must always complement the game design but not overpower it. They should reinforce the theme and derive from the visual, cultural, and social experience of the players. These design elements contribute both to the selection of the game (serving a promotional function) and to the enjoyment of playing the game (serving an entertainment function).

Successful game design comes from an appreciation of the role of gaming in our lives. Stimulating emotional responses can be an exciting challenge. As in

all forms of visual communication, the consumer (in this case the player) completes the communication equation—the game strategy is only half of the equation. What occurs during and after the game, in the players' emotional responses to the events of the game, is as deeply connected to the game design as the objective. Will the play be exhausting? Provocative? Does the game develop certain kinds of verbal, mathematical, or visual skills? Does it appeal to jealously or love, sympathy or greed, destruction or invention? Does it force relationships or build on existing ones?

Games are serious emotional business because gaming permits the creation of personal interactions of highly focused emotional energy. Play them at your own risk!

▲ KEY IDEAS

- The game objective is defined by cultural narratives operating within the population that plays the game.
- Game play is a microcosm of social practices; choose the ones you think are important, predictable, or appropriate.
- Develop a number of principal scenarios that derive from the objective, but leave room for unexpected scenarios.

Signage Systems

Signs are all around us. Signs mark specific points in an information flow. They indicate transitions, intersections, and points of adjustment. They are informational devices that help people make decisions and achieve goals. Promotional signs stimulate behavioral or attitudinal change. Instructional signs identify stages in a process. Directional signs help users navigate through a system.

Jason Disalvo
Metropolitan State College

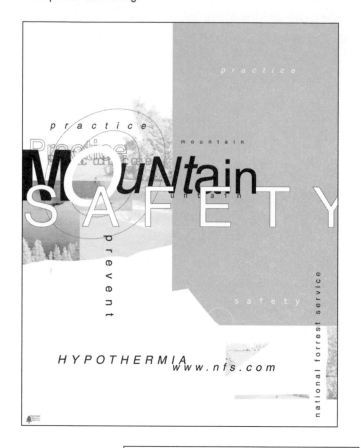

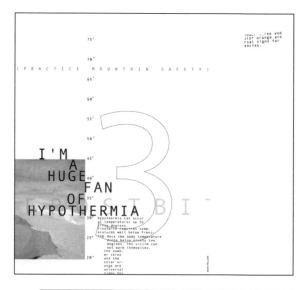

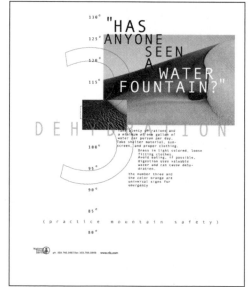

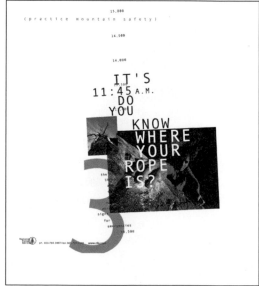

Signage systems are additions to an existing network, such as a transportation system, an inventory system, or an information system. They can also be supplements to an architectural space, as in museums, colleges, or malls. A careful study of the existing system, including its users and their goals, methods of access and egress, input and output states, transitional stages, and feedback loops, is required before design begins.

Building signage complements the architectural design strategies and materials and preserves the dynamic integrity of the site. Signage occurs in the important space where user interacts with building. It directs and informs, but it also integrates the physical experience of "place" with the emotional/intellectual experience of "purpose." Architectural signage also incorporates corporate and institutional branding characteristics and wayfaring devices. Special attention must be paid to materials and structural integration with the site. Architectural design strategies need to address three-dimensional concerns such as light, space, and material; lines of sight; transition points and framing devices; and program, plan, and spatial sequencing.

The design strategy has to accommodate multiple users with multiple goals. As in most information design projects, system levels will use a hierarchy of nested categories. Decide on a few, consistent design elements, such as color, shape, line, and type. These must be specific to the instances of the system while referencing the whole and fulfilling the client's needs.

Develop your signage so that each sign adds use value and ease of access. Start with a big system and break it down into the important moments in the flow. Observe what impediments exist to ease of use or to fulfillment of goals. Identify the patterns of use and the local and regional environment affecting and affected by the system; consult the regulatory agencies that make decisions about the system. Use the system yourself. Interview other users. Determine what parts of the preexisting system work well and which need improvement. Research similar systems and catalog the design elements.

Identify and document the colors, shapes, and directional devices in the system. Analyze the typography. Create new design elements in balance with the immediate environment and in support of the goals of the people who use the system. A successful solution will use shapes, colors, lines, and typography that can be expanded across all the possibilities of the system. Use colors that contrast effectively. Use simple copy and easily recognizable forms. These signage systems are usually read as two-dimensional spaces, and all principles of graphic organization (visual hierarchy, composition, and grid) are used.

Remember the context. A highway system has to be an effective communicator at 60 miles per hour. A museum signage system should inspire and inform in ways consistent to the tone and nature of the collection.

> ▲ **KEY IDEAS**
>
> - The design strategy for signage has to accommodate multiple users with multiple goals.
> - System levels will utilize a hierarchy of nested categories.
> - Design elements must be specific to the instances of the system while referencing the whole.
> - Create design elements in balance with the immediate environment and in support of the goals of the people who use the system.

Information Kiosks

Information kiosks come in many shapes and sizes, from your computer monitor to touchscreen walls. The important focus of such a project is to assess the information flow, identify the obstacles to that flow, and then design a display mechanism to redress the interruptions in the flow.

Establish an objective for your kiosk design. Information must be selected, edited, and put within a context to have meaning. At the most basic level, binary choices are still comparative choices (on or off, black or white, etc.) that must exist in a larger context (electromagnetic current in the first case or color in the second) to be useful, descriptive, or meaningful.

Information design organizes data within a use value system that sustains meaning and offers opportunities for interpretation, feedback, and corrective adjustments. This occurs through the creation of a program of sequenced, dedicated spaces; transitional moments; and vertical and horizontal flows. The basic steps of architectural design inform this approach.

1. *Establish the program.* This refers to the use for which the project is intended, including both the general purpose and the people who will interact with the system and make it real. It is functional and psychological; material and conceptual; poetic and structural.

2. *Select the site.* The information kiosk will exist in a specific environment: a small patch of land, an interior area, or a virtual space. Analyze the impact of the broader cultural and historical environments on the local environment. Consider issues of conservation and safety.

3. *Analyze the site.* Informal analysis: Look, feel, and observe. See who and why and how people use the site. Look for lines of approach. What elements can be altered or removed? Which ones cannot? Which ones can be accentuated, hidden, or revealed through specified approaches?

 Formal analysis: Notice the patterns of local light, both natural and artificial. Analyze the organization of space and circulation flows. Focus on the extant colors in foliage and building textures. Move from the small detail to the large overview and back again. Review topographical maps, city planning maps, aerial views, and other visual records of the site.

4. *Analyze information flow.* If all the required information were available at all times, there would be no need for your kiosk. Implicitly, then, there are obstacles to reading and understanding the information your kiosk represents. These may be physical; they may be cultural; they may be technical. Find out why the information that is to be accessed from your kiosk is not readily available. This will suggest innovative display methods.

5. *Develop a plan.* Create a system that can adjust itself in infinitely small ways as well as in larger, more dramatic ways. Develop feedback loops for the information design. Do some scenario thinking and role playing. Design a system that functions on incrementally larger scales. Based upon the multiplicity of flows at various scales, an organizational shape will begin to emerge.

6. *Create display design elements.* The display itself will develop from the organization of the information flow. Architectural elements will craft the spaces of the design. These elements bring the three-dimensional world of the site and display into the two-dimensional realm of the information design.

The 3-D world of space offers specific kinds of design opportunities. They include directional elements such as the axis of orientation, overhead and base planes, and circulation. The visual elements refer to views and vistas, framing devices, and transitions. The physical elements are materials, light, atmosphere, and shape.

Axis and orientation derive from the site itself. The kiosk integrates into a larger whole and yet has its own consistency and presence. Circulation flow and the horizontal and vertical dynamics of the site should be addressed in relation to the information flow when you begin developing directional elements.

The physical elements in and around the site and at the edge of the kiosk itself are the local and regional environments within which the system is to be useful and have meaning. To this, add format, color, typography, and graphic space of the display screen itself; then the transitions through the information architecture and the full range of this information design project will begin to suggest themselves.

▲ KEY IDEAS

- Assess information flow and the obstacles to that flow, and then design a display mechanism to redress the interruptions.

- Establish an objective for your kiosk design. Information must be selected, edited, and put within a context to have meaning.

- Information design organizes data within a use value system that sustains meaning and offers opportunities for interpretation, feedback, and corrective adjustments.

- Develop a program of sequenced, dedicated spaces; transitional moments; and vertical and horizontal flows.

- Use the basic steps of architectural design: program, site selection, site analysis, information flow, plan, and design.

Professional Perspectives

Stephen Pite
Program Director, Graphic Communications
The Katharine Gibbs School, New York

On Image and Type

The purposeful use of text and image to promote goods and services has always been at the heart of graphic design. Although these business goals tend to be defined from the client's point of view as an investment in product development, an overhead cost, and/or a marketing plan, graphic design is truly effective only when a client's goals are brought to consumer markets.

When we view design uniquely from the client side, we measure its success as a communication medium only in terms of the economic advantage it affords to the client. Successful design in this view is design that promotes the purchase of specific goods or services or that expands a client's market share or position. Though this effect is undoubtedly important, it is not the sole value of design.

Designers have long recognized the role of the consumer in the design process, but we need to ask deeper questions about how interpretive value, the psychology of identity, and the intersecting cultural contexts in which a mediated transaction takes place can be incorporated into our design strategies. The globalization of product production and distribution, and of the accompanying financial services, has produced massive changes in client-consumer relations. Industry now looks to consumer desire first, and then seeks to produce the goods and services that will fulfill this desire. Niche marketing and consumer choice are now the key ingredients of any successful marketing campaign. This pattern of transformation is no more apparent than in the objects of mass media. As design has taken an increasingly dominant role in today's communication media, concerns about its sources, content, and contributions have emerged. The growth of graphic design from a technology to a discipline may be the most important cultural phenomenon of the early twenty-first century. Our emotive response to visual communication has been

expanded to a global scale, deeply transforming traditional approaches to typography and imaging. This transformation is so thorough and so pervasive as to require a new pictorial vernacular that portrays the architecture of graphic space.

No longer is type confined to legibility and the representation of information. It is energizing and imaginative; it has become image. There is a curious connection between the evocative symbols of ancient cave paintings and contemporary typography that rejects rationalist design in favor of playful mystery and purposeful omission. Gone is the prescription that typography serve legibility first. The new typography reaffirms a past of mystery and interpretation by creating an interactive, constructionist site of meaning.

Today's typography embodies meaning but does not convey a uniquely prescribed version of truth. It reaffirms that information becomes recognizable only in context and as realized through design elements. Type must now define sites of transition between meanings, negotiate zones of visual difference, and communicate message. Type is infused with a programmatic purpose and determined by a contextual framework. Its efficiency is achieved through enhancement, drama, and mystery. Typography is an architecture in two dimensions. It actualizes graphic space and suggests an interplay of context and content. It organizes the visual environment of the transactional message.

The transformation of typography has been accompanied by a transformation in the role of image. The transition from advertising's "Big Idea" campaigns of the 1970s to design's "Big Message" programs of the 1990s corresponds both to client-side marketing techniques and product development and to consumer-side psychologies of identification and desire. But the change is both older and broader than a stylistic shift in advertising and design positioning. Word and image have negotiated for position in communication strategies since the beginning of human time.

The two elements of graphic design—words and pictures—create the editorial space whose content is derived from intention and synthesized interactively. As type becomes image, image takes on a more didactic function. It creates context and therefore meaning. Image creates a platform for message; it sets the tone and establishes the mood. It encourages diverse readings while setting loose parameters of meaning. It offers the opportunity to traverse the borders of strict target marketing, to redefine relationships, and to reaffirm the globalization of culture.

Images now serve as texture and tone. They establish zones of interpretation. They fix the parameters of permissible communication. Without the contextual meaning provided by images, typography is reduced to a compositional element, a static and decorative conveyor of message. Images have become layered and multidimensional. They satisfy by implication, suggestion, seduction, and pleasure. They distinguish time and place, reinforcing the concept of moment for the viewer.

These image-messages and word-pictures are conceived and consumed globally, signaling a new pattern to our visual language and shifts in the cultural conditions that contribute to its communicative efficiency. Our dramas now transcend national boundaries. Our stories share the codes and conventions of a world people. Ours is a new moment in graphic design.

chapter six

Three-Dimensional Design: Point-of-Purchase, Display, and Package Design

New digital interfaces—the stuff of advanced computer science programs and robotics—offer exciting opportunities to think about the way the structured interplay of multiple-sense stimulation will develop through the thoughtful praxis of design as this century unfolds. In the meantime, thereare already many everyday experiences where design has brought together the graphic and the physical into a symphony of designed experiences in real time and across four dimensions.

Three-dimensional design is more than just an extension of the graphic space of a flat page. Designing in three dimensions means joining graphic design with the physical experience of packaging and display in a human-referenced scale. All the physical experience of 3-D design is calibrated to that scale. The object/human interaction is defined in terms of both use value and product identity, but is adjusted to a human scale so it can be accessed. This distinguishes it from architectural design and aligns it more closely with product design.

Package and display design tends to have a short life. Its job is to enhance and extend the quality of the human interaction with the product. Packaging and display are promotional, and serve business goals in much the same way print promotion and advertising does—but now, we can add scale and physical dimension to the design strategy.

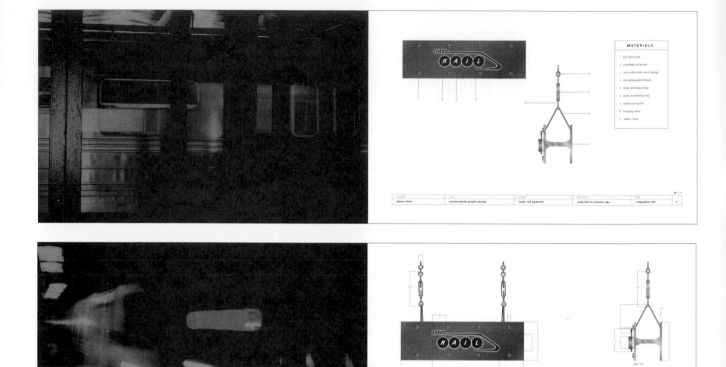

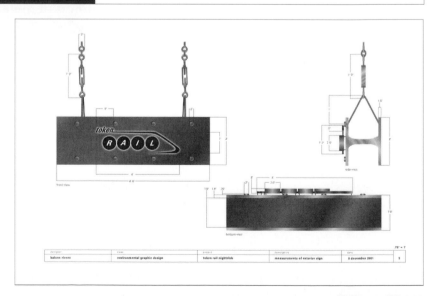

Kalene Rivers
Rocky Mountain College of Art and Design

Food and Beverage Labels

Almost every food and beverage item fits into a family of products, services, and brands. However, each product must have a unique identity, at least in the consumer's mind. This is where labels come in (see also, Chapter 5, on product labels). Labels serve an information function, complying with regulatory and inventory requirements such as ingredient listings, bar codes, and safety warnings. This information is generally allocated to a small area of the label and limited to very simple typography. The textual information often seems so foreign to the label design itself that it is overlooked. This seems to indicate that the consuming public is happy to ignore or discount design that does not "fit." This interesting phenomenon speaks volumes about the nature of design and its appreciation in the marketplace.

Sandra Couture
Tunxis Community College

The primary design issue consists of creating the product identity and enticing the pleasure palette of the potential consumer. Creating a product image of unique qualities, in addition to messages of safety, conservation, and economy, is the design strategy of the food and beverage label.

The consuming public is often wary of a corporation that produces massive numbers of brands, but accepts—indeed, embraces—the identity of a single product. Once the product has successfully penetrated the market, it no

Susan Alderman
Tunxis Community College

longer matters that is part of a large product line; its own identity is established. In contrast, if a new product is added to an already established product line, a unique presentation that uses the corporation colors or logo asserts both the uniqueness of the product and the track record of the brand.

Specific design elements for labels will include logo (often an illustrative abstraction of some particular quality of the product), size, shape, inking effects, and typography. Size and shape are unique to the label, inasmuch as labels are constrained by the actual size of the product and the typical human interaction with it. For instance, a wine label is limited by the size of the bottle and by the typical method of decanting the product.

The illustration and typography must work hand in hand. The graphic space of a label is rather small. There is no room for layers of graphic effects or for interchange of rhythms and tones. A close integration of typography and illustration is essential to creating enough visual impact to get the product off the shelf and into the consumer's shopping cart.

Hangtags and Display Signage

Point-of-purchase (POP) design combines so many elements of design as to constitute its own discipline. In fact, many of the designers who work in this area specialize exclusively in its unique conflation of environmental, architectonic, and informational concerns. POP design method requires breaking

▲ KEY IDEAS

- Food and beverage items fit into a family of products, services, and brands, but each product has to have a unique identity.
- Labels establish product identity.
- Labels promote unique product qualities, safety, conservation, and economy.
- Labels provide regulatory and inventory information and identify ingredients.

down these three areas and developing design strategies that speak to each yet come together as a whole.

In point-of-purchase design, the designer must remain constantly alert to the site-specific aspects of the display, the requirements of the consumer/producer interchange, and the necessity for clear directions that attract and inform.

Display signage offers some design opportunities similar to those encountered in the monumentalist approaches of billboard design. The signage must function within a busy visual environment, and stand out from it as well. Visit the site; conduct some site-specific analysis of traffic flow, the types of consumers, and consumers' movement patterns through the local environment. Conduct some informal surveys and find out how customers are making movement decisions through the store. Do the decisions reflect predictable consuming habits? Are the shoppers "surfing" through the space? Are they goal-directed and focused intently on acquiring their merchandise with the least possible interference? Do they want to move from one area of the store to another within a consistent physical/visual environment, or would they like to know—in clear and certain visual and physical terms—that the merchandise section has changed?

Jennifer Russo
Tunxis Community College

Change your perspective frequently. Look at the flow from up above. Walk through the store or set up in a single space and videotape the walking experience from different camera levels. Watch traffic patterns develop by studying the bank of security cameras that brings the whole store into view, and so on. Change perspective and you change the visual information input. Change scale and you will see different patterns.

Of course, your display signage has to arrest the flow, so make your design consistent with the architectural and architectonic environment, and with the store display system, but also make it a clear departure from the visual environment that surrounds the focus of attention. Display signage should direct and inform, but to do so it has to stand out from the clutter of the visual environment and make a direct reference to the items waiting for purchase.

Color, typography, and the architecture of the graphic space of display signage are the three primary concerns of the graphic artist after a site-specific design strategy has been determined. The color and type will support the architecture of the graphic space in the same way that columns and planes configure interior spaces within an architectural design program. The term *architecture* here refers specifically to the interrelation of design elements and three-dimensional forms in the creation of monumentalist information, not the structural and construction concerns of creating the signage.

Strength should be achieved through simplicity; navigation through targeting; decision making through reduction; reference through repetition. These are basic design strategies that can quickly direct the meandering or inquisitive consumer to the merchandise in question so that the transaction can be initiated.

The display signage will identify the space and the activity required to begin the purchase of the specific item. Hangtags will complete the information delivery and help the consumer make an informed decision to buy by offering additional but important and specific information (size, designer, ingredients or materials, cost, and so on).

Hangtags reinforce the design strategy of the display signage, miniaturize its design elements, and add critical information for consumer decision making.

This information must be clearly yet consistently presented within the grand scale of the signage, as well as within the corporate branding scheme. The display signage scale and the hangtag scale intersect, and should reinforce the interplay of design elements such as color, shape, and typography.

The basic idea is to get the information out clearly and effectively. This goal informs the information design of the hangtag. The designer needs to ask what information should be the focus of the emotional aspect of the hangtag: what is primary, secondary, and tertiary? This information hierarchy will flow from the intersection of the socially and emotionally determined self-image of the consumer and the economically and strategically determined self-image branding of the product producer. When these needs are similar, a business transaction can occur. If, for example, the consumer is looking for environmentally sensitive brands, and the producer has not made this a business priority, a match will be difficult. The hangtag information design should be based on accurate determination and strategic recognition of a mechanism that will offer an opportunity for a successful consumer/producer relationship. Choice of color, shape, texture, typefaces, and directional design elements will flow from this intended relationship and the information design hierarchy.

As a final thought, the hangtag can function as a visual fantasy in miniature, incorporating the special physical effects of three-dimensional design object, metallic inks, mirror finishes, and tactile experiences. However, it is the quality of the consumer/producer relationship, as defined by the client marketing team and branding experts and refined by the designer, that will determine the full range of the graphic choices. Keep the choices within the scope and scale of the architectural program that determines the structure of the display graphics as well as the specifics of the graphic design choices.

Sucessful point-of-view purchase design can help the viewer pleasurably negotiate the transitions from monument to miniature; from traffic flow to motion rest; and from goal-directed shopping to a more open, satisfying, free-flowing consumer experience that is based on the mutual fulfillment of needs, the reinforcement of brand, and positive decision making.

▲ **KEY IDEAS**

- Display signage is monumentalist.
- Display signage should direct and inform, and makes a direct reference to consumables.
- Display signage is site-specific.
- Design strategies include:
 — Strength through simplicity.
 — Navigation through targeting.
 — Decision-making through reduction.
 — Reference through repetition.
- Hangtags reinforce the design strategy of the display signage, miniaturize its design elements, and add critical information to help the consumer make an informed decision.

Cosmetic Packaging

Cosmetic packaging blends product design and signage. Product design creates the look and feel of the human/product interchange. By the use of specific materials, colors, and surfaces, cosmetic packaging glorifies the body by accentuating the feel of using the product and the potential physical improvements its use engenders. Cosmetic packaging is a celebration of the body.

Cosmetic packaging, from the graphic designer's point of view, affords an opportunity to enhance the product packaging in much the same way signage systems enhance architectural structures. What constitutes the essential message of cosmetics? Emotion, eroticism, imagination: these constitute the language of cosmetics. The design strategy then must extend and enhance this abstraction, using form, color, and line to achieve its goals.

Like food and beverage labels, typography and illustration intersect to form a tapestry of formal elements. Photography is distracting. It wakes the dreamer. Use exotic tones and shapely lines. Stimulate and seduce. Divulge nothing, but hint at everything.

Cosmetic products are highly identified with the manufacturer. They are part of a corporate branding campaign and the design elements are derived from the brand. There are also regulatory requirements to be met and other information that must be included. However, they are not as important as the information on products that will be ingested.

Three-dimensional design for a cosmetic line offers the possibility for a signage campaign in miniature. A color code and typographic treatment can be combined to present various levels of information, organized along conceptual themes that range from the practical to the dramatic. Such a signage treatment can be built around a lexicon of logos, color choices, and compositional elements that are scaleable and expandable. Research should focus on recognition of logotypes and other design elements to be sure the strategy will "speak" to the market.

▲ KEY IDEAS

- Cosmetic packaging is a celebration of the body.
- The essential message of cosmetics is emotion, eroticism, and imagination. The design strategy must extend and enhance this abstraction.
- Stimulate and seduce; divulge nothing, but hint at everything.

Specialty Products

Specialty products must speak directly to the unique desires of a niche market. Although these desires may change, they are not whimsical. They are consistent within local cultural preferences. The 3-D designer for these products must understand the niche market's desires and the historical and cultural underpinnings of those desires.

The bona fides of product lineage must be highlighted in specialty packaging and 3-D design. Reference to traditions, to lines of descent, to authorship and preeminence are translated into graphic elements through typography and illustration.

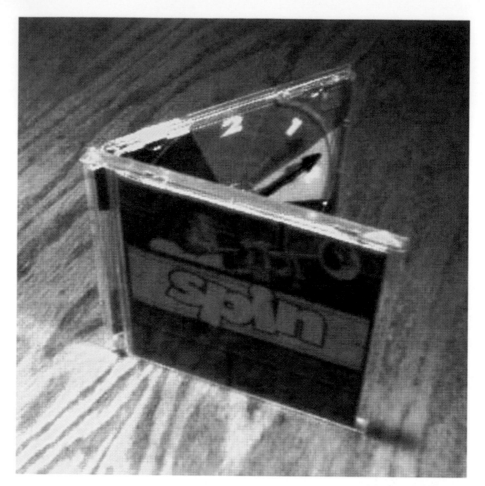

Jordan Hillyard
Metropolitan State College

Color, shape, and texture enhance the 3-D design strategy and provide context and framing devices for design content. The successful designer will collect old product catalogs, typefaces and pictorial references to bygone times. Unusual visual references to the past enhance the appeal and reinforce the lineage of the specialty product at hand.

Typography will be intimately involved in the branding of both the specialty product and the company that offers the product. In package and display design the primary typography is more like a logo. It conveys more image than textual information. It may hark back to a bygone time, or it may situate the product squarely in the path of future development. It may identify the product with a time period, a place, a literary character, or a cultural phenomenon, by using a well-recognized symbol or a personal icon.

▲ KEY IDEAS

- Consumer desires change, but they are not whimsical; they are consistent within local cultural preferences.
- Highlight product lineage with 3-D packaging.
- Unusual visual references to the past enhance the appeal and reinforce the lineage of special products.
- Primary typography conveys product image and identity.

Jewel Cases

CD design is covered in Chapter 2, on entertainment design. However, packaging is another aspect of entertainment design. Translating the "feel" of the art (whether it is music, literature, or film) into a tactile object designed to intrigue and stimulate the hand is a challenge.

The 3-D designer must take advantage of the numerous new—and old—materials available to prepare the moment for music. The feel of the CD lasts only for the brief moment that precedes the opening of the jewel case. It can, however, leave a lasting impression that echoes throughout the interest in the music contained on the CD itself. What is the nature of this brief but lasting moment? It is necessarily synthetic, like the entire physical experience of the CD. It is abstract like the feel of the music itself. Emotion is translated into layers of texture, light, and shape, appealing to the hand and mind alike.

The use of synthetic materials gives the designer an opportunity to reflect light by alternating glossy and matte finishes. Even without surface enhancements, the CD jewel case offers expansive opportunities for design when constructed out of paper products. Windows, pop-ups, and inserts can help extend the experience of listening.

▲ KEY IDEAS

- Jewel cases translate art into a physical event.
- Jewel cases intrigue and stimulate the hand.
- The physical moment is synthetic, but it can leave a lasting impression.

Shopping Bags

The shopping bag is a hybrid project, falling somewhere between a logo with interesting folds and a walking advertisement. It is the 3-D project that most resembles a two-dimensional graphic design. The design can be as simple as a company name and brand colors or as complex as a celebration of the entire retail shopping experience. It can commemorate a special occasion, a new product launch, a new retail outlet, a seasonal theme, or just about anything that expands the store's business and improves its visibility in the potential market. The point is to start with an open mind and look for opportunities to take this project to new realms of invention.

Assume that the shopping bag itself is sturdy, functional, and comes in a variety of sizes. Your design must be responsive to the material and scaleable. Focus on objectives. How can you help your clients achieve their business goals while increasing their market presence? Deciding on the appropriate theme for the target market is crucial. Remember, this shopping bag has to further the company's branding campaign and attract new shoppers to the store.

Shopping bags require a logotype approach. These are the equivalent of small monuments; the graphics must speak quickly and directly through color and strong type graphics. Photography can be used to enhance appeal only, not as story. Directionals such as lines, arrows, and bold graphics in complementary colors are more effective. This builds on the monumentalist approach and can add an architectural aspect to the 3-D space of the page. The hustle and bustle of consumer shopping, the level bags are carried at, and the rich collection of items consumers often end up carrying prohibit a long read of photography or copy.

Recognize that scale and point of view impact and frame viewer interaction with graphics. Visual communications depends not only on the visual language and cultural environment in which that language develops a recognizable syntax, but also on the physical environment in which the message is viewed. The angle of view, the range of the field of view, the distance from the viewer, and other physical factors affecting optics and line of sight are just as important.

Shopping bags have to be scaleable and cover a wide range of occasions and settings. Monumentalist graphics can be employed to excite the viewer because of the unlikely scale and angle. They should be designed in a modular strategy in which certain design elements can be "dropped out" and replaced

with a change of featured product, store address, or seasonal color scheme. Approach this as a series project, built around consumer-oriented themes, just as an advertising campaign unfolds over various media but always builds the brand.

> ### ▲ KEY IDEAS
>
> - The shopping bag is a walking advertisement.
> - Shopping bags require a logotype approach. They are the equivalent of small monuments. The graphics must speak quickly and directly.
> - Scale and point of view impact and frame viewer interaction with graphics. Consumer shopping prohibits a long read of photography or copy.
> - Shopping bags should be designed in a modular strategy. Approach this as a series project, built around consumer-oriented themes.

Gift Package

The gift box personalizes and protects, and to no small extent gilds the lily. The gift box follows the lead of its contents: it hints at the content form either through a window, or by graphically replicating the contours, or by the use of an image. It hints at value and builds on expectations through a photographic strategy or a specialized typeface. It brands through a color system or information layering that references other products in the line and the corporate image. Materials are unlimited except by budget and by design objective. Do not overimage. The use and enjoyment of the interior contents should be depicted, not displaced.

Gift packaging is designed to be thrown away. Consider issues of recycling and degradability, and familiarize yourself with alternatives to waste. You can use conservation issues to reinforce or even to reposition the brand as well, so there are sound business reasons to be environmentally conscious. These are always worth discussing with your client, but go armed with market research. Be sure you can quantitatively demonstrate that your market appreciates environmental conservation. Then find sources for appropriate materials and build the theme into the design of the package. The more successful your gift package design is, the more quickly the user will tear through it and get to the goodies inside.

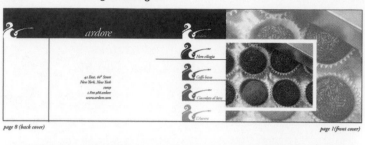

page 8 (back cover) page 1(front cover)

envelope

page 2 page 3

business card

back business card front

page 4 page 5

page 6 page 7

letterhead

Alvina Khromova
Concordia University—Nebraska

Gifts are celebratory. They mark an occasion, an event, a crossing. The gift package should be intimate and reflect personal achievement. Design should be modular, and a systemic strategy should be developed so that the design can be applied over a wide range of gift objects and to a wide range of occasions. The package should reference the company brand by incorporating its color scheme, logo, or other elements into the design strategy.

▲ KEY IDEAS

- Gifts are celebratory. They mark an occasion, an event, a crossing.
- Gift packaging should be intimate and reflect personal achievement.
- Gift packaging brands through a color system or information layering that references other products in the line and the corporate image.
- Gift packaging is designed to be thrown away. Consider issues of recycling and degradability.
- Design should use a modular and systemic strategy, applied over a wide range of gift objects and occasions.

Video Boxes

Video boxes for feature-length, theatrical release movies reference the promotional campaign of the film and protect the contents of the box. This, of course, greatly reduces the designer's ability to change the look of the video box, because the artwork and the material are predetermined. However, assume for a moment that this is a video box for an industrial or promotional film, and that there is no need to use a predetermined campaign that was part of a very successful film launch. Now what?

The video box should match the tone of the contents and clearly identify the company whose products are presented on the tape. The tone of tapes for ddisparate purposes will be significantly different, so the first thing to identify is the type of product, the business objective, and the target market. For example, a college promotional video serves a different objective from that of a software training tape, so design strategies will vary in tone and purpose.

This kind of video box project falls somewhere between entertainment and information design. The general public is now so used to the entertainment

design used for theatrically released feature films, and so accustomed to film's celebrity status, that it would be hard to design an industrial short or advertorial tape that did not include some basic entertainment design strategies. However, the viewer will be very disappointed if the entertainment design promises much more visual excitement than the video actually offers.

The design must convey a reassurance that the viewer can use the contents of the video to achieve a business or personal goal. The industrial, instructional, or promotional tape is intended for goal achievement, not entertainment. That requires strong type design that gets the requisite information delivered directly and efficiently. This can often mean minimal photographic imaging. The videotape box in this case is more of an enlarged business card, an integral part of a corporate identity, and an announcement that the contents can and will help achieve business or personal goals.

Of course, the relation of type to image will change depending on whether the goal referenced in the tape is a business or a personal goal, and on how and where the tape will be viewed. A personal goal might be the focus of a college promotional tape or of some other educational or self-improvement service. The tape is intended to be viewed at home. The design strategy would be personal and depict both the educational service and the personal transformation its use promises. Type will be engaging, direct, functional, and minimal. It will identify the service, be easy to read, be prominently displayed, and get right to the point.

These tapes are usually delivered through the mail, pusuant to a request in response to a direct mail or direct broadcast campaign, and may come with a good deal of promotional literature and other information products. The tape box should clearly identify the product and reinforce the goal-oriented nature of the tape. It will quickly become separated from the rest of the promotional material. If it serves its purpose, it will be viewed on a regular but declining basis for a short time, then be retired to the videotape library. Even there, its spine should continue to remind the viewers of its promise for personal growth.

ENTOMOLOGY INSECTS

MUSEUM OF NATURAL HISTORY
DENVER, CO

MUSEUM OF NATURAL HISTORY
DENVER, CO

Kalene Rivers
Rocky Mountain College of Art and Design

The business-oriented tape will probably be viewed in a more formal setting, perhaps as part of employee training. The packaging should speak of the reliability of the content, flavored with a bit of fantasy that implies just how pivotal the enclosed information is. The business should be identified clearly and the goal presented directly. This can be accomplished through the use of logos and minimal, but strong, photography. Typography should be minimal as well. Because employees will be required to view the tape, the type does not have to promote its contents; an executive decision has already been made to acquire and distribute the information. The back of the box can be used to list collateral information—but remember, if the audience is reading the back of the box, they are not watching the tape. Save this information for the collateral material, such as a pamphlet or a catalog that accompanies the tape.

▲ KEY IDEAS

- The industrial, instructional, or promotional tape is intended for goal achievement, not entertainment.
- The video box identifies the product, company, business objective, and the target market.
- Industrial and promotional videos are part of a larger advertising campaign.
- Industrial and promotional videos come with a good deal of promotional literature and other information products.
- The tape box must clearly identify the product and reinforce the goal-oriented nature of the tape.

Software Packages

Software package design incorporates huge amounts of both expectation and trepidation. It must reassure that the software is accessible, yet trigger incredible fantasies about what life enhancements this particular software can engender.

Software packaging takes information design into three dimensions. Develop a graphic structure in which information about the product, the product line, and the company is presented as part of a network of interlocking and reinforcing services. These would include technical support, upgrades, and user groups, as well as representing the product as one in a related suite of products that extend and enhance the use value of the one just purchased.

Software packaging usually has a variety of parts in addition to the outside package. There can be manuals, jewel cases, technical cards, advertisements, product catalogs, and registration material. The entire range of products that constitutes the "package" should be considered vital, interlocking pieces of the software package design.

First identify all the parts. Then develop an information system that will tie these parts to the software. Now expand the design and fully develop each piece. Then go back to the branding elements and be sure they still function as an information system. Be sure the color scheme separates sections and unifies the whole; that the typography is effective and clearly identifies the appropriate information level; and that these elements can translate across the various pieces. Graphic elements can be used as dividers and pointers, directing the viewer through the various levels of information organization. Develop an imaging strategy that puts the user into the picture. Be sure the photography is helpful to the learning curve.

The software packaging project can also be viewed as an interface design project. It incorporates a navigation strategy and an information architecture with a physical encounter that consists of a sequence of unveilings. Develop a series approach, one that incorporates graphic surprises that take advantage of the dimensionality of the packaging and the nonlinear time-based quality of the unfolding. The great fun of software packaging is that it is a nested series of pleasurable events.

▲ KEY IDEAS

- Software packaging incorporates both expectation and trepidation.
- Software packaging takes information design into three dimensions.
- Develop a graphic structure in which information about the product, the product line, and the company is presented as part of a network of interlocking and reinforcing services.
- Software packaging is a sequence of unveilings; a nested series of pleasurable events.
- Create graphic surprises that take advantage of the dimensionality of the packaging and the nonlinear time-based quality of is unpacking.

Professional Perspectives ◆

Laura Boutwell
Instructor
The Katharine Gibbs School, New York

The Freeway of Domes: Practicing (Information) Architecture for a New Renaissance

In the early fifteenth century, Filippo Brunelleschi (1377–1466) personified the pinnacle of the *ars* technician, the Renaissance Man, the inspired generalist, the practical philosopher, the artistic-scientist and scientific artist all rolled into one. In 1246, construction of the "Duomo" Cathedral in Florence, Italy, started; in 1419, the great church was still unfinished, because no one could figure out how to build a dome large enough for it. Enter Brunelleschi: he built the biggest dome in Christendom of its time—the equivalent of today's tallest skyscrapers—by translating the old classical hemispherical dome idea (which until then had been designed to be seen from within a structure) to a new, mathematically elegant octagonal superstructure, which was intended to be visible all over Florence (and in fact it still dominates the skyline). By pushing existing technologies in completely new directions, Brunelleschi made this dome the visual, historical, and gravitational center and symbol of the civic life of the city, and eventually the Renaissance itself. As if turning Florence and our notions of public space inside out were not enough, Brunelleschi then invented perspectival drawing by drawing lines onto a reflection of the dome—the medieval version of the invention of the camera.

The Renaissance Man (and they were, in that era, almost uniformly men) embodied the idea of the perfect intellect of a private citizen in the public service. For these paragons, and their philosophical descendents, life burst out of its religious delineations to embrace the human as the pinnacle of creation. Individuals and statesmen, rather than the Church, were the commissioners of art and science projects; at the same time, as an offshoot of perspective drawing, anatomical drawings were invented. We began, as a culture, to understand the physical makeup of things; to know the sum of our observable parts; to understand the architecture of a thing rather than entrust that knowledge to an unknowable deity. The concept of "public space" had, up until the Renaissance, been largely religious or vernacular—but the Florence cathedral was an invitation to all to come and marvel at humanism and technology together.

With the ability to draw spaces and objects with "photographic" verisimilitude, artists were able to turn the light of perspective on humanity: three-dimensional humans in urban contexts rendered in to two dimensions. For the first time, artists could use formulas, drawing conventions, and an evolving language of form and composition to represent town squares, piazzas, and meeting rooms full of people, often doing allegorical double duty but always buzzing with life. The neglected Greek and Roman ideals of *civitas*, urbanity, and the arrangement of spaces and buildings as shapers of human activity were revived, consciously analyzed, modeled, engineered, and realized. With the invention of perspectival drawing—though not entirely because of it—the discipline of architecture was invented: society concretized the design of public spaces and architectural education. (Previously, the master craftsman, mason, or carpenter would have planned a building, usually working with nothing beyond field sketches.) By working across dimensions (i.e., by projecting 3-D space onto a 2-D plane and history into the future) architects were freer than master builders to imagine citizen-users moving through and inhabiting the spaces they designed. They began to translate ideas and trade from distant or ancient cultures and new discoveries to the general populace.

So all that happened: cities, libraries, and universities flourished; people flocked to places of noisy exchanges of ideas; the Enlightenment happened, the Industrial Revolution, the Arts and Crafts Movement, the International Style, the Digital Revolution, modernism, postmodernism, and so on and so forth all happened; and we, as a species, armed with our always-newest technology, necessarily specialized. As we specialized, economics, chemistry, physics, natural science, ecology, theology, sociology, anthropology, linguistics, and statistics were created as distinct fields. Architecture itself, the great artistic synthesizer and bridge between art and society, cracked open wide, and now we have engineers, lighting designers, landscape architects, renderers, model makers, code writers, inspectors, zoning officials, signage designers, project managers, parking consultants, permit expediters, urban planners, and historians who all participate in the practice of architecture. (Obviously, this has occured in many disciplines, not just architecture.) And somewhere along the way, the Internet, the World Wide Web, graphical user interfaces, e-commerce, wireless phones, broadband, and sophisticated peer-to-peer networks were born. This I shall call *cyberspace*.

There is, already, an strong almost universal predilection among architects of both the built environment and cyberspace to apply architectural principles to cyberspace, to give shape to a technologically blank possibility with many familiar architectural metaphors. Because the use of metaphor—whether graphic or linguistic—is infinitely creative, there will always be some deep utility in making these analogies. We have grown accustomed to the idea of "entering" a "front door" of a website, of contributing to a "forum." Architecture should be interested in cyberspace because it is an invented, theoretical space. The question is, is it a nihilistic redefinition of the public space in relation to society, or an extension of it? In some ways, cyberculture is a retreat from reality, the implications of which are devastating to architecture and the public sphere in general, as the digital divide worsens and the possibility of a transcendent global democracy succumbs to corporate and state control of cyberspace. We hear about placelessness in urban theory; we are still shifting from libraries, town squares, parks, post offices, and houses of worships to a private sphere of airports, hotels, chain stores, shopping malls, and big-box retail outlets that have largely replaced the civic functions of the former. Again questions loom: What is this place that is regarded as spatial even though it is not? Are we losing our reality to technology? Has cyberspace contaminated the civic underpinnings of architecture? Is cyberspace the future of reality?

So now we come to a most clichéd architectural metaphor to describe this new polyglot über-forum: the information superhighway. Though this phrase is trite beyond belief, it is tenacious and expressive enough to bear some discussion. *Highway, turnpike,* and *freeway* all derive from the original term *expressway,* which in its initial form was not necessarily specific to autos or carriages; it meant merely a rapid, efficient delivery system of goods, ideas, or mail: a structural pipeline. The most common term we use to describe the "place" where the exchange of ideas happens is still just *the Internet*. We have other architectural metaphors: "chat rooms" and "on-line malls," and there are certainly "destination sites" that function like kiosks where people can buy things and read metaconversations about innumerable events and ideas. In film and video, we have the fundamentally intuitive perception of multidimensional reality that perspectival drawing gave us, but is a pipeline really the fundamental new architecture of cyberspace? Where is the Florentine Dome of the Internet? Does a symbol so universally understandable as a public space even exist? Is it even necessary to investigate the idea of building strong public spaces in cyberspace?

Brandon Quinn
University of North Colorado

I do not mean to reduce the metaphor of the information superhighway to plumbing too quickly (nor do I mean to denigrate a fantastic plumbing system!). A well-planned freeway is a marvel of social engineering; it is possible to drive across North America and Europe with a map the size of a credit card if the driver pays attention to the inherent structure of the language of the highway and maps. For example, even-numbered interstates go east–west; odd-numbered superhighways run north–south; green signs are directional, brown ones are recreational, blue ones are informative; ring-roads are prefixed with an additional number; the shapes of signs are iconic and graphic. Millions of tons of steel carry millions of people over extremely rugged, isolated terrain without undue danger because of the design success of the U.S. interstate system—which was, in fact, cooked up by the Eisenhower Administration as a public works project, and designed to employ hundreds

of thousands of people as part of a social safety net. One could go on to argue that the interstate highway system is directly responsible for the American economic global hegemony.

Most trenchant, perhaps, is the fact that the U.S. interstate system is, like cyberspace itself, essentially placeless. It seems supremely democratic and equalizing; it enables its users to go anywhere, but if you are on a highway between dots on the map, you are, quite literally, in the middle of nowhere. So, too, with cyberspace: you may surf the 'Net as long as you like, but you will always be at your computer terminal, in a space without a form. With the advent of first the telephone, then radio, then television, and finally the Internet and cell phones, our private spheres are bombarded with the messages of the globalism and intellectual trade that are the engine of the system. With the exchange of both public monuments and our interior lives for constant engagement with the public sphere, we may have forgotten the humanist urbanism of the Renaissance that started it all. The task of humanist designers is to create the understanding of public space within, essentially, a state of formlessness.

Digital artists are increasingly required to know the principles of elegant code, the science of color, the physics of sound, and the demographics of their audiences. Inventive, attentive, socially engaged digital designers will continue to draw inspiration from both the limitations of technological restrictions and the revolutions of technological ability. Like Brunelleschi, digital craftspersons today must master both creative expressiveness and the tools that will engender technological play. If we are to balance the ideas of science and art, we must know much more about the technological world than Brunelleschi, simply because there is more to know. We must wade through an information tsunami. As Richard Wurman described it, "this is a tidal wave of unrelated, growing data formed in bits and bytes, coming in an unorganized, uncontrolled, incoherent cacophony of foam. It's filled with flotsam and jetsam. It's filled with the sticks and bones and shells of inanimate and animate life. None of it is easily related, none of it comes with any organizational methodology" (*Information Anxiety* [Bantam, 1989]). We will always require someone to shape this overwhelming flood of data into our own image.

This means, essentially, that the form of a particular public-building type, like the Duomo of Florence, is essentially too singular to work within the

Susan Barron
University of North Colorado

concept of cyberspace. Perhaps this is why the analogy of the super-highway is so compelling and will not go away; the meaningful cultural connections we can make in cyberspace (if we can escape the escapism it offers us) are as much about wayfinding, signage, image manipulation, labeling, editing, distilling, and expressing as traditional placemaking. In other words, as Wurman put it, "the architecture of cyberspace may rely on its architects to create systemic, structural, and orderly principles to make something work—the thoughtful making of either artifact, or idea, or policy that informs because it is clear."

In the Renaissance, the need for a new method of representing space, which engendered perspective drawing, developed along with the societal need for a galvanizing space that belonged to the people. Brunelleschi's invention for the Florence cathedral primed a continent for a progressive age of science and art that lasted for 300 years. We find ourselves in need of a new perspective again: we find ourselves in need of a new Renaissance Human. Our ideas of public space are again fluttering amongst dimensions, beaming into outer space, twirling in all times simultaneously. The Internet flattens the extremely three-dimensional world, and to a certain extent time itself, onto a glowing screen smaller than Leonardo's sketchpads. Our methods of giving shape to atoms are as unique and individual as each of us.

What this means, I think, is that there is not likely to be a Brunelleschi among us, as we are all the architects of our own small public bubbles now. As equally empowered individuals, we are always responsible for the architecture of *civitas*. Our individual writings, organizations, interpretations, and representations seem, on one level, entirely private or anonymous, but with the increasing dissolution of the line between personal and public space we must be cognizant of the way these very personal decisions shape the physical world. Our architectural gestures in cyberspace, and the regular old 3-D world, may seem infinitesimal, but if we regard them as part of the "practice" of architecture—the way one may practice medicine, or religion, or democracy—and we perform them with the purity of Brunelleschi's intellectual motivation, cyberspace will make the world our Dome.

section two
Design for New Media

Marie Clanny
Briarcliffe College

New media generally refers to a design project expressed over time and crafted for the video space of television or computer monitors. Because of this, multiple approaches to narrative story structure must be explored; typical story formats have to be thought through, storyboards developed, and characters created; and historical or geographic contexts must be established. Entire three-dimensional worlds are created and then extended into the past and the future to become four-dimensional narratives of time, place, and action. Whereas literature, television, and films use a linear story format, a new form of story structure has recently appeared. The methodology of nonlinear story structure more closely imitates the way people think, incorporating multiple levels of story line, transference of plot and character within the multiple story lines, and seemingly infinite variation. Although the nonlinear story is highly crafted, it often appears to be spontaneous and even chaotic. The story lines cross each other, offering new perspectives on events that have already occurred or are about to occur. Past, present, and future (beginning, middle, and end) are not necessarily related sequentially. Design elements weave the unfolding stories together, not causality or time.

Digital Storyboards

Storyboards help develop concept, composition, and tone. They indicate the details of the characters and physical context. The storyboard is a good place to develop the basic moves and compositional elements before undertaking the intensive computing time that developing these projects requires.

Storyboards depict the main characters and events that form the design content of the story. Design elements are presented in sequence and in context. Together and sequentially, these elements are the visualization of a story structure. The story itself is the content.

Story structure can be either linear, with a clearly presented beginning, middle, and end; or nonlinear, with built-in and even interactive variations to the sequence. In nonlinear works, there can be multiple story lines that intersect or bifucate as the reader/player/user moves through the structure. In linear works, the story moves forward with built-in plot points and the viewer has a more passive role in determining outcome.

We are familiar with dramatic stories of love, war, and personal growth; comedies of the irrational and the unexpected; and tragedies of psychological or material crisis. Literature and film offer models for developing story structures. These stories often relate the travails and accomplishments of the main characters and take place within specific historical and/or geographic backdrops. Story structures use predictive and prescriptive sequencing that is understandable to audiences.

Alex Jonas
Purdue University

Jennifer Whitcomb
Purdue University

Kara Beaver
Purdue University

Aaron Reiter
Purdue University

Create (or purchase) a storyboard pad. If you create your own, use a desktop publishing program to create a template of the typical "cell" image sizes to use as you develop your projects. Generally they are 320×200 or 640×480 pixels. Print these out as if they were frames on movie film, and use them to develop your basic project moves.

The digital storyboard follows from the hand-drawn storyboard. Generally, it is a simulation of the final product, without the need to fully craft it in time-consuming 3-D programs or print to video or burn CDs. After the hand-drawn storyboards give a visual organization to the project, use Photoshop to develop digital storyboards. The layering feature can simulate animation when layers are turned on and off.

Each layer can be printed. The printed digital storyboards can be mounted for presentation to large groups or bound in "flip-book" fashion for presentation to smaller groups. This is often sufficient to get some constructive feedback from the other members of the creative team and make adjustments. Then present the project to the client for approval before incurring the cost of a full-blown production.

▲ KEY IDEAS

- New media generally means a design project for television or cyberspace, expressed over time.

- In linear stories, narrative story structure and genres must be explored. Sequential storyboards are developed, characters are created, and historical or geographic contexts are established.

- In nonlinear story structure, there are multiple levels of story line, plot, and characters. Past, present and future are not necessarily related sequentially. Design elements weave the unfolding stories together, not causality or time.

- Story lines cross each other offering new perspectives on events that have already occured or are about to occur.

- Storyboards depict the main characters and events that form the design content of the story.

Professional Perspectives

◆

Karen L. Dillon
Instructor
The Katharine Gibbs School, New York

Visual Storytelling

We are all story dwellers. We are all meaning-makers.

Film is not a language; it is a complex medium composed of multiple images that are sometimes juxtaposed with sounds and text. Nevertheless, a great deal of work in the field of media studies has debated the question of "Does film have a grammar?" Increasingly, the distinction between word and image is becoming blurred. Yet it is still fruitful to investigate the distinct conventions of pictorial and cinematic meaning-making, because these rules offer designers new opportunities and a broader cultural context. One project that raises many of the issues of visual storytelling, without requiring additional software beyond the programs designers already use, is the *photo roman*.

A *photo roman* is a pictorial story. It is distinct from a digital storyboard in that it is the end product, not an intermediary step. The *photo roman* allows the designer to gain a foundation of understanding from which to build future media projects, such as title design, motion graphics, animation, or even the pervasive, corporate Power Point presentation. Showing an example of the *photo roman* is helpful because not all designers are familiar with the form. A powerful example is the almost feature-length *photo roman* "La Jettée," made in 1965 by Chris Marker. It is available at many video stores.

The designer must grapple with three primary concepts in creating a *photo roman:* issues of story, issues of image, and issues of montage.

Story

Stories are the mechanism cultures use to "store" their moral codes. Stories of this sort are myths, legends, fairy tales, and religious parables, all of which offer obvious examples of how stories function as moral arguments. Less obvious, perhaps, is the idea that many novels, short stories, and blockbuster

films also describe a protagonist's moral dilemma or moral epiphany, thereby preserving for future audiences moral examples specific to a generation and culture.

There are other kinds of stories as well. Some stories are created merely to entertain. Some entertain us through humor; some through horror; and some, like a good whodunit, through our own hubris, because our entertainment is derived from figuring out the puzzle. But even these often retain at their core a moral argument. The moral argument, then, is the most common spine of narrative.

A discussion of the genres of narrative that interest students may clarify these issues. Asking designers to analyze their favorite story from a book, a film, or a myth often helps them to confront cultural biases about what is or is not a "good story." Students may challenge the theory that most stories have a moral argument by mentioning stories that do not seem to be created for this purpose. Inevitably they will bring up a David Lynch film or a Bertolt Brecht episodic play. It is of course true that time-based media, such as a film or a *photo roman,* can and often do employ other meaning-making strategies. For instance, a designer may wish to borrow from the structures employed by music. Music offers alternative models for moving an audience through time. However, a deeper examination of musical structures may suggest that many of the following specific considerations, such as repetition and juxtaposition, are still applicable to any time-based media product, even if one adopts a less literary-based model for storytelling.

Image

One of the interesting intersections between the discussion of stories and the decoding of pictures is that in both cases the student is confronted with the ways in which the audience is complicit in the construction of meaning. This may be an invaluable eye-opener for a student who is grappling with whether to create designs that please the artist or designs that please the audience. Both stories and images have meaning only when they interact with an audience.

A second challenge students face when first constructing visual stories is to grapple with what the single image can express. A brief review of photographic techniques will reveal certain pictorial strategies photographers employ to construct meaningful frames. A discussion about the ways in which

the photographic audience deconstructs or decodes the composition helps students to engage with their own perceptual experiences of images. Much of the designer's job lies in observing the various techniques image makers use, and then identifying them so that these techniques can become part of the arsenal the designer has at his or her disposal when creating. The following is meant to jump-start the thought process in this direction. It helps to look at photographic images while reading this material, so that you can see these techniques employed in actual photographs, with a variety of commercial or personal uses.

Composition

To demystify the "rules of composition," the designer can investigate how his or her own eye is moved through a photographic image by its construction. Where does the eye go first in the picture and why? Do most viewers tend to look to a particular area first? Ask others how they experience the same images. Is the "rule of thirds" or the "grid of fifths" pleasing in relation to the full frame? How does a strong, diagonal construction affect the audience's reading? Does the image seem more exciting and dynamic? Does the eye continue to circulate around an image, or are there both an entry place and a place where the eye exits the frame, creating a "quick read" feeling for the audience? In all investigations of this sort, there are no "right" answers (because the rules of composition are not inflexible laws), but rather individual and collective responses that may be useful in the creation of future designs.

Color and Tone

Though color may be introduced in other assignments, it is important to reiterate color theory here if the students are going to use color photography for their *photo romans*. Many ideas about color theory are really a continuation of the dialogue about how perception guides our visual decoding efforts. However, additional discussion about color associations and color perception help students to build on prior work.

Tone is a continuation of color, but with a photograph the term can also refer to the materials of construction, such as the surface the photograph appears on. *Tone* describes the range of dark to light within the image. Tone can influence our overall perception of an image. Is it a high-key image, with a strong shoulder of highlights and shadow areas that remain above middle

gray? Or is it a low-key image, with the shadow areas dominating and the entire range of tones resting at the tonal toe of the contrast ratio? Is the image high contrast, with white whites and black blacks but fewer tones overall? Or is the image low contrast, with many gradations of gray along the color scale? Investigate images of each kind, and ask for audience associations for each tonal choice. Is fashion photography more often high-key? Are *film noir* and detective stories more often high contrast or low-key? Does editorial magazine journalism tend to favor low-contrast images? Do newspapers choose high-contrast images? Ask why and investigate personal tastes and biases in relation to each answer.

Realism versus Expressionism

Since the invention of photography, use of the photographic image and its film counterpart has fallen to two distinct camps, the pictorialists and the realists. The pictorialists use photography as a visual expression of some idea, feeling, emotion, mood, or concept. Realists use photography to make fact-based, detailed observations of concrete objects visible within the physical world. Each of these two uses for photography has many diverse examples across many fields. Asking designers to identify both historic and contemporary examples of each style helps challenge preconceptions about images and students' allegiances to either photographic camp. A brief look of contemporary fashion photography, for instance, may make students more aware of a growing trend toward the "mockumentary," a genre that borrows the codes of realism and applies them to a fictional narrative.

Repetition

Great advances have been made in contemporary neuroscience toward figuring out how humans receive and store information. Most perceptual psychologists believe that repetition is one of the keys of synapse development. Common sense suggests that when information is repeated we have a better chance of retaining it; in many cases it takes repetition before we even perceive it. Thus, it should come as no surprise that repetition is often a basic element in composition. Repetition is so critical to understanding that it is not limited to visual perception: it has counterparts in the musical refrain and the literary *leitmotif*. Repetition activates the viewer's memory. This reactivation helps in our decoding. It is interesting to note how many photographs

rely on repeated subjects. For instance, in Eugene Atget's "Three Men on the Road in Italy," the similarity (repetition) of the costumes makes us pay attention to the uniqueness of their facial expressions. When two elements are repeated, a kind of juxtaposition occurs.

Juxtaposition within the Single Image

Juxtaposition takes place when any two or more elements are placed within a single frame. By juxtaposing elements within a frame, the photographer asks the viewer to engage in one of four activities: comparison, contrast, combination, or collision. A *collision* occurs when one of the elements challenges our reading of one of the other elements. Within a single photographic image, juxtaposition could be as simple as a pair of hands, one old and one young. Juxtaposition is the real cornerstone of the *photo roman* because a *photo roman* is built by juxtaposing one photograph with another.

Montage

A *photo roman* can employ four kinds of visual juxtaposition: picture to picture, picture to text, picture to sound, and/or individual picture to the larger story context. Picture-to-picture juxtaposition is *montage.* The Russian Formalist filmmakers and the American film theorist and cognitive psychologist, Rudolf Arnheim, did in-depth investigations into the range and function of montage. The basics can be summarized as follows: According to Lev Kuleshev's experiments, an audience's reading of a single shot is modified by the context of the images that precede or follow it. Thus, when we view images in a series, it is not only the individual images we decipher; we also ascribe meaning to the interrelation between the images. If students have spent some time trying to decode the meaning of the objects within individual photographs, they will have a foundation for understanding why humans seem to engage in this constant construction of meaning even amongst separate frames. The categories of interaction are the same as for objects within the same frame: they invite comparison, contrast, combination, or collision (when they challenge what is expressed in other images).

IT'S A BEAUTIFUL DAY IN THE NEIGHBORHOOD...

A BEAUTIFUL DAY FOR A NEIGHBOR....

I'VE ALWAYS WANTED TO LIVE IN A NEIGHBORHOOD WITH YOU...

I HAVE ALWAYS WANTED TO HAVE A NEIGHBOR JUST LIKE YOU...

SINCE WE'RE TOGETHER, WE MIGHT AS WELL SAY

LET'S MAKE THE MOST OF THIS BEAUTIFUL DAY...

WOULD YOU BE MINE?COULD YOU BE MINE?

WON'T YOU BE MY NEIGHBOR?

Tracy Bond
Katharine Gibbs School, New York

Rendering 3-D Space in a 2-D World

Just as students need to investigate the formal constraints and mechanisms of decoding a single image, investigating the decoding of successive images will increase their understanding of the operative mechanisms. Just as a critical approach to the rules of composition helps empower designers in their single-image decoding, the same critical approach to the conventions of cinematic space will inform decoding there. There are certain cinematic rules that should be examined and understood. The *photo roman* assignment offers a unique opportunity for the designer to grapple with these cinematic conventions.

All designers already confront the 2-D frame, and most recognize that the illusion of three dimensions through perspective is but one of the designer's tools. Because camera mechanics rely on light passing through a single point, photography is by definition a perspective-based art form. Use of foreground, middle ground, and background should always be a concern in photography. Depth of field, or the sharpness of these various areas within the frame, is important as well.

Point of View

Connected with physical perspective is the convention of point of view. Cinema, more than most art forms, has an emphasis on point of view. A shoulder in the foreground, facing away from the viewer—called "over the shoulder" in cinematic terminology—suggests to us that someone else is seeing, and perhaps interacting with, what we are seeing. Yet the same can be implied by showing us two separate shots: a subject looking, usually a medium close shot or a close-up, followed by a separate object or subject. We supply the final meaning: the first subject is seeing what we see. This is the basis of "shot–reverse shot" filmmaking, whether it is two talking heads we are watching, or two eyes seeing something followed by a cutaway to a gun on the floor. Remember that point of view is a form of juxtaposition that helps to surprise the audience.

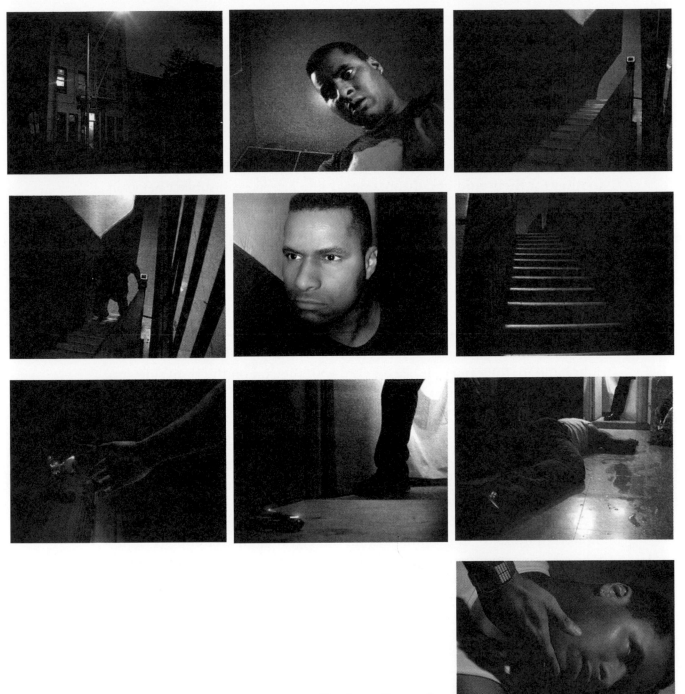

Abraham Fernandez
Katharine Gibbs School, New York

The logic of cinematic space is based on our prior understanding of spatial relationships. A convention that uses this prior knowledge is the 180-degree rule, which provides visual clues about the spatial relationships between two or more subjects. In its simplest form, the 180-degree rule suggests that there is an imaginary straight line between any two characters.

Imagine a *photo roman* that pays homage to the climactic shootout scenes in old Western movies. This one will feature an outlaw Gunslinger pitted against a good-guy Sheriff. If viewed from overhead, as the two characters face one another for their gunfight, the imaginary line bisects each subject between the eyes. This bird's-eye view shows the 180-degree line with complete clarity. On one side of the imaginary line are the Gunslinger's right side and the Sheriff's left side. On the other side of the line are the Sheriff's right side and the Gunslinger's left side.

Imagine that after giving this bird's-eye view, we (the photographer) want to show the Gunslinger's nervous hand fingering his gun in the holster. The chosen photographic frame is from behind the Gunslinger and shows his back, shoulder, and hip as he stares down his opponent. If the Gunslinger is right-handed, the camera is placed even with the gun on the right side. You see his back and holster in the foreground, but also the Sheriff in the distance, also ready to draw. We take this photograph. It contrasts two subjects important to our story.

Now, when we the photographer want to get the next image from the Sheriff's point of view, the camera has to be shifted to the other side. For the screen direction to remain consistent, we have to be on the Sheriff's left side. In other words, if we honor the 180-degree rule, we are not allowed to film the Sheriff from behind his right hand, even if he is right-handed. For optimum clarity in spatial relationships, the photographer should stay on the same side of the 180-degree line that extends between the subjects. If we do "jump the line," the juxtaposition will be disorienting for the audience.

This could be acceptable in this over-the-shoulder shot, because the Sheriff's position is still visible within the frame. A viewer's mind would be confused for only a moment before it would sort itself out.

However, if we as the photographer decide, after showing the Gunslinger's over-the-shoulder shot, that we want to cut to a close-up shot of the Sheriff's face, then it is imperative that we remain on the same side of the 180-degree line. If we do not remain on that side, but film the Sheriff's close-up from the side of the Sheriff's right hand, then confusion ensues. If we cut to a close-up of the Sheriff after the shot of the Gunslinger's holster, the Sheriff will appear to be looking off screen in a new direction, instead of at the Gunslinger. If the story includes the Sheriff looking around for the Gunslinger's accomplices, this photograph could be useful. But if that moment of the story demands that the Sheriff and the Gunslinger trade challenging looks, then we as filmmakers must honor the 180-degree rule so that the audience is not misled.

Though the 180-degree rule can be difficult to master, it is the basis of cinematic logic. A designer who understands it can use the shorthand filmmakers use to tell their stories with brevity and emotion.

Screen direction offers one additional convention: Movements that go either screen right or screen left must generally be honored from scene to scene. In other words, if the Sheriff rides in pursuit from screen right to screen left, the audience should not see the Gunslinger riding screen left to screen right in a separate shot, unless they are meant to believe that the Gunslinger has circled back and is now riding toward the Sheriff for their future shootout. This is perhaps even more critical in the *photo roman* because there is no movement across the frame to suggest deviations in course.

A final consideration, though not as crucial as either of the first two, is that a variation in camera angle of more than 30 percent makes for a more pleasing juxtaposition with a new frame. A variation of less than this amount is slightly confusing because it is neither entirely new nor entirely the same.

The Fourth Dimension

Time is the additional dimension in time-based media. Because the *photo roman* is a series of images that are juxtaposed one after another, the timing of these images contributes to our reading of them and the meaning we ascribe

to them. Images that are moved faster than 15 frames per second will seem to blur; if they are closely related and contain action, the action will appear to be continuous. This is how the multiple single-frame photographs of any movie become the film-viewing experience we enjoy.

How does the pace of the images contribute to a viewer's emotional response to the story? Most films are composed of many distinct shots, that are edited into scenes, that are juxtaposed into a two-hour film. Assessing one or two well-edited films for pacing is quite instructive. Watch a favorite scene many times. It is often helpful to count how many edits there are in a film scene, and then try and break the scene down further into how many different angles the filmmakers shot. If the designer draws thumbnail storyboards of this scene, he or she is mapping out a sequence that could become the inspiration for a *photo roman*.

The *photo roman* project is meant to raise issues of story, image, and montage, so that designers can begin integrating the technical methods of visual storytelling into their design work. The project can be done first as a photographic storyboard strip. Subtitles or text can be added to the images in a graphic design layout program. Finally, each image can be scanned or videotaped for a final time-based presentation. For an additional learning opportunity, sound effects, music, or even voiceovers can be added to the final sequence.

Although the discipline of digital filmmaking is a distinct body of knowledge, a foray into some of its basic principles can give students of design more tools and a breadth of knowledge that is often needed in this age of digital-media cross-pollination. The *photo roman* can be surprisingly powerful, emotionally poignant, and a unique design challenge. It satisfies many students with diverse career goals, and lays a solid foundation for future work in a variety of media. The appeal of storytelling for the developing designer often makes the complexity of the project fade in the face of the most human of desires: storing a part of ourselves inside a story that we want to share with others.

chapter seven

Interactive CD-ROM

The primary tools for interactive, nonlinear projects are audio, video, "flat" art, text, and still photography, which are combined in scripted, interrelated sequences. Some of these connections can be activated by the user, who uses buttons and mouse clicks to vary the ways in which the elements function. These multimedia files are accessed, at least in part, at the user's discretion; the exact sequence of design elements varies according to the user's moves.

Promotional CD-ROM

Successful advertising addresses values and lifestyle choices. When set into a narrative, these decisions become the focus of a story. What choices will the protagonist make and how will these choices be fulfilled? What challenges will be the turning points in the plot? Whose aid will the protagonist solicit, and how? Who is the villain, thwarting achievement of the protagonist's goals? What roles do the secondary and tertiary players have as the plot unfolds?

In crafting the promotion storyline, the designer needs to conceptualize a before-and-after scenario. What deficiencies did the protagonist exhibit (poverty, ill health, prejudice, weakness of character)? How did these deficiencies impede the realization of personal goals (wealth, beauty, happiness, family life, friendships)? How do the products or services being promoted contribute to the realization of these same goals? These questions both structure the basic storyline and constitute the design strategy.

The design elements range from the characters themselves to the environment of the geography and time period of the storyline. Color, texture, line, shape, and typeface must be crafted to move the storyline forward. Characters express the story through dialogue and motion. Text fulfills a sim-

ilar role, and can create audio bridges between scenarios and add information when the characters cannot. Typography can reinforce the mood, time period, and natural or cultural setting. Color can excite or calm, add psychological dimension, and denote the passage of time; texture can add the simulation of three dimensions or the drama of a dynamic stage to the story action. Lines and shapes can direct attention, highlight, separate, and isolate design elements and story action.

The point is that each design element will evolve in accordance with the story development. The changes expressed in the design elements embody the drama of the project. Each has to be developed over time in relation to the challenges and opportunities that constitute the choices of the central characters.

This may seem like what goes into any television commercial, because it is still linear and passive. Nonlinear, interactive projects are based on purposeful, planned intervention by the viewer into the storyline of the promotional product. For this reason, the promotion can be more powerful and more personal than the promotional strategies of print and broadcast media, where the viewer sits passively and just experiences the information. In an interactive promotion, the viewer inserts himself or herself into the story action and chooses scenarios, affects plot, and alters character development to gain greater knowledge about the product. The consumer can freeze the story to focus on the product and explore various options and alternatives.

Nonlinear, interactive design offers multiple variations within a fully crafted storyline. From the client's viewpoint, this means that a single design product can be effective in multiple niche markets, saving time and money while facilitating product communication. From the consumer's viewpoint, this empowerment of the individual user to affect the design sequence means that users can get directly to the content that meets their needs. In interactive promotional design, everyone benefits because the technology encourages the design goals of facilitating visual communication.

Design that simply highlights the product or service does not take full advantage of nonlinear interactivity. The starting point should be the dramatic story, with plot points controlled interactively. Next, the design elements, from characters to typeface and from contact to color, have to be developed. Multiple scenarios should be explored in which the needs and desires of various niche markets can be addressed and the range of the dramatic story can unfold. Product information must be interwoven into these scenarios so that the user can personalize his or her interaction with the promotional strategy.

Aaron Cantu
University of Texas—Pan American

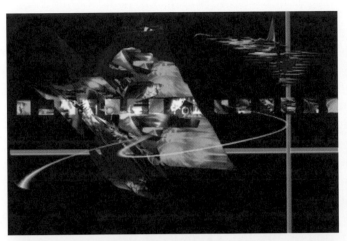

▲ KEY IDEAS

- Successful advertising addresses values and lifestyle choices. When set into a narrative, these decisions become the focus of the story action.

- Nonlinear, interactive projects are based on purposeful, planned intervention by the viewer into the storyline of the promotional product.

- Nonlinear, interactivity means that a single design product can be effective in multiple niche markets.

- Nonlinear, interactivity empowers the individual user to affect the design sequence, getting to the content that reflects his or her needs.

Educational CD-ROM

The educational CD-ROM does not focus on value-laden choices, but on relationships between information. These relationships can be causal, contextual, or theoretical. Their interrelatedness can be the source of drama and the storyline.

The goal of an educational CD-ROM will be to elucidate the interrelation of information in terms of cause (generally reserved for scientific topics), historical or geographic context (generally reserved for social topics), or theoretical construct (generally reserved for ideological issues). The type of information and of course the general knowledge level of the user should determine the strategic approach to structuring the information.

Interactive design strategies should be based on the user's knowledge base, motor skills, and visual sophistication. Video and audio clips can enhance a design strategy, but they cannot substitute for it. The design must come from the organization of the information, a study of its interrelatedness, and a sound grasp of the learning methods and styles of the participating audience. General learning models should be researched, as well as information content.

Once the strategy has been developed, it must be redefined in terms of design elements. The flow of information will occur through the design elements, whether they are characters, text, lines, shapes, or colors. These wayfaring devices create a visual structure that will suggest a map for reading the information. Contextual and dramatic devices can support the informational structure and add participant-appropriate visual events that help connect the information by inserting it into a story structure.

Interactive choices can be cued by the information organization and can enhance learning by empowering the user to follow guesses based upon cumulative and experiential knowledge. Incentives, rewards, and challenges can be written into the storyline; they may affect character development and the evolution of design elements, reflecting the participant's learning curve.

If the information is provided in a predetermined sequence that cannot be altered by the user, the interactive project has missed its goal. Participant interaction that can affect visual sequencing is more successful in utilizng the

communicative potential of the interactive CD-ROM. To fully actualize this potential, scaleability of knowledge must be addressed in the planning stages of the design strategy. As participants gain insight into the interrelatedness of the information at hand, they can intervene in the sequencing process and expand the scale of reference to see more clearly into the complexity of the information, explore some hypothetical instances or parallel theoretical models, or gain further contextual perspective.

Movement across levels of complexity can activate new sets of design elements, so that each "knowledge perspective" has its own visual identity. These design identities should be scaleable as well, so that the participant can ascend and descend in perspective. Knowledge level, interactive choices, and design elements should develop from this "accumulation" strategy.

Other learning strategies can also be developed, such as a "discovery" strategy, a "usefulness" strategy, or a "retention" strategy. Interactive moves will be cued by different kinds of scenarios.

In the discovery model, a knowledge level is accessed through guesswork, luck, and trial-and-error. Visual elements might be more dynamic, video and audio clips fast-paced. Mystery and surprise will suggest certain kinds of imagery and typeface choices. For a young audience, the scenarios might build on the intuitive thinking and chance discovery that are familiar in juvenile literature and film. For older audiences, reversals, risk-taking and innovation might be more effective.

In a usefulness model, choices that offer some specific and immediate solution to the problem-solving scenario at hand are rewarded. Knowledge can be gained through immediate and obvious choices that open gateways to the history of a particular problem. Other forms of usefulness can revolve around goal setting, time management, and task completion.

The retention strategy sees knowledge as a cumulative effort that achieves some ultimate goal. Having gained, and retained, information through a reward system, access to higher levels and greater rewards are achieved. These rewards are not necessarily material; they can be spiritual or philosophical. They offer an ever-expanding range of insights. Design elements that reference bridges, mechanical extensions, expansive paths, spiraling, and movement might be appropriate in the knowledge retention model.

▲ **KEY IDEAS**

- The educational CD-ROM focuses on relationships between information. These relationships can be causal, contextual, or theoretical.

- The type of information and the users' general knowledge level should determine the strategic approach to structuring the information.

- Contextual and dramatic devices can support the informational structure and add participant-appropriate visual events that will help connect the information by inserting it into a story structure.

- Interactive choices can be cued by the information organization and can enhance learning by empowering the user to follow guesses based on cumulative and experiential knowledge.

 — In the "discovery" model, knowledge level is access through guesswork, luck, and trial and error scenarios.

 — In a "usefulness" model, choices are rewarded that offer some specific and immediate solution to the problem-solving scenario at hand.

 — The "retention" strategy sees knowledge as cumulative effort that achieves some ultimate goal.

Entertainment CD-ROM

The entertainment value of an interactive CD-ROM springs from its unique medium and formatting. It is successful to the extent that it is interactive. Otherwise, a board game, a film, or a good book would be a more appropriate choice for pure entertainment.

In a sense, all interactive products can be considered games, in that they offer an end-goal, a method of engagement, and a unique environment. However, interactive CD-ROM entertainment products differ from other kinds of games in that they are not limited by the method of play or gaming strategy. There may be no end-goal other than the play itself. They can be open-ended, incorporating participant-created design elements such as the creation of new

Ramiro Lozano
University of Texas—Pan American

characters or new environments. They may be self-learning programs that simulate aspects of human behavior (artificial intelligence). They may be open to unpredictable input from player sources connected to the game through the Internet.

The point is that the play is interactive; that it is based upon creating and re-creating narrative scenarios through player input. Design strategy should also be open-ended. Design elements—colors, lines, shapes, textures, characters, typeface, and images—should all continuously evolve.

Challenges, opportunities, surprises, and novelties constitute the drama of the play from which pleasure must derive. But pleasure itself needs a context; we need signals and indicators, signs and prompts that will help us to achieve and recognize the fulfillment of our desires. These, of course, will always be audience-specific and will inevitably connect to the dramatic narratives we allow ourselves to indulge in. Digital interactivity does not contain any physical pleasures. Our digital pleasures are informational, contextual, and representational. Without design signals, we cannot know how our pleasure is to be defined. Design elements in an interactive CD-ROM help us to understand how to access our pleasure.

This digital pleasure strategy can occur through a variety of scenarios and storylines. One approach might be a reward-based strategy that offers cumulative gain through play. Challenges and impediments could be encountered along with multiple problem-solving scenarios that permit various results measured in some form of "pay-off." Another approach might be more experiential, without specific problem-solving challenges but with spontaneous and unpredictable scenarios accessed though participatory discovery. A developmental approach might be based on increasingly expansive access to information about a specific subject.

Ramiro Lozano
University of Texas–Pan American

The user interface is the primary design element: it presents, maps, and integrates the interactive narrative with the design elements. It offers instructions for use and facilitates access to the open information system. The interface is the entry point to the entertainment and is the structure within which the entertainment occurs.

Design elements evolve from the interface-participant strategy and act as navigational aids to accessing the interactive play. Gateways and databases might be hidden until certain scenarios have been played out, or they can exist as explicit choices or unsolicited intrusions. For example, Internet access can be denied until certain levels have been attained, or it can be spontaneous and unpredictable. Audio and video clips can be accessed through specific navigational tools or by random mouse moves.

The important idea is to build an open-ended design system that can reorganize itself according to nonlinear sequencing. Creating such an open system, which is both participant-sensitive and design-aware, is the challenge of interactive entertainment. Design solutions must offer a dynamic, open system of elements that reinforce the interactive strategy, while they build on the knowledge base and cultural preferences of the participating audience.

▲ KEY IDEAS

- Entertainment CD-ROMs can be open-ended, incorporating participant-created design elements such as the creation of new characters or new environments.

- Entertainment CD-ROMs can be self-learning programs that simulate aspects of human behavior.

- Entertainment CD-ROMs incorporate narrative scenarios that derive from player input. Entertainment CD-ROMs may be open to unpredictable input from players connected through the Internet.

- The user interface presents, maps, and integrates the interactive narrative with the design elements.

- Entertainment CD-ROMs use design solutions that offer a dynamic, open system of elements, reinforce the interactive strategy, and build upon the knowledge base and cultural preferences of the participating audience.

Edutainment CD-ROM

The ultimate value of interactive design is that it explicitly recognizes the user as an integral member of the design team. The designer can structure information, develop navigational tools, and affect scenario sequencing along a storyline for narrative believability—but none of this effort replaces the direct and creative impact of the participant.

This situation creates new opportunities for promotional design by bringing the potential consumer directly into the product presentation campaign. It permits the individualization of the advertising message, reinforced by direct customer buy-in. This simulates car-sale the "test drive" ploy, with the additional benefit of highly designed images and detailed textual information.

In educational design, this approach empowers the learner to construct knowledge that is meaningful and dependent on his or her abilities, interests, and desires. Learning strategies can incorporate the techniques of the modern curriculum and provide culturally specific information. The design package evolves around a narrative structure that makes learning visually pleasurable because it is based on learner interaction within an individually created context of meaning.

Damaso Navarro
University of Texas–Pan American

In entertainment design, interactivity offers engaging visual delights, reinforced in highly variable ways that include a wide audience within an open-ended design system. Interactive edutainment design develops a graphical interface that specifically emphasizes participant control. This structure integrates participant choices within a larger framework of planned and unplanned sequences. Although the experience remains digital, it is not completely virtual; it can be shared with others and gains complexity because of their integration within the narrative. Edutainment starts with learning-as-play; knowledge is constructed through a narrative storyline that reinforces knowledge acquisition while remaining fundamentally under the control of the learner.

Scenario sequencing can contain many of the incentives and drama discussed for other interactive projects. Additionally, because edutainment conjoins learning with gaming, an end game can be specified and a story structure can be developed in response to variable scenarios of play. The steps of play can mimic learning responses and incorporate cumulative and transferable knowledge, scaleability of complexity, surprises, and rewards. Curricular content can be integrated into storyline sequencing and can be tailored for participant-specific needs, abilities, and interests.

Damaso Navarro
University of Texas–Pan American

Interface design is critical, as are navigational tools. Together these make up the interactive platform upon which play takes place and learning is achieved. Storyline is critical, not for its content specifically, but for its communicative ability to sequence multiple levels of information. Interactive control occurs through both content and design choices, but the design structure must be recognizable and predictable or learning will be thwarted.

Here a participant has less control over design choices and more control over content sequencing. Design choices can serve as navigational tools and as visual predictors and organizers. Participant control can be fully realized only when the design choices structure the information contained within the interactive experience. Design serves an indexing function through information mapping, offering visual descriptors and navigational aids.

Genuine learning is both personal and collaborative. Story structure presents exemplary behaviors, meanings, and social relationships within a culturally determined network of interconnected and interdependent activities. That network has now expanded globally and cross-culturally. Internet connectivity has extended both knowledge base and learning context through links to

knowledge sources, databases, and chat rooms. These global sources can be accessed through and incorporated into the edutainment CD program.

Collaboration—whether with real, virtual, or Internet sources—can occur only after knowledge has been internalized by the participant. The construction of the sequence of knowledge acquisition must remain under the participant's control, while positive reinforcement can and should occur through actual collaboration with external, empathetic sources.

Animated characters can add information, reinforce guesswork, even warn or cheer at participant choices, but the design strategy must always focus on guiding the participant rather than the external characterizations and personifications of story. Video and audio clips, as well as special effects, fall into the same category as animated characters. They must reinforce the story without interrupting the participant's interaction with the knowledge base.

Damaso Navarro
University of Texas—Pan American

Damaso Navarro
University of Texas–Pan American

▲ **KEY IDEAS**

- Edutainment builds upon learning-as-play, where knowledge is constructed upon a narrative storyline that reinforces knowledge acquisition while remaining fundamentally under the control of the learner.

- In edutainment, knowledge is constructed through a narrative storyline that reinforces knowledge acquisition while remaining fundamentally under the control of the learner.

- In edutainment, the steps of play can mimic learning responses and incorporate cumulative and transferable knowledge, scaleability of complexity, surprises, and rewards.

- Curricular content can be integrated into storyline sequencing and can be tailored for participant-specific needs, abilities, and interests.

Professional Perspectives

Professor Michel Balasis
Assistant Professor
Loyola University, Chicago

Interface: A Paradigm Shift

Interaction between two or more human beings is the basis for much of what drives our modern society. To communicate, the human senses operate within an interface. Until the recent process of computerization began, the mode of communication had always been a human-to-human interface. A theory critical of the present state of technology could argue that we are entering a dehumanizing stage, by developing of the new human-to-computer interface.

The term *interface* is generally defined as the place at which independent systems meet and act on or communicate with each other. The shift to an interface based on human-to-computer interaction removes one of the expressive, emotional systems from the older human-to-human model and replaces it with an electronic digital information processing unit. Can we accurately determine the effect of eliminating human expression from one half of the new interface?

Human expression is the driving force of personality. Much of our language is nonverbal. What happens to the development of communication skills when much of our sensory interaction takes place on a digital platform?

The partial loss of some of the most primal forms of communication, such as gesture, feeling, and touch, will no doubt have a negative impact. It is a mistake to assume that the communication skills of modern society are flawless. Can we expect any positive effects from this paradigm shift in interface?

One of the most glaring inadequacies of our society is the lack of efficient communication across generations. By eliminating the differing elements of language used by different generations, such as slang and hand gestures, the new interface may foster cross-generational communication.

Human-to-computer interaction is driven by a form of software commonly referred to as the graphic user interface. As developed by Apple Computer, it is now the near-universal standard interface called "Windows." Windows is a visually oriented interface, which follows the recent conditioning of our society to immediacy in all forms of communication. Mass media are highly saturated with information in the form of visual imagery.

An advanced use of the personal computer is the development of electronic multimedia, which combine visual information with sound, animation, and interactivity. A multimedia developer is forced to be aware of the way the audience will interact with the computer. The most effective interface will be one that closely matches the natural human senses and their reaction to visual and audible stimuli.

The speed of technology evolution continues to accelerate and threatens to deteriorate human-to-human communication skills. Current interface technology, such as speech recognition and multimodal communication, is on the brink of being used widely. Further growth in the computerization of our society may facilitate new learning skills, but it remains to be seen whether it will activate or hinder human beings' communication with each other, in this generation and in succeeding generations. Can we develop a proactive interface?

chapter eight
Web Design

Web design is facing a significant challenge: defining good design for the Internet. This reflects a transformation from a technology to an art and requires the development of criteria that can define effective and compelling Web design. Ultimately, it will be the Web designer's ability to successfully integrate words and pictures in the promotion of goods and services that will convince clients that good Web design is good business. This vast broadcast medium is desperately seeking content. This is what Web designers can offer. They create, control, and conceptualize content.

As this new medium continues to evolve, design opportunities and areas of specialization continue to emerge. Until recently, information architecture generally referred to the structure and information flow of the site. This field is now emerging as a new area of specialization that measures usability and fuses the skills of market research and analytical approaches to quantifying design initiatives to project management. The information architect (IA) is now a specialized member of the project team, helping the design direction by looking at the site architecture and elements from the user's point of view to determine effectiveness in communication, display, presentation, and functionality.

Web Page Design

The first step in creative Web page design is to get beyond the technology and into the design itself. In Web page design, a thorough knowledge of the working parameters of Web capabilities and structure is essential background knowledge. It does not obviate the need to research, innovate, and creatively solve business problems through visual communication strategies.

As in any design project, the first step is research. The Web designer must research globally, using the Internet to its fullest extent. Staying current with the rapidly evolving and almost limitless possibilities for Web design choices will

John Gattas
San Antonio College

keep your work fresh. Follow as many of the current periodicals as you can. Spend time with the interactive and Web design annuals. Visit interesting sites and spend time analyzing the visual content as well as the technological marvels.

Of course, you will need to become thoroughly familiar with your client, the products and services your client provides, the customer base, and the competition's design strategies. Do not be afraid to ask why your client thinks it needs a Web site.

Consider the breadth of the now-global markets and discuss this in great detail with your client. There is a wide array of marketing techniques to bring new potential customers to your site, but if the site does not speak their visual language, their visits will not generate any sales leads. Designing in the new global village is more complex than when the world was a much smaller place.

Situate your Web page within an integrated marketing strategy. It is rare for a Web site to constitute an entire marketing plan. It can be the centerpiece of the marketing plan, supplemented by direct mail pieces and a follow-up/follow-through campaign, but rarely will it stand all by itself in the vast universe of e-commerce. Ask about the rest of the marketing plan even if you have not been contracted to contribute in any material way other than the Web site. Meet with the print design team, and find ways to integrate their design into your Web site. The consistency of the design message will pay off in brand recognition and customer loyalty and help your client stand out.

Web design uses typography, image, composition, line, texture, and visual hierarchy in the ways that are familiar to the print designer. However, there are some significant differences. The primary distinction is scaleability. Because

the designer never knows what size monitor the Web page will be viewed on, the design must be scaleable. This has a direct impact on compositional approaches and the creative grid structure.

A Web page must activate graphic space and communicate verbal and visual messages, using type and image, color and tone, lines and patterns. Visual organization will reinforce the hierarchy and create meaning through the assignment of primary, secondary, and tertiary levels of importance. Be sure the font choices, images, and composition state the message clearly. The central-point composition can be frustrating, in that it requires that the outside 10 percent of the "page" be limited in visual message, but other than that one restriction, you can develop a grid structure based on dynamic visual transitions and the interplay of 3-D and 2-D graphic space.

Be sure your Web page has "personality." The Internet is virtual. It has no form, no human contact, and no physicality. Yet desire—especially consumer desire—is always material. Web design can use its interactive potential to reach the full emotional range of internal response. Humor, surprise, and drama help achieve this. Audio clips and animation offer important tools to effect this strategy. Study gaming and video work, nonlinear CD-ROMS, and magazines to see what design opportunities exist, as your Web design grows from a single page to complex, interactive site.

The great thing about Web design is that growth in complexity and sophistication is inevitable.

▲ KEY IDEAS

- A thorough knowledge of the working parameters of Web capabilities and structure is essential background knowledge.
- Web design requires you to research, innovate, and creatively solve business problems through visual communication strategies.
- Situate the Web page within an integrated marketing strategy. It can be the centerpiece of the marketing plan, supplemented by direct mail pieces, and a follow-up/follow-through campaign.

The Mini-Site

Fundamental to Web site design is site architecture. An architecture is a pervasive actualization of form in the service of purposeful concept. It is both the site's information flow and its overall structure. It both structures space and creates ways to navigate through it. In a design sense, it embeds a pattern into the development of design elements, in that it inserts a repetitive and recognizable structure that permeates and integrates two- and three-dimensional space.

However, the Web site will never have any real physical form, and the concept can only be realized within the structure of current digital communications. Space in Web site design is created through the direct interaction of the user and the assumption of user control over the information display. Information architecture has grown into a specialized field. Informational architects (IAs) review all the Web design elements and information flows from a usability viewpoint and assess design consistency and functionality from the user's perspective.

The mini-site itself will consist of a series of interconnected pages. Think of these as individual moments in an overall design. Each should reference the other using common design elements so that the user has a tangible sense of the overall design, as well as a uniquely designed moment with the specific information at hand.

Nataya Pangapokakij
Savannah College of Art and Design

 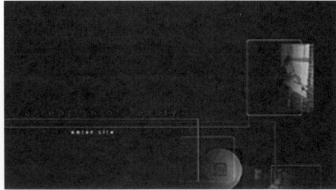

Simple design references can be achieved by incorporating a logo scheme, using colors that reference connections while highlighting specifics. Use a range of hues of basic color (sky blue, navy blue, electric blue, pale blue) and develop a typeface strategy that helps the user understand visually the level of detail available. Using a family of typefaces and alternating point size and case can affect this "mapping" strategy. A representation of the overall structure of the site can be created and used as a signage system, showing the user the matrix of nodes, connections, and pathways available at each critical juncture.

It is important to explore the marketing effects of various information-flow structures with your client. Picking the appropriate structure is the first step to successful site design. How many clicks will it take to gain access to important information? Create an information access strategy and an interface that supports the marketing strategy. The Web site will include background and foreground. Decide how active their interpenetration will be. Motion graphics and animated images demand a narrative story structure. Still images create a different dynamic and must work within an information hierarchy that creates visual communication and achieves meaning.

The contribution of navigational tools, audio files, and special effects cannot be overlooked. Assuming you will be moving from the simple to the complex as you become more familiar with this medium, it is good practice to consider how these design elements will be introduced, even at a relatively simple level of production. The overriding criterion in decision making about these design elements is site context—the interaction of design strategy with business goals.

If the purpose of the site is to sell product, aids to achieving this end must bring the consumer to the transaction point quickly and efficiently. If the goal is to achieve a blistering presence with just a few simple pages, special effects, audio clips, and animations can help achieve that goal. If the business strategy includes follow-through and direct mail, save some of the design punches for the related print campaign. If the plan is to position product by offering enhanced and expansive services through the Web site, navigation becomes crucial.

The only expert in Web design is the participating public, so do some good market research. It will help you make decisions about your design tools, and it will provide you with a quantitative basis to back up your creative approaches when it comes time to pitch the project.

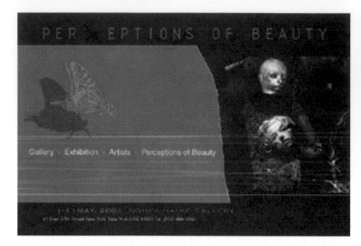 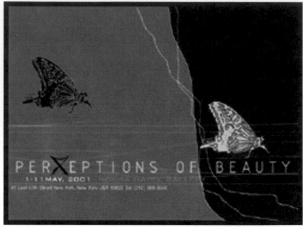

Phanas Phokthavi
Savannah College of Art and Design

▲ KEY IDEAS

- Site architecture is both the site's information flow and its overall structure.

- Information architecture measures usability and fuses the skills of market research and analytical approaches to quantifying design initiatives with those of project management.

- An architecture is a pervasive actualization of form at the service of purposeful concept.

- An architecture inserts a repetitive and recognizable structure that permeates and integrates two- and three-dimensional space.

- Creating the appropriate architecture is the first step to successful site design.

- Explore the marketing effects of various information-flow structures with your client.

- Create an information access strategy and an interface that supports the marketing strategy.

- The overriding criterion in decision making about design elements is site context—the interaction of design strategy with business goals.

Interactive Elements

The Web offers a unique set of design elements. They have been developed in response to the need to facilitate digital communication. Some of these require viewer intervention into the Web site.

Mouse clicks and cursor movement can generate a series of information sorts, change graphics, or access dynamic multimedia. Internal search engines, pull-down menus, information tables, and cascading pages can be accessed under the viewer's control.

Rollover image mapping and hidden links take control back from the user and create entertaining surprises and visual rewards. Interactive elements can be combined to create thematic complexity, realize creative strategies, and achieve business goals.

Each element must fit into a design strategy. Design elements that create and activate graphic space on the Web offer insights into the overall plan of the site while soliciting viewer input. The design and function of interactive and

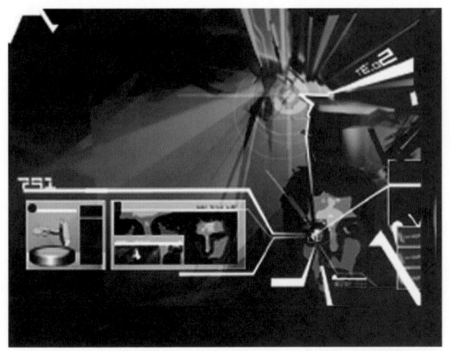

Clint Barnes
Roane State Community College

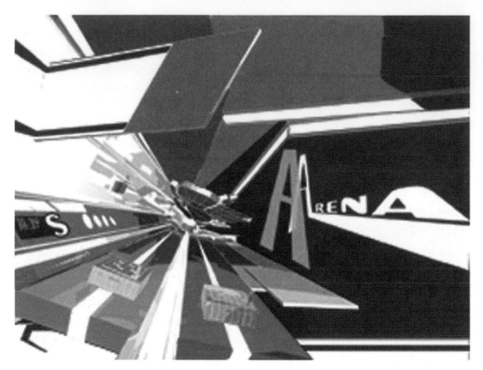

Clint Barnes
Roane State Community College

navigational elements, then, is to create opportunities for the viewer to alter the presentation of subsequent information. These spaces are active nodes of the Web site structure when they are encountered and become gateways to other information areas after they are used.

This suggests a certain malleability of graphic presence and a dynamic graphic function, both interesting criteria to address on the Web. If the function transforms through use, so can the design, calling graphic attention to the changing role of the element as the user adds or subtracts to the sequence of subsequent information display. These elements become active characters in the unfolding of a story. Their stage entrances and exits are determined by audience interaction, and their role in highlighting or accessing relevant marketing material and design content is an effective mechanism to achieve business goals.

▲ **KEY IDEAS**

- The Web offers a unique set of design elements, each of which must fit into a design strategy.
- Each element needs to fit into a design strategy.
- The design and function of interactive and navigational elements is to create opportunities for the viewer to alter the presentation of subsequent information.
- These spaces are active nodes of the Web site structure when they are encountered and become gateways to other information areas after they are used.

The Complex Web site

Mini-sites tend to grow as they become successful. Companies often begin small with their Web presence. Inevitably, the site will grow and the incremental additions will very shortly necessitate a total redesign. The internal structure of the corporation will be affected by its expanded presence on the Web and the need for a Webmaster will become clear. The existing intranet will expand to include new approaches to the Internet and slowly but surely the company will become a digital communicator. This pattern of change has moved beyond individual companies to whole industries, transforming an entire economy.

The complexity of the expanded Web site comes primarily from the breadth and depth of information accessed. In an ever-increasingly interconnected world, even a small bit of information can lead to exceedingly broad questions. The general scope of our daily lives has so greatly expanded over the past 10 years that no issue, no fact, no concept, and no question is addressed in a narrow context for very long. The successful Web designer becomes more of an editor than a content creator when it comes to information. Design is the method by which the information is accessed. It becomes the interface between strategic goals, the human experience, and the technologies of digital communication.

Design and information teams must be assembled, responsibilities delineated, timelines established, and review procedures developed. The breadth and depth of the requisite information, and the strategic use of links, search engines, interactivity, and information architecture, have to be examined from multiple points of view. Communications and technology problems require solutions. Methods of display must be finalized and system engineering started. The choice of an open system or a closed system will dramatically affect the quality and quantity of information. From there, the organizational and navigational approach will begin to take shape.

Thumbnails are transformed into digital storyboards. Layout is launched and coding commenced. Photography is assigned. Detailed research is begun. The design team begins to fully develop areas of the overall site, moving back and forth from close attention to specifics to a review of general perspective, revising information pathways, gateways, and nodes as obstacles arise to use of the site.

Issues of feasibility, functionality, delivery, and usefulness become a new set of criteria for judging the communicative and economic effectiveness of the site. What is the overall approach to the space of the page? Is it useful? Is there an organization grid or structure that signals transitions between levels of information? Does it work? How will imaging enhance the information architecture? How is it accessed? Are multimedia, animation, and nonlinear sequencing delivered in ways that help achieve the business goals? How can the design team quantify its strategic decisions?

Not all the questions can be answered all at once. The important thing is to get the site up, work out the technological bugs, and revise in real e-time and real e-space.

▲ KEY IDEAS

- The complexity of an expanded Web site comes primarily from the breadth and depth of information accessed.

- In an ever-increasingly interconnected world, even a small bit of information can lead to exceedingly broad questions.

- Design is the method by which information is accessed.

- Design becomes the interface between strategic goals, the human experience, and the technologies of digital communication.

The Personal Web Site

Creating a personal Web site offers an opportunity to explore Web design removed from the demands of business goals and client needs. It is a good place to begin addressing your role as a media content provider.

This design project must begin from some specific kinds of research. You can develop some interesting exercises to record aspects of your persona. You might have a friend videotape you as you go about your day. You might have someone interview the people you regularly interact with, just to see how different their ideas about you are from your ideas about you. Develop a variety of methods to solicit ideas about you from your network of social relations. Close family, distant family, work, school, church, clubs, various circles of friends and colleagues: each constitutes a different social environment in which we behave at least slightly differently.

Translate this material into words, pictures, sounds, and video. Make up alter egos that can stand in for you when you need them to. Be sure they reveal some usually hidden aspect of your self.

Create a site plan. Choose a layout that is most appropriate to how you are and how you want to be perceived, or that draws upon the idea of strangers looking at you from their own personal and cultural perspectives. How do you situate yourself within your site? Are you accessible via e-mail or chat rooms, or are you hidden from view? Does your audience have opportunities to redesign you via interactive participation, or are you simply on display?

Is your organizational plan linear or nonlinear? Do you need the full assortment of multimedia materials to convey a full sense of who you are, or can you pare down the presentation to bare essentials that can be mixed and matched by the user?

Do you have a goal for this site? Does the goal serve an editorial function in which some personal material is chosen over other material? Can your site be arranged so that only certain sections are available to certain kinds of people? Is it promotional? Are you selling a product or a service?

Philip Gray
Roane State Community College

Once your site plan is established, you can further develop each section, making decisions about content and media. Review where the different sections interact with each other, where the points of contact are, and how they are accessed. Develop a navigational system and some site signage that will signal these pivotal points. Then you can tackle design decisions on typography, color, and composition. These decisions should fit into the overall plan and reinforce the hierarchy of page layout, site organization, and information architecture.

Typography and color, along with your navigational tools and site signage, should provide a visual indication of where the user is in the site and how important the information being accessed is in relation to the other information provided within the section or the entire site. Composition or page layout both contains the media content and creates a visual identity corresponding to the information architecture, marking level, section, and transition points from section to section.

The design elements are the part of the site your viewing audience will see. The information architecture is the way in which they will encounter these design elements. The designer must pay equal attention to the creation of each and be sure that they are self-reinforcing—but the designer must also recognize the different functions the two approaches play in realization of a site.

Navigational tools can be animated characters, signs, buttons, or links. These are the methods by which each part of the site is accessed. They can be introductory and closing statements about the site level. They can be pop-up surprises that take the user to special sections of the site. They can be hidden rollovers or in-your-face graphics. These tools are your instructions to the user; they are signs that direct and instruct; they are both content and structure. Navigational tools are as important as page layout in the design scheme. They reveal the designer's intentions and form a key to understanding the site.

▲ KEY IDEAS

- A personal Web site offers an opportunity to explore Web design removed from the demands of business goals and client needs.
- Create a site plan.

 Is your organizational plan linear or nonlinear?

 Do you have a goal for this site?

- Develop each section, making decisions about content and media.

 Review where sections interact with each other.

- Create a navigational system and some site signage that will signal pivotal points.

- Utilize information architecture to measure the usefulness of design elements.

E-Commerce Web Site

The e-commerce site connects the busy producer to a vast network dedicated to highly personalized consumer choices that proffer instant gratification, safety, and convenience. However, for the most part, e-commerce Web design has not taken full advantage of its unique position. It has tried to reinvent the small specialty shop, the large department store, the suburban shopping mall, and the mail-order catalog all in one.

The small specialty shop offers quality items produced with a personal touch and brand-name authority. Brands such as Waterford, Tiffany, Sony, De Beers, Rolls Royce, and Leica and so on are examples. The specialty e-commerce site must address issues of authenticity and credibility while using Web technologies to replace the experienced refinement of the specialty salesperson. The only advantage the specialty e-commerce site has over the specialty store is that it is easy to access, always local, and always visually compelling. The site has to replace physical luxury with virtual luxury and human interaction with multimedia.

The large department store offers a range of related products, in order to ease shopping tasks while suggesting a sales volume that translates into customer savings. The e-commerce site can also offer a vast range of goods, but only careful organization can ease shopping and suggest economy. Browsing must be encouraged, but the customer should never get lost in the site.

The suburban mall brought diverse brand names under one architectural umbrella, with the added value of plenty of parking. So successful was the mall that it created a new sort of social behavior, which extended the shopping experience into a lifestyle. Malls became places to "hang out," meet friends, have dates, and do business. A well-designed e-commerce site offers an opportunity to replicate this extravaganza of modern socialization, this microcosm of interactive events, and to do so virtually with the full power of the Internet and its instantaneous global communication.

The first direct-mail catalogs provided unequalled opportunities for rural folk and busy businesspeople to shop conveniently for items that were otherwise unavailable. They brought choice and quality and assured customer satisfaction. They convinced consumers to let go of their money without the tangible object of their shopping desire in hand. Your e-commerce site has to match the complexity of the direct-mail catalog while ensuring ease of access and privacy. Reassure shoppers that their money is well spent; make shopping fun and intimate. Be sure the account information and transaction point are clear and secure, and you will be well on your way to creating a site that customers will visit and revisit.

The architecture of the site must make the range of products represented in the site easy to navigate and fun to discover. Special pages should be revealed at particular junctures: for example, a pop-up accessory page that is revealed after the purchase of a fashionable dress. Suggestions by an online expert can help

guide shopping decisions; special announcements for child/spouse/friend gifts can animate the site with interactive audio files. Sidebars can come up for e-lunch or e-coffee break, complete with chat room. The breadth of links and the opportunity for cooperative advertising are endless. The structure—and the identity of the site itself—are the only (self-imposed) limits for the designer.

The site must address five essential points: the point of entry, the inventory, the transaction point, signout, and finally, a special "goodbye and thank you" point. Of course, there can be nonlinear interrelations between the points, but their essential distinctions must be maintained.

The entry point must embrace the customer, put him or her at ease, and make the shopper familiar with the navigational tools and design elements at his or her disposal. This last point is essential, as it sets the visual tone for the entire site. Surprises, animations, even audio clips and special effects can occur throughout the site, but the first page must set the tone, outline the navigational structure, and introduce the design elements—all within five to ten seconds. Pull-down menus, interactive buttons, and rollover animations can add depth and excitement to the entry point. Audio clips can stimulate customer "connectedness" to the site, while high-quality animations can help the customer discover the intricacy of the site structure.

The inventory consists of the products and product lines. The inventory must be organized, structured, and highly accessible. Never let the customer leave the store without introducing new, related products and additional shopping opportunities. The inventory is the central concern of both client and consumer but is often the least designed. A navigational flow that permits the consumer easy access to the inventory, while still offering the opportunity to explore and discover, should be created.

The transaction point must offer absolute security, friendly and reassuring images, and a full recapitulation of the shopping experience, without overwhelming or boring the customer. If your site fails at the transaction point, it will not be an effective marketing tool.

The e-commerce site architecture must replace the knowledgeable and caring salesperson. Its great advantage is ease of access. Its great disadvantage is the lack of human touch. A well-designed site can redress the downside while improving on the upside. Find creative ways to put the helpful and expert salesperson back into the shopping experience without being distracting or

condescending. If your shoppers know what they need and want to get their shopping done quickly, give them ways to do so. But if the customer needs advice, product history, testimonials, or even demonstrations, be sure there are opportunities for that as well.

> ▲ **KEY IDEAS**
>
> * The architecture of the site must make the range of products represented in the site easy to navigate and fun to discover.
> * The e-commerce site must address five essential points: point of entry, inventory, transaction point, sign out, and special comment.
> * The entry point must make the shopper familiar with the navigational tools and design elements available.
> * The inventory must be organized, structured, and highly accessible.
> * The transaction point must offer absolute security and a full recapitulation of the shopping experience.

Promotional Web Sites

Along with advertising and direct mail, Web promotion is the next best thing to word-of-mouth. The promotional Web site should be part of an integrated marketing and public relations strategy if it is to attain its full potential. The design of the site should reflect the design approaches used in print and other broadcast media. Color, typeface, logo, approach to imaging: all should form a comprehensive message that reflects the company's values, its future plans, and its clientele's concerns. If there is a corporate design manual, the promotional site will incorporate many of the prescribed elements. If there is no manual, the first step should be to develop at least a basic one, so that the impact of the site can be extended and reinforced over different media—even if you do not have the entire branding job.

The next step is to fit the site into an interactive communication strategy by offering ways for clients and potential clients to use the site to receive additional information. That information may be a human voice over a phone

line, or it may be a printed piece such as a catalog or a capabilities brochure. It may be a promotional sample or a gift. Be sure to think-tank with the marketing and public relations departments on all the ways in which the site can be leveraged. It will make the site—and you—more valuable to your client. If you have not clarified the role the site is intended to play in the marketing plan, and the physical and strategic relationship the site has to the identity campaign, there can be no way to judge the success of the site itself. This can only lead to frustration for everyone.

The promotional site itself, like any advertising piece, must compellingly present a case for self-improvement and offer clear instructions to the viewer. The interface design should be concise, transparent, and engaging. Interactivity can be present, but it should be used sparingly. Get to the message and the product quickly, and then motivate the user to leave his or her personal information so that the next step in the marketing campaign can be taken. At that point there are multiple opportunities for personalizing through interactive participation.

Product or service information must be accessible and visually stimulating. The front end of the site should be image-driven, with visual simplicity and strong communication design the order of the day. Establish the compositional approach that will dominate the site, give the user a visual key to navigating the site, and promote the product or service line clearly.

Physical experience cannot be duplicated on the Web. Pretty landscapes and special effects cannot replace embodied knowledge gained by real-time interaction with the product or face-to-face encounters with key service managers. The designer needs to replace the complexity of physical experience with high-concept visual communication that delivers the message quickly, precisely, and pointedly. Consumption of the message serves as a gateway into a clearly organized information structure that can add dimension to the message, specificity to the product, and individualization to the promotion experience. The designer must stimulate the brain by offering it what it enjoys: ideas.

Audio files extend the presence of the site. Three-dimensional animation files expand the engagement orientation of the viewer. Navigational guides and wayfaring indicators locate the user within the site architecture, adding a reflexive physicality to the experience. Products can be seen "in action" through video clips, and services can be personalized through bold messages, directives, and strong images.

Clint Barnes
Roane State Community College

Never overpower or overwhelm. "Speak slowly and enunciate" is a good adage, translated to the methods and practices of visual communication. The Web is still mysterious to many consumers. Create a design strategy that reveals, entices, and surprises. Weave a tapestry of visual and audio pleasures, appropriate to the product or service and respectful of the values of the market.

▲ KEY IDEAS

- The promotional Web site should fit into an integrated marketing strategy.
- Use an interactive communication approach.
- Get to the message and the product quickly.
- Give the user a visual key to navigating the site.
- Use high-concept visual communication to create a gateway into a clearly organized information structure.
- Never overpower or overwhelm; create a design strategy that reveals, entices, and surprises.

Banner Ads

The design challenge for banner ads is to get users who came to the site for other reasons to give three to five seconds of their time. Cute won't cut it. The banner ad must be easy to absorb and just-this-side of intrusive. Let's start with the message. It must be short, bold, and audacious. Advertising strategy is not

informational or transactional. It is intrusive. It also has to be engaging, novel, and communicative.

A pleasant and effective way to be intrusive is to embed streaming audio files in your banner ad. Although you run the risk of competing with the host site's audio files, you can build your ad to load fast and first. This problem will only get more complex as the Web integrates more and more multimedia, but the need for clarity and advertising revenues will generate the appropriate solutions.

Work with a creative team, conceptualize the Web banner ad within a larger campaign, and build on product strength, client position, and a deep knowledge of the emotional responsiveness and cultural values of the market.

Images must be small, yet visually stimulating. Try the unexpected. Visual metaphor can have a special appeal. So can humor, drama, and simplicity. Vary strategies and test the markets. Everything from image to typography must speak clearly and quickly. Create short taglines that specifically reference your markets. Use a recognizable logo and activate the small space. Small can be very effective if it is used well. Build special surprises into a rollover image map, or even build in a link to the product home page, just in case your user is so captured by your banner ad that all previous intentions about using the Web get put on hold.

▲ KEY IDEAS

- The banner ad must be easy to absorb and just-this-side of intrusive.
- The banner ad must be engaging, novel, and communicative.
- Conceptualize Web banner ads within a larger campaign; build on product strength, client position, and a deep knowledge of the market.
- Vary strategies and test markets.
- Create short taglines that specifically reference your markets.

Web Animation

Animation for the Web shares many of the design requirements of animation for video. Each character must be fully realized, fit into a narrative story structure, and move the plot along. Characters can range from 3-D text to personalities in recognizable (or not-so-recognizable) bodies.

Clint Barnes
Roane State Community College

Web animation is both content and technology, but content is always the primary issue. What communication goals are to be achieved with the animated characters? How should these goals be achieved? How will the animation affect the overall design strategy? These are the questions to ask when you are deciding whether to animate.

Motion demands that graphics change over time. The change can be linear, as when a storyline is developed and graphics are used to propel the story toward points of transition, departure, revelation, and emergence. Or the change can be nonlinear, where cumulative developments transform in unexpected ways. If the change is interactive, the user can control the pace and form of change, at least to some extent. Using animation does not reduce the number of design decisions that have to be made to achieve the design goal. It only adds to the range of choice.

Animation can be used to create motion graphics, including titles or characters. In motion graphics, the simple design elements such as lines, text, and directionals are animated. There may be background layers and/or multiple foreground layers, each animated independently or combined to arrive at a special design effect.

Pictures can be animated along a storyline, as in a narrative short, or can be assembled to achieve a graphic strategy, such as in banner ads or in 'zines. The pace, tone, and texture of the animation achieved through editing techniques are as important as the content of the animation—and, of course, an audio track can be very useful to supplement an animated graphic presentation.

Animation can be used effectively in entertainment design for the Web, simulating music videos and other multimedia presentations. The rules for entertainment design still apply. Keep things in perspective. The design should not overpower the promotional content. But if you stay within these guidelines, animation can bring the Web page to life, recreating the dynamic experience of the art forms it publicizes. Video and audio files, along with full-on motion titles, can be brought together in an animated Web site that combines the creative power of the Web with the art of broadcast media.

Once the design strategy and Web page layout have been determined, it is time to create the characters and lay them into an animated time sequence. Once the sequence is developed and a story is revealed, fine-tuning on the edits and transitions is required. All sequences should be reviewed to be sure that each is fully crafted and fits into an overall scheme that supports the goals of the site.

Each animated character must positively contribute to the message of the design and to the goals of the client. There is little room for haphazard approaches, though there is a need for spontaneous inspiration, radical ideas, and innovative combinations. Planning in infinitely small detail cannot replace the "big idea"; nor can the overall concept take shape without great attention to detail.

▲ KEY IDEAS

- Using animation adds to the range of choice in design decisions to be made in achieving the design goal.
- The pace, tone, texture of the animation are as important as the content.
- Review all sequences to be sure that each is fully crafted and fits into an overall scheme that supports the goals of the site.
- Each animated character must positively contribute to the message of the design and to the goals of the client.

Interactive Web Sites

Because design is a form of communication, it requires the designer to build a visual bridge between the client and the consumer, to facilitate the interchange of ideas. Design is the form, the content, *and* the technology of that exchange. Recognize, however, that this exchange will always be incomplete, in that it is subject to the influences of broader concerns, such as the mechanics and methods of perception, the psychology and politics of economics, and the cultural patterns that create meaning in a society.

The Internet is a communication medium of unprecedented complexity. Although the early formation of the network seemed to rely on the technology of possibilities rather than the actual content of exchange, in very short order the possibility for dynamic cultural transformation developed into a network of actualization. Moments of contact became a subculture of connectivity. Surfing became a philosophy. A culture of practical prescriptions embraced a dynamic, multicultural radicalization that removed barriers to the free flow of ideas and initiated a transformation of culture that rivaled the invention of the printing press.

At its most basic level, interactive design means that the user will determine the flow of information by making decision at certain junctures of the site. These decisions will be recorded at designated places by mouse clicks. The result will bring up certain kinds of information directly tied to the decision

Woon Yong
Savannah College of Art and Design

Michael Casanova
San Antonio College

recorded by the user. For instance, at a certain point on the Web site, the user records whether he or she is male or female by choosing one of the bifurcated choices offered on a radio button. Certain information related to men will follow if the user selects the "male" button. Different information will follow if the user selects the "female" button. An interesting sidebar to this, of course, is that in neither case can the "real" gender of the user be determined. He or she can click on either button, or follow one and then backtrack and follow the other.

In any case, it is the user who determines the information flow; the designer provides an architecture that can accommodate the choices while still achieving the client's strategic goals. Because the site can accommodate all of the niche markets available to the client, and because the individualization of information offers a sense of empowerment to the user, interactive design can optimize marketing approaches.

The design challenge is to craft every scenario; design all the versions that can be accessed by the potential usership; and provide a continuity of product identity, clarity of purpose, and organized navigation throughout the entire site. This requires detailed preproduction through research, scenario planning, and storyboarding before entering the design phase.

Once the range of interactivity is settled and the content of the decisions has been determined, the site architecture must be constructed. The architecture will, of course, provide for the multiple streams of information that flow from decisions determined at the interactive nodes. The important thing to remember is that the user-participant is not creating information but affecting the order of access, thus increasing meaning or at least use value. Plan through every possible result of every possible choice. After this process is committed to paper, get some new perspective on it by concocting some outrageous scenario: "Would your site still achieve its stated goals if …" and fill in the blank with something you and your team have not thought of yet.

Once the site architecture is determined, it is time to start developing the design elements, assigning media creation, finalizing copy, structuring approvals, and market-testing parts of the site as it comes online. Each area of the complex, interactive site will incorporate different mini-sites, navigational aids, animation, text, flat art, and audio files. Use all the tools that you are familiar with, and try to incorporate some new approach or to develop some new technique with each site you design. Extend your range each time you design.

▲ **KEY IDEAS**

- The Internet has initiated a transformation of culture that rivals the invention of the printing press.
- Design is the form, the content, *and* the technology of the exchange between client and consumer.
- In interactive communications, the user determines the information flow. The user does not create information, but affects the order of its access.
- The designer provides a continuity of product identity, clarity of purpose, and organized navigation throughout the entire site.

'Zines

Electronic magazines, or 'Zines offer the editorial Web designer some most welcome relief from the frenetic pace of magazine publishing. They are always very personal and usually somewhat radical. They are explorations in creative design, Web technology, and mass communications, and exercises in cultural and personal awareness. 'Zines offer a public forum, a visual pleasure palace, and a respite from prescriptions. 'Zines take advantage of the Web's greatest potential—the unhindered distribution of information.

"Pulp" fiction differs from "noble" fiction principally through prescriptions on the appropriateness of ideas. Pulp fiction shares the same passion, communicative power, and references to social conditions, values, and belief systems that noble fiction does. However, these similarities translate into entirely different design choices, with the formality of noble design offering a marked alternative to the rawness and vitality of pulp fiction. The 'zine is similarly distinguishable from the advertising-driven, glossy content of live-style magazines. Relieved of print production costs and freed from process color, 'zines function in cyber world with its own, somewhat irreverent, approaches to media content.

'Zines live in a half-world. They are text documents in an image-driven medium. They are information points in a forum of constant change. They are electronic journalism that seeks high-concept design. 'Zines are conflicted, but because of that they are malleable and inventive. In the time of the emergence of e-paper, 'zines offer some interesting possibilities.

'Zines can be personal or commercial, but traditionally they are not promotional or industrial. They are not Web equivalents of a corporate newsletter. They can be image-driven or text-driven. They can incorporate innovative
design approaches or offer traditional journalistic layouts. They can assume
a one-way direction of communication from the writer-designer to the reader-consumer, or they can be interactive, using online chat rooms or an open-ended contributor list. They can integrate Web advertising or other forms of e-marketing and e-promotion.

Like any graphic design project, 'zines bring words and pictures together to communicate and examine ideas, opinion, and values. They do so in a global, broadcast medium of moving text, animated images, and audio support. In
'zines, words can become pictures, and pictures can become four-dimensional multimedia narratives. The full power of Internet technologies is at the disposal of the 'zine creator.

Content can reflexively refer to the 'zine's roots in journalism, referencing the personal and social freedoms initiated by the spread of literacy and sustained by a democratic press. This kind of approach could create open forums of interconnected writers, thinkers, and artists whose contributions to the content of the 'zine are also its primary form.

Ramiro Torres
Savannah College of Art and Design

Alternatively, the 'zine creator might take the mediated, entertainment approach, in which content is prepared and displayed, accessible to a variety of userships but not particularly dependent on any. This kind of site might offer content that is edited through a variety of strategies, including spontaneous shuffling of information, hidden links, and nested mini-sites.

Sony Agrawal
Savannah College of Art and Design

The journalistic strategy will dictate the approaches to information architecture, the form of the site, its elements, and the media content. The successful 'zine will attract a wide usership and offer opportunities for that usership to participate not only in content consumption but in content creation as well, using the full power of the Web and contemporary communications technologies.

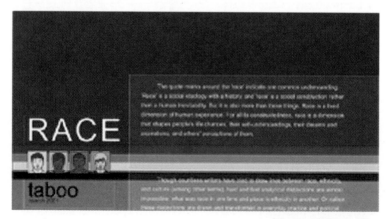

Manop Manaslip
Savannah College of Art and Design

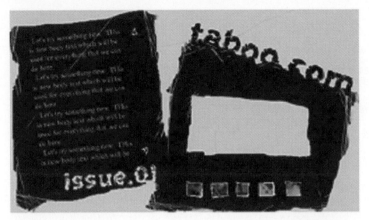

Michael Creighton
Savannah College of Art and Design

The challenge of the 'zine is to explore the form and content of communication while making original, compelling, and engaging contributions. In both a statement and a question, 'zines ask what it means to be a member of global subculture, even before that subculture has formed.

▲ KEY IDEAS

- 'Zines offer the editorial Web designer an alternative to magazine publishing.

- 'Zines are always very personal, and usually somewhat radical, exercises in cultural and personal awareness.

- 'Zines take advantage of the Web's greatest potential: the unhindered distribution of information.

- 'Zines are text documents in an image-driven medium.

- In 'zines, words can become pictures, and pictures can become four-dimensional multimedia narratives.

- The journalistic strategy will dictate the approaches to information architecture, the form of the site, its elements, and its media content.

Professional Perspectives

K. L. Thurlbeck
Instructor
The Katharine Gibbs School, New York

Brand Experience
Brandversation

Brand identity is a conversation, an interaction—a *brandversation*. Like any conversation, it leaves an impression. Of course, the nature of the impression will depend on the value of the interaction, the way it has been communicated, the way it has been received, and the extent to which it has been engaged.

By the mid-1990s, the Internet had changed the way we worked; the way we were educated; the way we played, shopped, and communicated. And it promised more. For anyone involved, this transformational time was exhilarating and exasperating. The learning curve was no longer a curve but a straight line moving vertically from its base. The future was again upon us with predictions of revolutionary change and rapidly developing evidence of that change. Movie theaters would cease to be, the Internet would bring the demise of radio and television, there would be no further use for the Post Office, the corner video store would be replaced by online, on-demand subscription services, and every brick-and-mortar store would become click-and-mortar.

Brandversation v1.0

Corporations rushed with a vengeance to grab history and launch their Web sites. These first-generation Web sites were little more than electronic brochures, and were commonly referred to as *brochure-ware*. These sites usually contained an "about us" statement, some corporate philosophy that had been resurrected from the company archives, dusted off, and lightly rewritten. Descriptions of the company's products and services, a careers section, and a "contact us" link were also included to finish off the site. Branding was considered to have been addressed if the company logo and slogan were in a prominent place and appeared in as close to corporate colors as possible.

Brandversation v2.0

Evolution into more adventurous territory spawned the birth of second-generation sites: interactive sites. Here a company's hope was to mine data, with the intent that this information would help it better understand the consumer. This collection of data would build a profile on the consumer and, in theory, provide the company with a rich understanding of the consumer's lifestyle and spending habits. The hope was to benefit both the consumer and the company. Usually this was accomplished by giving something to the consumer in exchange for filling out a customer profile. Case in point: *The New York Times* gave free access to its online edition to those who completed such a form. The form requested a brief personal profile and asked permission to e-mail information that the company thought might be relevant to the consumer. Once this was completed, the consumer had daily access to the news and the *Times* had a "cookie" (an information retrieval program) embedded in the user's computer. In theory, this cookie could provide a stream of information, including following the consumer's online navigational history.

Attention was paid to the brand experience, but only as it applied to the content of the product or service offered. If a company had a fun product or service, the experience was made more playful; more businesslike products or services gave a more straightforward experience. Although a plethora of data was collected, many companies did not know where to go with this information, where to store the ever-increasing supply being poured into their systems, or how to use it.

What *was* emerging was an exploration into user expectations and, in fact, into the way future business would be conducted and branded. Great effort was taken to ensure that consistent branding and a brandversation emerged between the content of the product or service, but contextual branding was only hinted at.

Brandversation v3.0

Soon third-generation, transactional sites appeared. Business could actually be conducted as information was harvested. For a brief moment in time, the idea of a Webcentric environment revealed a future where much more was possible. However, the original hope of having a low-cost media vehicle proved unreachable, as the drive toward Web advertising proved that bringing traffic to a site was a costly affair. The heavy lifting of driving eyeballs to sites proved to be a

Herculean task. The promise of Webcentricity proved to be the downfall of many sites. Only a few Web-only businesses prospered, although not necessarily financially. Companies like Amazon, which had developed a business model based on retaining each customer and refining customer profiles over a significant number of years(as long as 12 years), built better customer loyalty. Not only did their plan provide a model for an extended brandversation, but their ability to harvest information on their customers also permitted them to develop a richer brand experience. Contextualizing created rich experiences for customers and increased business opportunities for Amazon. For example, whenever a purchase was made, customers were presented with similar purchases of other customers and other suggestions in their category of interest. By taking the legwork out of the customer's research and showing interest in the customers' request, Amazon built a brand that is customer-centric. Contextualizing the customer's experience actually builds business for Amazon.

Brandversation v4.0

The destination site or destination fulfillment business model is undergoing a colossal evolution that goes beyond Webcentric or brick-and-mortar-centric models. It is a profound change that has refocused many corporations from a Webcentric perspective to one that is customer-centric. Simply providing an environment as a platform for content is not enough. The consumer wants more, demands more, and is being given more, and this has put more pressure on the brand promise.

The expanding digital bubble that surrounds each consumer also increases the pressure on every brand promise. Content is expected, but content alone does not constitute or guarantee success. Content must be delivered in a contextualized environment. Contextualized branding links touchpoints throughout the user's experience, making the experience more rewarding.

The Internet continually reconfirms that its power lies in the ability to connect people and ideas. The popularity of chat rooms, user groups, and e-mail are but a few everyday examples. Brand must also make that connection to the individual. Today, companies must act as though everyone has been wired into a wireless world.

Narrowcasting versus. Broadcasting

Contextualized branding does not look at communicating a general message to a large group of people. Quite the opposite: it narrowcasts a message, personalizing that message for a specific audience. By building an audience of ones with

targeted messages, every message adds value to the brandversation between the brand and the user. Johnson and Johnson's Tylenol banner campaign explored this concept by running banner advertisements on financial sites: the ads for Tylenol appear whenever the market drops 100 points or more.

The brand promise is an experience, a journey, and a friendly walk that always adds new value. It can bring consumers back or send consumers searching for another experience to meet or exceed their expectations. The more the brand promise considers the needs of the individual consumer, the deeper that consumer's loyalty to the brand will be.

Theme parks are exploring ways to improve brand experience by giving users smart cards that allow them to avoid waiting in long lines. By swiping a smart card at a card reader on the ride of choice, the user registers a place in line and is given a time to return. In our wireless environment, we will be soon be able to do this from our cars on the way to the theme park. Once we arrive, there will be no need to stand in lines, as the schedule will be preprogrammed on our mobile communication devices, ensuring more fun in the experience—a better branded experience.

Furthermore, knowing a customer's schedule would enable the theme park to send him or her targeted messages. He could receive instant messages as he moved through the park, suggesting times to eat and offering coupons or discounts for eating at certain times at certain food providers. Not only is this a benefit to our user's branded experience, but it helps draw customers into places in the park that may require traffic at that moment, improving the user's experience as well as the park's business.

Brand is a conversation that can take place at any of the encounter points that exist in a consumer experience. At a theme park, the user could enter the experience at any point through a phone call to the park or travel agent, or a purchase at a souvenir stand.

A credit card owner has multiple entrance points into the brand. The card owner could enter her experience by paying the bill on line or making a purchase at a store. Wherever she enters into the experience, she will be touched by the brand. It is the responsibility of the company to ensure a meaningful contextualized experience if it wants to retain the customer.

Contextualized Brand

The advent of the Internet has highlighted the importance of the brand experience. It has also revealed that the experience must be contextualized.

Brand experience is a one-fold proposition: brand and experience cannot exist without the other. For a brand to survive, it must display a very clear, distinguishable brand promise, focus, and goal. Product or service attributes go beyond the immediate benefits of a product or a service and are influenced by the attribute of the brand promise, as it is contextualized throughout the touchpoints of the consumer experience. Contextualizing the consumer experience means developing a branded experience that constantly exceeds a customer's expectation. Imagine a scenario in which you are connected to a true brandversation. Make it simple, a scenario booking a ticket at the airport for a business trip. You have a profile stored in your computer and send it to your online ticket broker. You want to arrive in New York and return a week later. As you book the ticket, you are given a list of car rentals, hotels, restaurants, and special events happening at the time of your visit, personalized to your own preregistered preferences (sports fans get a list of sports events, geeks find the latest techie shows); a reminder to send a gift to your dad for his birthday (with a suggested selection of gifts); and a wake-up service. Movies preselected according to your tastes await you at your hotel, with delivery to your room pending your confirmation. On the way to the airport, you check your wireless PDA and discover that the plane is running late, but you are given the option to change your reservation. If a revised flight plan is not possible, all your plans are updated and the hotel, car rental, video rentals, and dinner reservation are all notified, along with your confirmations and contact information.

It was the Internet space that reconfirmed what was previously known but has been somewhat forgotten. Branding means a great user experience. Good Internet branding went beyond a logo and tagline into real-time interaction for the online experience. But brand identity does not stop there. Developing a contextualized experience may include doing more than one company is able to provide. Coalition programs, partnerships between companies with the purpose of providing a seamless consumer experience, recognize the importance of granularly defining a company's brand in relationship to other companies in the emerging wi-fi environment. As consumers settle into their digital, wired bubbles, the demands for personalized experiences will intensify.

Don't Leave Home Without It

Our communication technology has us wired to the world, exposing the customer to the branded experience 24/7, anywhere, anytime. The more robust the technology becomes, the more creative minds find ways to employ it. M-technology notifies us when we are in the vicinity of a friend or business

contact. It offers us coupons redeemable at restaurants we are passing by. It notifies us that a book we are interested in has arrived as we pass by the store.

Today in Japan, NNT DoMoCo has put all of this in place. Teenage girls have totally embraced this technology, turning their mobile phone/e-mail/entertainment/wi-fi environment into a fashion item worn as a necklace. Salarymen are wired in and out of the office as Gen3 mobile technology becomes ubiquitous. NNT DoMoCo's success lies in its creative ability to align its brand with thousands of other companies.

Cell phone ownership among teenagers in Sweden is 100 percent. The opportunities to immerse an audience in digital communication is limited only by the ability to creatively use current and future technology.

Today's branded experience is an interconnected experience that links the user with a robust, meaningful, personalized, prioritized experience. It requires a brand vision that is creative, customer-centric, and globally encompassing. It requires a brandversation that is imaginative and compelling. It requires people with a relentless creative vision and imagination to continually evolve the brand experience.

chapter nine
Motion Graphics

Motion graphics create a frame and a method of engagement with the content they support. Start by developing your motion graphics on storyboards, paying particular attention to the business and communication roles your motion graphics will play. Consider narrative structure, character development, the copy requirements, and the design elements of light and color. Develop some distinct strategies and identify the key turning points. Your notion graphics will need to transform these turning points into visual stories. Begin thinking in sequences and montage, letting the story unfold through "negative space" where the audience members can add their own interpretive material and interactively engage with the design.

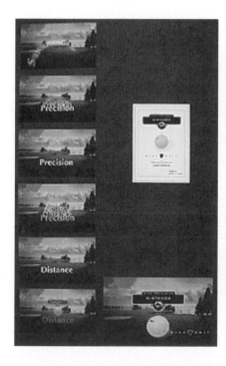

Marie Clanny
Briarcliffe College

Motion Logo

The approach to the motion logo is similar to that for a logo design for print, but translated into the medium of four-dimensional, time-based, broadcast design. Motion logo design is about creating a visual identity that defines a company in highly refined ways. A successful logo speaks about the company in terms of its future, not its past. It takes reflection and participation from the entire management team to formulate these goals; the designer must facilitate this process, keep it on track, and be sure there is meaningful input from all sectors of the corporation.

Once this is accomplished, a story should begin to emerge about where the company was and where it is going, how it is getting there, its relation to its market(s), and its position on relevant social issues. This story will suggest the characters and graphic sequences that will define the tone and texture of the motion logo. Motion graphics must incorporate drama and story structure to be effective.

Design elements will be of two sorts: characters and context. Characters can be almost anything, from live-motion people to moving text, but they must be defined by their relation to the storyline. Characters help move the story along by creating turning points in the plot through emotive contributions such as humor, drama, conflict, and resolution. Contextual design elements provide information regarding psychological and social setting, thereby preparing the way for the drama to unfold. It is this drama that constitutes the content of the motion logo.

Although a motion logo is clearly not a feature-length movie, audience perception for motion graphics is greatly affected by the kinds of story types and imaging sequencing seen in broadcast programming and theatrical-release films. Contextual elements must be researched, and characters have to sustain and extend the believability of the story. The motion logo designer needs to know all the principles of good identity design and then apply them to time-based media. Integrating audio files and special effects as design elements, crafting a logo that embraces good dramaturgy, and putting the elements together into a believable story that audiences can understand defines the complexity of working in motion graphics.

Sherri House
University of Texas—Pan American

> ▲ **KEY IDEAS**
> - Motion logos create a visual identity.
> - Design elements will be of two sorts: characters and context.
> - Characters help move the story along by creating turning points in the plot.
> - Context in the form of storyline provides information regarding psychological and social setting and creates drama.
> - Motion logos incorporate all the principles of identity design, applied to time-based media.

News Graphics

News graphics offer a visual key to news content. They complement—and offset—the entertainment value of the news broadcast while framing the veracity of the news with the identity of the channel. The news graphic introduces the news segment, incorporating some of the video footage or still photography that images the news story, and incorporates the station identity in its design elements.

These elements include the motion logo, typography, color palette, and organizational strategies used in the information design of the station identity. The information design strategy functions in a fashion similar to that of the corporate design manual. It prescribes and defines many of the design elements used to translate the textual and informational content of the news show into the information design strategy of the news graphics. Oddly enough, this strategy also affects the entertainment value of the news show, by bringing color, tone, and texture into a fully integrated, reinforcing graphic strategy.

News graphics themselves consist of two kinds of visual structures: the image content and the framing device. Image content is often an editorial decision. However, to use image manipulation through cropping and angle of view, along with story-telling devices such as montage and sequencing, the news graphic designer must understand the twin contributions of the news producer and the news consumer.

The designer's role is to enhance and clarify news coverage in response to journalistic considerations while creating an appealing and consistent delivery device that will be recognized and appreciated in all its visual complexity by the viewing audience. This emotional and intellectual interaction reinforces both the credibility of the coverage and the reputation of the station.

▲ **KEY IDEAS**

• News graphics frame the veracity of the news with the identity of the channel.

• News graphics interpret the textual and informational content of the news.

• News graphics enhance and clarify news coverage while creating an information design strategy and entertainment value.

• News graphics reinforce both the truth-value of the coverage and the reputation of the station.

Sports Graphics

Sports graphics image both the statistical information and the entertainment value of a broadcast sports event. They constitute a visual frame that reinforces the emotional complexity and the entertainment value of the contest. They contribute to the visual identification of the station and integrate the design elements of the sponsors and teams.

Sports graphics, like most of the categories of motion graphics, are both a framing device and an information design system. In this particular kind of motion graphics, however, the entertainment value of the audio tracks and special effects must be incorporated in the information design strategy. Sports graphics play a pivotal role in expanding the context of play.

Sports graphics extend the time of the sports event by framing instant replays and historical shorts. They extend the space of the event by describing a grid of interlocking relationships. They extend the entertainment value of the event by interweaving personal stories of passionate achievement with the emotions of competition.

Sports graphics are a microcosm of entertainment and statistical design, conjoining the fantasy of physical prowess with the cold reality of mathematical comparison. They must be psychologically expressive and emotionally expansive, while referencing the rules of play and the objectivity of fair measurement.

Sports graphics should be open design systems into which the designer can incorporate the identity design elements of the teams, stadium, municipality, sponsors, advertisers, station, and channel. The principal goal is to display the statistical and personal information required to expand the context and impact of the play.

Graphic structure, typography, and composition reference the regularity and predictability of mathematical relations. Imaging and color reference the dramatic production value required of broadcast entertainment. Special effects, animation sequencing, and audio effects reference the dynamic chaos of chance.

The purpose of sports graphics is neither to replace the unfolding drama of the sporting event nor to compete with its production design. The sports graphic must integrate the colors and imagery of the sport event itself through cutaways to live action, dynamic comparison to previously recorded play, and the inclusion of the people and pageantry of the live event.

▲ KEY IDEAS

- Sports graphics join statistical information with entertainment value.
- Sports graphics reinforce the emotional complexity of the contest.
- Sports graphics extend the time of the sports event by framing instant replays and historical shorts.
- Sports graphics extend the space of the event by describing a grid of interlocking relationships.
- Sports graphics extend the entertainment value of the event by interweaving stories of passionate achievement with emotions of competition.

Opening Title Sequence

The opening title sequence for film and broadcast programming has become the focus of design attention as digital technologies continue to expand the range of opportunities for graphic designers. This particular design challenge brings together all the complexity of entertainment design, identity creation, story structure, and character development.

The film title designer—working in close collaboration with the film director, production designer, and art director—will first need to define the role the film title sequence will play in the introduction to the film. Will it frame and play off the film story as it unfolds? Will the title sequence serve as a short, narrative introduction to the film, setting up the first scene? There are many variations on these two basic strategies, but they are the two most common approaches to title design.

The title sequence must set up the filmic sequence it joins with. It is not enough to illustrate the meaning of the film or to highlight the principal cast or some of the pivotal events. The opening title sequence itself is an introduction to the setting and meaning of the drama; a way to create a dynamic, visual introduction to the film while the audience's anticipation is growing and its mood is forming. A successful film title design establishes the gateway into the world of the cinematic experience. It has to be visually rich and exciting, while remaining relevant to the film story and the audience.

The goal of the opening title sequence is to identify the principal contributors to the fiction that is about to unfold. There are contractual and regulatory aspects to the order, point size, and relationship among the participating corporations and individuals that structure the specific sequencing of the title design. However, for the most part, the title designer's job is to open the film—thematically, aesthetically, and structurally. To this end, image, text, and audio are employed, along with special effects, computer-generated animation, set design, and lighting design. All of the techniques and crafts used in the creation of the film can be put at the disposal of the title designer.

Before determining the title order, special effects, and co-imaging requirements, it is best to start a film title sequence by establishing the relationship between the title sequence, the overall story, and the meaning of the film. Is the title sequence the place to provide thematic introduction, historical or geographic information, or backstory? Is the title sequence the place to

introduce primary or secondary characters, or to foreshadow the turning points of the plot? Should the titles establish clues to the characters' psychology or motivation, or to the moral issues in the drama? Will the titles help the audience believe in the story or in the main characters? What dynamic relationship will be established?

The title sequence should set the tone, pace, and texture of the opening scene of the film. Will it create a special psychological mood in the audience? Horror? Joy? Arousal? Repulsion? Will it offer secrets and hint at the action to unfold? Will it set the pace for a fast, high-concept opening, or prepare the audience for an intimate moment of hushed tones, passionate revelation, and forbidden embrace?

Imaging may be supplied by the film director or shot especially for the title sequence. It may also be crafted by an animator, illustrator, photographer, or other artist. Eventually, the film title sequence will be output to film by a service bureau and then inserted into the film sequence by an editor. In the case of a video, the service bureau is omitted and the digital image is inserted right into the timeline of the video edit. As always, end use will determine many of the production requirements and final methods of finishing the project.

The design elements for film titles, in addition to imaging and layering of images, include typography and composition. Just as in print design, typography and composition must be conceptualized as elements within a visual hierarchy, the structure of which is based on the completion of a task and arrival at a goal. Use a narrative device that dramatizes an architecture of visual information. Use light to activate graphic space. The goal of this device is to facilitate bilateral communication between an audience and a film.

Typography should function as a compositional element, a visual marker for the audience's eye. Following the type should be a visual pleasure, an expedition through the details and intricacies of the screen, a ride over the layered depths of the moving image, an emotional passage into a new world.

Every film calls for the invention of a new typeface, one that is just right for the concerns of the story. If time and circumstance do not permit the creation of a new typeface, an innovative and evocative use of existing typefaces is required. Every film is a marvel; a series of miracles of timing and direction that take place once and then are gone forever, except as recorded images. Title design should celebrate this miracle; add its own contribution; and then step, quietly and graciously, out of the way.

IT'S ALMOST HERE

IT'S ALMOST HERE

~~IT'S ALMOST HERE~~

IT'S ALMOST HERE

COMING SOON

Enrique De Anda
University of Texas–Pan American

▲ **KEY IDEAS**

- The opening title sequence is the gateway into the world of the cinematic experience.
- The opening title sequence introduces to the setting and meaning of the drama.
- Establish the relationship between the title sequence and the meaning of the film.
- The title sequence should set the tone, pace, and texture of the opening scene of the film.

Special Effects

Special effects for motion graphics involve the dramatic and exaggerated use of lighting and texturing on pictorial and typographic design elements. Of course, there are many other kinds of special effects to achieve the desired atmospheric illumination, from computer-generated imaging to the use of certain camera techniques and film techniques.

Effects that are put to movement and integrated into a film scene or into the video sequence can be considered "animated" in that they are subject to changes and alterations according to a storyline. Digital effects are created with the same approaches to sequencing as are the more traditional forms of cell animation.

There is a conceptual crossover as well as technical one. Special effects are generally either pictorial or typographic enhancements. Pictorial special effects involve the creation of transitional moments when images merge, dissolve, and change in texture, form, color, and tone; and when the effects of lighting, focus, and angle bring certain parts of the transformation to the audience's attention to dramatize a plot point or character change.

Ramiro Lozano
University of Texas—Pan American

Pictorial effects are often applied to specific image layers or within layers to localized portions of the image. They can be used to call attention to details in an attempt to either clarify or confuse. Typographic special effects are digital simulations of light and texture applied to the surface of text. This creates optical effects that add character and mood to letterforms, enhancing drama and atmosphere. These special effects can be particularly useful when integrating words into the motion imagery. They can enhance the three-dimensional filmic space and frame specific image sequences.

Special effects can bring the audience's attention back to the story. They can reinforce a realism by their very artifice. They say, "It is, after all, only make-believe."

▲ KEY IDEAS

- Special effects involve the dramatic and exaggerated use of lighting and texturing on pictorial and typographic design elements.

- Special effects that are put to movement can be considered "animated" in that they are subject to changes and alterations according to a storyline.

- Special effects are generally either pictorial or typographic enhancements.

- Pictorial special effects involve the creation of transitional moments, and can be used to call attention to details, or dramatize a plot point or character change.

- Typographic special effects add character and mood to letterforms, integrate words into the motion imagery, and enhance the three-dimensional filmic space and frame specific image sequences.

Professional Perspectives

Lisa Graham
Associate Professor
University of Texas at Arlington

Moving into Web Motion Design

Motion design has been, until recently, primarily the domain of film, video, and animation artists and designers. In recent years, however, the evolution of sophisticated Web motion and animation tools has opened up opportunities to integrate motion design into Web ads, games, pages, and sites. Web designers now have the opportunity to create evocative and expressive motion designs that enrich user's Web experiences.

The Changing Web

For years, graphic communicators designing for the Web felt stifled by the technological limitations of relatively crude software and slow download speeds. This combination of software and download speeds restricted expression and had a dramatic impact on the look and feel of the Web. Web sites were mostly static, with simple rollovers and looping GIF animations, and were structured around tables, frames, and HTML code. Many Web sites were essentially brochure-ware with limited interactivity. Consequently, Web sites were often boring and stifling.

However, the software used to construct Web sites is constantly changing, and so too is the way designers can expressively communicate using the Web. Designers now have powerful software tools, such as Macromedia Flash and Director, that allow them to combine animation, interactivity, and sound in evocative motion designs. In the hands of a knowledgeable, savvy motion designer, these software tools are flexible enough to develop content deliverable with slow modem speeds as well as across broadband connections.

The good news for designers is that the Web, no longer limited to essentially static displays of information and some interactivity, now has the potential to provide expanded experiences for the user. Consequently, there is a crying

need for a new kind of designer, one who can combine the traditional principles of graphic design with effective motion to structure an effective communication in a technologically rich environment. The not-so-good news is that mastering the ever-changing tools takes time—lots of it—and a passionate belief in the communication potential of motion design.

The Communication Potential of Motion

Communicating through motion is far from new, and is understood to some degree by everyone, often independent of language. When a mother beckons to a child who is out of earshot, that child understands her intent by her stance and movement. A dancer wields his body's movement and speed with sophisticated precision, conveying urgency, delirium, dignity, calmness, and a host of other emotional states. No words are spoken; it is the motion that helps us experience and understand the message.

It is the way things move that is important. Marshall McLuhan, in his book *Understanding Media* theorized, "The medium is the message." By this he meant that the medium used to communicate a message is as important as the message itself; that the medium in which a message is presented has as powerful an impact as the meaning of the message itself. Motion designers need to be as concerned about how visual elements move as they are about the type and the images of the message itself. Motion design is as much about speed, rhythm, pacing, choreography, and movement as it is about effective type and image choice, size, color, and placement.

When type, images, and audio are combined with motion, the expressive potential of the Web dramatically expands. Type and elements moving rapidly across the screen signify urgency and dynamic vitality; elements moving slowly across the screen visually convey dignity, reserve, and perhaps even deliberation, depending on typeface choice, placement, and visual relationships to other elements. Audio lends a complex richness to the experience, as melody, rhythm, duration, and intensity enhance the communication. Choreography of motion and audio elements is key; a crescendo moment, for instance, falls short when the music clip ends seconds before the images do.

Motion, employed creatively, can enrich the interactive experience, especially to provide better feedback for users. Feedback is important because it tells the user that an action or a request has been initiated: it tells the user something is happening. Instead of two- or three-state rollovers where elements simply change color (such as a text link that swaps from blue to red when the

pointer rolls over it), the motion-enhanced rollover might instead feature an animation. The animation may be of anything—expanding menus, paragraphs of text, a video clip, or a combination of all of these—that further explains and enhances the text.

Perhaps the most exciting and rich aspect of motion is its potential as a global language. The Web is a global medium, and once a page is posted on the World Wide Web, it is available to any computer connected to the Web, regardless of location. Although the text on the Web pages themselves is in a specific language, the way elements move onscreen can communicate some essential core of the message, especially if designers reach to build a global motion language of symbols and movement. The development of an international motion language is a long way away, although there are some symbols in use in other visual applications (such as airport signage) that could form part of a global visual language. We are not there yet, but we might be in the future. Given the economic potential of a global visual language to support international marketing, it is worth the attempt.

Focus on the Essentials

Effective motion design, like effective print design, is dependent on a designer researching the problem and developing a visual form that clearly communicates. Deconstructing the problem to find its essential core is crucial to avoid gratuitous and inessential special effects. The Web is rife with agonizingly long intro pages filled with Flash special effects. These long intros seem to exist to show off the designer's virtuosity and control of the software, but display little in the way of communication insight. Even worse, complex Flash pages can take a considerable time to download, which further hampers their ability to communicate—users are inclined to move on to another site rather than sit through a long download. Stripping away layers of unnecessary bells and whistles focuses on the essential, communicates the message more clearly, and speeds up download time.

Focusing on essentials also means paying attention to the details. Alignment, consistency, and unity are as important in Web pages as in printed pages, maybe even more so. Even slightly misaligned elements seem to jump and shimmy in a motion design. A moving line, for example, that shifts even one pixel for a split second attracts immediate attention. The human eye has an incredibly sophisticated ability to catch even slight variations of alignment in moving elements. Stringent attention to alignment of visual elements is an absolute necessity.

Using colors, images, and typography consistently establishes a visual style and strengthens unity. In Web sites that contain a lot of motion design, reuse of motion elements throughout the pages also offers the pragmatic benefit of speeding up download time. For example, a site that reuses a Flash motion element in a standardized navigation bar placed on multiple pages will download faster than a site that uses completely different motion elements on each of its pages' navigation bars. The download speed advantage comes from the fact that once the motion element downloads, it resides in cache memory; when the user links to another page that also uses that element, it displays quickly onscreen with no need to download the data again. A reusable library of visual elements thus strengthens visual consistency and offers greatly improved download speed. Such attention to essential technological details is as much an integral part of the motion designer's task as designing attractive visuals.

Pay Attention to the Technological Limitations

The technical environment will always have limitations, especially when compared to the imagination and high expectations of designers and users. It is in our nature to always want more from our experiences, including interactive, motion-design ones. These technical limitations change as the technology to create and distribute Web content evolves, but they will always exist, just as there will always be creative individuals striving to push the envelope of what is possible in any medium.

Although the availability of broadband communications continues to improve, primarily in urban cities, much of the rural United States (as well as the rest of the world) is still limited to the 28.8K and the 52K modem. One of the basic principles of interactive design is to design to the lowest common technological denominator; therefore, these modem speeds still have to shape the motion designer's work. Ignoring the rest of the world in favor of a relatively small number of high-tech broadband users is a mistake—and in business, a potentially costly one.

Another limitation (or opportunity, depending on your viewpoint) is the rapidly growing medium of wireless communication, such as wireless phones and personal digital assistants. Small in screen and graphics capabilities, wireless communication devices currently offer little support for motion graphics, and are heavily dependent on text-based Web pages. This limitation will certainly change along with the wireless communication technology. Still, the point is that technology constantly evolves, and so too must a motion designer's body of professional knowledge.

Even the most technologically savvy motion designers, if they want to create clear communications, must ask these two key questions: "How can I simplify this message so it will communicate better and faster?" and "How can I focus the motion and visual elements in the message to make it download faster?" Focusing on what is important and sticking to a visual plan are critical, because of the severe limitations on the amount of data that may be transferred across limited bandwidth. Successful simplicity does not necessarily mean a lack of images, or even forgoing special effects, but it does mean that the motion designer must develop a stringent plan and stick to it. The designer has to look for the possibilities and use them to the best advantage to deliver a meaningful message to the user.

Be Aware of User Habits

Delivering a message to a user requires some understanding of what users will and will not wait for. The novelty days of the Internet and the Web, when people would wait 10 or more seconds for a visual to download, are gone. Nowadays users expect—no, demand—quicker delivery. If a motion design does not download in five to ten seconds, most users will simply move on to another site. That wait time may shrink even further in the future.

A motion designer may create the most evocative, visually intriguing communication piece ever in the history of all humankind, but unless it downloads quickly, most of the intended audience will not receive it. Sites with excessive bells and whistles and heavy "wow" factor also risk user avoidance: if the site is difficult to understand or navigate through, the user will not bother.

A Different Breed of Cat

Motion design thrives on innovation and exploration. The medium as it exists on the Web is in constant flux, with software offering increasingly sophisticated motion techniques. Designers who express concepts through emotion and motion take on a tall task, and are a different breed of cat. The characteristics of a successful motion designer are driving curiosity, flexibility, adaptability, and the courage to say, "I don't know how to do that … but I'll find out." Motion designers, because of the relentless advance of technology, are constantly challenged by changing parameters, changing technologies, and the everpresent risk of failure. They also understand that taking on the risk of failure is a powerful learning tool. Despite these challenges, the communication potential of motion is real, exciting, and as of yet unrealized, leaving plenty of room for adventurous, energetic motion designers to define the medium and their expressive place within it.

Postscript

Collaboration

This book was intended all along to be a collaborative effort, the work of a community. That project is our final one. In today's digital design world, the need and the opportunity to collaborate require new skills and attitudes of today's creative teams. It takes patience and practice to get them right.

It is indeed unfortunate that humans do not come into this world with a user guide. The complexity of interpersonal skills, the ability to embrace all that life has to offer, and the survival skills requisite for happiness are hard-won at the very best. And yet, it is conceivable that it is the attempt to acquire those skills that gives life meaning.

Teaming

Successful teaming builds on a foundation of basic respect for ideas, history, and craft. It proceeds through the refined verbal skills of listening, presentation, and constructive criticism. It develops the abstract skills of organization and planning. Life experiences and relationship skills add clarity to creative problem solving, help define personal identity, and build self-confidence. Becoming a designer takes self-knowledge and a certain willingness to take reasonable risks.

The new patterns of economic production and distribution and the technical advantages of the Internet have help to create a broader, cross-cultural outlook for managing systems. Strategies stretch over continents, markets are infinitely diverse, and production and distribution schedules are complicated by geopolitics. Out of the increasing complexity has emerged new ways of thinking about how all the pieces fit together. Bottom-up perspectives, scenario planning, and think-tanking skills are requisite to achieve business goals in a future that is nothing less than volatile. Business moves at the speed of fiber optics to take advantage of unexpected opportunities and in response to unpredictable system failures. Designers have to run to keep up.

How to

There are some tools that can help in this faster-than-yesterday demand for effective visual communication design. Design teams need to hone their skills in the heat of demanding production schedules. Every project has both inside and outside limitations. Outside limitations include budget and project timeline. These must be well defined by the client and refined by the experience of the art director. The art director or project manager should be keenly aware of the skill sets available in the design team, know a multitude of services that can turn projects around at a moment's notice, and understand the financial pressures that the client works under. Helpful guidance to achieve goals on time and under budget is the way the project manager can educate the client.

Inside limits include the array of talent in the design team and the art director's effective division of labor. More importantly, the art director must infuse the design team with shared goals and motivation. Leadership is a talent in and of itself. It comes from a real interest in the project, good listening skills, and the ability to carry a good deal of the load. Managers should not expect more dedication to a project by their team than they themselves are willing to give.

Think-tanking is an effective way for everyone on the team to have input, share goals, clarify objectives, keep everyone on the same page, and talk through various scenarios. A good way to make this happen is to have an "open easel": a centrally located drawing table with an unlimited supply of paper (perhaps on a roll), where all the design team members can jot down ideas, develop sketches, and create a visual record of the trajectory of the project. Consider this a collaborative thumbnail. Treat it with respect, and it will help bring the team together and keep it focused, vital, and productive.

Thanks to All!

As this project took shape its form and content could not have come into this world without the dedication and inspiration of the following people:

A special thanks for all the support and encouragement to my wife, Karen Dillon and my brother, Jonathan Pite. Thanks also to all the folks at On Word Press who made the publication of this text possible: James Gish, Jennifer Thompson, Mike Prinzo, Thomas Stover, and Jaimie Wetzel.

Contributors

The Faculty

Lisa Abendroth,
The Metropolitan State
College of Denver

Osman Akan,
The Katharine Gibbs School,
New York City

Stace Asher,
The Metropolitan State
College of Denver

Michel Balasis,
Loyola University, Chicago

Ravinder Basra,
Savannah College of
Art and Design

Petronio Bendito,
Purdue University

Laura Boutwell,
The Katharine Gibbs School,
New York

Edwin Cuenco,
University of Texas,
Pan American

Doug DeVita,
The Katharine Gibbs School,
New York City

Fashion Institute of
Technology, New York

Karen L. Dillon,
The Katharine Gibbs School,
New York City

Paula DiMarco,
California State University,
Northridge

Dominic Gebbia,
Briarcliffe College

Lisa Graham,
University of Texas at
Arlington

Michelle Hadjopoulos,
The Katharine Gibbs School,
New York City

Elzbieta Kazmierczak,
SUNY Buffalo

Gary Keown,
Southeastern Louisiana
University

Stephen Klema,
Tunxis Community College

George Lim,
Rocky Mountain College of
Art and Design

John Meza,
Marywood University

Linda Pages,
International Academy of
Design and Technology

Tim Pahs,
University of Wisconsin,
La Crosse

Barbara Polh,
Briarcliffe College

Guido Porta,
Northern Virginia
Community College

Anne Powers,
Roane State Community
College

Mary Quarte,
Brooks College

Brian Slawson,
University of Florida

Jeff Sheppard,
Rocky Mountain College of
Art and Design

Curtis Steele,
Arkansas State University

Bill Thrash,
Trident Technical College

K. L. Thurlbeck,
The Katharine Gibbs School,
New York City

Anna Ursyn,
University of North Colorado

William Wolfram,
Concordia University,
Nebraska

Donnita Wong,
The Metropolitan State
College of Denver

Nancy Wood,
San Antonio College

The Students

Susan Alderman

Melissa Adkins

Sony Agrawal

Marissa Arellano

Bethany Ash

Tara Babich

Lukasz Bagan

Carlos Baquedano

David Bain

Miriam Baker

Guadalupe Barba

Clint Barnes

Susan Barron

Nickolas Bartlett

Chris Barron

Kara Beaver

Rita Benembarek

Aaron Bieber

Barbara Bielawski

Michelle Bisson

Matthew Blackford

David Blain

Seth Boggs

Tracey Bond

Alberto Bonello

Kristina Bosian

Brady Bowers

Jennifer Brown

Jamie Burkhalter

Jean Campas

Aaron Cantu

Michael Casanova

Alejandra Cerda

Judith Champagne

T. Cheesman

Kazimiera Cichowlaz

Marie Clanny

W. Stanley Conrad

Carla Corneille

David Correll

Sandra Couture

Ryan Cox

Mike Creighton

Rachel Cua

Theresa Cyr

Mike Davies

Aundra Davis

Rachel Davis

Enrique De Anda

Edward De Los Reyes

Jessica DeMichiel

Paula DiMarco

Jason Disalvo

David Dolek

J. Patrice Doolittle

John Duckworth

Joel Duffield

Carl Fay

John Floyd

Rachelle Franco

David Fuka

Abraham Fernandez

Marissa Garza

John Gattas

Charles Glanovsky

Gerardo Gorena

Cinthia Gorman

Angela Gregerson

Philip Grey

Adrian Guerrero

Matthew Haag

Benjamin Harwell

Christopher Harris

Kacy Hendrickson

Monica Hernandez

Jordan Hillyard

Dana Horan

Sherri House

Emily Hoyt

Petra Hromaova

Chess Hubbard

Jennifer Jacobs

Ryan Jenkins

Sarah Johnson

Talia Johnson

Alex Jonas

Jacky Kallberg

Thomas Keeley

David Kindvall

Christian Klahr

Jennifer Kloster

Thurston Kloster

Alvina Khromova

Wan-I Lai

Joe Lamarra

Mark Landry

Tara Ledesma

Calvin Lee

Rachel Leising

Pamela Lence

Richard Letterio

Jessica Lewis

Luis Licerio

Matt Lucas

Anthony Lupo

Zach Long

Albert Lopez

Cristobal Lopez

Cinnamon Lowe

Ramiro Lozano

Edward Ludington

Yolanda Luna

Jeremy Maendel

Scott Magrath

Manop Manaslip

Steven Martinez

Genevieve Mayer

Laura McCloskey

Eric Michael

Regina Miller

Damaso Navarro

Ritsuko Nakane

Camilla Nilsson

David Oldenberg

Nataya Pangapokakij

Christopher Parisi

Katrina Peerbolte

Phanas Phokthavi

Jason Powers

Cynthia Pulling

Brandon Quinn

Aaron Reiter

Josh Roberts

Rocio Rincon

Jeanette Rivas

Kalene Rivers

James Russo

Jennifer Russo

Robert Santiago

Stephen Sanderson

Betsy Sargent

Rolando Segovia

Rebecca Schnackenberg

Todd Shanefelt

Perry Silverman

Bryan R. Simpson

Naomi Smith

Sarah Sobkowiak

Lauren Sollberger

Cory Sova

Ron Stafford

Leah Standley

Anna Stellitano

Theresa Stevens

Mel Sul

Charles Theobald

Elizabeth Todari

Angela Torrence

Ramiro Torres

Steve Trujillo

Stephen Turner

Marzena Tutak

Connie Ueng

Mitzi Vaughn

Wilson Vientos

Her Vue

Erick Weitkamp

Jennifer Whitcomb

Cory Whitlock

Jerod Wilson

Jen Wise

Mary Beth Woiccak

Daniel Woodruff

Woon Yong

Rachel Ziegler

Toni Zotto

Margaret Zurowski

Index